Sex at Work

Attraction, Orientation, Harassment, Flirtation and Discrimination

Mari Florence

with Ed Fortson

SILVER LAKE PUBLISHING
LOS ANGELES, CALIFORNIA

Sex at Work
Attraction, Orientation, Harassment, Flirtation and Discrimination

First Edition, 2001
Copyright © 2001 by Mari Florence and Silver Lake Publishing

For a list of other publications or for more information from Silver Lake Publishing, please call 1.888.663.3091. Outside the United States and in Alaska and Hawaii, please call 1.323.663.3082.

Library of Congress Catalogue Number: pending

Mari Florence with Ed Fortson
Sex at Work
Attraction, Orientation, Harassment, Flirtation and Discrimination
Includes index.
Pages: 342

ISBN: 1-56343-737-6
Printed in the United States of America.

ACKNOWLEDGMENTS

I have to thank Jim Walsh, the publisher of Silver Lake, for persuading me to take on this project. While I've certainly had a love/hate relationship with this subject, it was Jim who kept it fresh and exciting.

Writing a book like this is always a collaborative process. Despite the hours spent alone reading over legal cases and attempting to dissect them, it is the meaningful conversations with close friends and colleagues that help your thoughts and opinions to gel. Simply put, I could not have completed this book without the hard work, friendship of and insights from:

Ed Fortson, who offered his research and writing skills, and great insights into why the business world can, yet does not, deal properly with these issues;

Megan Thorpe and Kristin Loberg, who took my germinating ideas and created true, cohesive thoughts that formed the backbone of this book;

Nina Wiener, who not only helped me set a foundation for this book with her research, and was a thoughtful sounding board throughout the project;

Dennis Sandovalinares, who, without much guidance, jumped into this project as research assistant and helped to uncover issues I never knew existed;

Deborah Churchill-Luster, who as always, was my greatest cheerleader;

Buck Winston, who religiously drank martinis with me at 410 Boyd and constantly reminded me of the bigger picture; and

Cord Nuoffer, who lovingly gave me the space and time to think.

Mari Florence
Los Angeles, California
November 2000

TABLE OF CONTENTS

People, Politics, Policies and...Sex

> The real social impact of workplace behavior often depends on a constellation of surrounding circumstances, expectations, and relationships which are not fully captured by a simple recitation of the words used or the physical acts performed. Common sense, and an appropriate sensitivity to social context, will enable courts and juries to distinguish between simple teasing or roughhousing...and conduct which a reasonable person would find severely hostile or abusive.
> —Supreme Court Justice Antonin Scalia

Sex is a word that draws attention, regardless of whether it refers to the physical act or to the identity of a person's gender. From the first time we learn about sex, humans intuit more than one definition and many images—good and bad. (And even the terms *good* and *bad*, when referring to sex, are subjective.)

Sex is about procreation and the evolution of mankind. Sex is about human drives, instincts and the behaviors that define our lifestyles. Sex is about gender and its role in society. Sex is a defining part of most systems of morality. Sex is about anything you want it to mean, so long as it pertains to human nature and the conditions that define who we are.

Sex is inevitably, confoundingly, endlessly political.

This book explores sex in a particular setting—work—and looks at the reasons why sex is such a stubborn issue there. More specifically, it looks at the reasons why some people want the law to police sexual behavior…when the law prefers this duty to remain with private individuals. It's an axiom among lawmakers that you can't legislate mo-

rality. Yet workplace regulations and popular politics try to do just that.

In the early 1990s, Anita Hill seemed to set the political standard for sex at work matters when she testified before the U.S. Senate about Supreme Court nominee Clarence Thomas's inappropriate workplace behavior years before. Allegedly, he had asked her out, talked about X-rated movies and joked about a pubic hair on a Coke can while he was her boss at—ironically—the Equal Employment Opportunity Commission.

Hill, an articulate and educated law professor, brought to the public consciousness a topic that had previously been filed away in the "happens to other people" file. Thomas was forced to make the unenviable argument that he hadn't forced himself on Hill and that her career hadn't been adversely affected. These arguments outraged political partisans who said that Thomas had explained vast power differentials between Hill and himself and that the Senators "just didn't get it."

The country was riveted to its televisions, listening to Hill's accounts of Thomas's behavior…and Thomas's logically dodgy (though ultimately successful) rebuttals. The Senators, following party lines, prodded and poked Hill and Thomas. The whole episode opened personal matters to public scrutiny.

A decade on, Clarence Thomas—having survived Hill's charges and made it to the Supreme Court—sat in judgment of a President charged with inappropriate sexual behavior in the workplace years before. Bill Clinton was being sued by Paula Jones. Jones claimed that, when Clinton had been Governor of Arkansas and she had been a state employee, he had invited her into a hotel room, exposed himself to her and asked for sex. (She said no.)

The political lines had changed. Some partisans who had supported wide-ranging definitions of *sexual harassment* during the Thomas/Hill hearings now argued that Clinton's alleged behavior was no big deal. Clinton hadn't forced himself on Jones…and her career hadn't been adversely affected by the episode.

Clinton ultimately settled with Jones, paying her almost $1 million to drop her case. By that time, though, he was embroiled in other sexual scandals. Although White House intern Monica Lewinsky's alleged Oval Office trysts with Clinton were consensual by her own account, they appeared to involve the sort of vast *power differentials* between participants that some legal theorists argue preclude valid consent. The charge from another woman, Kathleen Willey, that Clinton kissed and groped her when she came to see him about a job, had overtones of simple quid-pro-quo harassment.

In the wake of all these allegations, Clinton's defenders insisted that his problems were fabricated by a "right-wing conspiracy" designed to besmirch his reputation. In his time, Clarence Thomas had likened the actions of his opponents to a "high-tech lynching." It's important to point out that both men survived the allegations with their careers intact. Clinton's legacy, however, will always be blemished.

Although political partisans will cry havoc or yawn boredom according to their allegiances, the issue of sex at work couldn't be more vital today. As companies and institutions incorporate rules and guidelines to manage sexual behavior in the workplace, they tread a thin and politically charged line. They intend to instill more responsibility in their employees; they risk creating absurd bureaucracies that only make matters worse.

Sex isn't *just* politics, though; it's psychology, too. Over a hundred years ago, Sigmund Freud tried to make sense of human behavior in a sexual context—and fathered the modern psychoanalytical movement. His work attempted to understand the human psyche, its development and all of its consequential drives.

For Freud, the human being is in perpetual conflict with itself, torn between animal nature and cultural ideals. He recognized that we are discentered and unknown even to ourselves. How we act—alone or in the company of others—and how we respond to or internalize our perceptions are products of our upbringing and environment. And, most importantly, the evaluation of our actions is by necessity highly subjective.

Not even Freud could formulate a scientific method by which we can discriminate right from wrong when it comes to sexual behavior. That is why law that governs human sexual behavior effectively is difficult to come by.

Whether or not someone agrees with Freud's theories, it is hard to deny that psychology underlies sexual behavior and the ways we fumble with its management. The purpose of this book, however, is not to extrapolate the psychology behind peoples' sexual behaviors; it is to explore today's workplace dynamics—where negative images of harassment and discrimination twist knots into the pure, primal image of sex.

Serving as the backdrop to our study will be relevant (albeit, broad) laws, including the Civil Rights Act of 1964 and 1991; important court decisions dealing with privacy, discrimination and harassment; and dominant cultural issues.

This book is about more than just quid-pro-quo harassment or harassing environments. The ongoing debate over society's proper treatment of consensual sex, adultery and same-sex marriage cannot be neglected. Such debates form tomorrow's laws.

According to a survey conducted by *Working Woman* magazine, a typical Fortune 500 company loses $6.7 million per year in absenteeism, low productivity and employee turnover resulting from on-the-job harassment. The National Organization for Women (NOW) reports that 50 to 75 percent of employed women will experience sexual harassment on the job. Exactly what *is* sexual harassment? Moreover, when do subtle hassles become severe problems? These are some of the complex questions that need definition—even before they need answers.

While on-the-job harassment hurts corporate bank accounts, managing and preventing unwanted behavior can be costly, too. People want protection from the next offender—be it a colleague, a corporation or an employee who threatens a lawsuit; but they also want entitlement to their own personal life. Roughly half of today's romances at work lead to lasting relationships or marriage, according to a survey conducted by the American Management Association.

Finding the balance between regulating behavior and respecting one's privacy or freedom when it comes to one's own sexual life is a key social issue. And a challenge to corporate America's employment policies.

We live in a culture that is profoundly confused about sex. This, as we will see, sets the stage for a conflict of interest that cannot be comforted or compromised by the law. When it comes to issues of sex at work, too many variables exist for laws to govern definitively. Our ambitions at work spill over into our personal lives; colleagues become friends and companions, and the line between our professional and personal lives vanishes. A level of risk enters the arena when we allow this to happen, and there is no reason why we shouldn't be able to control our own actions if we accept the risk.

Despite our urge to keep sex and its related issues at home or in the bedroom, sex has come to play a major role in our daily, working lives. Here is where the ideals of our culture (i.e., working harder) and that of our animal nature (i.e., searching for sexual attention), create an eternal conflict. And, despite our want to place limitations on sex, we find ourselves entangled in its web, which is persistently woven by basic human behavior.

Sex sells blockbuster movies, bestselling books, magazines and tabloid journals. Sex can jumpstart a person's career...or cause it to fall apart. In an historical context, the topic of sex at work has been slowly building over time—through civil rights and feminist movements to legal proceedings like Clarence Thomas's and Bill Clinton's. Never before have we felt more comfortable talking about sex at work, perhaps because the course of history has immunized us from its taboo. Or, perhaps we've been groomed by history to accept the changes that have taken place in the workforce. Ironically, however, this acceptance has done nothing clarify the issue.

Sixty-one million women directly influence the American workforce today; gay and lesbian rights fill legislative proposals; and social conditions constantly shift expectations and circumstances between the sexes. In comparison to when Freud did his work, our tolerance for the present socio-sexual status at work is enormous. Nevertheless, af-

ter two generations of law, politics and business practices aimed at balancing the roles that men and women play in the workplace, sex remains a major controversy.

Pivotal questions remain: Are there practical differences between equity feminism and more extreme gender politics? Can a company rightly fire an employee for having an adulterous affair? Will corporate America lead the way to recognizing same-sex marriages? The challenge is to rethink our attitudes about sex so we can work maturely and productively, while still vying for certain inalienable rights.

High-profile cases give the impression that sexual harassment, gender bias and discrimination are rampant in the United States, when in truth, the type of abusive actions that foster a hostile work environment comprise a small fraction of workplace interaction. Nonetheless, those actions—committed by a nasty few—have set a tone for dating and interpersonal relationships in thousands of companies across the United States.

Popular notions of sex have us believing that it dictates our working lives. If you don't think this is true, go and peruse the covers at any magazine stand. Urban myth has sex breeding litters of lawsuits and has companies settling harassment and discrimination claims right and left—as a result of common office interactions. Today it is common to think that, if sex is abused or if we are wronged by issues of sex, we can sue for damages and make a lot of money. To the contrary, looking closely at what conditions characterize sex at work and what standards must be met in a court of law, we see that these claims are hard to make. With the exception of rape or murder, the law refrains from policing and punishing most human sexual behavior.

Some Personal Notes

Like most women my age, when I think about the event that pulled sex at work out of the dark corner and into the mainstream spotlight, the first thing that comes to my mind is the Clarence Thomas/Anita Hill hearings in 1991. Hill's allegations against Thomas made sexual harassment part of our national dialogue. The image of a poised, educated woman being barraged with intimate questions by the largely male congressional panel hit a nerve with most Americans.

In researching this book, I encountered hundreds of situations and cases that pointedly describe the universal challenge of managing sex at work, as well as the untold ways of defining sex and its role. Recent case law shows that profanity, crude jokes or even the occasional sexual comment aren't enough anymore. In essence, the courts refuse to create a new code of politeness in the workplace. As such, I will provide you with some tools for handling sexual attraction at work and how to maneuver when you think another's actions have overstepped the boundaries of reasonable conduct.

From romance to rape, sex at work deserves more attention than one book because so many angles and perspectives intersect at once. But this book analyzes the issues from both legal and business angles. A consistent theme will emerge that business people—and people in general—can use to harmonize a confusing array of sexual mores and motives. Solutions don't reside in laws or courts; they rest in the way that each individual handles his or her sex life and impulses, and in the way that companies and institutions encourage responsible attitudes.

The cases I have chosen as focal points in each chapter deal with particular issues that relate to the overall picture of sex at work. They will allow us to frame this present-day picture with respect to legal definitions, rights, assumed responsibility, company policies and the elusive right to privacy. (In fact, privacy deserves its own chapter because it is such an important concern today, and whether we like it or not, privacy is frequently sacrificed when it comes to sex at work.)

Given this framework, we will take a step back and resolve the picture with an enlightened perspective. We will look at sex at work from its simplest terms of attraction and flirtation, to the complex manifestations of harassment, discrimination and orientation.

In our final look at this picture, the disconnect will remain between how popular culture perceives the role of sex in our lives—from the boardroom to the bedroom—and how the law interprets sex for the purpose of settling claims. There is no way to rectify this disconnect, short of tolerating certain behavior and knowing when the law can provide some clarity.

Part One:

Sex

Discrimination

In the ten years since Anita Hill sat before Congress, the terms *sexual harassment* and *gender discrimination* have catapulted to the forefront of public consciousness. These terms, often used interchangeably, describe a vast range of gender-related interactions from the trivial to the truly reprehensible.

Sexual harassment is just one of several forms of sex discrimination. Discrimination can also include issues of equal pay for equal work, equal access to jobs, promotions and career tracks, wrongful demotion or termination, and issues surrounding pregnancy and the balance of family and work. Men may also face sex discrimination.

Whether you're an employer or an employee, and no matter the size of your organization, you need to learn to recognize, combat and eliminate sex discrimination. This begins with prevention. Of course, this idea is easier said than done because the forms and meanings of sex discrimination seem to multiply and mutate with virus-like speed and perniciousness. Just when we think we've identified every method of discrimination and begin to prepare vaccines, another form—and another infected group—pops up, more complex and even more difficult to combat.

The Ninth Circuit U.S. Court of Appeals decision *Jennifer L. and Charles Passantino v. Johnson & Johnson Consumer Products, Inc.* serves as a classic example of how employees, employers and the courts go to great lengths to define—and interpret—sex discrimination. Often, the effects of sex discrimination are subtle and hard to identify.

Jennifer Passantino began working for Johnson & Johnson Consumer Products Inc. (CPI) in 1979. Over the next 18 years, she rose through the ranks at CPI to become one of its most successful female managers, and was characterized by executives as "a leader in her field."

In 1988, with several promotions under her belt and CPI's permission, Passantino relocated to Tacoma, Washington. In 1989, she was promoted to National Account Manager—a position she held for the remainder of her employment with CPI.

Passantino sold approximately $12 million in product annually (within a division with total sales of $48 million). But her success was all the more remarkable because she worked extensively in CPI's military division, characterized by one of its own executives as an "old boy network." Despite this success, Passantino's career prospects deteriorated rapidly after she complained that her advancement within the company was being limited by sex discrimination.

Passantino testified that she was on the "developmental" path, which is the career path for employees within sales who are in line for executive and management positions. Adding to her eligibility, her performance reviews were consistently "outstanding" and "above average."

For example, her 1992 performance report read in part:

> Jennifer demonstrates very strong selling skills, organizational ability, and good business judgment. She has developed the sales and promotional plan for Key Accounts, generating $12 million in Johnson & Johnson annual volume.

It added that she was "well-qualified" and should be "strongly considered" for promotions within CPI's parent company, Johnson & Johnson. In fact, as the Western regional manager, Passantino was rated the employee with the greatest promotional potential in her division.

But the company's method for determining who was to advance within the company was neither systematic nor fair. Instead, employees were promoted through what the trial court would later call "the worst

kind of a good old boy system that allowed discrimination and discouraged reasonable questions about the promotion process."

Despite her qualifications for promotion and a string of positive reviews, Passantino began to suspect that—because of her sex—she had been passed over for several promotions for which she was qualified. Several events gave her reason to suspect discrimination.

First, her supervisor—despite his generally good reviews—exhibited sexist behavior. He referred to women buyers as "PMS," "menstrual" and "dragon lady." He also stated that most women probably just wanted to stay home. In addition, Passantino said that two coworkers also had a condescending attitude toward women.

Most importantly, during her 1993 performance evaluation meeting, Passantino's supervisor told her that she should consider looking outside the company for employment because he did not believe that either the company or his boss was committed to promoting women.

In 1993, both Passantino and Jackie Upshaw, the only other female manager in the military division, voiced complaints about the behavior of the men in her division. Following their complaints, however, the offensive behavior of all three men increased both in degree and frequency. In addition, at Passantino's subsequent performance evaluation meeting, her supervisor gave her a low rating for "relationship with peers." Coincidentally, the coworkers who bore equal responsibility for the problems between them and Passantino, did not receive a reduced performance rating for relating with peers.

From this point on, Passantino felt she was slighted when trying to speak, and was the subject of derision generally. Coworkers rolled their eyes at her suggestions, side-bar conversations took place among other managers that excluded her. In short, after Passantino complained, she was no longer taken seriously.

In 1994, her opportunities for advancement appeared to close down even more. Following Johnson & Johnson's reorganization, Passantino expressed interest in a sales administration manager position, but she was not interviewed for the job and the position was filled by a male

coworker. And, in October of that year, Passantino learned about three newly-created positions. However, these jobs were filled, before she had a chance to apply and, without being advertised openly. The men who filled the positions included two whom she had complained about and one from outside the division.

In November 1994, Passantino contacted CPI's Equal Employment Opportunity (EEO) officer and was warned several times that if she made a complaint, she would have to "live with the burden of coming forward" because the decision to complain "could have many ramifications." In spite of these warnings, Passantino formally complained to Doug Soo Hoo in the Human Resources Department.

Without revealing Passantino's identity, Soo Hoo offered to perform a salary analysis in order to see if there was any truth to her suspicion that she was being paid less than similarly-situated male workers. However, Soo Hoo never provided her with the results of his inquiry and in December 1994, Passantino decided to lodge a formal complaint.

In response to her complaint, a meeting was held in New Jersey with Soo Hoo, Passantino's supervisor, John Hogan, who was Vice President of Sales, Passantino and Ruth Hague from the Employee Assistance Program. Passantino recounted her complaints and her supervisor responded that the military market was an "old boy network" in which it was hard for women to be successful. He also asked Passantino directly if she thought he was a sexist.

At a second meeting in February, Passantino was given a good performance review and told she was qualified for a number of promotional positions. Then, Hogan told Passantino that a salary analysis had revealed no discrepancies and no discrimination.

Although Passantino never saw this analysis, a salary analysis document was placed in her personnel file. This document falsely reported that one of Passantino's colleagues (about whom she had complained) received an excellent performance rating of "5," while in fact he had received a "4." Another performance review in the document similarly misrepresented another male manager's performance rating. Passantino asserted that these ratings were fabricated in order to jus-

tify the fact that these male workers were better paid than she. Apart from this, her complaints were not addressed.

At a subsequent division meeting, everyone was told to "shape up and act professional" or they would be "off the team." Both Passantino and Upshaw claimed that they understood this to be a public rebuke of them for their complaints. According to the women, they felt that they were being told that if they did not shut up they would be fired.

Passantino, unsatisfied with CPI's response to her complaint, informed them of her intentions to seek private legal counsel and filed an EEOC complaint in June 1995. Thereafter, Passantino experienced what she believed was a range of retaliatory acts by CPI, making it nearly impossible for her to perform her job effectively. Job responsibilities (such as her training duties) were removed, accounts were transferred to other employees without notice and she was no longer included in division managers' meetings, such as those concerning development of the division business plan. In addition, her performance objectives were reduced (which, according to her testimony, indicated that she was considered less capable than before her complaint) and her job title was changed (and then restored after she protested).

Passantino also testified that other actions were taken that ultimately undermined her performance. According to Passantino, her supervisor became distant and communicated less with her, she received product and sales information late...and she lost out on bonuses (including an award trip) and sales opportunities as a result. Passantino also stated that her supervisor made comments demeaning her participation in the policy groups that she had joined, even though she had joined them upon his suggestion, in order to enhance her advancement within the military division.

Passantino provided evidence to prove that, prior to her complaints, she had been regarded as well-qualified for promotion into upper management. After her complaints—particularly the "public" EEOC complaint—however, it was a different story. Passantino was told that she would have to accept taking a step back in order to advance, and that she should accept a district manager job—the lowest position within her job grade. Her review also stated, for the first time in years, that

she was not qualified for a national account manager position. Her 1997 promotional assessment described her as "not to VP level," an obvious sign that, as Passantino put it, she was "losing ground."

CPI also retaliated against Passantino by offering her demotions, without always making clear that the jobs offered were below her current level. After initiating her complaints, Passantino received three offers of district manager positions. She rejected these jobs as demotions. Then, in August 1995, she was offered a national accounts manager position in Dallas. Although this would have been a lateral move, it would have been undertaken as a part of a test group, with the distinct possibility of layoffs in the immediate future. Passantino accepted on the condition that CPI guarantee her one year of employment, absent cause for termination, as insurance against the inherently risky undertaking. CPI refused.

In March 1996, Passantino rejected a district manager position in Los Angeles because it was a "step backwards" with no potential for salary growth (and a higher cost of living).

Passantino was then offered a demotion to a position as a sales administration manager, with a much lower salary range. In this position, she would have lost her company car, had no opportunity for commissions and would have had to live in a more expensive area. Passantino accepted the position, however, on the condition that she receive a year of guaranteed employment. Again, the company rejected her conditional acceptance.

Finally, Passantino rejected another position, which was a step back with no potential for salary growth. During the same period, Passantino expressed interest in a new military marketing position, and was told that she should not be interested in that position because it paid less, even though the position paid $20,000 more than the position she held at the time.

Ultimately, Passantino was told that because she refused to accept these district manager positions (which were demotions), she would not be considered for higher positions. She was also told that her decision not to accept the demotions meant that she could be deemed

no longer promotable. After August 1996, Passantino did not receive any further offers.

At trial, it was revealed that Passantino had been lied to about the level of a job she had asked about in 1996, a position that in fact would have been a promotion. Passantino was told that the position was lateral, or at the "same level" of the job she currently held, and that it was "not a promotion from where you're at today." However, corporate records showed that the job was actually Level 4, one level above her present level.

In January 1996, Passantino sued CPI in the United States District Court for the Western District of Washington for violations of Title VII and the Washington Law Against Discrimination. CPI immediately moved for a change of venue to New Jersey, which was denied.

Passantino testified that, as a result of this stressful series of events, she constantly worried, cried and felt trapped and upset. She felt she was forced to spend less time with her family because she feared she would lose her job, given that her performance rating had been declining. She suffered stomach problems, rashes and headaches that required medical attention. In addition, she sought counseling from her pastor. Most important, her advancement within the company was brought to a halt.

At trial, the jury returned a large verdict in Passantino's favor. It found that, although CPI had not discriminated against Passantino, it did retaliate against her for complaining about what she perceived as sex discrimination. The jury awarded her $100,000 in back pay, $2 million in front pay, $1 million in compensatory emotional distress damages and $8.6 million in punitive damages.

CPI moved to strike or reduce the punitive and compensatory damage awards; the trial judge agreed in part with the motion. The court reduced the punitive damage award to the $300,000 Title VII cap and affirmed the remainder of the award. (Title VII limits compensatory and punitive damages based on the size of the corporation. For an employee suing CPI, a company with more than 500 employees, damages are capped at $300,000.)

CPI then moved for judgment as a matter of law or, in the alternative, for a new trial or to amend the judgment; both requests were denied. The court awarded Passantino $580,414 in attorneys' fees, costs and expenses. CPI appealed.

The appeals court looked at CPI's policies, its management's behavior and the detailed history of the lawsuit. It couldn't agree with CPI's argument for overturning the award.

The "work environment" contemplated by Title VII constitutes a term, condition or privilege of employment. Therefore, "a cause of action [exists] for persons forced to work in an environment where sexual harassment has created a hostile or abusive atmosphere."

Passantino's multi-million dollar verdict represented success on a significant issue, which achieved a substantial portion of the benefit sought from the suit.

In the end, the appeals court declined to second-guess the district court's decision.

What Is Sex Discrimination?

Sex discrimination, in its most basic sense, refers to any situation in which a person or group of persons is mistreated or denied certain rights, access to or opportunities because of its sex. Title VII of the Civil Rights Act of 1964 makes such discrimination illegal, identifying discrimination against women as the primary problem.

But the issue remains complicated, legally. In the past, the Supreme Court has noted, "[t]he prohibition against discrimination based on sex was added to Title VII at the last minute on the floor of the House of Representatives.... [T]he bill quickly passed...and we are left with little legislative history to guide us in interpreting the Act's prohibition against discrimination based on 'sex.'"

However, as the court recognized in *Price Waterhouse v. Hopkins*, Title VII can be interpreted to include many forms of sex-related discrimination, so long as sex is *one* of the focuses of the discrimination. And,

"since we know that the words 'because of' do not mean 'solely because of,' we also know that Title VII meant to condemn even those decisions based on a mixture of legitimate and illegitimate considerations," the Supreme Court has concluded.

It's tempting to regard the blatant forms of sex discrimination as fossils of a past like segregated drinking fountains and lunch counters. Why not? Women now comprise 47 percent of the total workforce. Over 45 percent of management positions are now held by women (up from 26 percent in 1980.) The majority of small businesses are female-owned and more than half the students entering law school and medical school are women.

The statistics sound so great, in fact, that it's become common to hear the "enough already" grumblings from those who feel the pendulum has swung far enough—if not too much. And the courts have encouraged this response by considering the legality of affirmative action programs for women, which effectively discriminate against men.

But the old saying that the devil can quote Scripture to serve his own purposes certainly applies to these statistics.

Sex discrimination still casts a shadow over the American employment marketplace...and those of most developed economies. This may be a lingering effect of older problems. But the effects *are* still lingering. Consider:

- Only 3.8 percent of Fortune 500 top executives are women; and

- As of 1997, women still were paid 71 percent as much as men doing the same jobs.[1]

In short, there's still life left in some of these fossils, and some new forms of sex discrimination have sprung to life as well. For example:

- A pregnant woman is fired or put on unpaid leave because there's no "light-duty" work available for her.

[1]This statistic is technically correct but slightly misleading. Recently, sociologists have adjusted average incomes for variables like part-time employment among women and the fact that many leave the workforce for 10—sometimes 20—years to raise children. These women do not re-enter the worforce at the same level as their male colleagues who've been consistently climbing the ladder. Thus, when economists factor in things like education, workplace seniority and tenure, the gender gap tightens.

- A man working for the Jenny Craig weight-loss company is told that the only way he'll ever get promoted is "...if you have a sex-change operation and start wearing a push-up bra."

- A lesbian attorney is fired from her Georgia state government job when her boss learns she participated in a marriage ceremony (albeit non-legally binding) with her female lover. Current laws could not prevent her dismissal.

- A lesbian organization is sued when it ousts a transgendered (male-to-female) member for being too male and aggressive.

- A male airline pilot is fired after he has a sex-change operation. The courts uphold the airline's right to do so.

- A former Wal-Mart employee who acted as the Louisville, Kentucky, store's Santa Claus sues the company for gender discrimination after she was replaced by a male Santa. The mother of a child objected to having a woman Santa after her child reportedly pinched Santa's breast through her suit and said, "Mom, Santa Claus is a woman."

The above examples illustrate that women still face sex discrimination, and that the notions of sex discrimination have expanded to include any and all variations of sexual orientation imaginable—gay, lesbian and transgendered (including cross-dressers and the surgically altered from one sex to the other).

Understanding the iterations of sex discrimination in today's workplace is tricky. Should it be okay for Wal-Mart to insist on having a male Santa Claus? The company tried the female version, but children didn't go for the ruse. Is that a bad thing? What's next, female Santas refusing to wear a beard? Concentrating on such silly extremes detracts from legitimate discrimination issues. At the same time, however, dealing with the extremes may help us define and redefine what's important in our culture.

To understand how we got here with respect to sex discrimination laws, and to provide a basis for dealing with the shifting currents that new laws and court decisions are bound to stir, you'll need to become a legal scholar on both a state and national level.

Now, we'll take a closer look at the Civil Rights Act of 1964, the Equal Employment Opportunity Act of 1972 and the revised Civil Rights Act of 1991—and explore some court cases that determine how the antidiscrimination laws are applied and enforced.

In the Beginning...

Title VII of the Civil Rights Act of 1964 specifically prohibits discrimination on the basis of sex. The Act requires that applicants with like qualifications be given employment opportunities irrespective of their gender.

Several observers—including respected news analyst Daniel Schorr, the Washington *Post* and authors William Petrocelli and Barbara Kate Repa in their book, *Sexual Harassment on the Job*—suggest that the federal government's intervention in sex discrimination and sexual harassment issues occurred by accident.

The word *sex* was added to the list of categories protected by Title VII at the last minute, in a political maneuver that backfired. A group of congressional conservatives added the language prohibiting discrimination on the basis of sex because they thought it was so obviously preposterous that it would scuttle the entire bill when it came to a final vote. They miscalculated. Seriously.

The 1964 Act also created the Equal Employment Opportunities Commission (EEOC), which was set up to enforce the new laws. Today, filing a complaint with the EEOC is the first step in pursuing any gender discrimination grievance, including sexual harassment. However, the EEOC initially ignored the Title VII gender discrimination part of the law. The first Supreme Court decision involving gender discrimination came in 1971 with *Ida Phillips v. Martin Marietta Corporation*. The case dealt with the allegation by a woman that she had been denied a job because she was a woman with preschool-age children, while men with similar families were hired. It was an issue of discrimination rather than one of harassment.

Author Catharine MacKinnon is generally credited with coining the term sexual harassment—or at least popularizing it—in her book *Sexual*

Harassment of Working Women. But MacKinnon's book didn't appear until 1979. (The 1964 Civil Rights Act doesn't contain the term sexual harassment; neither do any of the original EEOC guidelines.)

As late as 1976, a federal court refused to apply the 1964 Civil Rights Act in favor of a woman who was held against her will and assaulted by her boss, then fired for refusing to have sex with the man. Rather, the judge stated that "a physical attack motivated by sexual desire" wasn't covered by Title VII simply because the incident "happened to occur in a corporate corridor rather than a back alley."

Interpreting the Act to our present understanding took years. And in those years, various situations played out in the courts—some of which made headlines and courtroom TV drama. In fact, it wasn't until 1980 that the EEOC—with a woman, Eleanor Holmes Norton, at the helm—finally identified sexual harassment as a form of gender discrimination forbidden by Title VII. The EEOC then incorporated regulations to illegalize workplace sexual harassment. Today, the EEOC's basic manual reads:

> Sexual harassment is sex discrimination not because of the sexual nature of the conduct to which the victim is subjected but because the harasser treats a member or members of one sex differently from members of the opposite sex.

It's also worth noting that gender discrimination claims have been filed and upheld when managers display stereotypical attitudes, not just for overtly discriminatory actions such as denying jobs or trying to pay women less.

For example, a manager or supervisor who consistently treats one gender in a verbally condescending, patronizing or belittling way may create a liability for the company if he (or she, for that matter) consistently treats the opposite gender with more respect.

In 1991, Congress enacted an updated version of the Civil Rights Act. Arguably the most significant aspect of the new act was that it sharpened Title VII's teeth by authorizing jury trials for cases. Moreover, it specified punitive damages between $50,000 and $300,000,

depending upon company size. Victims who prevailed in court could also recover attorneys' fees and others costs associated with their trials, over and above the punitive damages.

Under the 1964 Act, victims could recover back pay. The 1991 Act retained that feature but also made possible awards for emotional distress. It also took aim at discriminatory seniority systems. And, it shifted much of the burden of proof in discrimination cases to the employer.

Since the 1991 Act's new penalties for non-compliance, the number of Title VII claims and the size of jury awards and settlements have skyrocketed. Title VII has still not been extended to protect gays and lesbians, but it can help settle same-sex sexual harassment claims.

Subtle and Overt Results

The most overt result of gender discrimination is that employees are suing employers for a wide range of allegedly discriminatory practices and conditions. With this perspective comes the idea that employees are winning huge settlements or jury-awarded penalties. That's one of the most striking outcomes of the revised Civil Rights Act of 1991. The 1991 Act clearly increases both an employer's risk of being sued for discrimination and the amount of financial damage a judgment could do. The 1991 Act allows courts to compensate for such things as emotional distress and permits employees who win discrimination cases to recover expert witness and legal fees.

Of course, whether this is good news or bad depends upon which side of the lawsuit you're on. Either way, the statistics are striking: The EEOC reported that discrimination claims, including sexual harassment, rose 70 percent in the three months following the Clarence Thomas/Anita Hill hearings in 1991. Claims rose another 42 percent between 1993 and 1997.

At the same time, the average monetary award for employment claims such as wrongful termination and sexual harassment topped $300,000. Even if you just made millions of dollars on a dot-com startup, that's still a lot of money; and you're not in business to spend time in court making attorneys rich.

The costs of mishandling discrimination and harassment incidents have leapt higher than the NASDAQ in the 1990s. In 1997, a former executive for Miller Brewing Company won a $26.6 million jury award for wrongful termination. (This was the infamous "Seinfeld" case that revolved around the retelling of a sexual joke from a television show.) And the former executive had been the alleged *harasser*.

Particularly disturbing for corporations nationwide: In addition to the whopping judgment against Miller as a company, two Miller executives were also found personally liable for mishandling the incident. (For a more detailed discussion of this case, see Chapter 7.)

As recently as March 2000, the federal government agreed to divide $508 million among 1,100 women in the largest gender discrimination settlement to date. The women were denied on-air broadcast jobs and other positions with the U.S. Information Agency's radio unit, the Voice of America, solely because they were women. Worse still, the case has been dragging on for 23 years since the first complaints were filed. In the interim, the government lost 46 of 48 trials related to the case even though it had class action certification. Finally, to cut losses, the government decided to settle. But that means, in addition to the $508 million in damages, the government will also have to ante up some $12 million dollars in back pay and interest plus attorneys' fees. That's a hefty fine for taxpayers.

Researchers and psychologists are beginning to study the more subtle and destructive effects of gender discrimination, including sexual harassment. We'll delve into these issues in more detail in Chapter 2. The following is a list of some of the negative effects of sex discrimination:

- Financial and emotional hardship. For an employee facing discrimination, having to endure the travail is hard enough. But the personal and professional risks, stresses and potential damage involved in coming forward and pursuing a claim cannot be discounted.

- High turnover rates and loss of morale. Employees quit because they perceive that their advancement is blocked or denied be-

cause of their sex. This costs employers time, effort and money for hiring and retaining new workers. Employees' lives are often negatively impacted when they must face the uncertainty of changing jobs under duress. This leads to workplaces that are tense and unpleasant.

• Decline in productivity. Employees adopt a why-bother attitude when they perceive that hard work or excellence won't be meaningfully rewarded.

False Discrimination and Harassment Claims

Some advocates of repealing or restricting antidiscrimination law argue that sex discrimination has become a hotbed of false claims. This argument is hard to substantiate. In the end, it seems more a statement of social or political *zeitgeist* than real legal trend.

There's no question that an increased focus on sexual discrimination and harassment at work comes with its own bag of negative effects: tension, suspicion, uneasiness and outright fear among employees and employers. Sex discrimination is a high-stakes problem for all concerned. Companies face greater liability exposure for not dealing with complaints swiftly and justly. And, the 1991 Civil Rights Act coupled with recent Supreme Court decisions and state Fair Employment Practices (FEP) laws have raised the price bar even higher. These developments have also increased liabilities for not only employers, but managers and supervisors as well.

Some employees—and many managers—may feel as if they're walking on eggshells, afraid to say anything to anybody. This is because some companies have enacted antidiscrimination policies that go so far as to prohibit glancing at a coworker's body for longer than five seconds.

Furthermore, some men feel as if they're constantly and unfairly under suspicion. Since women are the likely target of discrimination and harassment, men are vulnerable to blame. Others feel unfairly disadvantaged by affirmative action programs that favor hiring and promoting women over equally or more qualified men. Add to that the

results from a recent *Time* magazine survey: 10.8 percent of women polled indicate they had engaged in sexual relations with their supervisors, and 64 percent of those said that career advancement resulted from their office affairs.

Of course, not all men are harassers and not all women sleep their way to the top of the ladder. But some men *do* harass; some women *do* sleep their way to the top; and a few men and women *do* use claims of discrimination and harassment for less than honorable intentions.

However, a report by the American Psychological Association found that the number of bogus claims was just 1 percent in 1997. Why? According to USC law professor Susan Estrich, who writes a monthly column, "Portia," for American Lawyer Media:

> Professional women have understood that bringing such a lawsuit, regardless of the chances of ultimate success, can be a career-breaking move, a lengthy pursuit of an uncertain remedy that is certain to brand the plaintiff as a troublemaker, or worse.

Catalyst, the nonprofit research group that has done groundbreaking work on women in corporate America, found that although the vast majority of women who left corporate jobs in the 1990s said they were leaving to spend more time with their families, their subsequent actions proved otherwise; only 15 percent of the women surveyed were still at home six months later; and nearly three-quarters cited the lack of opportunity for advancement as one of the reasons for their departure.

In short, the professional consequences of bringing even a *legitimate* discrimination claim can be high. Bringing a bogus one can be deadly. And that—at least as it applies to bogus claims—is fair.

The Pregnancy Discrimination Act—A Double-Edged Sword

Confusing and conflicting laws and court rulings intended to eliminate and punish discriminatory practices can lead to unintended negative consequences, too.

Thorny examples of this double-edged sword have cropped up for working women who become pregnant and need to work in "light-duty" assignments during part of their pregnancy and postnatal recovery time. The Supreme Court recently upheld a lower court's 1998 ruling that, under the Pregnancy Discrimination Act (PDA), "an employer is obligated to ignore a woman's pregnancy and to treat the employee as well as it would have if she were not pregnant."

The intention of the PDA is to prevent discrimination against pregnant women, and to protect women from being unfairly transferred, forced to use up leave time, put on unpaid leave or fired because they become pregnant. However, an increasing number of women are filling traditionally "male" jobs that require significant physical exertion such as lifting heavy tools and materials or operating heavy equipment, making it harder to accommodate "light-duty" assignments. In fact, today, even the traditionally "female" jobs often require more lifting than most pregnant women should do in the later stages of pregnancy and postnatal recovery.

Here's the rub: In some industries, light-duty assignments are few and reserved for workers who are injured on the job. Companies understandably would rather keep an injured employee working rather than having to pay workers' compensation while he or she sits at home. But if the PDA requires employers to "ignore" the pregnancy and treat the employee as if she were not pregnant, then she doesn't qualify for the light-duty assignments.

Besides, if light-duty assignments are scarce, it's understandable that the company wouldn't want to have a pregnant woman occupying a task for months while injured workers are sent home—and paid workers' comp because there is no work for them do.

In grappling with these matters, the courts have issued conflicting rulings. In the case of a mail handler who was refused accommodations because she was pregnant, the 6th Circuit Court of Appeals ruled that the company should have treated her the same way it would have treated other workers injured on the job. That, of course, is in direct opposition to the ruling regarding the PDA.

In another, more tragic case, a pregnant New York City bus driver was refused light-duty assignments. Despite the fact that she had miscarried in previous pregnancies, she continued driving her bus rather than use up leave time. When she miscarried again, she sued her employer. Ultimately, the Supreme Court upheld the lower court's finding that her employer was liable.

The verdict in *Dimino v. New York City Transit* sends a shocking message to employees and employers with regard to work and pregnancy issues. The case, detailed in the September 16, 1999 issue of the *New York Law Journal*, illustrates how both parties needlessly aggravated a situation that could have been handled without the expense, grind and loss of productivity associated with a long, drawn out litigation.

Pregnant Staten Island transit policewoman Christine Dimino requested restricted duty in a letter reminding her employer of potential "serious liability exposure" if the request was denied.

Instead of finding a restricted duty assignment, the Staten Island Railway and Rapid Transit Authority Police Department said it had no such assignments available, and placed Dimino on medical leave.

According to Dimino, she was unlawfully removed from her job as a transit police officer because of her pregnancy, out of an impermissible motivation of protecting the fetus.

But transit officials say that her threat to litigate was what drove their decision to put Dimino on medical leave.

While the transit agency's decision may have been provoked by Dimino's letter, U.S. District Judge David G. Trager felt that there was enough evidence to have the discrimination claim tested in a trial.

The 64-page opinion weeded out many of plaintiff Christine Dimino's causes of action as baseless; but it said there was a genuine issue of material fact as to whether the Transit Authority unlawfully refused to allow her to work.

Judge Trager lamented that the case, "is the result of the unwarranted confrontational tactics adopted by [Dimino] and perhaps recommended by her attorney."

And, in fact, Dimino's first contact with her employer over pregnancy risks threatened litigation. The department's decision came after it received Dimino's written request for restricted duty, which included the following sentence: "There is also a risk of danger to the public I protect, my fellow officers and not to mention a serious liability exposure."

Judge Trager explained the Transit Authority's response saying it "justifiably attempted to shield itself from the liability to third parties mentioned by [the Transit Authority] and possibly to [Dimino] herself." He added, "Understandably, but unfortunately, goaded by [Dimino's] counsel's tactics, it chose a response that has only managed to increase its legal exposure."

Dimino, however, argued that restricted duty assignments are available and by placing her on medical leave, the Transit Authority engaged in pregnancy discrimination as well as other violations of Title VII of the Civil Rights Act and the Americans with Disabilities Act.

Judge Trager preserved the pregnancy discrimination counts and a count against her employer for retaliatory conduct. But Trager also added that Dimino's request for limited duty combined with the lawsuit threat could hand her employer a non-pretextual reason for placing her on leave. "It also undermines her claim that she was fully able to perform police duties," he said.

However, "[A]s thin as [her claim] is, Dimino has created an issue for a jury with regard to the propriety or impropriety of defendants' actions," said Judge Trager.

The court also had harsh words for the employer's handling of the case, saying that they could have asked Dimino to sign a waiver, and insist that she be examined by doctors to determine her capability to perform her job.

The case sends a strong message to employers when it comes to pregnancy and the workplace: Issues should be addressed and disposed of head on. Any attempt to circumnavigate the issue only makes matters worse. In this case, the Transit Authority only succeeded in creating a confusing train of events, which the court determined, could not definitively rule out the possibility of unlawful discrimination. The court held:

> Employers are well-advised to accommodate women as much as possible during pregnancies—not only to avoid legal liabilities, but also to decrease their chances of losing valuable, potentially long-term employees or of creating resentment in those who are returning from shortened maternity leaves.

The issue is far from reaching an equitable, or even a clear, resolution. If the courts can't agree and even the laws are conflicting, employers can only hope they don't have to deal with the issue until there's some clear legal guidance. Meanwhile, the best thing to do is to keep up to date on state laws governing pregnancy and maternity issues, stay tuned for developments in the courts and Congress, try to be fair and get a good employment lawyer right away if a problem arises.

Unruly Customers—Another Double-Edged Sword?

The 1998 Council on Ethics in Economics discussion about the effects of recent Supreme Court decisions on today's employers dealt with the relatively new and sticky issue of customers that harass employees.

"When customers harass an employee with their demands," said Attorney Frederick M. Gittes, "what commonly [occurs as customer liability] is called a customer preference case." A customer walks in and says: I only want to work with lawyers who are Jewish, or I only want a male attorney. If you—as an employer—cater to those preferences, you are liable.

That sounds fair enough, right? If you're a woman lawyer at a firm and the person assigning the clients gives in to a client's demands to work

with men only, the act of indulging that prejudice is considered a form of discrimination. What about a scenario involving a woman looking for a new doctor who calls up a doctor's office that has, say, seven doctors, three of whom are women. The caller says she wants to be seen by a woman doctor. Is the doctor's office liable for gender discrimination if the appointment maker complies with the woman's request? It seems preposterous. Yet, if the law office case is discriminatory, the doctor's office case should be, too.

This last example is yet another suggestion that perhaps the most subtle but pervasive negative result of gender discrimination for our society isn't the discrimination itself but our increasingly litigious response to anything that even hints at discrimination. As in so many aspects of life at the dawn of the 21st Century, we are quick to see ourselves as victims of one sort or another in—and out—of the workplace. Today's employees are quick to look for someone to blame, preferably someone they can sue for a lot of money. Statistically, the stock market is a better bet, but often times, an employer will do.

Besides, society is creating a monster out of antidiscrimination and anti-harassment lawsuits. Some of the same laws that were designed to protect women are turning around to bite them. It's legitimate to wonder if relying on often-conflicting state and federal laws is the way to achieve discrimination-free workplaces.

A recent article about Jane Gallop, the feminist university professor accused—and found innocent—of sexual harassment by two of her female students, comments that "...so many young academic women are gravitating toward a grim, fearful 'protectionist' version of feminism...."

Some argue that society creates this same scenario through its reliance on Title VII. However, it's not just fearful, 'protectionist' feminists who are feeding the Title VII creature; it's sincere, fair-minded, well-meaning men and women of all social and political persuasions.

There's no question that discrimination is bad in all its forms and that it must be eliminated. The question is, how? Are we on the right track? It's easy—and accurate—to argue that integration would not

have happened at all—or until years later—without government intervention. Detroit would have taken far longer to produce fuel-efficient, low-emission cars without government pressure. Yet this time, maybe there's a better way to find a better balance between impersonal legal dragons and personal responsibility.

Reverse Discrimination

Cases of reverse discrimination or discrimination by women against men are undeniably far more rare than cases involving men discriminating against women. In fact, only 9 percent of all discrimination claims are reverse discrimination cases involving women discriminating against men, according to recent statistics from the EEOC. However, in today's workplace, the numbers of men and women are now roughly equal. And perhaps more significant, women fill nearly half of all management positions.

With this in mind, it's reasonable to expect that cases of reverse discrimination will increase. Court records already document numerous cases of sex discrimination perpetrated by women against men.

One pivotal reverse discrimination case involves male employees of Jenny Craig, Inc. That's the same diet company that put itself in the limelight by hiring Monica Lewinsky as a national ad spokeswoman. Only a few Jenny Craig affiliates used the ad, a telling commentary on the soap opera aura that surrounded the whole Clinton/Lewinsky affair—that is, compared to the real gravity of the Clarence Thomas/ Anita Hill confrontation. And Anita Hill didn't try to capitalize directly on her unexpected notoriety. Did the Jenny Craig marketing folks think Monica Lewinsky was, or might become, a model for women's rights? If so, it wasn't the company's first miscalculation.

Long before Monica and her thong came along, Jenny Craig (the company, not the woman) was having some trouble with men...and sex...at work. In 1994, seven male employees of a Boston Jenny Craig location filed discrimination complaints against the company.

The most vocal of the employees, Joseph Egan, alleged that he had been complimented for his looks and that *that* escalated to female

supervisors asking awkward personal questions and admitting that they had had sexual fantasies about him.

"If a man had said that, it would be on talk shows all over the place," Egan told the media. "But when it happens to men, it's no big deal. It's like, 'You're a guy. So what?'"

Egan, who'd worked at Jenny Craig for four years as a salesman and store manager, quit in February 1994. The state agency investigating his claims found probable cause of gender bias. This finding sent Egan and Jenny Craig to mediation.

In his complaint, Egan claimed his supervisor asked him to fix her car, check the daily flavors at a local yogurt shop and drive her around in his car at lunchtime so that she could secretly observe her boyfriend. Besides the illegal treatment, Egan claimed he'd been denied promotions because of his gender. He had asked to be sent to corporate headquarters for training, which other managers at his level had received, but the request was denied.

Egan argued that he resigned because the company treated him unfairly and curtailed his income and promotion potential.

Another former employee claimed that an assistant regional manager tried to discourage him from joining the company, saying that it was "improbable" that a man would be able to relate to women with low self-esteem and other problems associated with being overweight.

During a staff meeting, one male employee was discussing an open position with four or five of his female supervisors. As the conversation ended and he turned to walk away, one of the women called out that the only way he could be promoted was if he got a sex-change operation or wore a push-up bra. The man admitted the comment was probably meant as a joke, but he claimed it was part of a pattern.

Some of the women in management were sympathetic to the claims made by the men. One former sales trainer said, "They were somewhat singled out.... It was really a woman-oriented company."

Another former manager said:

> You just had to have this up, peppy...mentality, and [some managers] felt that the men just didn't fit in. [The company] did not want to hire men because men wanted management, men wanted more money, they wanted it faster, because they had families [to support].

This is a stunningly old-fashioned response. And it's the kind of generalization that Title VII prohibits from the workplace. However, it's not really clear whether the former manager is stuck in the clichés of the 1950s or the company itself is.

Jenny Craig's official response was a broad denial of the charges that covered all of the essential aspects of a workplace diversity claim:

> [C]laims of discrimination asserted by several former male employees...are unwarranted and, we believe, insupportable. ...considering the seriousness of the problem of gender discrimination and sexual harassment in our society and the workplace, it is unfortunate that the limited resources of governmental agencies and the judiciary must be wasted on such frivolous claims.

> [C]ompliance procedures are in place and enforced to prevent gender or other discrimination in the Company's diverse workforce. ...our employee training programs emphasize personal growth, and that advancement within the Company is based only on demonstrated performance and ability.

Even though the company's response was well-structured, it couldn't undo the ruling by the Massachusetts Commission Against Discrimination. It eventually settled Egan's and several other men's claims.

Indirect Victims

Men have successfully sued under Title VII for gender discrimination as so-called *indirect victims*. One case involved nine men and 14 women

who sought work in a *New York Times* mailroom. Under a union agreement with the paper, women and minorities were to be added to the workforce by starting out as "extras" and would be hired from a list of candidates on a day-to-day basis. As the women and minorities gained work experience, they would be advanced into the traditionally all-white male mailroom positions.

However, the women claimed that they were denied work because their names somehow never made it high enough on the "extras" seniority list. The nine men claimed that they were also denied work because their names were "sandwiched" between the names of the women. When the hiring was cut off before the women's names moved high enough on the list, the men listed lower were excluded as well. Thus, the claim of "indirect victim."

The men and women lost their first trial, but the 3rd Circuit Court of Appeals reversed the lower court's ruling. In her ruling, Judge Jane R. Roth wrote:

> Because the male appellants have pled specific facts to demonstrate a concrete injury as well as a nexus between the alleged injury and the sex-based discrimination, we conclude that they have established standing. Their allegations that sex discrimination adversely affected their being hired as extras, as well as their seniority on the priority list, demonstrate actual injury. We hold that indirect victims of sex-based harassment have standing to assert claims under Title VII if they allege colorable claims of injury-in-fact that are fairly traceable to acts or omissions that are unlawful under the statute.

Of course, as a manager or employer, you're more likely to encounter a sort of mini-Jenny Craig situation than the *Times* scenario. As more women reach positions in which they supervise both men and women, your challenge—if you're higher on the ladder—is to be wary of reverse discrimination as you would any other form of discrimination. The overall trend in all aspects of employment discrimination law and practice is to treat all employees exactly the same regardless of

gender or sexual orientation. Affirmative action's days seem to be numbered. Gone, too, are the days when it was okay for women to tell racy jokes in the workplace but not for men to do the same.

Furthermore, some employment law experts advise not taking a woman's active participation in racy banter—or even her initiating it—as evidence that she is really a willing player in the dynamic. She can later claim—in court where she's suing your company and possibly you personally—that she felt she had to participate in order to succeed in the hostile environment that you, as an employer, allowed. By the same token, it's reasonable to expect that some men may feel discriminated against or harassed if they feel expected to chuckle when the male-bashing jokes make the rounds.

Diversity Training: Is It Necessary and Does It Work?

The blessing and the curse of workplace diversity is that it is a virtuous idea. Long before antidiscrimination laws took effect, enlightened business people sought a balance of race, gender and background in the workplace because it was the right thing to do—and because it strengthened a company's collective experience.

Since the mid-1970s, workplace diversity has been regulated into a compliance issue. Whether or not business people value diverse workforces, they have to obey a complex body of federal and local laws that try to control how people are hired, managed and—if necessary—fired.

No matter how fairly an employer treats its employees, no matter how well a company follows legal advice, no matter how well a company trains management personnel to be consistent and fair in its treatment of employees, discrimination remains a business risk.

It's not enough to manage diversity. You have to *master* diversity. And this is where diversity training comes into play.

Corporate America is running scared from lawsuits involving gender discrimination—including harassment. Both the number of claims and the amount of money awarded in damages have gone ballistic. The

Supreme Court recently ruled that:

> ...an employee who refuses the unwelcome and threaten-
> ing sexual advances of a supervisor, yet suffers no adverse,
> tangible job consequences, can recover against the employer
> without showing the employer is negligent or otherwise at
> fault for the supervisor's actions.

Reports of astronomical awards and settlements such as the $104 mil-
lion Home Depot paid for claims involving gender discrimination and
United Parcel Service's $80.7 million for sexual harassment have struck
deep in the hearts of companies of all sizes, not just the giants. Some
small claims border on the ludicrous: In 1996, headlines ogled over
two waitresses who sought back pay and more than $25,000 in dam-
ages from a Pittsburgh restaurant when a Barbie doll was mutilated in
a deep fat fryer. Alleging that it was part of a satanic ritual—or at the
very least unsanitary—the women claimed that the malicious act dis-
criminated against them. To this end, discrimination claims go from
the obvious to the absurd and trivial.

Regardless of company size, the chances of having to deal with work-
place-related lawsuits is increasing. And as a means of reducing the
liability exposure, most employment risk management experts in the
country urge companies not only to formulate clear, concise and com-
plete antidiscrimination and anti-harassment policies, but to make
certain those policies are read and understood by every employee.
Diversity training is the method for effectively communicating those
policies.

It would be nice to think corporate America would undertake diver-
sity training even if the threat of huge lawsuits were not hanging sword-
like over their collective head. Yet very little is said about the ethics
and social benefits engendered by such training. The objective is to
reduce or correct behavior that could result in discrimination and
harassment lawsuits.

Training will never guarantee the elimination of potential for law-
suits, but it can significantly lower the number of potential situations.
Moreover, if action is taken and punitive damages are awarded, those

damages could be drastically lower if the company proves that it has tried to prevent the creation of a "hostile work environment."

The message here is echoed by many experts: You have to do more than write down a great-sounding antidiscrimination policy. You have to demonstrate that you also make it mandatory for employees to undergo some form of training designed to alert them to the problems and proper solutions for eliminating discrimination.

Employees generally feel better toward the company and are more productive when they believe that fair antidiscrimination policies are in place and are supported by management. Knowing that an avenue for resolving problems exists is also a key ingredient to the success of any business.

When the Boss Is the Bad Guy, Where Can You Turn?

You're in a very tough and tricky spot when your boss is the villain. Many employees and managers have felt forced to quit their jobs rather than try to fight or endure an oppressive situation. And that's a real shame. Nobody should have to tolerate discrimination in any place— let alone the office.

That old gangland saying that the fish stinks from the head, as grossly graphic as it is, certainly applies when the boss is the bad guy. And when I say "guy," I'm referring to a person in general, be it a male or female. When the root of the problem begins with the boss, the entire workplace is affected. An atmosphere of gender oppression, unfairness, low productivity and overall low morale evolves into an unsuccessful enterprise. It's bad enough when the offending boss is in a middle-management position. But the problems are magnified when it's the big boss, the company owner or the one at the top of the organizational chart.

What good is having the best written antidiscrimination/harassment policy if the boss doesn't take it seriously or even violates it? What good are the most up-to-date diversity training programs, the most perfect complaint and investigation procedures and the stiffest penalties if the one who's supposed to be the ultimate judge and jury is the

one doing the damage? The answer is that there is no good in these situations, and the solutions aren't so easy. If diversity training fails, in the long-run, this may mean that a company will fail.

Given the ratio of men to women bosses in the workforce today, it's not surprising that most bad-guy bosses are men. And the latest observers of workplace discrimination note that the offenders aren't just the old guard who came up during the old days and, like old racists, don't seem to be able to learn any better. Sad to say, a surprising number of Baby Boomers and even Generation Xers—all of whom ought to know better—reach a corner office or start their own companies and start behaving as badly as their forefathers.

But let's be equal here: A discriminating attitude can also manifest itself in female bosses, too. With either men or women bosses, if they relied on a tight, same-gender support group to help them reach their positions or help establish their companies, then they may unconsciously tend to continue that same-gender reliance at the expense of the other. In other words, there's an "old girl" network phenomenon as well as the better known old boy's version.

So what should you do about a bad-guy boss? In simplest terms, you can file a complaint directly with the EEOC. In fact, the EEOC's history shows that it handles more discrimination cases between bosses or supervisors and their underlings than those between coworkers. But as a general rule, you'll have a much stronger case if you've followed your company's internal complaint procedure first. In larger companies, these procedures are usually set up so that you can take your complaint to at least one person other than your direct supervisor. That's so you can report problems with your supervisor if necessary.

But what if your company is smaller and either there's no complaint procedure or the bad-guy boss is the only one to whom you're supposed to complain? I'll admit, you've landed into a scary situation. And unfortunately, as a practical matter, there isn't one simple answer that can cover all the possibilities. You can contact the EEOC for advice. You'll need to find out what your state and local Fair Employment Practices (FEP) laws are, and how you proceed with a claim.

(Remember that the EEOC guidelines and Title VII only apply to businesses with 15 or more employees. State or local laws may cover smaller companies.)

Meanwhile, you'll need to document—in detail—each incident: exactly what happened, when, where and what your response was. You'll need to keep any evidence such as copies of e-mails, letters, etc. It's stressful and difficult to make a discrimination claim against a reasonable company. A bad-guy boss raises the stakes considerably.

There's Strength in Numbers, But Whose Strength Is It?

Coworkers may be more afraid of the consequences of sex discrimination charges than the person making them. To avoid a he said/she said situation, you may need others to back you up by corroborating your accounts or by admitting they, too, were harassed. At some point, you'll need to confide in at least some coworkers. There's always the chance they won't back you up. In fact, they may fear for their jobs so much that they'd betray you to the boss, putting your job in jeopardy. But that is a risk you simply have to take.

The fight for a discrimination-free workplace is good and honorable, but it's still a fight. Talk with others who've gone through what you're considering before you take a serious step. The sad, sorry truth is that, all things considered, sometimes it really is better to withdraw your guns and move to another land than to stick around and fight, especially if you're under a bad-guy boss in a company that doesn't value you. Sometimes there's honor enough in knowing when to leave bad people alone to stew in their own smallness.

If you're a manager or supervisor yourself, you're in a particularly delicate position. Cases in which managers are being held personally liable are on the rise. Say, for example, your own boss is harassing someone who reports to you. It's very risky to do nothing when you learn about it, even if the person being harassed does not complain directly to you. If a complaint is ever filed—even with someone else in your company's complaint chain—the victim can rightly claim that you knew about the problem and did nothing. And if the victim does complain to you, you absolutely must pursue the matter with com-

plete diligence. Managers simply can no longer afford to delay, ignore or otherwise hinder discrimination complaints just because their own boss is the alleged perpetrator. In more and more scenarios, you can be held liable.

Venue Shopping in Title VII Cases

Returning now to the case that opened this chapter, Consumer Products Inc. (CPI) argued that venue was improper in the state of Washington, because the unlawful employment practices at issue occurred in New Jersey.

CPI argued that when someone alleges a discriminatory failure to promote, the decision not to promote is the sole act that can constitute the unlawful employment practice for venue purposes. Thus, under CPI's theory, for purposes of promotion claims, unlawful employment action "is committed" where the decision to take that action is made. Jennifer Passantino countered that the unlawful action occurs where its effects are felt.

Passantino alleged a variety of acts, both of discrimination and retaliation, in addition to the actual failure to promote. However, because she worked out of a home office, it was likely that none of the decisions to engage in unlawful actions against her occurred in Washington. So, where would the lawsuit be heard?

Title VII authorizes suit "in any judicial district in the [s]tate in which the unlawful employment practice is alleged to have been committed" as well as in the district where employment records are kept, in the district where the employee would have worked but for the alleged unlawful practice, and, if those provisions fail to provide a forum, in the district where the employer keeps its principle office.

Some courts have noted that "this broad provision for alternative forums was necessary to support the desire of Congress to afford citizens full and easy redress of civil rights grievances."

The effect of Title VII's venue provision is to allow suit in the judicial district in which the employee worked or *would have* worked.

Thus, the statute itself and analogous case law suggest that venue should be found where the effect of the unlawful employment practice is felt: where the employee works, and the decision to engage in that practice is implemented.

In Passantino's case, the appeals court noted:

> CPI, however, would have us reject such a rule, at least for cases involving failure to promote, in favor of one that would allow venue only where the decision to commit the unlawful employment practice is made. We find this theory unpersuasive for several reasons. First, CPI's theory would require us to draw a distinction between promotion claims and other types of Title VII claims—which allow venue where the plaintiff is employed. Had Passantino been wrongfully discharged or subjected to a hostile work environment, she could have sued in the district in which she worked. Nothing in the text or history of the statute's venue provision suggests that a different rule should apply in failure-to-promote cases. Plaintiffs unlawfully denied a promotion, like those discharged, feel the effects of their injury where they actually work.

CPI suggested that the rule advanced by Passantino would leave corporations which employ people in far-away home offices vulnerable to suit in other courts, a problem which it warns will increase in today's Internet age. CPI was concerned that "potential plaintiffs could evaluate their preferred locations for bringing a lawsuit and simply locate their home offices within that jurisdiction."

The appeals court summed up its ideas on venue shopping:

> ...we doubt that many people would reorganize their entire lives by moving home offices to other judicial districts in anticipation of as yet uncommitted acts of discrimination, in order to file Title VII actions in those districts. It is of more concern that national companies with distant offices might try to force [employees] to litigate far away from their homes, as CPI seeks to do here. CPI's theory would create a

substantial burden on [employees] working for national sales companies, a burden inconsistent with the beneficent purposes of Title VII.

The court noted that the issue wouldn't always be clear-cut. Title VII's venue provision "obviously contemplates" the possibility that several districts could provide an appropriate venue for the same legal action. For example, a company could keep business records in an office located in one judicial district but engage in discriminatory hiring practices at a different office in another district. An action could then be brought properly in either district.

Disputes over where a lawsuit is tried may seem like a small, legalistic issue. But the court's arguments show why it is important: A company can use a tactic like moving the trial to a distant location to discourage employees from making sex discrimination claims in the first place.

Economists refer to this tactic as increasing transaction costs to the point of inactivity. And, in the workplace, it can be brutally effective. That's why courts try to prohibit this approach whenever they can.

Retaliation and Punitive Damages

One of the reasons that making a retaliation claim is so common: Federal law makes it easier to get punitive damages against an employer who has retaliated against someone making an honest claim. Under Title VII of the Civil Rights Act of 1964, an employee may establish a prima facie case of retaliation by showing that:

1) she engaged in activity protected under Title VII;

2) the employer subjected her to an adverse employment decision; and

3) there was a causal link between the protected activity and the employer's action.

Title VII's anti-retaliation provision is meant to bar employers from taking actions which could have "a deleterious effect on the exercise of these rights by others." Like venue shopping, this kind of action aims to discourage employees from making claims in the first place.

Title VII allows employees to report actions that they reasonably believe are discriminatory, even if those actions turn out to be lawful. And the law encourages employees to do so—without the fear of being fired in response.

Passantino argued that the type of actions her employer took could discourage other CPI employees from speaking freely about discrimination. The court believed her argument, concluding that "the actions the jury could properly have attributed to CPI were sufficient to constitute retaliation within the meaning of Title VII."

CPI argued that there was insufficient evidence to establish that the adverse employment actions occurred because of its desire to retaliate against Passantino. However, the court noted that causation may be established "based on the timing of the relevant actions." Specifically, when adverse employment decisions are taken within a reasonable period of time after complaints of discrimination have been made, retaliatory intent may be inferred.

This makes retaliation sound like an easy thing to allege...and a nearly impossible thing to deny. But there are a few things companies can do to blunt these charges.

The 1998 Supreme Court decision *Burlington Industries v. Ellerth* established an affirmative defense to liability where an employer shows by a preponderance of the evidence that "the employer exercised reasonable care to prevent and correct promptly any sexually harassing behavior," and that "the employee unreasonably failed to take advantage of any preventive or corrective opportunities provided by the employer." However, as the court in *Burlington* expressly states, "[n]o affirmative defense is available...when the supervisor's harassment culminates in a tangible employment action."

So, the defense may be available when the employer can deny liability for a hostile environment created by a supervisor who is ignoring company policy; but it doesn't allow the employer to escape liability for discriminatory tangible employment actions, because such actions are necessarily those of the company itself.

Retaliation is this kind of action. Proving it requires evidence that senior management of the company was knowingly involved.

Employers aren't *always* subject to punitive damages for tangible employment actions by managers or supervisors, because there may be reasons to limit damages when companies engage in good faith efforts to comply with Title VII—even if they ultimately fail to prevent discriminatory conduct.

The standard for determining when evidence is sufficient to support punitive damages was established by the 1999 Supreme Court decision *Kolstad v. American Dental Association.* In that case, the court rejected the District of Columbia Circuit's interpretation of Title VII, which would have required "egregious" conduct by an employer before punitive damages could be available.

Instead, the court stated that an employer may be liable for punitive damages in any case where it "discriminate[s] in the face of a perceived risk that its actions will violate federal law."

The court made it clear that, although egregious conduct could be evidence of evil intent, such conduct was not required to establish punitive damages liability. In general, intentional discrimination—such as retaliation—is enough to establish punitive damages liability. However, the court also acknowledged that there could be some instances in which intentional discrimination did not give rise to punitive damages. It described three areas in which a court could find intentional discrimination but not award punitive damages.

First, if the theory of discrimination made by the worker was novel or poorly recognized, the employer could reasonably believe that its action was legal even though discriminatory. Second, the employer could believe it had a valid BFOQ (bona fide occupational qualification) defense to its discriminatory conduct. Third, in some (presumably rare) situations, the employer could actually be unaware of Title VII's prohibition against discrimination.

Common to all of these exceptions is that they occur when the employer is aware of the specific discriminatory conduct at issue—but

nonetheless reasonably believes that conduct is lawful. Retaliation, almost by definition, could not fit in the category.

In addition to clarifying the standard for intentional discrimination claims under Title VII, *Kolstad* also expanded the availability of the *Burlington* defense to punitive damage claims. Companies may establish an affirmative defense to punitive damages liability when they have a bona fide policy against discrimination—regardless of whether or not the prohibited activity engaged in by their managerial employees involved a tangible employment action.

In *Kolstad*, a female employee—Carole Kolstad—was denied a promotion within the American Dental Association because of her sex. The people primarily responsible for her failure to receive the promotion were William Allen, who was the acting executive director of the ADA, and Leonard Wheat, who was the acting head of the Washington state office where Kolstad worked.

The court began its decision by noting that the standard governing punitive damages in Title VII cases requires proof of "malice or reckless indifference" to the rights guaranteed by Title VII. For Allen, the court stated that, because he held the highest position within the ADA, the only question for the district court would be whether or not he acted with malice or reckless indifference. For Wheat, the court noted that the lower court would have to determine whether or not Wheat served in a "managerial capacity" and whether or not he behaved with "malice or reckless indifference."

What does all this mean? Simple. The *Burlington* defense is useless against punitive damages when the officers who engage in illegal conduct are senior enough to be considered proxies for the company.

Although the purpose of Title VII is served by rewarding employers who adopt antidiscrimination policies, it would be undermined if those policies were not implemented. That lack of implementation would mean that the policies served only as a device to allow employers to escape punitive damages for the discriminatory activities of their managerial employees. (Of course, some employers may snicker that that's all the policies are, anyway.)

To make a *Burlington* defense effectively, a company must show not only that it has adopted an antidiscrimination policy but that it has also implemented the plan in good faith. And that notion of *good faith* has been the source of many legal disputes.

Conclusion

The mechanics of sex discrimination claims are—relatively—simple. The person making the claim has to show that he or she was adversely affected by some action that an employer or its proxies took that was based on sex.

That word *sex* means, mostly, gender. But it can mean certain activities or characteristics related to gender. The one notable thing that it *doesn't* mean is sexual orientation (which we will consider in greater detail in Chapter 3).

The mechanics of these claims may be straightforward; but, the adverse effects needed to prove them are difficult. That's why the law— governing sex discrimination as well as other forms of workplace bigotry—is unusually supportive of the person making the claim.

For employees, this isn't the easy street to big settlements...as some sleazy lawyers may suggest. A sex discrimination claim has to survive the prima facie stage, the employer's justification and the responding pretext stage. That's a lot of legal work, a lot of legal fees and a lot of room for error. For employers, this legal standard (and the scores of precedent decisions which have sprung from it) means antidiscrimination policies and procedures have to be in place from the beginning—and they have to be implemented in good faith.

This isn't a fuzzy matter like harassment or hostile environment. There simply is no room for sex discrimination in the workplace.

Harassment

The old joke that sexual harassment is a pickup line that didn't work isn't true. But perhaps not for the reasons you think. In the aftermath of recent Supreme Court rulings, there doesn't have to be any verbal communication or physical contact.

So, you don't even need to *say* the pickup line.

It is sufficient that an employee merely overhear offending jokes or conversations and feel powerless to stop them or escape hearing them. It is sufficient that the employee sees what he or she considers to be harassing behavior between others, whether those directly involved feel harassed or not. It is sufficient that the employee sees offending photographs, cartoons, graffiti or written jokes somewhere in the work-place—and not necessarily in public or common areas of the work-place. The offending material may be in a coworker's private office where the employee would have to make a real effort to see it. Just knowing it is there can be sufficient to create sexual harassment.

Sexual harassment, which is the issue most people associate with sex-at-work issues, involves complexities that confound even legal schol-ars. For one thing, harassment is—technically—a form of discrimina-tion; so, all of discrimination's details apply. For another, harassment almost always comes down to subjective standards of behavior—the familiar he said/she said disputes that we see repeatedly throughout this book.

But harassment involves even fuzzier notions than he said/she said disputes. Because existing federal law applies what it plainly calls a

"subjective" component to the definition of harassment, it involves what you might call he felt/she felt disputes. And when you move into this realm of battling perceptions, the ground gets very soft.

What can people do when they are faced with these nebulous problems? The best advice is to step back from the details of the dispute, evaluate any larger problems the people involved may have with each other—or their jobs—and try to negotiate a solution that emphasizes broad process rather than personal grudges.

This, of course, can be a difficult job. For everyone.

The May 2000 U.S. Court of Appeals decision *Srabana Gupta v. Florida Board of Regents, et al.* laid out a typical case of sexual harassment. As this typical case turned out, the person making the charges lost.

A native of India, Srabana Gupta came to the U.S. in 1988 for graduate school. She eventually earned a Ph.D. in economics from the University of Florida in 1994. In the spring of 1994, Gupta applied for a tenure-track position as an assistant professor of economics at Florida Atlantic University. She was invited to come to Florida Atlantic for a weekend of interviews.

Rupert Rhodd, an associate professor of economics and chairman of the search committee for the position Gupta wanted, met her at the Fort Lauderdale airport when she arrived. During the weekend, Rhodd was responsible for accompanying Gupta to meetings, including lunch and dinner with other faculty members.

When Rhodd first met her at the airport, Gupta perceived that he "looked [her] up and down." Later that afternoon, Rhodd suggested that he, Gupta and Neela Manage—an Associate Dean of the College of Social Sciences—have lunch at a Hooters restaurant. But they didn't go there. Instead, at Manage's suggestion, they had lunch at Houston's Restaurant.

After a tour of the campus and interviews with several professors, Rhodd and another Florida Atlantic faculty member took Gupta to

dinner at Mango's, which Gupta described as "a bar." Rhodd suggested that Gupta change into casual attire before dinner.

A few weeks after the interview, Gupta called Manage to ask whether the University had decided whom it was going to hire for the position. Manage said that the committee had not yet decided.

A few days later, Rhodd called Gupta and said that the search committee had decided to hire her for the position. Prior to Gupta's acceptance of the assistant professor position, Rhodd—at Gupta's request—negotiated an annual salary increase for her from $35,000 to $40,000.

Gupta planned another trip to Fort Lauderdale to find an apartment. Rhodd offered to help—arranging Gupta's hotel reservations and driving her around the city. During this trip, Sarah Ransdell, another member of the search committee, also showed Gupta around the Fort Lauderdale area. One evening, Gupta accompanied Rhodd, Ransdell and Ransdell's boyfriend to dinner at Shooters—which Gupta described as "a bar" and "a place where single people meet."

At several points during this second trip, Gupta felt that Rhodd was looking at her intensely. This made her feel uncomfortable.

Gupta joined Florida Atlantic's faculty as an assistant professor of economics in August 1994. During the 1994-1995 school year, Rhodd was the coordinator of the division in which Gupta taught; one of his responsibilities was coordinating the schedules of courses taught by each of the professors in the division.

Rhodd was supportive of Gupta and often went out of his way to help her. At one point, he told her, "If you need anything, just come and talk to me. If you have any problem, come and talk to me." After Gupta complained about the size of her office, Rhodd moved her to a larger one. He also volunteered to drop Jamaican food off by her house when she asked where she could find spicy food. She declined this offer, though she did eat lunch with Rhodd quite often during the first few weeks of the school year. Soon, Rhodd began calling Gupta at home at night. As she described it:

> [H]e used to call me at home.... Quite frequently—two times, three times, you know, a week on an average.... He would call me either late at night, often 9:30, 10:00 o'clock at night, or over the weekends.... He said, "Are you talking to your boyfriend? Where is your boyfriend?"

His phone calls continued steadily until January 1995.

Gupta started eating lunch with other people—and Rhodd seemed upset. First, he teased her that "You don't go to lunch with me any more." Later, he turned bitter, saying that some of the teachers with whom Gupta had lunch were "racist" and "evil." About that time, when Gupta was wearing a skirt that was above her knee, she noticed that Rhodd "was staring at [her] legs." It made her "uncomfortable" and she felt compelled to stop wearing short skirts to work.

In the following months, Gupta allegedly experienced several upsetting meetings with Rhodd. Among these Gupta claimed:

- She entered Rhodd's office to discuss her teaching schedule; he "just rolled his chair and came close to me and he put his hand on my right thigh." His hand was partly on the inside of her thigh. It happened very quickly, and Gupta moved away very quickly.

- Rhodd touched her bracelet and said, "It is a very nice bracelet."

- Rhodd touched a ring Gupta was wearing.

- Gupta entered Rhodd's office; "he suddenly rolled his chair towards [her] and he said, 'What kind of material is that?' and he lifted the hem of [her] dress" about four inches with his hand.

- On a very hot day, Gupta entered Rhodd's office and discovered that he had on his undershirt but had taken off his dress shirt. She offered to come back later, but he told her to wait and "unbuckled his belt and pulled down his zipper and start[ed] tucking his [dress] shirt in."

Rhodd also made some comments to Gupta that she later characterized as harassment:

- Once he commented, "You are looking very beautiful." Twice he told her, "Indian people are really decent, and the Caribbean and Western people are really promiscuous. I can look at you and I can tell...you don't have much experience."

- One morning, after a bad thunderstorm the night before, Rhodd called Gupta and asked if she needed a ride to a University seminar. During that conversation, he said, "Oh, you were all by yourself on a dark and stormy night? Why didn't you call me? I would have come and spend [sic] the night with you." Gupta understood Rhodd's suggestion to mean "that he wanted to [have a] sexual relationship with me." She told him, "Don't talk to me that way. You are talking nonsense."

- On another occasion, Rhodd stated that he considered men superior to women, that women are like meat and that "men need variety in women."

- Rhodd came into Gupta's office and asked her, "Why do you look so unhappy? Have you fallen for a man you can't talk about?" She responded, "What are you talking about?" He replied, "I give you six months to fall for a man about which you won't be able to talk about." Gupta thought that Rhodd was referring to himself.

In the fall of 1994, Gupta confided in Ransdell that Rhodd had told her that certain people in the College of Liberal Arts were racist and that he would protect her. Ransdell assured her that these people were not racist.

In November 1994, Gupta had another conversation with Ransdell in which she told her about Rhodd's comment that men are superior to women and his statement that he would have spent the night with Gupta during the storm. Ransdell told her: "Don't talk to anybody about it. Keep your mouth shut. I'm not going to tell it to anybody. And look for another job."

Gupta also talked with several junior faculty members who were women—including Neela Manage, who'd been on the search committee that hired Gupta initially. The first time she spoke with Man-

age, Gupta said that she was distressed by Rhodd's behavior. According to Gupta, she also told Manage that "there was more to it, but I did not mention anything much more than those things." Manage told her to "be very careful."

Later that same month, Gupta went to Manage's office to talk to her again. Gupta began crying because she felt "unsafe and uncomfortable." She talked with Manage about the possibility of transferring to another Florida Atlantic campus. Manage told her that she saw no reason why Gupta could not apply for a position at another campus, but that Gupta should be careful because the acting chairman of the Department of Economics (who would make the decision) and Rhodd were "very good friends."

In December, Gupta again talked with Manage and told her about Rhodd "wanting to come and spend the night with me, [and] all of those incidents." Manage told Gupta that she should talk to the Dean of the College of Liberal Arts.

Gupta had a meeting with the Dean in which she said that she was having some problems with Rhodd. She explained that Rhodd was giving her inaccurate information and telling her that it was not important that she attend certain meetings.

The Dean asked Gupta if she would describe Rhodd's behavior as sexual harassment. As Gupta recounted, she responded:

> I told him that I did not want to talk to him about the details at that point in time, but I told him that, you know, Doctor Rhodd was going out for promotion and I could have put him into lot [sic] of trouble if I wanted to. I told him that; that is, I gave him enough indication.

The Dean told her that, if Rhodd's behavior was in the nature of sexual harassment, "it's not going to stop that easily." However, Gupta thought if she "blew the whistle on Doctor Rhodd, that would really hurt his career." She did not want to do that.

In January of 1995, Gupta heard a rumor that Rhodd was telling others that Gupta was not doing her job and should be fired. Gupta told Ransdell about the rumor, and Ransdell told her again to "look for another job." Gupta met with the Dean again and told him about the rumor she had heard. This time, she also stated formally that Rhodd had been sexually harassing her.

Gupta met with one of the University's sexual harassment counselors, Debra Minney, in January of 1995. Minney informed Gupta that Florida Atlantic used two types of resolution proceedings, informal and formal. Gupta chose an informal resolution of her complaint against Rhodd. As part of the informal resolution process, the Dean prepared a document in which he listed all of the specific allegations made by Gupta. Rhodd then responded to Gupta's allegations.

And he stopped calling her at home.

Based on what Gupta and Rhodd said, the Dean drew up a draft statement of the allegations that he hoped the parties would find mutually agreeable. But Gupta would not sign the Dean's draft. As a result, a Florida Atlantic attorney prepared a proposed informal settlement agreement which was presented to Gupta in March of 1995. Gupta didn't find this proposal acceptable, either.

The matter was referred to Paula Behul, Florida Atlantic's Director of Equal Opportunity Programs. Behul asked Gupta to describe in writing the parts of the settlement agreement she found objectionable. Gupta didn't responded to Behul's request.

In September 1995, Behul met with Gupta and asked Gupta to submit a written response to the proposed agreement by October 9, 1995. Gupta failed to meet that deadline.

Because of Gupta's failure to cooperate in the informal resolution process, Behul closed the case on October 12, 1995.

When she found out that Florida Atlantic had closed the case, Gupta filed a formal charge of discrimination with the EEOC.

In April 1996, the EEOC sent Gupta a right to sue notice. On June 25, 1996, Gupta filed a three-count lawsuit against Rhodd and the Florida Board of Regents in federal district court.

The first count alleged that Rhodd had sexually harassed her "under color of state" law and had thereby deprived her of her rights under the Equal Protection Clause. The second count alleged that the Board was liable under Title IX for Rhodd's discriminatory conduct. The third count alleged that the Board was also liable under Title VII of the Civil Rights Act of 1964, on theories of hostile work environment and quid-pro-quo sexual harassment. (Gupta later amended the complaint to drop the Title IX count.)

On May 6, 1997, Gupta filed a supplemental complaint adding another count against the Board. The new count alleged that after Gupta had filed an internal complaint with the University and a formal complaint with the EEOC against the Board and Rhodd, the University unlawfully retaliated against her in violation of Title VII.

Gupta's claims were tried and submitted to a jury.

The jury returned a verdict finding that Rhodd was not liable but that the Board was liable under Title VII for sexual harassment and retaliation. The jury awarded Gupta $45,000 in compensatory damages for the sexual harassment claim and $50,000 in compensatory damages for the retaliation claim.

The Board appealed and the appeals court criticized Gupta for making a weak claim. Near the start of its decision, the court wrote:

> …the evidence presented at trial does not support a finding that from an objective viewpoint the alleged sexual harassment was so frequent, severe or pervasive to constitute actionable sexual harassment under Title VII. [Offending] statements and conduct must be of a sexual or gender-related nature—"sexual advances, requests for sexual favors, [or] conduct of a sexual nature,"—before they are considered in determining whether the severe or pervasive requirement

is met. Innocuous statements or conduct, or boorish ones that do not relate to the sex of the actor or of the offended party, are not counted. Title VII, as it has been aptly observed, is not a "general civility code."

Then, the court turned to the specific charges Gupta made. It took a hard line against her fine sensibilities:

> Gupta complains of several things that no reasonable person would consider to be of a gender-related or sexual nature. For example, she complains that Rhodd told her to steer clear of certain faculty members because they were evil and racist. Those statements merit no mention in a discussion of sexual harassment, except perhaps to serve as a clear example of what it is not. ...She also criticizes him for telling her to come and see him if there was anything he could do for her. Mere solicitude, even if repetitive, is not sexually harassing behavior.

That last sentence is a critical one. Many people try to make some complaint—any complaint—to explain their subpar job performance and will grasp desperately at behavior that they would like to make seem harassing. The court implied that this was what Gupta was doing—grasping at legal straws.

The court went on:

> Another matter Gupta complains about that is either not sexual in nature, or insufficiently so to be due any real weight, is that Rhodd suggested he, Gupta and Neela Manage go to lunch at a Hooters restaurant a few hours after she arrived for her interview with the University.

> Gupta may have been offended by that suggestion, and apparently was, but we do not think that a reasonable person would have thought that such an invitation, unaccompanied by any sexual remark and not pressed when it was declined, was necessarily based on the sex of the invitees or was a sexual comment or suggestion of any kind.

In short, the court concluded:

> Inviting a member of the opposite sex to be part of a group
> going to dinner at a bar is not evidence of sexual harass-
> ment.

Gupta complained that Rhodd had told her, "You are looking very
beautiful." She did not say he made any kind of sexual gesture along
with the remark—or even that she perceived he was leering at her
when he said it—only that he complimented her looks with those
words. The court rejected this complaint as establishing harassment:

> It is debatable whether such a compliment is sexual in na-
> ture, but assuming that it is, we do not believe that a rea-
> sonable person would deem it to be offensive. ...Words
> complimenting appearance may merely state the obvious,
> or they may be hopelessly hyperbolic. Not uncommonly
> such words show a flirtatious purpose, but flirtation is not
> sexual harassment.

The court pointed out that talk or behavior—even sexual talk or
behavior—is not itself harassing unless it is "severe, threatening or
humiliating."

Frequently calling an employee at home and making even innocuous
inquiries may be annoying or inappropriate behavior, but it does not
equal severe or pervasive sexual harassment—if it is sexually harassing
conduct at all.

Another factor in determining whether conduct and statements are
"sufficiently severe or pervasive" to create a hostile work environ-
ment is whether the conduct and statements unreasonably interfere
with an employee's job performance—a factor that involves both a
subjective and objective inquiry.

As the Supreme Court has observed, in a normal office setting inter-
action between employees is to be expected. What one employee
might perceive as conduct that crosses the proverbial line, another
might perceive as banter.

The court noted:

> We cannot mandate that "an employer be required under pain of legal sanctions to ensure that supervisors never look or stare at a subordinate whom they are supervising in such a way that she might think they are 'coming on' to her." Nor can we mandate that an employer be required to ensure that supervisors never touch employees on the hand or finger or ask them to lunch.

During the trial, Gupta had claimed that she suffered from depression, nervousness, anxiety, nose bleeds, fatigue, weight gain and other physical manifestations of stress as a result of Rhodd's behavior and her fear that she would be fired. She said that those ailments affected her research and caused her to miss deadlines. She also said that she stayed away from the University's campus as much as possible to avoid seeing Rhodd.

Gupta's charges met the "subjective prong of the required showing." But subjective feelings and personal reactions are not the complete measure of whether conduct is of a nature that it interferes with job performance. If it were, the most unreasonably hypersensitive employee would be entitled to more protection than a reasonable employee would.

The standard does have an objective component, though. And, applying it, the court concluded that the talk and behavior in question would not have interfered with a reasonable employee's performance of her job. It wrote:

> The alleged harassment in this case exemplifies "the ordinary tribulations of the workplace," which the Supreme Court [has] held do not constitute actionable sexual harassment. Gupta failed to present evidence that Rhodd's conduct was in anyway "physically threatening or humiliating," or that a reasonable person would view the conduct as "severe." A finding that Gupta's complaints constitute sexual harassment would lower the bar of Title VII to punish mere

bothersome and uncomfortable conduct, and would "trivialize true instances of sexual harassment."

The Parameters of Harassment

Most of the case law that has defined the legal terms of sexual harassment is less colorful than the *Gupta* decision. However, these other decisions have established what a person must show to make a case for harassment. And it's a high, complex standard.

The EEOC's *Guidelines on Discrimination Because of Sex* define sexual harassment as occurring when:

1) submission to [unwelcome sexual advances, requests for sexual favors and other verbal or physical conduct of a sexual nature] is made either explicitly or implicitly a term or condition of an individual's employment;

2) submission to or rejection of such conduct by an individual is used as the basis for employment decisions affecting such individual; or

3) such conduct has the purpose or effect of unreasonably interfering with an individual's work performance or creating an intimidating, hostile or offensive working environment.

An employee pressing charges against an employer for sexual harassment can proceed under two theories: quid-pro-quo harassment and hostile work environment. As we have seen before, quid-pro-quo claims are relatively easy to substantiate—a supervisor says, "Have sex with me or I'll fire you" and the employee gets it on tape.

The courts' interpretations of quid-pro-quo sexual harassment cases are very clear and hard-hitting. If indeed an employee suffered negative job-related consequences as a result of refusing even a single unwelcome sexual advance, then quid-pro-quo sexual harassment can usually be proven.

These claims are relatively rare, though. Most supervisors who want to have sex with an employee are less direct about it.

Of course, the requests for sexual favors may be implied. They can even be so subtle that the harassed person may only recognize them in retrospect—after he or she is passed over for a promotion or a plum assignment, or is otherwise penalized for no apparent reason. Only then does the person remember somehow, sometime, somewhere declining to go along with an implied or subtle proposition.

Still, quid-pro-quo harassment makes up a shrinking part of the EEOC's caseload.

That leaves the more common—but more difficult to prove—hostile environment claims (the kind of claim that Srabana Gupta made). In order to be actionable, a hostile environment claim must focus on behavior related to the employee's gender. In order to succeed on his or her claim, the employee must demonstrate two things:

1) that the workplace is "permeated with discriminatory intimidation, ridicule and insult that is sufficiently severe or pervasive to alter the conditions of the victim's employment and create an abusive working environment; and

2) that a specific basis exists for imputing the conduct that created the hostile environment to the employer.

The 1986 U.S. Supreme Court decision *Meritor Savings Bank, FSB v. Vinson* is the one that defined sexual harassment as a form of sex discrimination. And it also applied the broadest terms to the law, stating: "[t]he phrase 'terms, conditions, or privileges of employment' evinces a congressional intent 'to strike at the entire spectrum of disparate treatment of men and women.'"

However, federal law—specifically, Title VII of the Civil Rights Act of 1964—does not prohibit "genuine but innocuous differences in the ways men and women routinely interact with members of the same sex and of the opposite sex." The prohibition of harassment on the basis of sex forbids only "behavior so objectively offensive" as to alter the terms or conditions of the victim's employment.

The 1999 federal appeals court decision *Mendoza v. Borden, Inc.* described the elements that an employee must establish to support a

hostile environment claim under Title VII based on harassment by a supervisor. An employee must establish:

1) that he or she belongs to a protected group;

2) that the employee has been subject to unwelcome sexual harassment, such as sexual advances, requests for sexual favors and other conduct of a sexual nature;

3) that the harassment must have been based on the sex of the employee;

4) that the harassment was sufficiently severe or pervasive to alter the terms and conditions of employment and create a discriminatorily abusive working environment; and

5) a basis for holding the employer liable.

The fourth element—that the conduct complained of was "sufficiently severe or pervasive to alter the conditions of employment and create an abusive work environment"—is the element that tests the mettle of most sexual harassment claims.

A recurring point in the opinions treating hostile work environment claims is that "'simple teasing,' offhand comments and isolated incidents (unless extremely serious) will not amount to discriminatory changes in the 'terms and conditions of employment.'"

The Supreme Court has stated:

> The objective component of the "severe and pervasive" element prevents "the ordinary tribulations of the workplace, such as the sporadic use of abusive language, gender-related jokes and occasional teasing" from falling under Title VII's broad protections....

Furthermore, the 1998 federal court decision *Phillips v. Merchants Insurance* established that: "behavior that is immature, nasty or annoying, without more, is not actionable as sexual harassment."

Requiring an employee to prove that the harassment is severe or pervasive ensures that Title VII does not become a mere "general civility

code." This requirement is regarded "as crucial, and as sufficient to ensure that courts and juries do not mistake ordinary socializing in the workplace—such as male-on-male horseplay or intersexual flirtation—for discriminatory 'conditions of employment.'"

If the complained of statements and conduct are of a sexual nature, there are four factors that courts consider in determining whether they are sufficiently severe and pervasive to alter an employee's terms or conditions of employment—from an objective standpoint. These factors are:

1) the frequency of the conduct;

2) the severity of the conduct;

3) whether the conduct is physically threatening or humiliating, or a mere offensive utterance; and

4) whether the conduct unreasonably interferes with the employee's job performance.

In the 1999 appeals court decision *Minor v. Ivy Tech State College*, the court noted regretfully:

> It is not enough that a supervisor or coworker fails to treat a female employee with sensitivity, tact, and delicacy, uses coarse language, or is a boor. Such failures are too commonplace in today's America, regardless of the sex of the employee, to be classified as discriminatory.

Retaliation

One of main things about which an employer has to be careful when dealing with a sexual harassment claim is how it treats the person making the charge.

Retaliation is a separate violation of Title VII—not dependent on the proving of the original claim. So, to make a winning retaliation case, an employee need not prove the underlying claim of discrimination which led to her original complaint—so long as she had a reasonable good faith belief that the discrimination existed.

As you might guess, these retaliation complaints get a lot of attention from attorneys because they are slightly easier to make—and win.

When—and How—Is an Employer Liable?

An employer is not automatically liable for damages in a sexual harassment claim, even if a sexually hostile work environment has been created by a supervisory or managerial employee.

With respect to a hostile workplace claim, an employer faces liability for its own negligence or recklessness, typically its negligent failure to discipline or fire or its negligent failure to take remedial action upon notice of the harassment. Prompt and effective action by the employer will usually relieve it of liability.

But an employer can be found liable if the harassing employee relied upon apparent authority or was aided by the agency relationship. Under a theory of apparent authority, an employer may be liable where the agency relationship aids the harasser "by giving the harasser power over the victim."

A consensual relationship developing between employees necessarily falls outside of Title VII's purview. As one federal trial court ruled: "The laws are not designed to...prevent consensual sexual relationships between employees."

An employee must establish a basis for the employer's liability rooted in common law agency principles. When the alleged harasser is a supervisor, the employer is presumed to be absolutely liable.

However, when the alleged harasser is a coworker, rather than a supervisor, the employer will be held liable only for its own negligence. The predicate negligence can be established if the employer provided no reasonable avenue for the complaint, or the employer knew (or should have known) of the harassment but unreasonably failed to stop it.

The EEOC guidelines also state:

> An employer is responsible for the acts...of its agents and
> supervisory employees with respect to sexual harassment re-
> gardless of whether the specific acts complained of were
> authorized or even forbidden by the employer and regard-
> less of whether the employer knew or should have known
> of their occurrence.

This "knew or should have known" guideline achieved the practical
status of law when the Supreme Court handed down its decision in
Meritor. Then in 1998, the high court delivered a should-have-known
double whammy in *Faragher v. City of Boca Raton* and *Burlington In-
dustries v. Ellerth*, which we'll detail later in this chapter. *Faragher* and
Burlington also reasserted a very plaintiff-friendly standard for the sec-
ond general category of sexual harassment: hostile work environment.
From the high court's ruling: "...an employee who refuses the unwel-
come and threatening sexual advances of a supervisor, yet suffers no
adverse, tangible job consequences, can recover against the employer
without showing the employer is negligent or otherwise at fault for
the supervisor's actions."

Under the rule set forth by the Supreme Court in *Faragher*, an em-
ployer is subject to vicarious liability for actionable discrimination
caused by a supervisor. However, the employer is not "automatically"
liable; rather, the employer may raise an affirmative defense that looks
to the reasonableness of the employer's conduct in seeking to prevent
and correct harassing conduct and to the reasonableness of the
employee's conduct in seeking to avoid harm.

For an employer, it may be scary enough that the company can be
held liable whether or not the higher-ups knew the harassment oc-
curred. But the extra element is that there no longer need to be "ad-
verse, tangible job consequences" to support the harassment charge.
In other words, no quid-pro-quo or negative career impact is neces-
sary.

This, by the way, was the theory behind Paula Jones's charges against
Bill. Several courts jousted over the questions of whether Jones's claims
of suffering post-incident adverse consequences in her work were sup-

ported by the facts. Could she establish that Clinton created a severe and pervasive atmosphere that amounted to a hostile environment? Did she have to?

The courts have seldom supported harassment claims based upon a single, isolated incident where no quid-pro-quo was proven. This stand has lead some women's rights advocates to argue that, in effect, harassers now get one free pass. From a certain perspective, that's true.

Neither men nor women can generally be held accountable under Title VII for a one-time-only offensive comment, insult, gesture or touch, unless it's a severe assault. But that's only under Title VII. (Of course, Title VII is not the only remedy available. All the regular sexual assault laws can still be applied. For example, if Bill Clinton really did expose himself to Paula Jones and try to force himself on her, why not charge him with indecent exposure or criminal sexual assault?)

However, a one-time-only incident of sexual assault or harassment can be sufficient to create a hostile working environment if the company fails to take effective steps to respond to a victim's complaints and prevent the possibility of similar incidents in the future. Say, for example, that you or an employee you supervise complain to management that a particularly disturbing or frightening incident of sexual harassment has occurred. You or the employee fear that a similar incident will recur unless something is done right away to prevent it. Meanwhile, since you or your employee live in fear while waiting for the company to respond, your workplace is a hostile environment. And if your company, or you as a manager, fail to respond quickly and effectively, then the victim has a case for hostile environment sexual harassment based on a single incident in which no quid-pro-quo was involved.

Two recent court decisions support this view. In the 1998 case *Lockard v. Pizza Hut*, a waitress, Rena Lockard, complained to her supervisor that a male customer was harassing her by making sexually offensive remarks. Lockard said she knew the man from previous visits and did not want to wait on him. In fact, she had asked not to have to serve him on at least one previous visit. This time, as before, her supervisor

insisted that she continue to wait on him, even when Lockard reported that the man had pulled her hair. The supervisor failed to intervene with the customer or to allow Lockard to discontinue waiting on him before the customer assaulted the waitress again. This time he fondled her and bit her breast. Lockard quit the job and sued Pizza Hut. The court ruled that the employee's legitimate fear after she had been assaulted, the manager's failure to respond and the single attack itself amounted to sufficient grounds for a hostile workplace claim under Title VII.

The second noteworthy single-incident case didn't even involve a sexual assault. The 1999 case, *Smith v. Sheahan* concerned a female guard, Valeria Smith, in the Cook County Jail who suffered injury severe enough to require surgery when a male coworker named Ronald Gamble pinned her against the wall and twisted her arm. Smith reported the attack to her supervisor, who reportedly made arrangements to keep the two guards from having to interact. But beyond that, the Sheriff's Department for which the guards worked took no other action and didn't discipline or penalize Gamble. In one indication of the department's inadequate response, Smith was advised to "kiss and make up" with Gamble.

Smith brought charges of criminal assault against Gamble. He was convicted but not sentenced to jail time. Instead, he received a promotion while Smith received a reassignment that was clearly a demotion. That's when Smith sued the department under Title VII, and presented testimony by several other female guards documenting a pattern of abusive behavior by Gamble toward female guards.

She lost the first round. But on appeal, 7th Circuit Judge Diane P. Wood noted:

> Breaking the arm of a fellow employee because she is a woman, or, as here, damaging her wrist to the point that surgery was required, because she is a woman, easily qualifies as a severe enough isolated occurrence to alter the conditions of her employment.... A jury would also be entitled to conclude that the assault Smith suffered was severe enough to

alter the terms of her employment even though it was a single incident.

Under Title VII, a hostile work environment occurs when the "terms of employment" are sufficiently "altered" by harassing behavior.

As for the fact that the assault against Ms. Smith was not of an overtly sexual nature, the court cited the 1998 Supreme Court ruling *Oncale v. Sundowner Offshore Services, Inc.* (which we'll explore in Chapters 3 and 5). The court in *Smith* interpreted *Oncale* to establish that harassment need not have a directly sexual content or be motivated by sexual desire. It only needs to be behavior that is directed at one gender rather than both. The court cited Gamble's history of "verbally abusing only female colleagues."

What do managers and business owners have to learn from *Lockard v. Pizza Hut* and *Smith v. Sheahan?* The three big lessons are:

- Men (or women) don't necessarily get "one free pass," especially if the single offense is particularly severe.

- The offense does not have to be motivated by sexual desire or have sexually abusive content; it can be simple verbal or physical abuse that singles out one gender.

- Managers and owners must respond quickly and decisively to harassment complaints, bearing in mind the two previous points.

The Key Precedent Decision

Against the weight of legal precedent, the 1986 U.S. Supreme Court decision *Meritor Savings Bank v. Mechelle Vinson* established that even a person who willingly engages in sexual activity with a coworker—in Vinson's case, she had a long-running affair with her boss—can still decide later that he or she was coerced and that the affair amounted to sexual harassment.

Most sexual harassment lawsuits decided in federal court rely on the terms and definitions set out by this decision.

The *Meritor* decision shot arrows of fear through the hearts of numerous office romances. Will a lawsuit become the favored response of a jilted office lover? *Meritor* also sparked a debate among commentators, feminists included, as to the proper role of personal responsibility for decisions—good and bad. As some women have noted, we finally made progress on the issue of "What part of no don't you understand?" Now we're confronted with "What part of yes don't you understand?"

In 1974, Mechelle Vinson met Sidney Taylor, a vice president of what later became Meritor Savings Bank and manager of one of its branch offices. Vinson asked about employment at the bank; Taylor gave her an application, which she completed and returned the next day. Later that same day, Taylor called her to say that she had been hired.

With Taylor as her supervisor, Vinson started as a teller-trainee and was eventually promoted to teller, head teller and assistant branch manager. She worked at the same branch for four years.

In September 1978, Vinson notified Taylor that she was taking sick leave for an indefinite period. In November, the bank fired her for excessive use of that leave. She sued the bank for wrongful termination and violating Title VII by allowing Taylor to sexually harass her.

Vinson claimed that, after her probationary period, Taylor invited her out to dinner and, during the meal, suggested that they go to a motel to have sex. At first she refused. But he was persistent and, out of what she described as fear of losing her job, she eventually agreed.

According to Vinson, Taylor made repeated demands upon her for sexual favors—usually at the branch, both during and after business hours. She estimated that over the next several years she had intercourse with him some 40 or 50 times. She also claimed that Taylor fondled her in front of other employees, followed her into the women's restroom when she went there alone, exposed himself to her and even forcibly raped her on several occasions.

She said that, because she was afraid of Taylor, she never reported his harassment to any of his supervisors and never attempted to use the bank's complaint procedure.

Taylor denied Vinson's allegations. He said that he never fondled her, never made suggestive remarks to her, never engaged in sexual intercourse with her and never asked her to do so. He claimed that Vinson made her accusations in response to a business-related dispute. The bank also denied Vinson's allegations—and asserted that any sexual harassment by Taylor was unknown to the bank and engaged in without its consent or approval.

The trial court ultimately found that Vinson "was not the victim of sexual harassment and was not the victim of sexual discrimination" while employed at the bank. It believed that sexual harassment doesn't pass muster if there was no economic effect on the alleged victim's employment.

After noting the bank's express policy against discrimination and finding that neither Vinson nor any other employee had ever lodged a complaint about sexual harassment by Taylor, the court ultimately concluded that "the bank was without notice and cannot be held liable for the alleged actions of Taylor."

Vinson appealed. The court of appeals ruled in her favor. It noted that a violation of Title VII may be predicated on either of two types of sexual harassment:

- harassment that involves the conditioning of employment benefits on sexual favors; and

- harassment that, while not affecting economic benefits, creates a hostile or offensive working environment.

The court of appeals reversed the lower court decision because Vinson's complaint was of the second type and the trial court had not considered whether a violation of this type had occurred.

The appeals court also ruled that the trial court's conclusion that any sexual relationship between Vinson and Taylor had been voluntary was irrelevant. As to the bank's liability, the appeals court held that an employer is absolutely liable for sexual harassment by supervisory personnel, whether or not the employer knew or should have known about it.

It held that a supervisor, whether or not he possesses the authority to hire, fire or promote, is necessarily an "agent" of his employer for all Title VII purposes, since "even the appearance" of such authority may enable him to impose himself on his subordinates.

The bank pressed the case to the U.S. Supreme Court, which agreed to consider it. The high court started its review by noting two points about Title VII's application to sexual harassment cases.

First, the language of Title VII is not limited to "economic" or "tangible" discrimination. The phrase "terms, conditions or privileges of employment" illustrates a legislative intent "to strike at the entire spectrum of disparate treatment of men and women" in employment.

Second, the EEOC issued enforcement guidelines in 1980 which specified that "sexual harassment" is a form of sex discrimination prohibited by Title VII. The EEOC guidelines supported the view that harassment leading to noneconomic injury can violate Title VII. In fact, they described the kinds of workplace conduct that are actionable under Title VII: "[u]nwelcome sexual advances, requests for sexual favors and other verbal or physical conduct of a sexual nature."

Even more to the point, the 1980 guidelines provided that certain kinds of sexual conduct constitutes sexual harassment, whether or not it is directly linked to an economic quid-pro-quo. This held true if "such conduct has the purpose or effect of unreasonably interfering with an individual's work performance or creating an intimidating, hostile, or offensive working environment."

Most importantly, the high court ruled that:

> ...since the Guidelines were issued, courts have uniformly held, and we agree, that a plaintiff may establish a violation of Title VII by proving that discrimination based on sex has created a hostile or abusive work environment.

In reaching this conclusion, the Supreme Court cited the 1982 federal appeals court case *Henson v. Dundee* approvingly. That decision had held:

Sexual harassment which creates a hostile or offensive environment for members of one sex is every bit the arbitrary barrier to sexual equality at the workplace that racial harassment is to racial equality. Surely, a requirement that a man or woman run a gauntlet of sexual abuse in return for the privilege of being allowed to work and make a living can be as demeaning and disconcerting as the harshest of racial epithets.

Vinson's allegations—which included not only pervasive harassment but also criminal conduct—were plainly sufficient to state a claim for "hostile environment" sexual harassment.

The high court stressed that:

The gravamen of any sexual harassment claim is that the alleged sexual advances were unwelcome. The [trial court] erroneously focused on the voluntariness of Vinson's participation in the claimed sexual episodes. The correct inquiry is whether Vinson by her conduct indicated that the alleged sexual advances were unwelcome, not whether her actual participation in sexual intercourse was voluntary.

However, it did allow that—while "voluntariness" in the sense of consent is not a defense to such a claim—an alleged victim's sexually provocative speech or dress might be relevant in determining whether he or she found particular sexual advances unwelcome.

On the issue of liability, the bank argued that Vinson's failure to use its established grievance procedure, or to otherwise put it on notice of the alleged misconduct, insulated it from liability for Taylor's wrongdoing. A contrary rule would be unfair, it argued, since in a hostile environment harassment case the employer often will have no reason to know about, or opportunity to cure, the alleged wrongdoing.

The Supreme Court rejected most of the bank's argument. The mere existence of a grievance procedure and a policy against discrimination didn't insulate the employer from liability. In fact, the bank's general nondiscrimination policy did not address sexual harassment

in particular, and thus did not alert employees to their employer's interest in correcting that form of discrimination.

The bank's argument that Vinson's failure to lodge an official complaint insulated it from liability would have been "substantially stronger if its procedures were better calculated to encourage victims of harassment to come forward."

Justice William Rehnquist, writing for the court, boiled the conclusion down to six essential points:

1) hostile environment sexual harassment is a form of sex discrimination actionable under Title VII;

2) the employee's allegations of sexual conduct were sufficient to state a claim for hostile environment sexual harassment;

3) a sexual harassment claim doesn't require a direct economic effect on the employee;

4) the correct inquiry on the issue of sexual harassment is whether sexual advances were unwelcome, not whether employee's participation in them was voluntary;

5) evidence of an employee's sexually provocative speech and dress was not [relevant in this case], though it might be relevant in some contexts; and

6) mere existence of a grievance procedure and policy against discrimination, coupled with an employee's failure to invoke that procedure, did not necessarily insulate the employer from liability.

Those points remain the defining terms of sexual harassment.

The Supreme Court Broadens the Scope of Title VII

The Supreme Court's double-whammy we mentioned earlier—and the two remaining parts of our defining trilogy—both came in June 1998. Both *Faragher v. City of Boca Raton* and *Burlington Industries v. Ellerth* are essential to the current understanding of harassment issues. In both cases, the courts considered a company's liability for sexual

harassment between supervisors and employees, and whether or not a company can be held liable if a supervisor's higher-ups (that is, "the company") didn't know about the abuse.

In *Faragher*, a female lifeguard, Beth Ann Faragher, sued the City of Boca Raton, Florida, because she claimed to have been the target of a sustained pattern of sexually abusive behavior and derogatory remarks initiated by two of her supervisors. One of them said to Faragher, "Go out with me or clean the toilets for a year." Faragher and other female lifeguards suffered unwanted touching, some of it blatantly sexual in nature. The supervisors frequently propositioned the women for sex and made suggestive and crass sexual remarks. They even pantomimed sexual acts, sometimes while lewdly groping the women.

One female lifeguard—but not Faragher—complained to the city about the supervisors' behavior. The city responded by reprimanding the two men and exacting a financial penalty.

However, Faragher never reported the harassment to anyone with authority over the two offenders. And she didn't decide to sue until after she left the job and entered law school. The first trial disclosed that the city had an anti-harassment policy, but that the lifeguards had not received it. Still, Faragher was awarded one dollar for her Title VII claim, reportedly because she had not complained at the time of the harassment.

On appeal, however, the appeals court took away Faragher's dollar. Faragher, it said, was not entitled to hold the city responsible since she never informed them of the problem. That makes sense to many employers. If no one lets you know there's a problem, how can you be liable for not fixing it? When Faragher took her case to the Supreme Court, the answer was: vicarious liability. You'll need a lawyer to explain all the ramifications of that, but the overall idea is that employers are generally liable for the actions of their employees, whether or not the employer knows about or is informed about the specific conduct. It's an extension of the notion that your company is liable if an employee causes an auto accident and hurts someone while on company time or company business, or while driving a company vehicle.

The high court also found that Faragher's workplace was a sufficiently hostile environment to allow a Title VII claim even though she did not suffer any adverse economic or employment effects as a result. So the Supreme Court reversed the appeals court and found in favor of Faragher.

Burlington Industries v. Ellerth was similar to *Faragher* in that Kimberly Ellerth did not suffer adverse employment action, did not complain to company officials about her harassment and sued only after she quit. Ellerth was a sales rep for Burlington Industries in Chicago. Ted Slowik, from the New York office, was not her immediate supervisor, but had overall supervisory control of the Chicago office. He took an unwelcome sexual interest in Ellerth, and repeatedly promised promotions if she slept with him and threatened job-related negative consequences when she refused. Far beyond the "one free pass," Slowik established a pattern of threats and attempted coercion.

During one of Slowik's advances, he told Ellerth, "I could make your job very hard or very easy." During an interview about a promotion, he suggested she wear short skirts, implying that the promotion depended on it. "You're going to be out there with men who work in factories and they certainly like women with pretty butts and legs," he said, according to Ellerth.

However, Slowik's threats of job-related negative consequences were never carried out. Ellerth got her promotion. She quit over a dispute with her immediate supervisor, not Slowik. During her employment, she never reported Slowik's harassment, even though she was aware of Burlington's written anti-harassment policies and of the procedure she could have followed to deal with her harasser within the company. Besides, she didn't even mention the harassment when she quit. Only later did she state harassment as the reason for her departure.

In ruling in Ellerth's favor, the Supreme Court sent chills through corporate America. It didn't matter that Ellerth never complained. It didn't matter that the company had an anti-harassment policy and resolution procedure, or that she knew it and ignored it anyway. It didn't matter that Ellerth only came up with the harassment charges after she quit.

Perhaps worst of all from the risk management perspective, it didn't help that Slowik's threats were never carried out, even though Ellerth rejected his advances and presumably never even wore the short skirts.

The Supreme Court found that a company can be held liable under Title VII for hostile environment sexual harassment even when the victim suffers no adverse employment action after refusing the unwelcome advances. Companies, it seemed, were completely stripped of possible defenses against harassment suits.

Yet, from the employee's point of view, the rulings in both *Faragher* and *Burlington* are good news. Another important decision, *Harris v. Forklift Systems*, had already established that no adverse psychological consequences need to be shown in order for an employee to sustain a claim of sexual harassment. In that case, a boss asked an employee to fish for coins in his front pocket and to meet him at a motel for salary negotiations. The two new cases eliminate the need to show adverse employment action, to complain before you quit or to follow company complaint procedure.

What it all boils down to is that the Supreme Court is apparently sending the message that an employee need not tolerate a sexually hostile or oppressive workplace environment, no matter what.

Personal and Corporate Responsibility

In the whirlwind of controversy following *Faragher* and *Burlington*, the main theme was who should be responsible for sexual harassment. Concerning the cases, Justice David Souter wrote:

> When a fellow employee harasses, the victim can walk away ...but it may be difficult to offer such a response to a supervisor. When a person with supervisory authority discriminates in terms and conditions of subordinates' employment, his actions necessarily draw upon his superior position over people who report to him. An employee generally cannot check a supervisor's abusive conduct the same way that she might deal with abuse from a coworker.

Justice Anthony Kennedy expressed the court's decision on liability:

> An employer is subject to vicarious liability to a victimized
> employee for an actionable hostile environment created by
> a supervisor with immediate (or successively higher) author-
> ity over the employee.

Kennedy also addressed how a company might limit its liability or
present its defense:

> When no tangible employment action is taken, a defend-
> ing employer may raise an affirmative defense to liability or
> damages, subject to proof by a preponderance of the evi-
> dence.

He added that the defense would require two showings. First, that the
company "exercised reasonable care to prevent or correct promptly
any sexually harassing behavior"; and second, that "the employee un-
reasonably failed to take advantage of any preventive or corrective
opportunities provided by the employer or to avoid harm otherwise."

However, Ellerth knew about Burlington's anti-harassment policies
and procedures, failed to follow them and won anyway.

The message to employers is very clear: Have a sexual harassment
policy, make sure every employee is aware of it; have a complaint
process to deal with sexual harassment problems and make sure em-
ployees are encouraged to use it; and make sure there are several people
to whom aggrieved employees can report, in case a supervisor is the
offender.

Managers and supervisors might think the *Burlington* and *Faragher*
decisions take them—personally—off the liability hook. If you're one
of those, you'll have to think again. Even though Title VII may not
apply to individual managers or supervisors, state or local FEP laws
may apply.

Meanwhile, there's no question that the trend of court decisions is to
make employers increasingly liable. Legal defenses for companies are

dwindling fast. And it's scant comfort that as many as 80 percent of the claims filed with the EEOC are not deemed worthy of action. The awards in the cases that do make it are rising fast. In response, many companies are paying for special insurance to cover possible losses from discrimination and harassment cases. And unless there's a sudden change in the courts' attitudes, there's no good reason to expect that employer liability will do anything but continue to increase.

When Women Harass

"Can we imagine John Wayne filing a sexual harassment suit...?" That question was posed by sociologist and author Frederick R. Lynch. Actually, he was talking about same-sex harassment and the end of the sentence was "...against another guy." But Lynch might just as well have been talking about women sexually harassing men. The same myth applies. Lynch says, "Male behavior is dominated by the John Wayne model."

Lynch's quote touches upon a sensitive nerve that runs deep in the collective American male psyche. But we need to go one step further to explain why that nerve is so raw. It's surely closer to the truth of the male's collective unconscious (and consciousness and conscience) to say that male behavior is dominated by the *collapse* of the John Wayne model, and by the lack of another acceptable model to replace it.

What do we mean by the collapse of the John Wayne model vis-à-vis women and sexual harassment by women? In general, it means that a great many men are fully aware that it's no longer acceptable, legally or socially, to treat women as the weaker sex in need of protection. It means it's not acceptable to step in and punch someone out for insulting a woman. It means that Wayne's usual on-screen, over-politeness toward women in itself could be seen as a form of gender discrimination in today's workplace. And it means that men can no longer expect to act as macho heroes and expect women to be impressed at all, let alone reward them with sweet, servile devotion and sexual favors.

Problem is, most people of both sexes seem much more clear about what's not acceptable than about what is. The John Wayne model is out, but what model is in? Of course, the ideal view is that no single

model should be in. We should all be empowered to find our own models based upon our individual personalities—and the John Wayne model would presumably be okay—even for some women, too.

The multi-model notion clearly wouldn't fly in today's workplace. In fact, sexual harassment lawsuits are establishing a new model of male behavior in the workplace. It's mostly a list of what men can no longer do and say (that they could when the John Wayne model prevailed). It's a set of dos and don'ts designed to modify men's speech, behavior and demonstrated attitudes to conform to women's preferences. If that sounds overblown, consider that still only nine percent of sexual harassment cases involve men harassed by women.

Consider this observation from *Sexual Harassment on the Job* by William Petrocelli and Barbara Kate Repa:

> To a certain extent, a woman employee makes her own rules as to what is—and is not—acceptable workplace behavior. Once a woman reasonably defines the boundaries of what is personally offensive to her, it will often be considered sexual harassment for a coworker to cross such boundaries.

That sounds fine on one level. In a larger sense, however, it's a strange and sad situation. These rules and boundaries impact the whole spectrum of social and moral interactions between men and women. Their effect extends well past the workplace. They permeate all aspects of our lives. This new model of male behavior isn't coming from the Church with the threat of hell. It's not coming from heroes or positive role models. It's coming from corporations with the threat of job loss or jail.

Some critics wrongly intuit that women have gained power from these personal boundaries—but boundaries would not be necessary if ill-mannered coworkers (or supervisors) behaved professionally. The truth is that women are not empowered to restrict or define a man's roles in the workplace through a skewed notion of alleging sexual misconduct, just as men no longer define women's roles. Off-color remarks,

jokes and intimate commentaries of a sexual nature have no place at work. Simply put, they are inappropriate and cannot be defended as "romantic conversation." These behaviors send mixed messages and should not be condoned in the workplace setting. And behavioral changes begin with the individual.

We've spoken extensively about what happens when men harass women, largely because men are responsible for the majority of harassment between the sexes. But what happens when women harass men? How can a man handle inappropriate behavior that not only detracts from his workplace experience, but also undermines his notion of masculinity?

Thomas Ferri is an internal affairs investigator at what has been called New Jersey's toughest prison. He's the one officials call in to investigate internal prison crimes and problems such as the killing of one inmate by another. He's also the one who is suing the Department of Corrections and Deborah Davey, Ferri's supervisor, for sexual harassment.

Ferri alleges months of sexual taunting and lewd behavior by Davey that included partially undressing in front of him more than a dozen times in the office they shared. According to the *Star-Ledger Newark*, Ferri's attorney Alan Schorr reported, "She was undressing in front of him and...demeaning his manhood and saying other unprintable things." When Ferri objected and asked her to stop, Davey reportedly laughed in his face. "Sexual harassment is not about sex," Schorr said. "It's about power. They knew this woman had power problems and she used this manner to exert her power. It was, look, I can do these things in front of you and call you these names because you can't do anything about it, because I'm your boss."

After his complaints, Ferri claims he was subjected to months of verbal abuse in which Davey demeaned his masculinity "with a barrage of vulgar and disgusting language." Finally, Ferri filed a complaint with the Department of Corrections Commissioner. But just 10 days later, Ferri was transferred to a smaller prison—presumably tantamount to a demotion. Worse still, the head of internal affairs—supervisor to both Ferri and Davey, and also a woman—frankly told Ferri he was being

transferred because he complained. Her deposition transcript reports, "I transferred him because he complained of a hostile working environment. And I knew...it would not be a good idea to have the two of them working together." Manager alert: This is not a good reason to transfer a victim of harassment; better to transfer the perpetrator.

To make matters even worse, Ferri claims Davey, upon news of Ferri's transfer, ransacked his office and dumped all his personal effects into a box.

Ferri's case is similar to an earlier sensational trial which ended in a jury award of $3.75 million to a male prison guard who sued a female coworker for sexual harassment. In that instance, the *Star-Ledger Newark* reported that Robert Lockley, a prison tower guard was "subjected to years of harassment and ridicule by a female guard, Rhonda Turner, and her friends after he rebuffed her sexual advances. The father of two said his 15-year marriage was nearly ruined and his life made miserable by "a four-year campaign of ostracism, catcalls and jokes, including the suggestion by his supervisor that he 'just sleep with' Turner." The jury sided with the male, awarding reportedly the largest reverse sexual harassment award ever.

You probably remember Lord Acton's saying that "power tends to corrupt, and absolute power corrupts absolutely." Sexual harassment is about power, not sex. With women increasingly in management positions in a competitive workplace where the getting and wielding of power is what it's all about, we can only hope that women can avoid the pitfalls that have tripped so many men. Then perhaps the number of reverse sexual harassment cases will remain small or even diminish.

The Personal Point of View

It's interesting and a little bit disconcerting to note that, at the very same time the EEOC, court decisions and anti-gender discrimination policies are trying to eliminate gender stereotypes and advance the proposition that all employees should be treated absolutely equally, the overwhelming evidence from both informal polls and academic research concludes that men and women have fundamentally differ-

ing views of what constitutes sexual harassment. For example, a poll conducted by the U.S. Merit Systems Protection Board found that of 20,000 federal employees, 72 percent of the women considered sexually oriented remarks by a supervisor amounted to sexual harassment while 58 percent of the men found the same remarks to constitute harassment. Other published surveys show an even wider gap.

In trying to sort out how to determine what workplace behavior constitutes sexual harassment, the courts experimented with a "reasonable woman" standard. If a reasonable woman could consider the conduct harassing, then so be it. Given the difference in perception between men and women as to what rises to the level of harassment, and the fact that the overwhelming percentage of claims were filed by women, the courts decided the reasonable woman standard was best. To some, this standard seemed to entail an assumption of guilt—that a borderline action was meant to be harassment. Then in 1993, the Supreme Court ruled that a "reasonable *person*" standard was more just. But many women's rights advocates argue that standard unfairly skews the standard toward the male perspective.

Now that the Supreme Court has broadened Title VII to encompass same-sex harassment, the reasonable woman standard can no longer be universal. Some courts have sought to apply a reasonable person standard.

Common sense would dictate that the "reasonable" standard would depend not only upon whether the case is male-on-male, female-on-male, male-on-female or female-on-female, but also upon the specifics of the workplace atmosphere which spawned the dispute.

Yet, a manager or employee doesn't need to wait for the courts or even a company to issue anti-harassment proclamations, rules and regulations. In fact, we all might actually be better off to rely on ourselves to nip potentially harassing situations in the bud. It's a matter of personal empowerment rather than running to the authorities at the first hint of a threat.

Some anti-harassment consultants and resource books suggest that companies set up complaint systems that encourage employees to re-

port any potentially harassing behavior they see or hear—even if they're not directly involved. They suggest implementing dress and conduct codes and bans on all banter that could be perceived by anyone as sexual. And they suggest that managers intervene when they hear or see tawdry behavior.

"We often find that history is rewritten when things turn sour between an employer and a woman who has participated in joking of a sexual nature," says Brenda Eckert, a partner in the labor and employment law department at Shipman & Goodwin in Hartford, Connecticut. Sometimes this happens because the woman did not get a particular assignment or advancement she wanted. But whatever the cause, when history is rewritten, you can bet you won't like the plot. Says Eckert, "The woman may later claim that she was offended, and she was joking along with everyone else to reduce her embarrassment."

"It's a red flag if you find a woman laughing at or partaking in sexual conversation that you think is beyond what a reasonable woman would find funny or appropriate," says Eckert. "Often, a woman will try to diffuse her embarrassment by laughing along with everyone else."

While this may sound extreme and will unduly foster the stereotype that women can't and won't raise their own red flags when something is amiss, the workplace reality for many women is far from the ideal. Many women *can* and *will* stand up for themselves, but there are just as many who truly believe that, in certain work environments, they cannot make a stand and will not be heard. And often, the very person(s) responsible for setting the tone of a department or company is the same individual making the inappropriate comments. Employees take their cue from management, and managers do not always walk upright.

We're not suggesting that companies shouldn't have anti-harassment policies and complaint procedures. They certainly should. And you shouldn't hesitate to use them if you experience quid-pro-quo harassment. But if you feel your working environment is turning hostile, we suggest that you first claim your own power and confront the offending behavior yourself. For example, let's assume you're a woman, and a coworker makes what you consider to be sexually offensive remarks

or unwelcome sexual advances. Politely tell him that you'd rather not witness such behavior. Let him know how you feel about the behavior; give him a chance to correct it or in the least, become aware of it.

Given the difference in perception between men and women as to what's harassing behavior, a woman may be surprised to hear the guy apologize, sincerely explain that he meant no offense and stop the unwelcome behavior right away. How is a guy supposed to know his advances are unwelcome if you don't tell him so? In an ideal world, he should know better—yet men's behavior has been tolerated for so long that most guys are simply unaware of what behaviors are appropriate and what are not. Of course, if he doesn't cease and desist, then you certainly should turn to the company's complaint procedure. And you should pursue it as far as necessary to enforce your right to work in a harassment-free environment.

However, by being willing to empower yourself to speak up—and stand up—for yourself first, you may be surprised at how much your demeanor discourages potential harassers from targeting you at all. It's the same personal dynamic that women's self-defense classes teach. Simply adopting a non-victim mentality makes you far less likely to be victimized.

Some observers of workplace dynamics contend that women are reticent to speak up about harassment for a whole list of reasons. These range from fear of being considered a troublemaker, to an age-old acculturated feeling of responsibility—"what did I do to cause this"— even though you're merely a victim, to shame, to hopelessness because the power structure in most companies is still male-dominated. Yet the truth is that dwelling on any—or all—of these fears and false self-messages is only more likely to keep you a victim or make you one. That's not to say that standing up for yourself is easy. Fear is powerful. Support groups abound can help empower you and make you stronger than a passive victim.

Personal empowerment for both men and women in the workplace must also include taking personal responsibility for learning to distinguish between verbal or physical gestures that relay healthy, natural romantic impulses and those that pervert sexual energy into the abuse of

power which constitutes harassment or abuse. The reality that unwanted sexual advances—even verbal ones—can constitute harassment should be troubling to both men and women.

Companies have shown that they'll respond to harassment allegations by clamping down harder on any and all behavior that has any sexual or romantic aspect whatsoever. But the companies are motivated by the threat of lawsuits; and those threats come from employees. If employees learn to recognize and accept romantic overtures in the workplace—including allowing leeway for unwanted advances—then employers won't have reason to ban certain behaviors.

After all, if harassment is about the abuse of power and not sex, then let's concentrate on ways to eliminate the abuse of power—not eliminate the sex. We all know that it's impossible to eliminate sex—healthy, natural, romantic attraction-type sexuality—from the workplace. Don't we all know that trying to suppress romance will only make the harassment problems worse? We don't want to put our companies in the position of having our supervisors monitor all our hallway chats and write us up if we giggle the wrong way. Romance is too important—and vital to healthy human behavior—to leave to risk management types. Not to mention the threat of allowing companies to further invade our personal lives.

In short, employees actually drive the companies to do what they do. It takes employees to concentrate on eliminating sexually charged abuse of power and to nurture healthy romantic impulses and expression. Employees can monitor their aggression and make sure it doesn't get channeled into abuse. Likewise, they can learn to allow a few "unwanted sexual advances" as long as they aren't truly overbearing and abusive.

First Steps to Stopping Harassment

From the employer's point of view, the Supreme Court made the necessary first steps in stopping harassment crystal clear—at least as far as employer liability is concerned.

In the cases of *Burlington* and *Faragher*, the Supreme Court wrote, "When no tangible employment action is taken, a defending employer may raise an affirmative defense to liability or damages, subject to proof by a preponderance of the evidence."

The defense would require two showings. First, that the company "exercised reasonable care to prevent or correct promptly any sexually harassing behavior" and second, that "the employee unreasonably failed to take advantage of any preventive or corrective opportunities provided by the employer or to avoid harm otherwise."

Practically all employment practices experts agree that this means employers must have clear, concise and communicated (in writing) anti-harassment policies and an equally clear and effective complaint procedure that employees are actively encouraged to use.

An extra note of caution: The courts have been clear that there is no defense for quid-pro-quo harassment. If an employee can show that he or she suffered adverse employment action as a result of refusing to exchange sexual favors, then liability is absolute.

However, the whole issue of hostile environment is problematic. The legal system can give women broad protection against sexual harassment that is grounded specifically in an understanding of the female mind—or it can ignore gender differences and give women less protection. Neither prospect offers a reliable model to employers.

Nevertheless, the process for combating a hostile environment is fairly straightforward:

- Have a written policy stipulating that sexual harassment and retaliation against anyone who claims sexual harassment "is prohibited and will not be tolerated";

- Explain—precisely—the kinds of activities that constitute sexual harassment. Examples are useful in this process, but make sure that they aren't taken to be the only kinds of harassment you forbid;

- Identify—in advance—particular individuals within the company who will investigate harassment complaints. Make sure these people have at least a basic understanding of the legal definitions of harassment and are credible to coworkers;

- Start an in-house investigation as soon as a complaint is made. The investigator might ask the alleged victim what remedial action he or she wants you to take. The answer may indicate how serious the alleged victim considers the charge and may pave the way for a quick and easy solution;

- Resolve all investigations with a finding of fact. People may not be satisfied with your conclusions. They may go on to complain—or already have complained—to government agencies. But the report helps you establish a good-faith effort to resolve the alleged problem;

- Highlight your sexual harassment policies regularly, updating workers on recent cases that relate to your business or region.

If you're an employer already facing a sexual harassment case, you can limit your liability by taking remedial action. You can always clarify your company policy barring sexual harassment and encourage communication by holding antidiscrimination workshops for employees. In most cases, you can perform an in-house investigation. If you find the complaint valid, you can take disciplinary action against the alleged harasser—but be very careful doing this.

Employers who react zealously when a worker accuses a colleague of sexual harassment can end up in court just as quickly as those who do nothing. You have to make sure to treat the accused harasser fairly—no matter how guilty you may believe he or she is.

Gender stereotypes—especially when they tend to denigrate women in the workplace—can not only contribute to a hostile work atmosphere, but also work their way into a company's written documents. There they can be used as evidence against an employer if a harassment or discrimination claim is pursued.

And stereotypical biases aren't just confined to older males who came up through the good ol' boy days.

"This is really more often the case these days," says one Washington, D.C.-based attorney who has been involved in several of the Supreme Court's sexual harassment decisions. "People from the Baby Boom generation reach a certain level of seniority in a company...and they don't know what to do. So they try to act like their fathers...or fat cat businessmen from old movies. [They are] 35-year-olds with baby faces drinking martinis at lunch and smoking cigars all afternoon. And then—whoops—they let loose some zinger about how Mary down the hall who's really bright and billing tons of hours is too much of a ball-buster to ever deal with clients. They're just not thinking."

How can employers avoid these kinds of problems? How does an employer rein in the swaggering yuppie who's complaining about the pushy dames in the office between puffs on his Macanudo? Here are some suggestions for the employer. We'll be adding to, referring and repeating many of these throughout the book:

- Don't tolerate managerial or supervisory comments that include unfounded generalizations about what men or women "tend to be" or "should be like." Even said in jest, these kinds of comments create misperceptions—and not just among people who'll sue. People who hear salty comments in a closed meeting are more likely to let something stupid slip in the hallway.

- Don't personalize reviews or evaluations. Keep the focus on the job. When managers start offering their impressions of an employee's physical demeanor or personality, they are heading for trouble.

- Within reason, try to use gender neutral terms in supervisory comments and company documents. Taken to the extreme, this can turn into awkward political correctness. However, having a paper trail of gender neutral policies makes discrimination more difficult to prove.

- Train managers and supervisors to avoid stereotyping language in recruitment, performance evaluations, promotions, memos and public documents. These guidelines should apply in all business contexts—whether in the office or outside. Supervisors should carefully consider what they say, even in private conversations with subordinates or peers.

- Establish objectivity whenever you can. Even seemingly non-quantifiable areas such as interpersonal skills can be objectified with behavioral rating scales. Where objectivity is impossible, try to establish consistency. Consistency may be the hobgoblin of little minds, but it lessens the chance of lawsuits.

- Review the composition of your workforce on a regular basis. Diversity laws can't tell you whom to hire or promote, but they can indicate where problems lie. Knowing that angry employees can use statistical trends to establish prima facie discrimination, you can look for potential problems. Segregation of women into lower-level jobs may indicate a pattern of behavior based on improper gender stereotypes.

- Be aware that isolated individuals in otherwise homogeneous environments make many discrimination and harassment claims. Promoting a woman who isn't best qualified to a senior position doesn't solve your gender mix problems. It may actually increase them. This doesn't mean you should adopt broad quotas—in fact, it means the opposite. Promote people who deserve to be promoted. That strengthens their position.

- Keep policies clear and update them regularly. When information and criteria are ambiguous, stereotypes can provide structure and meaning to confused employees. Stereotypes shape subjective perceptions most when data are open to multiple interpretations. (Refer to Chapter 7 for the details of company policies. That is where we discuss what and how policies work.)

Conclusion

The average jury award for employment claims doubled from $168,000 in 1990 to $299,000 in 1996. Surely it's much higher than that now. Title VII claims are capped between $50,000 and $300,000 depending upon company size, but many state courts allow unlimited damages in sexual harassment suits. And companies of all sizes are increasingly vulnerable.

Employment practices liability insurance, which protects against sexual harassment and discrimination claims, can cost as much as $10,000 to

$15,000 per $1 million of coverage for a company of 200 employees with no loss record.

In a perfect world, a company wouldn't need the insurance. It wouldn't need the anti-harassment policies and procedures and it wouldn't need the antidiscrimination training seminars. But the employment world isn't perfect. That's what gave rise to the legitimate claims of gender discrimination and sexual harassment—and to the abuses and excesses of those claims, too. Sexual dynamics can't be legislated out of the workplace, no matter how many conduct policies, dress codes, lawsuits and punitive awards there are.

Sex will always be a driving force in the workplace. The challenge is to find a new common ground of mutual respect, trust and cooperation among employees. We must distinguish between natural, healthy romantic attraction and the abuse of power that perverts sexual energy into harassment and discrimination. We won't stamp out harassment and abuse by banning office romances. In fact, such oppression is bound to make matters worse. We must deal with sexual harassment by learning how to effectively manage our workplace environments. This includes managing power struggles, sexual drives and competing social values and mores.

Like it or not, the workplace is the forge and anvil upon which the new social/behavioral models are being hammered out. That process entails a lot of heat, fire, noise and steam. Yet only by standing the heat long enough to eliminate sex harassment and gender discrimination while leaving the romantic spirit alive will companies and employees thrive. To ignore that challenge would be the costliest mistake of all.

In its most basic sense, sexual harassment means that an employee is treated differently because of how superiors or peers respond to his or her sexual identity. It entails a threat—either direct or indirect—or some kind of negative impact to coerce complicity.

Ridiculing a coworker's sexual orientation, forcing a subordinate to have sex and even engaging in a consensual sexual affair with a peer can all be considered sexual harassment, depending on circumstances.

These circumstances bedevil most employers. They often involve only the parties to the allegations—which means a he said/she said conflict without witnesses. They also sometimes involve subtle issues of intent, when different people honestly believe totally different versions of a single episode.

Orientation

The Supreme Court decision *Michael Oncale v. Sundowner Offshore Services* has become one of the most significant rulings in American law involving sexual orientation in the workplace.

In late October 1991, Oncale was working for Sundowner Offshore Services on a Chevron U.S.A., Inc., oil platform in the Gulf of Mexico. He was employed as a roustabout on an eight-man crew which included John Lyons, Danny Pippen and Brandon Johnson.

Lyons, the crane operator, and Pippen, the driller, had supervisory authority. On several occasions, Oncale was forcibly subjected to sex-related, humiliating actions against him by Lyons, Pippen and Johnson in the presence of the rest of the crew. Pippen and Lyons also physically assaulted Oncale in a sexual manner, and Lyons threatened him with rape.

Oncale's complaints to supervisory personnel produced no remedial action; in fact, the company's Safety Compliance Clerk, Valent Hohen, told Oncale that Lyons and Pippen "picked [on] him all the time too," and called him a name suggesting homosexuality.

Oncale eventually quit—asking that his pink slip reflect that he "voluntarily left due to sexual harassment and verbal abuse." When asked at his deposition why he left Sundowner, Oncale stated "I felt that if I didn't leave my job, that I would be raped or forced to have sex."

Oncale filed a complaint against Sundowner in the United States District Court for the Eastern District of Louisiana, alleging that he

was discriminated against in his employment because of his sex. The district court held that "Oncale, a male, has no cause of action under Title VII for harassment by male coworkers." On appeal, a panel of the 5ᵗʰ Circuit agreed.

The Supreme Court agreed to consider the case. And Justice Antonin Scalia wrote one of the court's most succinct statements on sex at work.

Title VII of the Civil Rights Act of 1964 provides, in relevant part, that "[i]t shall be an unlawful employment practice for an employer...to discriminate against any individual with respect to his compensation, terms, conditions or privileges of employment, because of such individual's race, color, religion, sex or national origin."

From this basis, Scalia wrote:

> We have held that this not only covers "terms" and "conditions" in the narrow contractual sense, but "evinces a congressional intent to strike at the entire spectrum of disparate treatment of men and women in employment." ...When the workplace is permeated with discriminatory intimidation, ridicule and insult that is sufficiently severe or pervasive to alter the conditions of the victim's employment and create an abusive working environment, Title VII is violated.

Title VII's prohibition of discrimination because of sex protects men as well as women, and in the related context of racial discrimination in the workplace, federal courts have consistently rejected the presumption that an employer will not discriminate against members of his or her own race. The same idea can be applied to gender.

Scalia went on to write:

> Because of the many facets of human motivation, it would be unwise to presume as a matter of law that human beings of one definable group will not discriminate against other members of that group.

If our precedents leave any doubt on the question, we hold today that nothing in Title VII necessarily bars a claim of discrimination "because of...sex" merely because the plaintiff and the defendant (or the person charged with acting on behalf of the defendant) are of the same sex.

The Supreme Court saw no justification in the statutory language or other precedent decisions for a categorical rule excluding same-sex harassment claims from the coverage of Title VII. As some courts have observed, male-on-male sexual harassment in the workplace was assuredly not the principle evil Congress was concerned with when it enacted Title VII. But statutory prohibitions often go beyond the principle evil to cover reasonably comparable evils, and it is ultimately the provisions of our laws rather than the principle concerns of legislators.

In short, Title VII prohibits discrimination because of sex in the terms or conditions of employment. There is no justification in Title VII's language or the court's precedents for a categorical rule barring a claim of discrimination "because of...sex" merely because the plaintiff and the defendant (or the person charged with acting on behalf of the defendant) are of the same sex.

Some of the parties to the case argued that recognizing liability for same-sex harassment will transform Title VII into a general civility code for the American workplace. But the court found *that* risk no greater for same-sex than for opposite-sex harassment—and that it would be adequately managed by careful attention to the requirements of the statute.

Specifically, the Supreme Court concluded:

> Recognizing liability for same-sex harassment will not transform Title VII into a general civility code for the American workplace, since Title VII is directed at discrimination because of sex, not merely conduct tinged with offensive sexual connotations; since the statute does not reach genuine but innocuous differences in the ways men and women routinely interact with members of the same, and the opposite,

sex; and since the objective severity of harassment should
be judged from the perspective of a reasonable person in
the plaintiff's position, considering all the circumstances.

Scalia pointed out that the Supreme Court has never held that work-
place harassment, even harassment between men and women, is au-
tomatically discrimination because of sex merely because the words
used have sexual content or connotations. "The critical issue, Title
VII's text indicates, is whether members of one sex are exposed to
disadvantageous terms or conditions of employment to which mem-
bers of the other sex are not exposed."

Courts and juries have found the inference of discrimination easy to
draw in most male-female sexual harassment situations, because the
conduct in question typically involves explicit or implicit proposals of
sexual activity; it is reasonable to assume those proposals would not
have been made to someone of the same sex. The same chain of infer-
ence would be available to a person alleging same-sex harassment, if
there were credible evidence that the harasser was homosexual.

As we have seen already—and will see throughout this book—this
legal theorizing leads to some tortured decisions.

In the *Oncale* decision, the Supreme Court pointed out that harass-
ing conduct need not be motivated by "sexual desire" to support an
inference of discrimination on the basis of sex. A jury might reason-
ably find such discrimination, for example, if a female victim is ha-
rassed in such sex-specific and derogatory terms by another woman as
to make it clear that the harasser is motivated by general hostility to
the presence of women in the workplace.

A person claiming same-sex harassment might also offer direct com-
parative evidence about how the alleged harasser treated members of
both sexes in a mixed-sex workplace.

The person would always have to prove that the conduct at issue was
not merely tinged with offensive sexual connotations, but actually
constituted discrimination because of sex.

The Status of Gays in the Workplace

By all accounts, the late 1990s were watershed years for gay and lesbian rights. All across the country, gay rights activists and observers were elated that the long-overdue progress seemed so impressive. For some, a critical mass was finally reached between activism, public awareness and acceptance, and the interplay of both positive and negative gay-related events. Positive media portrayals of gays and lesbians, including the television sitcom "Ellen," with a lesbian lead character, helped the push from one side. On the negative side: the horrific murder of Matthew Shepherd and several other barbaric assaults against gays and lesbians. Somehow, enough of us reached and passed the enough-is-enough threshold to spur what many hailed as the most significant decade in gay rights history.

For example:

- 1999. California Governor Gray Davis signs three new gay rights laws that provide: hospital visitation rights for gay couples; health-care and pension benefits for state-employed gay couples; bans on discrimination in jobs and housing; adoption rights for gay couples; and bans on harassment of gay teachers and students in public schools and colleges.

- August 1999. The New Jersey Supreme Court rules that the Boy Scouts may not use sexual orientation as a basis for discrimination.

- June 1999. A gay police officer's $380,000 award for being harassed by other male officers is upheld by a New York federal judge.

- December 1998. An Oregon appellate court rules that employment statutes against gender discrimination in firing, hiring, promotion, pay and benefits must apply to sexual orientation as well as biological gender.

- August 1998. The U.S. House of Representatives defeats 252 to 176 a bill seeking to nullify President Bill Clinton's executive order of May 28, 1998 barring job discrimination in federal agencies based upon sexual orientation.

- March 1998. Supreme Court in *Oncale v. Offshore* rules that sexual harassment is not the exclusive domain of opposite sexes. Same-sex harassment claims can be pursued under Title VII.

- 1996. The U.S. Supreme Court rules Colorado's (and thus any state's or local government's) anti-gay statutes unconstitutional.

Karen Matthews, writing about the progress in the June 27, 1999 *Cincinnati Enquirer,* quoted Kerry Lobel, executive director of the National Gay and Lesbian Task Force. Ms. Lobel said, "We've made a sea of change in not just public opinion but public policy as well. We see that in areas like civil rights, hate crimes, family issues and sodomy repeal, we have more possibility of legislative change than ever before."

But the person who summed it up best was Tom Ammiano, president of the San Francisco Board of Supervisors and a gay activist, when he said, "The love that dare not speak its name now won't shut up."

Yet, many gay rights activists insist there's still a long way to go. Some say we haven't even taken the first truly meaningful step, at least not on a national level. If that view seems extreme, consider this: In terms of job discrimination, Title VII of the Civil Rights Act still has never been ruled or interpreted by the courts to apply to gays and lesbians, let alone the transgendered. The famous *Oncale* case allows same-sex harassment claims to be pursued under Title VII. We'll discuss that case in more detail in Chapter 5. Briefly, the Supreme Court ruled that men could, under a new/broader definition of the word, sexually harass men and women could harass women. But the decision, while indirectly significant for gay rights, did not address Title VII's failure to prevent employment discrimination based upon sexual orientation. So as far as Title VII is concerned, it's still perfectly legal, for example, for the State of Georgia's Attorney General's Office to fire a lesbian just because of her sexual orientation.

A Bad Legal Treatment of Orientation

The standard against which all sexual orientation-related issues must be compared is the November 1996 federal appeals court decision *Arthur Wrightson v. Pizza Hut of America.* The case, one of the most-

often cited cases involving sexual orientation issues, wasn't exactly a shining beacon of logic and clarity. In fact, the decision could be called the Dred Scott of sexual orientation.

The case involved a male employee who brought action against his employer—alleging that a homosexual male supervisor and other homosexual male employees subjected him, as a heterosexual male, to "hostile work environment" sexual harassment in violation of Title VII of the Civil Rights Act of 1964.

Arthur Wrightson was 16 years old when, from March of 1993 until March of 1994, he was employed as a cook and waiter at a Pizza Hut restaurant located in Charlotte, North Carolina. During that time, Bobby Howard, an openly homosexual male, was Wrightson's immediate supervisor.

Wrightson's coworkers included five openly homosexual males— Leonard Wilson, Brandon Johnson, David Jackson, Shane Campbell and one other. Three of Wrightson's coworkers were heterosexual males—Michelangelo Macri, Brad Wentzel and Aaron George Sim.

In late 1993, Howard and the other homosexual male employees began sexually harassing Wrightson and the other heterosexual male employees.

Whenever that Pizza Hut hired a male employee, the homosexual employees attempted to learn whether the new guy was also gay. If he was (and sometimes even if he wasn't), they would often haze him by pressuring him to have sex with one or more of them. And this is what Wrightson experienced from his first day on the job.

The harassment continued "on a daily basis" for seven months, in the presence of and within the knowledge of upper management and even after Wrightson complained.

The harassment took the form of sexual advances, in which Howard graphically described homosexual sex to Wrightson in an effort to pressure him into engaging in homosexual sex. According to Wrightson's complaint:

> ...during working hours [Howard] made numerous comments to [him] of a graphic and explicit nature wherein Howard...would graphically describe his homosexual lifestyle and homosexual sex, would make sexual advances towards [Wrightson], would subject [Wrightson] to vulgar homosexual sexual remarks, innuendos and suggestions, and would otherwise embarrass and humiliate [Wrightson] by questioning [him] as to why he did not wish to engage in homosexual activity and would encourage and invite [Wrightson] to engage in such homosexual activity.

In addition, Howard repeatedly touched Wrightson in sexually provocative ways. On several occasions, for example, Howard ran his hands through Wrightson's hair, massaged Wrightson's shoulders, purposely rubbed his genital area against Wrightson's buttocks while walking past him, squeezed Wrightson's buttocks and pulled out Wrightson's pants in order to look down into them.

Macri, Wentzel and Sim were similarly pressured and harassed by Howard.

Although Howard's conduct was the most egregious, the other homosexual employees also engaged in a similar pattern of harassment of Wrightson and the other heterosexual coworkers.

Wrightson and his heterosexual male coworkers made it absolutely clear that the harassment was unwelcome. Wrightson, for example, specifically told Howard and the others to stop the harassment on numerous occasions. Macri told the homosexual males that if they did not stop, he would file a complaint against them. Wentzel told the homosexual employees to "shut up" each time they directed a sexual comment toward him. Sim also repeatedly complained to Howard about the harassment.

Notwithstanding these protests, the harassment continued.

The manager of the Pizza Hut, Jennifer Tyson, and assistant manager Romeo Acker were aware of the harassment and of the heterosexual males' objections to it. According to the complaint:

[Wrightson]...and his mother, Cathy Celentano, com-
plained on numerous occasions to [Wrightson's] immediate
supervisors, store managers of the subject Pizza Hut and other
supervisors and managers of [Pizza Hut] about the verbal
and physical sexual harassment which was being directed
at [Wrightson] by [Pizza Hut's] employees.

Tyson and Acker even personally witnessed the harassment on sev-
eral occasions. Neither Tyson nor Acker, however, took any disci-
plinary action against Howard or the others.

After one incident, Wrightson's mother complained directly to Acker
and Tyson about the harassment. Tyson admitted to Wrightson's
mother that she was aware of the harassment and also that Howard's
actions constituted sexual harassment, but she contended that she
was unable to control Howard. At one point, Tyson even called a
meeting at which she ordered the homosexual employees to stop ha-
rassing Wrightson and the others, and advised them that their con-
duct violated federal law. After this meeting, the homosexual employ-
ees joked about the possibility of a federal sexual harassment suit, and
the harassment only continued and intensified.

Tyson and Acker took no formal action against Howard or the other
homosexuals at any time.

On August 15, 1995, Wrightson filed an action against Pizza Hut in
the United States District Court for the Western District of North
Carolina, alleging that he had been sexually discriminated against, in
violation of Title VII of the Civil Rights Act of 1964.

Specifically, Wrightson alleged that, because of the actions of Howard
and the other homosexual employees, he had been subjected to a
hostile work environment in violation of Title VII, as interpreted by
the Supreme Court.

However, relying on the Fifth Circuit's holding in *Garcia v. Elf Atochem
North America* that "harassment by a male supervisor against a male
subordinate does not state a claim under Title VII even though the
harassment has sexual overtones," the district court held that no Title

VII cause of action lies where the perpetrator of the sexual harassment and the target of the harassment are of the same sex. Wrightson's complaint was dismissed.

Same-Sex Harassment v. Sexual Preference

Wrightson appealed, arguing that the district court erred in dismissing his claim because same-sex sexual harassment can exist under Title VII if the perpetrator of the sexual harassment is homosexual.

Wrightson relied on *McWilliams v. Fairfax County Board of Supervisors* (1996). In *McWilliams*, the same appeals court had ruled that no Title VII claim for "hostile work environment" sexual harassment could be made when both the perpetrator and target of the harassment were heterosexuals of the same sex. But the cases weren't exactly the same:

> In *McWilliams*, however, we expressly reserved the question of whether Title VII prohibits same-sex "hostile work environment" harassment where the perpetrator of the harassment is homosexual. Today, we squarely address this issue, and hold that a claim under Title VII for same-sex "hostile work environment" harassment may lie where the perpetrator of the sexual harassment is homosexual.

Wrightson alleged that his male supervisor and several male coworkers were homosexual. He further alleged that, "because of his sex" and for the purpose of forcing him to engage in homosexual sex, he was discriminated against by his homosexual supervisor and homosexual coworkers. He objected to and resisted these sexual overtures.

The harassment took place over a lengthy period of time, with the full knowledge and acquiescence of Pizza Hut management. In addition, other heterosexual male employees of Pizza Hut were subjected to the sexual overtures by the supervisor and coworkers.

So, the appeals court ruled that Wrightson had presented a cognizable claim not only that he was sexually harassed by his homosexual supervisor and coworkers, but also that he would not have been harassed but for the fact that he is a male.

Pizza Hut, on the other hand, argued that, even assuming a claim for same-sex harassment lies under Title VII, the district court's dismissal must be upheld because Wrightson's claim actually is not that he was harassed because of his sex, but rather that he was harassed because of his sexual orientation as a heterosexual.

This didn't match up with the claim Wrightson had made. He specifically alleged that he was discriminated against "because of his sex, male." The unequivocal allegation that he was discriminated against "because of his sex" was alone sufficient to withstand Pizza Hut's motion to dismiss—and more than adequate when coupled with his allegations that the harassers were homosexual and that other males (and no females) were the targets of the harassment.

The appeals court concluded:

> In holding, as we do today, that a claim may lie under Title VII for same-sex hostile work environment harassment, we recognize and appreciate the reasons for the reticence of many of the federal courts to recognize a cause of action under Title VII for same-sex discrimination. We, as they, have no doubt that such an expanded interpretation of Title VII will result in a significant increase in litigation under this antidiscrimination provision.

So, the appeals court concluded that a claim may lie under Title VII for same-sex hostile work environment sexual harassment where the individual charged with the discrimination is homosexual. But it went a little further, blaming Congress for the quandary that it faced:

> Ultimately, however, our role as courts is limited to faithfully interpreting the statutes enacted by the Congress and signed into law by the President. And where Congress has unmistakably provided a cause of action, as it has through the plain language of Title VII, we are without authority in the guise of interpretation to deny that such exists, whatever the practical consequences.

One of the judges dissented from the opinion—and pointed out the underlying logical problems of the majority's decision:

> In [this] case, both parties are male, though Howard's group is homosexual and Wrightson is heterosexual. To hold Title VII applicable to heterosexual/homosexual but not to heterosexual/heterosexual conduct produces a result more discriminatory than [an earlier] ruling...that same sex discrimination is not covered by Title VII. The statute was intended to lessen, not to increase, discrimination.

> [We have] held that same-sex heterosexual on heterosexual harassment is not actionable. If *McWilliams* were read with the single factual difference being proof by the plaintiff that he was homosexual rather than heterosexual, I do not envision that the disgusting remarks not found to be actionable under Title VII would become so where the behavior on one side was heterosexual and the other homosexual.

No Gender Limitations

In the past, as in the initial ruling above, courts were swayed by gender—of the victim and the perpetrator—in same-sex harassment claims. But, as the appeals court established in *Wrightson*, Title VII broadly prohibits employers (whether male or female) from discriminating against individual employees (whether they be male or female) on the basis of the latter's gender. Through its proscription of employer discrimination against individual employees, the statute obviously places no gender limitation on the perpetrator or the target of the harassment. Therefore, the only possible source of a condition that the harasser and victim be of different sexes is Title VII's causal requirement that the discrimination be "because of" the employee's sex. In this causal requirement there is no such limitation either.

Interpreting "Because of" & "But for"

An employee is harassed or otherwise discriminated against "because of" his or her sex if, "but for" the employee's sex, he or she would not have been the victim of the discrimination.

As a matter both of textual interpretation and simple logic, an employer of either sex can discriminate against his or her employees of the same sex because of their sex, just as he or she may discriminate against employees of the opposite sex because of their sex. That is, a male employer who discriminates only against his male employees and not against his female employees, and a female employer who discriminates against her female employees and not against her male employees, may be discriminating against his or her employees "because of" the employees' sex, no less so than may be the employer (male or female) who discriminates only against his or her employees of the opposite sex.

In all four instances, it is possible that the employees would not have been victims of the employer's discrimination were it not for their sex. There is, in other words, simply no "logical connection" between Title VII's requirement that the discrimination be "because of" the employee's sex and a requirement that a harasser and victim be of different sexes.

Conflicting Opinions

Although the EEOC's interpretation of Title VII is not binding, the Commission's antidiscrimination provision specifically states:

> The victim does not have to be of the opposite sex from the harasser.... [T]he crucial inquiry is whether the harasser treats a member or members of one sex differently from members of the other sex. The victim and the harasser may be of the same sex where, for instance, the sexual harassment is based on the victim's sex (not on the victim's sexual preference) and the harasser does not treat employees of the opposite sex the same way.

In other words, according to the EEOC, a claim under Title VII may lie, if:

> ...a male supervisor of male and female employees makes unwelcome sexual advances toward a male employee because the employee is male but does not make similar ad-

vances toward female employees, then the male supervisor's conduct may constitute sexual harassment since the disparate treatment is based on the male employee's sex.

However, the 1979 federal appeals court decision *DeSantis v. Pacific Telephone & Telegraph Co.* held:

> Title VII's prohibition of "sex" discrimination applies only to discrimination on the basis of gender and should not be judicially extended to include sexual preference such as homosexuality.

Ten years later, the federal appeals court decision *Williamson v. A.G. Edwards & Sons, Inc.* said the same thing even more plainly:

> Title VII does not prohibit discrimination against homosexuals.

Williamson and *DeSantis* render illogical a conclusion that a heterosexual and a homosexual situation involving two males is one falling under Title VII because of the sex of one of the protagonists.

In *McWilliams*, the court held:

> To interpret Title VII's prohibition of discrimination "because of" sex to allow for the federal recognition of a same-sex harassment claim, i.e. heterosexual male on one side, homosexual male on the other, whereby the heterosexual alleges that he was discriminated against because of his sex, is to stretch Title VII's "because of" sex language to include "unmanageably broad protection of the sensibilities of workers simply 'in matters of sex.'"

The absence of legislative history to guide the courts can be read in either of two ways: 1) Congress's failure to exclude the possibility of same sex claims should be interpreted as allowing for such claims; or 2) Congress simply never fathomed that Title VII would be used in the manner in which the majority today holds, and hence, Congress,

not the courts, should address, in the first instance, whether Title VII's "sex" language should apply when a heterosexual male alleges that he was harassed by a homosexual male.

This issue demonstrates the wisdom of the Constitution's three branches of government, which leaves to the legislative branch, not the judiciary, the task of making the law.

Therefore, in the absence of any legislative history addressing the inquiry before the court, the Oxford English Dictionary definition of *sex* offered the best available guideline. That definition was:

> Either of the two divisions of organic beings distinguished as male and female respectively, the males or the females...viewed collectively, or of "sexual" as, [o]f or pertaining to sex or the attribute of being either male or female.

In other words: As sexual activity between two male—or female—heterosexuals does not fall within Title VII's ambit, neither may sexual activity between two male—or female—homosexuals be actionable.

Sex v. Sexual Orientation

In *Oncale*, the Supreme Court established: "harassing conduct need not be motivated by sexual desire to support an inference of discrimination on the basis of sex." However, "Title VII does not prohibit all verbal or physical harassment in the workplace; it is directed only at discriminat[ion]...because of...sex."

The high court added that no matter what an employee's theory, "he or she must always prove that the conduct at issue was not merely tinged with offensive sexual connotations, but actually constituted discriminat[ion]...because of...sex."

One issue that the high court in *Oncale* did not address is whether discrimination on the basis of sexual orientation could constitute discrimination on the basis of sex for the purposes of Title VII. However,

lower courts that have addressed this issue have consistently held that discrimination on the basis of sexual orientation is not discrimination on the basis of sex under Title VII. Typically, the question of whether an employee could allege a claim for discrimination based on sex turns on a court's interpretation of the word "sex" in Title VII.

Typically, it is a maxim of statutory construction that, unless otherwise defined, words should be given their ordinary common meaning.

So, in order to determine the ordinary and common meaning of the word *sex*, courts use the dictionary definition. The 1999 U.S. Supreme Court decision *Sutton v. United Airlines* discussed several such definitions:

> The New Shorter Oxford English Dictionary lists multiple definitions for "sex," including: 1. Either of the two main divisions (male and female) into which many organisms are placed on the basis of their reproductive functions or capacities.... 4. The difference between male and female, especially in humans.... 5. Of or pertaining to sex or sexual activity; arising from a difference or consciousness of sex.

> Applying the aforementioned principle of statutory interpretation, the Court holds that Congress intended the word "sex" in Title VII to refer to the first two definitions noted above—distinguishing between male and female—rather than the third—referring to sexual activity.

As the Sixth Circuit noted in the 1992 case *Dillon v. Frank*, one can find this intent in "the context in which [the word 'sex'] was placed [in the statute], along with either immutable characteristics (race, color, national origin) and a characteristic so deeply rooted for most that it is almost immutable (religion)."

Similarly, the Second Circuit has noted that "the other categories afforded protection under Title VII refer to a person's status as a member of a particular race, color, religion or nationality. 'Sex,' when read in this context, logically could only refer to membership in a class delineated by gender, rather than sexual activity regardless of gender."

It seems clear from the context of the statute that Congress intended the word "sex" in Title VII to refer to biological distinctions rather than to sexual activity or consciousness of sex.

Several cases decided before *Oncale* discussed the distinction between discrimination on the basis of sexual orientation and discrimination on the basis of sex.

In *Swage v. The Inn Philadelphia and Creative Remodeling* (June 21, 1996), the court noted that the "appeals courts [which] have considered whether Title VII prohibits conduct based on an employee's sexual orientation agree that it does not."

In *Hicks v. Arthur* (January 11, 1995), the court held that a complaint was flawed where it included "a claim of discrimination based on sexual orientation under Title VII although [sexual orientation] is not a protected class [under Title VII]."

Finally, most recently, in the District of New Jersey, a court noted that sexual harassment based on sexual orientation "would not be actionable under Title VII."

Since *Oncale*, a number of other courts have had the opportunity to consider whether *Oncale* affected the analysis of sexual orientation as a protected class. Those courts to consider the issue have consistently held that sexual orientation is not a protected class, even in the wake of *Oncale*.

In the 1998 case *Higgins v. New Balance Athletic Shoe, Inc.*, an employee argued that the discrimination that he suffered based on his sexual orientation constituted discrimination on the basis of sex. The court in *Higgins* considered Title VII's coverage of discrimination on the basis of *sex*, as defined by other courts, and discrimination on the basis of *gender*—a concept in which "because of sex" would encompass "personality features and socio-sexual roles typically associated with 'masculinity' or 'femininity'"—and rejected the gender approach.

In holding that Title VII required an interpretation of the word "sex" in a more traditional manner, the *Higgins* court stated, "In its current

form, Title VII does not provide a remedy to persons who have experienced harassment motivated solely by animus toward the plaintiff's sexual orientation."

In *Carreno v. Local Union No. 226, International Brotherhood of Electrical Workers* (September 27, 1990), a district court was presented with a case of insults to an open homosexual. The court concluded that these insults, "derogatory comments such as 'Mary' and 'faggot,'" were based on sexual orientation—the fact that Carreno was a homosexual—rather than sex—the fact that Carreno was a male. So, such comments, the court ruled, were not within the ambit of Title VII.

Benefits Issues

So far, the gnarly knot of the legal relationship between biological gender and sexual orientation—especially when it involves the issues of employment rights and benefits—has largely been left to the states to try to unravel. Note that President Clinton's executive order concerning gay rights applies to federal agencies only. It holds no sway over state or local governments or private businesses. Attempts to include gay and lesbian rights—that is to protect sexual orientation as well as biological gender—in federal civil rights and hate-crime legislation, have failed in every Congress since 1994. The Employment Non-Discrimination Act (ENDA) was introduced as H.R. 1863 by Rep. Studds in 1995, and was endorsed by President Bill Clinton. It sought to protect the employment rights not only of gays and lesbians, but of heterosexuals—indeed all employees—regardless of race, gender or color.

H.R. 1863's digest offered these clarifications:

1. [T]his Act does not apply to the provision of employee benefits for the benefit of an employee's partner; and

2. [A] disparate impact does not establish a prima facie violation of this Act. Prohibits quotas and preferential treatment.

3. Declares that this Act does not apply to:

a) Religious organizations (except in their for-profit activities);

b) The armed forces; or

c) Laws creating special rights or preferences for veterans.

In addition, H.R. 1863: Provides for enforcement; disallows state immunity; makes the United States liable for all remedies (except punitive damages) to the same extent as a private person; allows recovery of attorneys' fees; prohibits retaliation and coercion; and requires posting notices for employees and applicants.

A slightly reworked bill actually made it to a Senate vote in 1996. It contained basically the same employment protections for gays and lesbians, but the bill's sponsors found it necessary to strengthen the wording that guaranteed—and reassured the conservative right—that the Act would not create special- or protected-class status for gays and lesbians that would somehow grant them special treatment. It only sought to guarantee the most basic of equal rights. To that end, Section 2 of the 1996 bill included:

> A covered entity, in connection with employment or employment opportunities, shall not—1. subject an individual to different standards or treatment on the basis of sexual orientation; 2. discriminate against an individual based on the sexual orientation of persons with whom such an individual is believed to associate or have associated; or 3. otherwise discriminate against an individual on the basis of sexual orientation.

Just like Title VII of the Civil Rights Act, ENDA would apply to businesses with 15 or more employees. The bill still would not dictate equal employee benefits for all workers; hence, gay and lesbian partners would not be guaranteed spousal benefits. The prohibition against any affirmative action or quotas on the basis of sexual orientation remains clear.

Major religious organizations such as National Council of Churches, the Union of American Hebrew Congregations, the National Catho-

lic Conference for Interracial Justice and the Southern Christian Leadership Conference have all lined up behind ENDA. So have many large corporations.

Nevertheless, ENDA has yet to be passed by either the House or the Senate, let alone by both. Why is that? The easy answer, of course, would be that homophobia is still rampant; a festering infection in the nation's collective bloodstream that occasionally erupts into open sores as murder or violence toward gays and lesbians, but generally manifests as a widespread lethargic unwillingness to treat them fairly.

To be fair, there are many deeply religious people who regard homosexuality as a sin. For these people, it is unacceptable that government protect—and thus tacitly endorse—homosexuality as it does innate characteristics such as biological race and gender.

Much of the religious opposition to ENDA centers on the opinion that homosexuality is merely a choice, and a sinful one at that. In fact, the whole notion of sin—with the exception of original sin—is that you have a choice: between right and wrong.

Thus, the Capitol Hill Prayer Alert sees fit to oppose ENDA because it would "...extend special favor to people based on their chosen behavior...."

Supporters of gay rights take issue with this view on at least two grounds. First, the Act does not grant any special favors to anybody; it merely outlaws discrimination against all employees. Second, medical evidence is mounting that homosexuality is biologically innate—just like race and gender. That's why they prefer the choice-neutral term "sexual orientation" to the choice-implying "sexual preference." If homosexuality is innate, then the notion that it is chosen behavior is flawed. And it can't be a sin.

There is mounting support for ENDA...or similar legislation. A July 1998 poll undertaken for *Newsweek* magazine by Princeton Survey Research Associates "...found that 83 percent of the general population [feels] that gays and lesbians deserve equal rights in obtaining jobs." A 1996 national survey by Greenberg Research also found that

70 percent of self-described Christians "...believe that gays and lesbians should be protected from discrimination in the workplace...."

So we haven't heard the end of ENDA. Supporters cite the key House vote supporting President Clinton's Executive Order barring sexual orientation-based discrimination in federal agencies and the Supreme Court's *Oncale* decision as evidence that the logjam won't hold back the rising tide much longer.

Meanwhile, how much employment antidiscrimination protection gays, lesbians and transgender people can expect depends upon state and local laws. For example, if Robin Joy Shahar had been hired by the California Attorney General's Office rather than Georgia's, she wouldn't have been fired solely for being a lesbian. (This inconsistency is an argument for a federal statute barring employment discrimination based on sexual orientation.)

Shahar, a law student, impressed her superiors when she clerked during the summer of 1990 in the Georgia Attorney General's office. Then-Attorney General Michael Bowers offered her a staff attorney position to commence in September 1991, after she completed law school.

Shahar accepted and was reportedly very excited about the prospects of starting her professional career. Meanwhile, she and her partner of several years—a woman—decided to celebrate their commitment to each other in a non-legally binding marriage ceremony in July 1991.

According to Shahar, shortly after that she was summoned to the Attorney General's Office. She reported that she looked forward to the visit, thinking that she was to be given her first work assignment. Instead, she was handed a termination notice.

Shahar's termination letter from Bowers said in part:

> This action has become necessary in light of information which has only recently come to my attention relating to a purported marriage between you and another woman. As chief legal officer of this state, inaction on my part would

constitute tacit approval of this purported marriage and jeopardize the proper functioning of this office.

Shahar sued, contending that the termination violated her constitutional right of equal protection under the law and her right of association. She could not sue under Title VII of the Civil Rights Act since sexual orientation has not been ruled to be covered by Title VII.

Shahar lost in federal court and in the 11th Circuit Court of Appeals. The first judge noted that her relationship was protected by the constitution, but that her dismissal was also lawful. The implication is that Bowers wasn't saying she shouldn't have the relationship, only that she couldn't be employed because of it.

In the appeals court, Georgia's law against homosexual activities came under consideration. If the women claimed to be married to each other, the court reasoned, they were probably also having homosexual relations, which is against Georgia law.

Of course, the court was not in a position to *undo* Georgia's law, no matter how out of date it may seem. The court concluded that Attorney General Bowers's conclusion—that it was "problematic" to employ an attorney in his office who was breaking the law—was defensible. And there's no Georgia law against firing Shahar merely because she is a lesbian.

In rejecting Shahar's appeal, the Supreme Court let stand the appeals court ruling. Shahar was reportedly very disappointed but said, "There is often a lag between the public's perception and intolerance of unfairness and the court's willingness to rectify unfairness. In the future, people will look back on this case with embarrassment."

The ACLU keeps track of similar cases from around the country. Here are a few from its files:

- In 1994, Mark Sension was hired by the University of Denver to be the Associate Director for Operation of the Ricks Center for Gifted Children, a private school run by the University. About a month later, his supervisor learned that he is gay. Soon after,

Mark was fired without warning and escorted from the building by university security personnel. He was told that his firing was an "issue of trust" because he did not make his sexual orientation clear during his hiring interview.

- Jeffrey Blain was hired in January 1993 to work in sales for Golden State Container, a Phoenix-area manufacturer. He had a good work record, receiving a 37.5 percent raise during his first six months. But several months later, Golden State fired him for no reason. Blain took Golden State to court, claiming that he was fired because he is a gay man. The judge instructed the jury that "an employee is not wrongfully terminated if he is fired for being homosexual." Blain lost his case when the Arizona Court of Appeals upheld the lower court's ruling saying that discriminating against a worker based on his or her sexual orientation violates no laws or public policy.

- In 1991, Cracker Barrel restaurants adopted a policy refusing to employ anyone "whose sexual preferences fail to demonstrate normal heterosexual values."

 When Cheryl Summerville, a cook at an Atlanta suburbs franchise, learned that management had fired certain gay employees, she told her manager that she was a lesbian. Reluctantly, her manager gave her an official separation notice reading: "This employee is being terminated due to violation of company policy. This employee is gay."

- Daniel Miller, an accountant from Pennsylvania, was fired when his employer of more than five years evoked a clause in his job contract that barred gays from the company. Unable to file suit because Pennsylvania does not protect against discrimination based on sexual orientation, Daniel established his own accounting firm. Many of his former clients followed him. His former boss then took him to court and won a $172,000 award because the clients had switched.

Non-gays have good reason to support antidiscrimination legislation for sexual orientation, too. In the vast majority of states, straight (heterosexual) employees can be fired or discriminated against if the employers suspect or falsely accuse them of being gay or lesbian.

In just one ACLU example, Oregon Fireman Steve Morrison found himself systematically shunned and harassed at work after he participated in a parade protesting Oregon's 1992 anti-gay initiative. His coworker caught a glimpse of him on a local news program and wrongly concluded Morrison was gay. Morrison received hate mail, was charged with incompetence and was eventually taken off a good rotation—a career threatening blot on his record. After lengthy administrative proceedings, Morrison was able to get the trumped-up charges removed from his record. And he transferred to another station.

Oregon's employment non-discrimination laws were expanded to include sexual orientation in 1998. And other states and localities are following suit. Still only 11 states have sexual-orientation non-discrimination statutes. They are: California, Connecticut, Hawaii, Massachusetts, Minnesota, New Hampshire, New Jersey, Oregon, Rhode Island, Vermont, Wisconsin and the District of Columbia. In addition, 165 counties and localities have similar statutes.

Why is American society so fixated on sexual identity that basic rights have to be litigated and legislated? Despite the richness of cultures and ideals that have emigrated into this country, the mindset of the controlling interests is fundamentally puritanical—our very land was founded by eliminating and interning its native cultures.

While Americans have many virtues, freethinking is not one of them. Like cattle, we follow the framework of our environment, whether it's family, tradition or religion. And, like a festering wound, our unwillingness to embrace others' ideas, cultures and lifestyles creates the weak-mindedness that defers simple human respect to courts of law.

Other Benefits Issues, Including So-Called "Civil Unions"

If you have anything at all to do with employer-provided benefits— whether you're a manager, owner or an employee—you're probably already aware of the great brouhaha over same-sex marriages or civil unions and benefits for same-sex partners. It's a big concern. And not just for social, moral or religious reasons. The number of people an employer must provide benefits for—over and above the actual number of employees—can certainly affect a company's bottom line. Yet,

every day, it seems, another group or significant-other category claims entitlement to spousal or, to be politically correct, domestic partner (DP) benefits. The issues involved in same-sex marriages are slightly different from those associated with same-sex DPs. We'll look at DPs first, and then move on to same-sex marriage issues.

Employer Obligation

The Lambda Legal Defense and Education Fund, an advocacy group for same-sex DP-benefits, reports that as of late 1997, nearly three-quarters of companies with 5,000 or more employees offer health and other benefits for the domestic partners of employees. In addition, a growing list of states, four at last count, as well as local governments, offer DP benefits for public-sector employees. And, President Clinton's 1998 Executive Order on DP benefits mandates that they be offered to same-sex domestic partners of federal employees.

Yet, there's still no federal law obligating private-sector companies to provide benefits for same-sex domestic partners. Some opponents of the President's Executive Order warned that private companies doing business with the federal government would be required to comply, but that has not come to pass.

In fact, as we've already discussed, there isn't even a federal law barring the most basic job discrimination based on sexual orientation (i.e. gay, lesbian or transgender). Title VII of the Civil Rights Act of 1964 protects against discrimination based on race, color, religion, national origin and sex. But the courts have not interpreted the word sex to include sexual orientation.

The Supreme Court's 1998 ruling that Title VII covered same-sex sexual harassment did not address sexual orientation specifically and did not extend protections for sexual orientation to other forms of discrimination. So, same-sex DP-benefit issues are not included in Title VII coverage.

ENDA would outlaw job discrimination against people of all sexual orientations. However, the Act specifically excludes the obligation for companies to provide benefits for same-sex domestic partners.

To date, private companies can still make their own choices as to whether or not to extend employee benefits to same-sex domestic partners. Traditionally, companies have not offered benefits to so-called live-in partners of unmarried heterosexuals. And the fact that some companies now offer them to gay and lesbian couples has created an ironic twist—and more work for lawyers. A male employee of Bell Atlantic in New York recently sued the company in federal court for gender discrimination because the company refused to extend benefits to his live-in girlfriend when unmarried domestic partners of gays and lesbians received them. According to the employee, that amounts to discrimination against heterosexuals based on sex.

What's the big deal about benefits for employees' unmarried partners-whether they're same-sex or hetero? From a company's perspective, it's the bottom line, of course. Lambda's Basic Facts About Domestic Partner Benefits on its Web site at http://www.lambdalegal.org argues that the costs to employers are "insignificant" and "negligible." Lambda adds, "...accruing costs of domestic partner benefits are exactly comparable to the costs of adding spouses when employees marry."

Yet, as practically any small business owner can tell you, there's no such thing as an "insignificant" or "negligible" cost. And for a small businesses, there is no real comfort in the fact that the costs of adding a DP are "exactly comparable" to adding a spouse (and in many cases children, too). Costs are costs, whether they're big or small. If the costs were really insignificant, how did the no-benefits-for-unmarried-partner tradition arise? At least one practical answer is that requiring marriage—and verifying it—kept companies from having to dole out insurance and other perks to people who didn't actually qualify for them.

For example, a man takes a job, then a friend—let's say a single mother of two says, "Hey, I don't have any insurance for me or the kids, and, by the way, we'd sure like to use the company daycare center. Can't you just say you're married to me?" Another argument is that unmarried relationships are less stable than married ones, creating problems for company benefits administrators when live-ins move out and another takes his or her place. So the easiest, least expensive option is for companies to deny benefits to unmarried DPs.

However, from the same-sex DP point of view, requiring marriage as a benefits qualifier inherently discriminates against same-sex couples. Why? Because same-sex partners cannot get legally married. So, no matter how committed, long-term or permanent these relationships are, they don't have—and cannot possibly get—the paper to prove it and thus qualify for benefits.

So maybe the better argument is that, despite the additional cost, extending benefits to same-sex DPs is the only fair and non-discriminatory option. Lambda offers several practical, business-friendly reasons, too. Among them:

- To recruit and retain valuable employees; employers improve their competitiveness by offering these benefits.

- A fair benefits policy promotes good morale and company loyalty; it makes clear that lesbian and gay employees are valued members of the workforce.

- Employees are more productive in an environment where they know that their families are secure and that their employers respect them regardless of sexual orientation and marital status.

- Polls show that the vast majority of the American public believes that lesbians and gays should be free from discrimination in the workplace.

- Companies which promote fair work conditions have a more positive public image.

What about unmarried heterosexual couples? Well, unlike same-sex couples, at least heteros have the option of marrying in order to qualify. But the courts are still undecided on the issue. The Bell Atlantic case may set the precedent for requiring companies to extend benefits to all unmarried DPs if they extend to any of them.

Several major companies have recently found this to be true. In June of 2000, the Big Three (General Motors Corp., Ford Motor Co. and Daimler Chrysler AG) and Coca-Cola extended health care coverage to same-sex domestic partners of their U.S. workers. The companies see this as a low cost way to lure new workers in a tight labor

market. According to Coca-Cola President and Chief Operating Officer Jack Stahl, "The Coca-Cola Company is committed to attracting and retaining the most diverse workforce in the world."

A Practical Solution for Benefits Fairness?

You'd be forgiven for wondering if the whole unmarried DP issue—same-sex and hetero alike—isn't creating a quagmire in which companies will soon be forced to provide benefits for anyone and everyone who claims to be a DP. Would it make better sense to retain the traditional, time-honored prohibition against benefits for unmarrieds, but allow same-sex couples to get married? This way, the same standards would apply to everybody. An employer wouldn't have to provide benefits to every temporary pelvic affiliate who cycles in and out of an employee's bedroom—gay or straight. And if same-sex couples are committed enough to get married just like heteros, then the same-sex spouses deserve the same treatment as hetero spouses. Problem solved. At least, according to savvy business people and gay and lesbian rights advocates.

If same-sex couples are disadvantaged by the company benefits situation, consider how discriminatory it is to deny them the rights which married couples enjoy. According to Marriage Equality, an advocacy group for same-sex marriage, there are over 1,000 distinct and separate rights, privileges and responsibilities associated with being married. And, of course, same-sex couples are barred from these rights regardless of how long they've been together or how committed they are. Most of these inequities were recently addressed in Vermont's Civil Union Bill, the first law in the country extending most of the same public legal rights to same-sex partners that married spouses have always had.

For reasons we'll explore in a moment, Vermont chose to call its same-sex marriages "civil unions"; but the requirements and procedures for entering civil unions are virtually identical to the marriage licensing and certification process.

According to the Vermont statute:

- Parties to a civil union shall have all the same benefits, protections and responsibilities under law, whether they derive from statute, administrative or court rule, policy, common law or any other source of civil law, as are granted to spouses in a marriage.

- A party to a civil union shall be included in any definition or use of the terms "spouse," "family," "immediate family," "dependent," "next of kin," and other terms that denote the spousal relationship, as those terms are used throughout the law.

- Parties to a civil union shall be responsible for the support of one another to the same degree and in the same manner as prescribed under law for married persons.

- The law of domestic relations, including annulment, separation and divorce, child custody and support, and property division and maintenance shall apply to parties to a civil union.

Marriage Equality's summation of the bill's benefits include:

- Property: Partners are entitled to joint title, transfer from one to another upon death and transfer tax benefits.

- Taxes: State taxes on married couples and parties to a civil union will be the same. However, Vermont's law has no effect on federal taxes or Social Security.

- Lawsuits: Someone in a civil union can sue for the wrongful death of a partner, the emotional distress caused by a partner's death or injury, and the loss of consortium caused by death or injury.

- Probate: Probate law and procedures related to spouses apply to civil partners.

- Adoption: Civil union partners are entitled to all the protections and benefits available when adopting a child. Same-sex couples already are allowed under state law to adopt, but the laws will now reflect that those couples will be treated as spouses.

- Children: If a partner becomes a natural parent during the term of a civil union, the rights of the parties with respect to the child are the same as those of a married couple.

- Insurance: State employees [of Vermont, and state employees only] are treated as spouses for insurance or continuing care contracts.

- Abuse: Parties to a civil union qualify for various abuse programs as spouses.

- Heath Care: Medical decisions that a spouse can make can also be made by those in a civil union. Hospital visitation and notification are treated similarly. Family leave benefits are identical.

- Testimony: As with spouses, partners in a civil union cannot be compelled to testify against one another.

If you're married, you already enjoy all the rights and privileges addressed above. And a great many Americans agree it's time the same rights and privileges are accorded to committed same-sex couples. So what's holding everything up? That nettlesome little notion called *sin*. Or morality. Or even social conscience. Whatever it's called, the fact is that a great many Americans view homosexuality as wrong.

Some religious extremists are fond of quoting the Biblical passage in Romans suggesting that homosexuals be put to death. That's in the Old Testament, of course, back there with *an eye for an eye, a tooth for a tooth*, women as chattel and other ideas we've wisely put behind us. Moreover, various polls and surveys indicate between 70 and 80 percent of Americans, religious conservatives included, favor granting equal employment rights regardless of sexual orientation.

But same-sex marriage is another matter, apparently. Some people of good conscience feel that it goes too far in validating a "lifestyle" they believe is wrong. They worry for the children. Same-sex marriage, they say, would send the wrong signal to their children—endorse it in the minds of their children. Sound familiar? In the early 1960s, there was similar talk about racial integration. The Bible was quoted as condemning miscegenation or the mixing of races. Many worried hands wrung over how it would only be a matter of time before there would be—gasp—racially-mixed couples.

There's no easy way to settle this debate. Gay rights supporters aren't always the opponents of people with sincere religious conviction. But

this issue gets muddled in the argument between sexual morality and sexual liberty. And for progressive-minded individuals, the idea of calling out someone else's lifestyle as unacceptable is frightening—after all, if the tides turn, any one of us could be next. In other words, we have an ethical obligation to honor our neighbor's sexual identities, whether we agree with them or not.

State Fair Employment Practices Laws

As a manager, employer or employee, you must be aware not only of gender discrimination and sexual harassment laws and regulations from the federal government, but also those originated at the state and local levels.

State and local Fair Employment Practices (FEP) regulations are often at variance with their federal relatives. And to make matters more confusing, sometimes federal law or federal courts supersede local or state law. And, other times they don't.

The U.S. Supreme Court can rule that Colorado's so-called "anti-gay initiative" can't be enforced. Yet, the state can pass an antidiscrimination law that makes Title VII's rules (the federal rules) apply to smaller companies than the federal law specifies. And that's okay.

The Supreme Court can rule that state and local police agencies can't be forced to implement some of the provisions of the Brady bill pertaining to background checks for gun purchases. Yet, the Supreme Court can rule that Title VII covers same-sex sexual harassment, so all the states must now recognize same-sex sexual harassment, too.

Sorting It All Out

Confusing? For most of us, it's better just to accept—as one clever legal observer put it—that law and logic aren't always on the same train. The important thing is that, whether you're an employer or an employee, your state or local FEP laws may affect you differently than federal law. They may give you more protection or less.

They tend to change more rapidly, too.

And, as you try to keep up, bear in mind that the state or local agency or entities responsible for writing and enforcing FEP rules may not have FEP or Fair Employment Practices in their names. They may be called Human Rights Departments or Civil Rights or Department of Labor or Equal Rights or something else entirely. You may need to put in a little phone time to find the right place for the information you're looking for.

State FEPs can be generated by the legislature or by the courts. Recently, the courts have been taking more active roles, especially when lawmaking bodies have been slow to act. This was the case recently when the Oregon Court of Appeals handed down a ruling that barred job discrimination based on sexual orientation. The appeals court also required all governmental entities, including state agencies, counties, cities and school districts, to provide health benefits to partners of lesbian and gay employees.

The same-sex partner benefits provisions were not required of private businesses, only public agencies. But gay-rights activists were elated anyway. Oregon is the first state in which the antidiscrimination and benefits laws came from the courts rather than from the state legislature. The court ruling held that an Oregon employment statute banning sex discrimination in hiring and in the workplace applies to sexual orientation as well as biological gender. That's a first, too.

In *Tanner v. Oregon Health Sciences University* (1998), the Oregon Court of Appeals made the landmark ruling that a public sector employer's denial of insurance benefits to domestic partners of homosexual workers violated the "equal privileges and immunities" guarantee of the Oregon Constitution.

Tanner is also of significance to all employers because it indicates that adverse employment actions taken on the basis of sexual preference in contexts other than benefits eligibility could violate a state's employment discrimination statute.

Before it became a public body independent of the state of Oregon, the Oregon Health Sciences University (OHSU) provided each employee with a designated amount of benefits and authorized each

employee to select insurance benefits. Health insurance coverage for "family members" was one available option, but unmarried domestic partners did not fall within the eligibility criteria.

The State Employee Benefits Board denied insurance benefits to the long-term domestic partners of three lesbian nursing professionals who sought judicial review, contending that the practice violated Oregon's employment discrimination statute.

Only declaratory and injunctive relief and attorneys' fees were sought.

The court's first ruling was that OHSU's eligibility criteria on their face was predicated on marital status alone, without specific reference to sexual orientation. Nevertheless the denials had the effect of discriminating against homosexual couples, who cannot marry under Oregon law.

This was held to violate ORS 659.030(1)(b), which generally prohibits employment discrimination "because of an individual's...sex...or because of the...sex...of any person with whom the individual associates."

However, the *Tanner* court ruled that no unlawful employment practice had been committed because the "benefits plan" savings exemption of ORS 659.028 applied.

Under that exemption, an employer is not liable where the adverse treatment occurred as a product of the terms of a bona fide employee benefits plan and the discrimination is not part of a subterfuge to evade the purposes of ORS 659.030(1)(b).

The court's second ruling was that the eligibility criteria violated article I, section 20 of the Oregon Constitution, which commands that, "No law shall be passed granting to any citizen or class of citizens privileges or immunities, which, upon the same terms, shall not equally belong to all citizens."

The court held that homosexual couples are a "true" class within the meaning of the privileges and immunities clause, because historically

they have been regarded as a distinct, socially recognized group sub-ject to adverse social or political stereotyping or prejudice.

Furthermore, the court held that the discriminatory eligibility criteria could not pass muster under the "strict scrutiny" justification test.

This portion of *Tanner* is of little relevance to private employers, be-cause the privileges and immunities clause applies only to govern-mental entities.

OHSU has changed its eligibility criteria to give unmarried domestic partners access to benefits, and initial media reports indicate that OHSU is not inclined to seek review of *Tanner* by the Oregon Supreme Court. Therefore, *Tanner* remains a precedent binding on trial courts until another case works its way through the state appellate system.

While many issues over the scope and applicability in *Tanner* will need to be clarified, the decision has already changed the landscape of employer liability for adverse actions which impact employees on the basis of sexual preference, in several respects.

Some public sector employers have amended their eligibility criteria to grant unmarried domestic partners the same access to benefits as spouses of other employees.

Both private and public sector employers should recognize that had the adverse action in *Tanner* been something other than denial of insurance benefits, the special exemption would not have applied, and there would have been an unlawful employment practice.

In that event, the exposure includes attorneys' fees and equitable re-lief, including back pay.

For example, denial of employment on the basis that the applicant has a gay partner would discriminate on the basis of the gender of an individual with whom the job applicant associates, in violation of ORS 659.030(1)(b), and the savings exemption of ORS 659.028 would be of no avail.

Private and public sector employers should insure that all aspects of their recruitment, promotion, compensation and operational processes do not, either by intent or effect, discriminate in these ways on the basis of sexual preference.

Legalese aside, the message for both employers and employees is that there are several ways to skin the discrimination cat. And the state and local levels may be where most of the skinning occurs in the next few years. That can be good and bad news for gender-discrimination and sexual harassment cases, depending upon which side you're on.

Transgender & Transvestites

There's little doubt that it's just a matter of time before all states recognize employment non-discrimination rights for gays and lesbians. However, cases involving transgendered people, while still very rare, pose even more complicated questions. First, transgender is the new term that covers transvestites (cross-dressers) and those who have their sex surgically changed from male to female or vice versa.

One big problem for transgender rights also stirs up strange heterosexual taboos, too. Most straight men accept as a fact of life that it's not okay for them to go into a restroom full of women even if the call of nature is beyond urgent and there's no modest alternative; but if a woman joins the men, everyone gets a hoot out of it. The problem is similar for pre-surgical transgenders who dress as women but still have penises. Even U.S. Representative Barney Frank, D-Mass., an outspoken and forceful advocate of gay and lesbian rights, admits that transgender issues pose problems for gay and lesbian progress. In an interview with Bay Windows, a Boston-area gay newspaper, about including transgender people in ENDA, Frank said, "I've talked with transgender activists and what they want is for people with penises who identify as women to be able to shower with women. There are no votes for that."

Unfortunately, the outrageous image of cross-dressing, reinforced by Dennis Rodman and several recent films in which stars of the magnitude of Wesley Snipes and Patrick Swayze depicted in-your-face trans-

vestites, only serves to distract from legitimate transgender concerns, especially those of post-operatives.

Does the word "sex" in Title VII protect transsexuals from discrimination? To be sure, this is an issue that most employers won't have to face. But it does show why some diversity experts like to make a distinction between sexuality and gender. Consider the case of *Ulane v. Eastern Airlines*.

In the 1984 decision *Ulane v. Eastern Airlines, Inc.*, a federal appeals court in Illinois held that: Title VII does not protect transsexuals; and, even if the transsexual employee was considered female, the trial court made no factual findings necessary to support a conclusion that the employer discriminated against her on this basis.

Kenneth Ulane was hired in 1968 as a pilot for Eastern Airlines, Inc., but was fired as Karen Frances Ulane in 1981.

The court told the story:

> [Ulane] was diagnosed a transsexual in 1979. Although embodied as a male, from early childhood [Ulane] felt like a female. Ulane first sought psychiatric and medical assistance in 1968 while in the military. Later, Ulane began taking female hormones as part of her treatment, and eventually developed breasts from the hormones. In 1980, [Ulane] underwent sex reassignment surgery.

After the surgery, Illinois issued a revised birth certificate indicating Ulane was female, and the Federal Aeronautics Administration certified her for flight status as a female. Eastern Airlines was not aware of Ulane's transsexuality, her hormone treatments or her psychiatric counseling until she attempted to return to work after her reassignment surgery. Eastern knew Ulane only as one of its male pilots. It fired the legally female Ulane; and she filed a charge of gender discrimination with the EEOC, which issued a right-to-sue letter. She did.

The trial court recognized that homosexuals and transvestites do not enjoy Title VII protection, but distinguished transsexuals as persons

who, unlike homosexuals and transvestites, have sexual identity problems. The judge agreed that the term "sex" in Title VII does not comprehend "sexual preference," but held that it does comprehend "sexual identity."

The district judge based a ruling in favor of Ulane on his finding that "sex is not a cut-and-dried matter of chromosomes." He concluded that sex is in part a psychological question—a question of self-perception—and in part a social matter—a question of how society perceives the individual.

The appeals court didn't agree, ruling: "While the [court] does not condone discrimination in any form, it was constrained to hold that Title VII does not protect transsexuals, and that the district court's order on this count therefore must be reversed for lack of jurisdiction."

It did not define "sex" in such a way as to mean an individual's "sexual identity." It ruled: "The words of Title VII do not outlaw discrimination against a person who has a sexual identity disorder, i.e., a person born with a male body who believes himself to be female." Furthermore, "...a prohibition against discrimination based on an individual's sex is not synonymous with a prohibition against discrimination based on an individual's sexual identity disorder or discontent with the sex into which they were born."

More importantly, the appeals court found no cause to conclude that Eastern had discriminated against Ulane as a female. The trial court's findings all centered around the conclusion that Eastern did not want "[a] transsexual in the cockpit."

The court of appeals reversed the order of the trial court and ruled in favor of Eastern. And it interpreted the law to apply to gender, a thing which is controlled by chromosomes, but not to sexuality, a thing which is controlled by psyche.

As an employer or manager, it's not likely that you'll have to face transgender issues. But employment issues involving more mainstream gays and lesbians are more common, and the legal landscape for them

is changing fast. Employment law experts stress the importance of keeping up with the changes, especially on your local and state levels where most of the action is.

The "Gay Mafia": Discrimination by Gays and Lesbians

Arrogance. Hubris. Paradox. It's hard to settle upon just the right word for the flaw in the heterosexual mindset that so doggedly opposes equal employment rights for gays and lesbians. It goes beyond homophobia. If these straights really fear homosexuals, then it makes sense that they'll increasingly feel the need for themselves to be protected against discrimination by homosexuals as gays and lesbians gain more economic and political power.

So, you'd think straights would want non-discrimination statutes that protect everyone equally regardless of sexual orientation. Yet opponents of gay workplace rights would rather not seek protection based on sexual orientation. This is a paradoxical position. What would the opponents do if a gay business owner discriminated against them because they were straight? Would they stay true to their politics and not seek any protection under the law?

Indeed, without employment non-discrimination protection, firing based on sexual orientation can cut both ways. The only thing keeping a gay or lesbian boss from firing a heterosexual worker just because he or she is straight is a sense of fairness. And the argument could certainly be made that gay or lesbian bosses have no obligation to treat straights any better than they feel straights have treated them.

Still, as the law stands, gays have no employment equal-rights protection. So, in a sort of backwards logic, the specter of reverse discrimination might actually serve to spur some straights to support ENDA or some other employment non-discrimination legislation.

Sometimes, perceived discrimination can spark from the complex gender-within-gender issues involving transgender people. In 1999, the Associated Press reported that a lesbian organization in British Columbia had been ordered to pay a $2,000 fine for banning a transgender person from its drop-in center. According to the report:

The Vancouver Lesbian Connection is to pay about $2,030 to Susan Mamela, a pre-operative transgendered person, meaning she hasn't had surgery to change her sex to female. She began attending the University of British Columbia's Gender Clinic in 1995 and has received hormonal therapy.

The tribunal order was entered in British Columbia Supreme Court, giving it the effect of a court order.

Mamela described herself to the human rights tribunal as a radical lesbian feminist who rejected society's attempt to define her and "make a woman out of me."

"My client's view is that she's not a woman and never can be a woman because it's a social-political construct based on a lot of stereotypes and restrictions," Mamela's lawyer, Clea Parfitt, said. "She prefers the term female," Parfitt said.

Mamela approached the lesbian group in February 1996 to become a member. She was told she couldn't join because she had been born male. But after its annual meeting in May 1996, the group changed its membership policy to include transgendered and bisexual women.

Mamela was a member of the group until March 1997, when she was asked to leave after an argument over what constitutes womanhood. Mamela was accused of being "aggressive and mannish." The group also felt it was inappropriate that Mamela should answer phones to the women's crisis line because she had a male-sounding voice.

According to the Associated Press Newswire report for October 15, 1999, the tribunal upheld Mamela's complaint and ordered the group to pay the penalty in compensation for injury to Mamela's "dignity, feelings and self-respect."

Gay Rights and Sexual Harassment Law

The March 2000 federal court decision *John J. Bibby v. The Philadelphia Coca Cola Bottling Co.* dealt with the consideration of gay rights under sexual harassment law.

John Bibby began working for the Philadelphia Coca-Cola Bottling Co. (PCCB) in June 1978, shortly after graduating from high school. Approximately 30 days after beginning his employment with PCCB, Bibby joined the International Brotherhood of Teamsters, Local 830, a union which has a collective bargaining relationship with PCCB. The terms of Bibby's employment were governed by a collective bargaining agreement (CBA) between PCCB and Local 830.

The first incident of Bibby's complaint occurred in 1993, when he became ill. Bibby experienced weight loss and vomited blood and claims he "felt compelled to disclose his alternative male lifestyle to [PCCB]." On August 12, 1993, Bibby experienced chest and stomach pains so severe as to cause him to double over in pain. That same day, Cliff Risell, PCCB's Vice President of Operations, approached Bibby's workstation from behind, and found Bibby slumped over, apparently asleep. Risell yelled to Bibby, at which point Bibby jumped to his feet, and stated that he had severe chest pains. Bibby told Risell that he needed to go to the hospital.

Risell allegedly told him, "So go." However, before Bibby could leave the plant, Risell, accompanied by Dennis Anderson, a Local 830 shop steward, stopped him and told him he was suspended with intent to terminate for sleeping on the job and for leaving his assigned post.

During Bibby's suspension, he claims to have been offered $5,000 with six months' benefits and six months' unemployment by Risell and John Kolb—PCCB's director of human resources—if he would quit. Bibby alleges that he was told that, if he did not accept this offer, he would be terminated.

Bibby fought the suspension and was terminated. On December 17, 1993, after an arbitration hearing was held pursuant to the CBA, an arbitration panel ruled against PCCB, finding that Risell had attempted an improper discharge of Bibby. Bibby was reinstated with full back pay and all benefits.

After being reinstated, Bibby experienced tension with Risell and other coworkers. On December 23, 1993, less than a week after he was reinstated, Bibby, coworker Frank Bertchsci and Risell were together

in the employee locker room. Bertchsci got up, came over to Bibby, made a fist and told Bibby to leave. Bibby claims that Bertchsci then grabbed him, threw him against the lockers and screamed that he would beat him badly.

According to Bibby, all of this occurred in Risell's presence, and with Risell's tacit approval. Bibby reported the incident to company officials, but no action was taken.

On January 22, 1995, Bertchsci again threatened to harm Bibby.

Bob Taylor, a supervisor, was present for this incident and told Bibby and Bertchsci that if they did not stop, Taylor would fire them both. Bertchsci did not stop, though, yelling to Bibby, "Everyone knows you're a faggot," followed by, "Everyone knows you are as gay as a three dollar bill," and, "Everyone knows you take it up the ass." Later that day, Bertchsci also called Bibby a sissy.

Bibby reported the threatening statements to Fran Smith, PCCB's production manager supervisor. However, no action was taken. Bibby also claimed that he suffered a number of adverse employment actions in the wake of his winning the arbitration hearing and the report of the statements.

Bibby was transferred to an undesirable night shift and when he complained to Risell about this, Risell allegedly told Bibby that he had the "power to drop the charges and end this."

Bibby also claimed that Risell singled him out for enforcement of the rules. For instance, Risell wrote him up for wearing an out-of-date version of the official uniform, an action which, according to Bibby, Risell did not take with any other employee. Risell also wrote Bibby up for minor infractions of the dress code, such as having two buttons on his shirt unbuttoned and for not wearing proper safety glasses, when other employees were not disciplined for the same infraction.

Bibby asserted that this unfair treatment that he suffered came not only from Risell, but also from other supervisors. Bibby also claimed that he was always watched more closely than other employees.

In April 1996, Bibby had an accident with a forklift. He claimed that, because Risell expedited proceedings before the safety board, the safety board heard the case in one week instead of several months. Risell asked the safety board to fire Bibby, because he had two accidents charged against him and company policy permitted dismissal in such cases. The safety board did not do so; instead, it charged Bibby with a preventable accident causing $5,000 damage—a written notice which was added to his permanent employment record.

Bibby filed a grievance regarding this determination but was unsure of the outcome. He claimed the handling of the forklift case was contrary to PCCB's practice not to report such actions.

Risell testified that workplace accidents were tracked based on whether they were preventable, and how much damage occurred. Employees were then charged with points based on these factors, and, if they accumulated enough points, they were fired.

In November 1997, Bibby complained that a coworker with low seniority had been promoted to acting foreman without posting a position, a violation of the CBA. Upon review, Local 830 agreed, and informed PCCB that Bibby was entitled to the position. However, when faced with that determination, Risell eliminated the acting foreman position.

One week later, Risell reinstated the employee in an acting foreman position, and Bibby again complained. Ultimately, the position was reassigned to another department.

Bibby also alleged that graffiti containing sexual slurs was drawn in the bathroom, singling him out for his sexual preference. And, despite his complaints, he claimed that while other graffiti was routinely removed from the bathroom at work, the graffiti targeting him was not removed.

As a result of the harassment he faced at work, Bibby said he suffered from depression, stomach and intestinal disorders.

He went to see a psychologist, Edward Dougherty, for the depression. After interviewing Bibby, Dougherty found that Bibby was suffering from posttraumatic stress disorder related to his experience at PCCB. Dougherty prescribed continuing psychological and/or psychiatric care for Bibby, including individual therapy sessions twice a week.

Bibby filed a lawsuit on June 30, 1998, alleging—among other things— violations of Title VII and a state law claim for intentional infliction of emotional distress. The lawsuit named not only PCCB, but also a number of PCCB's individual employees.

The court dismissed the charges against individual employees but allowed the suit to go forward against PCCB.

Bibby claimed PCCB created a hostile work environment on the basis of sex.

PCCB argued that Bibby's Title VII claim should be dismissed because Bibby had not made out a prima facie case of discrimination. Specifically, PCCB claimed that Bibby had not shown that he suffered discrimination on the basis of a protected characteristic. Although Bibby claimed he was discriminated against because of sex, PCCB argues that any discrimination suffered by Bibby was discrimination based on sexual orientation—a non-protected class under Title VII.

In order to prove employer liability for a hostile environment based on sex created by a coworker, an employee must demonstrate that:

1) the employee belongs to a protected class;

2) the employee was subject to harassment, that is, unwelcome sexual advances, requests for sexual favors, or other verbal or physical conduct of a sexual nature;

3) the harassment was based on sex;

4) the harassment affected a term, condition, or privilege of employment, becoming so severe and pervasive as to create a hostile work environment; and

5) the employer knew or should have known about the sexual harassment and failed to take appropriate corrective action.

Bibby failed this test because he could not show that the harassment was based on sex, as is required under Title VII.

Bibby referred to only three statements of a sexual nature, the January 22 comments and the graffiti. The January 22 comments all involved a coworker telling Bibby, an open homosexual, "everyone knows you're a faggot"; "everyone knows you are as gay as a three dollar bill"; and, finally, "everyone knows you take it up the ass."

Certainly, these comments are not pleasant—and they are inappropriate. Nonetheless, they are not actionable under Title VII, because they all were clearly targeted at Bibby's sexual orientation, and not at his sex (as in gender).

Similarly, the graffiti in the bathroom of which Bibby complains said, "Some faggot [sic] keeps pulling this away from the wall to see some dick," followed by, "Yeah, yours," on the wall. Again, the language and context are unpleasant, but the graffiti was clearly aimed at sexual orientation, rather than at Bibby's sex.

The court concluded that any discrimination that Bibby suffered was based on his sexual orientation, not his sex.

Bibby also asserted a state law intentional infliction of emotional distress claim against PCCB, alleging that PCCB's conduct was sufficiently outrageous to justify such a claim.

PCCB argued that such a claim is appropriate for summary judgment because the claim is preempted by federal labor law, specifically the National Labor Relations Act (NLRA), that the claim was time-barred under the applicable statute of limitations, and that the conduct in question does not rise to the level of outrageousness required by Pennsylvania law. During his deposition, Bibby repeatedly stated that the disparate disciplinary treatment that he faced resulted from asserting his rights under the CBA.

However, Bibby did not mention a claim for retaliation in his complaint, and it wasn't clear exactly which of PCCB's actions Bibby perceived to have been in retaliation for exercising his rights under the CBA, and which actions he perceived to have been aimed at his sexual orientation.

The court also noted a paucity of evidence on the claimed link between the harassment and the exercise of a protected right. It concluded that no affirmative justification to retain jurisdiction over the state law claim was present. Bibby would have to take that claim to a state court.

In addition, Bibby's Title VII claim is premised on sexual orientation discrimination. Because sexual orientation is not a protected class under Title VII, the court granted PCCB's motion for summary judgment and declined to exercise supplemental jurisdiction over Bibby's state law claim for intentional infliction of emotional distress, dismissing that claim without prejudice.

Conclusion

Issues of sexual orientation in the workplace raise a lot of troubling questions about U.S. antidiscrimination law. In short, U.S. law doesn't do much to protect homosexuals, transsexuals and other sexual minorities.

The silver lining to this cloud is a kind of libertarian optimism. Since the government isn't doing much to protect the workplace rights of homosexuals, private sector employers (with some prodding from individual states) are taking the lead. By offering homosexuals increasingly balanced access to job-related benefits—group health and disability insurance, pension benefits, etc.—corporate America has led the movement toward legal parity for sexual minorities.

This unusual twist has forced interest groups on both sides of the issue—corporate employers and homosexual rights advocates—to find a new approach to the identification and negotiation of rights and benefits.

In the end, homosexuals may find their best results come from approaching workplace equality from the perspective of loosely affiliated free agents...rather than a rigidly defined "minority group." Their might may focus on fair access rather than redress (which, as we have seen elsewhere in this book, is the spirit of antidiscrimination law, anyway).

Some homosexual rights groups may argue that this approach is nothing more than the old "separate but equal" argument that U.S. courts rejected as impossible generations ago.

But that's not really a true and complete understanding of the situation. The treatment of homosexuals in the workplace may be something that's improving at the same time that notions of work are changing generally. The old style of workplace parity efforts—for all groups—focused on the strong hand of a paternalistic legal system. It assumed bigotry and bias. The new style of workplace parity efforts focuses on equal access to benefits and non-interference with commerce (even commerce as basic as negotiating a wage). Its assumptions are less moralizing.

That is a good thing.

Privacy

Privacy is an elusive right. It's not as certain as most people think.

When Elaine Stipetich began having an extramarital affair with a coworker, never did she think that her supervisor's disapproval would result in an invasion of privacy. And never did she think it would be so difficult to prove that invasion in a court of law.

In this chapter we will explore the commonly held *belief* that every citizen should enjoy a right to privacy, especially when it comes to issues of sex, whether at home or in the office. Contrary to what popular culture says about our rights and privileges, the U.S. Constitution contains no clause to shield us from intrusions as simple as Peeping Toms or a boss who reads lunchtime e-mail. This first case, *H. Elaine Stipetich v. William J. Grosshans*, demonstrates how private matters unrelated to work can wreak havoc in the workplace, sacrificing one's dignity and perceived right to self-determination.

In 1983, Stipetich began working as a probation and parole officer in the Janesville office of the Wisconsin Department of Corrections' Division of Probation and Parole. Stipetich received excellent appraisals of her work from 1983 to 1991. However, in early 1990, Stephen Tupper, her DOC field supervisor, suspected that Stipetich and another officer in the Janesville office were having an extramarital affair.

Although Tupper noted that the affair caused a change in Stipetich's behavior, he continued to find her work satisfactory when he audited her performance in February 1991. Stipetich, on the other hand, al-

leged that Tupper began to discriminate against her on the basis of her sex. She contended that he started closely scrutinizing her work and behavior, tried to discredit her among her coworkers, and forbade her from discussing her personal life with others in the office.

After complaining to Tupper about his behavior for several months, Stipetich filed a union grievance and an affirmative action complaint with the DOC on November 4, 1991. On November 22, Tupper began an audit of Stipetich's case load and concluded that she was performing unsatisfactorily in several aspects of her job.

On January 15, 1992, Stipetich filed a discrimination charge with the Wisconsin Personnel Commission against Tupper.

Later that month, Eurial Jordan, the division administrator for the Division of Probation and Parole, wrote to Stipetich, informing her that she was required to undergo a psychological evaluation with a doctor chosen by the division. According to the note, the evaluation was required if she were to continue her employment. And, until the disclosure of the results, she was suspended indefinitely with pay.

On January 29, Stipetich underwent an evaluation with Dr. Eric Hummel. However, Stipetich signed a limited release of information, allowing Hummel to relay only a basic opinion of her ability to work. Hummel concluded that Stipetich was able to perform many of her job duties, but was limited in her ability to work with her coworkers—including Tupper. He also concluded that she would be limited when it came to interacting with clients.

In order to further evaluate Stipetich's abilities and reach a more comprehensive conclusion, Hummel suggested that he obtain an expanded release of information from her. Thus, at the insistence of the division, Stipetich provided Hummel with a full release. Following the release, Stipetich underwent an exhaustive evaluation, which disclosed information on her family background that she considered extremely embarrassing and personal.

Following this evaluation, Hummel stated that Stipetich had a "reasonable chance" of performing her duties as a probation and parole

officer if she was transferred to another office. Specifically, Hummel said that he had "significant doubts" about Stipetich's ability to work effectively under Tupper's supervision.

On March 4 of the same year, Stipetich was told that she could choose between reassignment to a probation and parole office in Elkhorn or Madison, or have her employment terminated. The next day, Stipetich accepted the transfer to an office in Madison, but she did so under protest, since she was not given the option of remaining in the Janesville office or transferring to nearby Beloit. Stipetich felt that she had not been treated fairly or given fair options under the circumstances.

In 1997, Stipetich filed a complaint in the Dane County Circuit Court, and claimed that she had been subjected to sex discrimination and retaliation in violation of Title VII of the Civil Rights Act of 1964. She also alleged that her right to privacy, due process and equal protection under the First, Ninth, Tenth and Fourteenth Amendments to the United States Constitution had been violated.

The trial court granted summary judgment in favor of the Wisconsin Department of Corrections' Division of Probation and Parole on all of Stipetich's claims except for the claim to invasion of privacy for the full release of information to Hummel.

Stipetich appealed.

The Department also appealed, arguing that the court should have granted summary judgment in its favor on the invasion of privacy claim because they were entitled to "qualified immunity."

Stipetich, on the other hand, argued that the court erred in granting summary judgment in favor of the Department on her claims of sex discrimination and retaliation under Title VII. She contended that she made out a prima facie case of sex discrimination and retaliation, and that there remained material issues of fact to be determined.

In employment discrimination cases under Title VII, an employee must prove that he or she has been the victim of intentional discrimi-

nation. The key word here is *intentional;* in order to be guilty, an employer has to discriminate consciously against an employee.

In order to support her argument, Stipetich had to supply sufficient evidence to allow a rational jury to find that she was subjected to discrimination *intentionally.*

And, in employment discrimination or retaliation cases, a plaintiff can present sufficient evidence to avoid summary judgment in two ways: (1) by presenting enough direct or circumstantial evidence to demonstrate that the employer intended to discriminate; or (2) by presenting indirect evidence of intentional discrimination under what has been termed (since *McDonnell Douglas Corp. v. Green*) the "*McDonnell Douglas* burden-shifting approach."

Under the *McDonnell Douglas* approach, an employee must first establish a prima facie case of discrimination—meaning, on the face of the case and in the absence of any evidence to the contrary, he or she suffered discrimination. Then the burden shifts to the employer to produce a legitimate, nondiscriminatory reason for the action it took. If the employer meets this burden, the employee must then prove that this legitimate reason was merely a pretext for discrimination. This gives an employee the chance to prove that the employer's reason for discrimination was unfounded and unrelated to his or her ability to perform at a job.

Stipetich did not produce direct or even circumstantial evidence of the Department's intent to discriminate or retaliate against her. Because of this, the appeals court concluded that the trial court properly granted summary judgment to the Department on Stipetich's sex discrimination and retaliation claims.

First, the court explained, Stipetich didn't present sufficient evidence to establish the prima facie case required under *McDonnell Douglas.* Second, there was no evidence that she suffered adverse employment actions as required in both sex discrimination and retaliation cases.

The definition of *adverse employment action* varies from federal circuit to circuit, but courts have continually defined the term to refer only

to severe situations. In fact, one 1996 case concluded that the action requires "a materially adverse change in the terms of employment." This means that the action be more subversive than a mere inconvenience or modification of job responsibilities.

Put simply, an adverse employment action is not limited only to a loss of employment or a reduction of pay or monetary benefits, but it must be both detrimental and substantial.

For example, acts such as a demotion, significantly diminished responsibilities and refusal to hire or promote can qualify as an adverse employment action; however, an employer's moving an employee to an undesirable location (such as the basement), or requiring an employee to relocate personal files while forbidding the use of the firm's stationery can also fulfill the definition in some courts. Defining the disruption is the gray area that is hard to prove (as seen in this particular case), which is often left to the courts to decide.

The court found that Stipetich did not produce evidence that she suffered negative treatment that rises to the level of an adverse job action. There was no evidence that her transfer to the Madison office caused her to lose any pay or benefits. Stipetich's transfer appeared to be "purely lateral." Although the environment in which she worked changed, Stipetich produced no evidence that her job responsibilities changed substantially or that she lost any of the "accouterments" or perks (i.e. business cards, company parking spot, laptop, etc.), of her position that might signal that she was being demoted.

Logistically speaking, Stipetich had to travel from Janesville to Madison to work—a new inconvenience—but she was reimbursed $4,000 for her travel expenses. She was also given the option of transferring to Elkhorn, which was closer in distance to Janesville than Madison.

Furthermore, the court found that Stipetich's suspension with pay did not amount to an adverse employment action under any act or body of law. Contrary to Stipetich's argument that she had suffered from an adverse job action because she was denied several promotions as a result of the Department's discriminatory conduct, the court disagreed. In its disagreement, the court enumerated the specific conditions that

must be met when establishing a prima facie case for failure to promote, which include that a plaintiff demonstrate that:

1) he or she applied for a promotion;

2) he or she was entitled to the promotion; and

3) the person who received the promotion had the same or lesser qualifications.

Stipetich described another woman who advanced in the Department more quickly than she; but Stipetich provided no specific evidence of promotions she applied for that she was entitled to and that were given to someone else with the same or less qualifications.

Stipetich also asserted that Tupper intentionally created a hostile work environment by excessively scrutinizing her work, discrediting her with coworkers and forbidding her from discussing her personal life in the office. She argued that this creation of a hostile work environment amounted to an adverse employment action.

Again, the court disagreed, based on the fact that Tupper did not sexually harass Stipetich. Nor did Stipetich produce any evidence to support her claim that she was the victim of sexual harassment.

Finally, the court concluded that Stipetich failed to demonstrate that she had been deprived of a property or liberty interest requiring procedural due process. This conclusion brings us to the most interesting aspect to this case—claiming the right to due process under the Fourteenth Amendment.

Stipetich maintained that Tupper deprived her of her constitutionally protected rights to remain employed at Janesville and to preserve her reputation. You may ask what these rights have to do with the Fourteenth Amendment. Let's look at its wording:

> No state shall make or enforce any law which shall abridge the privileges or immunities of citizens of the United States; nor shall any state deprive any person of life, liberty or prop-

erty, without due process of law; nor deny to any person within its jurisdiction the equal protection of the laws.

The Supreme Court historically has interpreted *liberty* to refer to those fundamental rights not necessarily enumerated in the Bill of Rights. And, in general, liberty has often been viewed to equal *privacy*. You can decide to enroll your child in school B as opposed to school A; you can study Tagalog if you so choose; you can marry whomever you want (except for someone of the same sex, as we have already seen) without state or federal intrusion. These choices, and the right to choose them, are rooted in what we consider to be private decisions. Thus, one's fundamental right to have and hold a job is a liberty rooted in one's fundamental right to privacy, according to this broad interpretation of the clause.

So, by threatening Stipetich's job if she didn't choose to transfer to another office, she was, in essence, losing her right to stay in Janesville and pursue her career there. Furthermore, claiming a loss of reputation as a result of the discrimination and its work-related consequences (i.e. forced transfer), Stipetich tabled yet another key component to the above due process clause: property.

An individual's *reputation* can be interpreted to mean property—something that a person owns and has a constitutional right to protect. When Stipetich attempted to prove that she had suffered a loss of reputation, she hoped this cause for action and due process would bend the decision in her favor. This is not how our laws, however, work. And Stipetich was merely grasping at straws in a fight in which she was never to have the upper hand.

The Constitutional Background

While the law serves to protect one's right to things like property and a job, the law also provides *equal protection* to an employer and his right to make decisions about his company (which he owns), even if that includes firing an unsatisfactory employee or shifting people to various offices to turn a better profit.

In order to demonstrate a right to procedural due process, an employee must establish that a constitutionally protected property or liberty interest is implicated.

In the past, several courts have held that property interests are not created by the Constitution, but are created and defined "by existing rules or understandings that stem from an independent source such as state law-rules or understandings that secure certain benefits and that support claims of entitlement to those benefits." Separately, these understandings are called *penumbra*—which means, literally, the "shadows around" the rights explicitly named in the Constitution.

The Supreme Court has had a history of dealing with various issues concerning a person's constitutional right to privacy. Sudden changes in technology and an overall increased interest by society, government, corporations and individuals in the livelihoods and conduct of people have put individual privacy under much scrutiny.

While the notion of a constitutional doctrine protecting the right to privacy may be relatively new, the concept of the right to privacy as part of our legal tradition has its roots dating back to the 19th century. In 1890, Samuel Warren and Louis Brandeis published an article on the right to privacy, using the classic common law expression concerning privacy-based property. They concluded that common law recognized a man's house as his castle and invincible, and for the courts to allow idle curiosity to enter a man's personal livelihood within the home is absurd.

But it was not until 1965 that the Supreme Court clarified a specific constitutional right to privacy in *Griswold v. Connecticut*. In this case, the Executive Director of the Planned Parenthood League of Connecticut and a professor at the Yale Medical School who served as Medical Director for the League at its Center in New Haven were convicted and fined $100 each for breaking Connecticut's anti-contraceptive law.

The 1958 law contained two main parts. First, any person who used any drug, medicinal article or instrument to prevent conception would be fined at least $50 or imprisoned between 60 days to one year, or

both. The second part stated that any person who "assists or counsels the prevention of conception can be prosecuted and punished as if he or she were the principal offender."

The Planned Parenthood people were found guilty of the second account— giving information and medical advice to married persons to prevent conception.

On appeal, Justice William O. Douglas stated the opinion of the court, articulating a right to privacy based on the penumbra of rights allocated in the First, Third, Fourth, Fifth and Ninth Amendments. He especially focused on the Ninth Amendment, which states that specific rights granted in other amendments and the body of the Constitution cannot deny other rights retained by the people.

For Douglas, one of those retained rights was the right to marital privacy, "a right that is older than the Constitution, older than political parties, older than any other issue." Douglas declared that Connecticut law clearly infringed on the right to marital privacy, and the convictions of the director and the professor were reversed.

Although *Griswold* focused on the details of contraceptive methods, the case raised more general questions about personal choices. The Constitution doesn't say anything about how people treat their own bodies...or choose the kind of education their children get. Or the person or persons with whom someone chooses to have sex. Of course, these are all choices that most Americans—regardless of their political affiliations—believe people should be free to make.

Therein lies the problem. Personal associations—including sexual relationships—among citizens require a certain amount of privacy. But the Constitution *explicitly* offers only limited and specific protections to privacy. Sure, it seems to *imply* the rest; but that implying requires some highly debatable legal interpretation.

Griswold makes the point that certain amendments require a fairly far-reaching right to privacy. The Fourth and Fifth Amendments provide protection against all governmental invasions of the sanctity of a citizen's home and the privacy of his or her life. The Ninth Amend-

ment provides that the "enumeration in the Constitution, of certain rights, shall not be construed to deny or disparage others retained by the people."

The Supreme Court decided that forbidding the use of contraceptives instead of regulating their manufacture and sale had what it called a "maximum destructive impact," and that this invaded certain protected freedoms.

In focusing on privacy, the Supreme Court emphasized the value of the Ninth Amendment. Just because a certain right may not be guaranteed in so many words by the Constitution, the government cannot assume that the right—such as the right of privacy about sexual choices within a marriage—is not established and solidified in society. And, if it is so established, the Ninth Amendment protects that right.

That is why the Supreme Court focused on the issue of privacy and not just birth-control methods. The court set a precedent for future privacy issues with its assessment of certain amendments of the Constitution in *Griswold*.

Property and Liberty Rights

In a more concrete sense, a person's reputation and job can be considered property and liberty interests.

The courts also say that in order to "have a property interest in a benefit, a person clearly must have more than an abstract need or desire for it. He [or she] must have more than a unilateral expectation of it." The liberty interests protected by procedural due process are not specifically defined. A person's reputation falls within the scope of property or liberty interests protected by procedural due process because when "a person's good name, reputation, honor, or integrity is at stake because of what the government is doing to him [or her]," due process is essential.

However, a person's reputation is protected by procedural due process only when damage to the reputation is accompanied by the alteration or elimination of a right or status previously recognized under state

law. Another aspect to note here: it can be argued that a *good* reputation may constitute property, but may only be protected from *government* action. Hence, if your neighbor ruins your reputation, the court may not recognize a need for due process.

In *Stipetich*, the court concluded that the trial court had properly granted summary judgment on her due process claim because she did not produce sufficient evidence that she had been deprived of a constitutionally protected property or liberty interest. And, with respect to protecting her reputation, Stipetich was not entitled to procedural due process because any damage caused to her reputation was not accompanied by the elimination or alteration of a right or status recognized by state law.

The Department of Corrections won, and Stipetich's exhaustive attempt to prove her sex discrimination case—sweeping an affair and even her reputation under her claim to privacy—failed. In fact, in many cases the victim of legitimate claims to sex discrimination loses because of the way in which the laws are written and interpreted. Despite our increasing desire to shield ourselves from the intrusiveness of others, the bottom line is that the right to privacy is an elusive right at best.

Do We Have a Right to Privacy?

What many may not realize—and what may startle some people—is that the word *privacy* does not appear anywhere in the U.S. Constitution. Rather than an explicated law, the right to privacy is a legal *concept* that encompasses an amalgam of principles recognized by courts or lawmaking bodies. Claims of a right to privacy and issues surrounding this right are dealt with on a case-to-case basis because there really is no clear and present definition.

Often at opposition to the right of privacy are other freedoms guaranteed by law, such as freedom of speech, the press and information. To infringe upon one's right to privacy is all too often a simultaneous infringement on another's right to gather information. Where society decides to draw the line and make rules is the challenge, as well as the endless debate.

Another commonly misunderstood idea is that the Constitution inherently guarantees protection against other individuals. In truth, the Constitution only protects individuals against *government* intrusion, hence clauses like "unreasonable searches and seizures." The safeguarding document exists to protect citizens from the government, but not from private individuals.

If you are looking for a legal definition of privacy—and one most poignant to how society construes privacy—Supreme Court Justice Louis Brandeis perhaps said it best over 100 years ago: the right to privacy is "the right to be let alone." And, given this definition, it's worth noting that Brandeis was arguing for a right against private individuals—employers, neighbors, friends and the press.

Brandeis effectively placed privacy on the books as something that doesn't necessarily have to do with government. This type of privacy has established itself as a tort, that is, a legal cause of action born from a statute or common law (which is a law courts recognize based on legal history). Concerns about privacy and evolving technology date as far back as the 19th century, so you can imagine what Brandeis would say today given computers and all that they allow—or as some would say, problems they foster in terms of a hostile environment.

These days, we spend more hours in the office, interacting with more people and learning to deal with different dynamics. The technology and dot.com phenomenon have upended traditional work styles and many workers who have paid their dues over the years are finding that their supervisors are often younger than they are, are people of color—or even women. In fact, the days of the old boy network are fast running out as women have taken a more prominent role in the workforce (and are estimated to surpass men by the year 2003).

With this changing workplace, and its increasing demands, we are thus having to spend most of our days—and the majority of our lives—in situations that are not inherently private. When it comes to the workplace, should an employee have a reasonable expectation of privacy? Yes, of course. But the crucial word here is *reasonable*.

As companies find themselves increasingly liable for damages result-
ing from their employees' improper actions, they are turning to a host
of routine and seemingly intrusive practices to protect their interests.
Later in this chapter we will encounter the notion of "seclusion" and
how "intrusion upon seclusion" (i.e. an invasion of privacy when you
previously believed you were secluded) is dealt with in the courts. For
now, a stronger case can be made for the rights of employers and the
means by which they gather and utilize private information.

These days, employers are regularly settling sexual harassment claims.
At the same time, they are continually monitoring, testing and sur-
veying us as we work—dillydally on the Internet or smoke a cigarette
during our lunchbreak. Once we step out of our homes, how we choose
to spend the day can be easily clocked and legally observed with tech-
nology. Given this level of scrutiny, we are increasingly being judged
by not only our work, but our lifestyles, behaviors, beliefs and even
sexual preference and orientation. Some may argue the unfairness of
today's vigilant environment, but employers base their reasoning on
the tough level of competition and their need to provide a safe and
productive workplace.

Employers have a right to make a profit, and stemming from this idea,
the right to pick the best worker for the job, as well as one who doesn't
come with high liabilities. Rising health care costs and the fact that
employers are finding themselves more responsible for the actions of
their employees place the burden of background checking on the
employer. For example, employee theft costs U.S. retail businesses
upwards of $25 billion annually—the leading cause of retail loss.
Avoiding such losses requires a certain level of employee prescreening—
and therein lies the debate. Finding the balance between protecting
against "negligent hiring" (a recognized tort, blaming employers for
failing to adequately check the histories of workers) and protecting a
worker's right to privacy is never an easy task.

One may ask about the so-called "career victims," individuals who
have made it a practice of navigating between companies just long
enough to gather grounds for a claim and file suit. This adds another
layer of paranoia to employers, but in comparison to other risks—the

risk of theft or the risk of dubious on-the-job behavior—this liability is practically negligible.

It's a tug-of-war between truth and fiction. The lawsuit-happy climate of recent years has generated this pervasive urban myth that sex discrimination and/or harassment lawsuits are bankrupting corporate America. Yet there is a real disconnect between the wagging tongued editorials in business mags and the reality: These lawsuits are hard to prove and very rarely yield the kind of seven-figure settlement seen on the evening news.

Employers, however, shouldn't be too quick to adopt a cavalier attitude toward these issues. "Workplace comfort" is one of the most common responses to the employee-posed question, "What are you looking for in a job situation?" And as the workplace continues to compete for quality employees, the bean counters are going to weigh the merits of potential lawsuits against employee happiness.

It's a tough environment for businesses today. As an employee, you should be aware of this current—albeit harsh—climate of business and accept a higher tolerance for an employer's intrusiveness. While many organizations do not disclose their privacy policies, others are forthcoming. In any event, an employee should question the company about privacy issues and how it treats individual privacy both on-the-job and off. Regardless of what you learn, talk to fellow employees and assume that any activities conducted on the premises or by using company property or facilities are monitored. To say we own a right to privacy is far from the reality of the modern world, for the principles that govern privacy are embedded in our belief system and not necessarily our legal system.

Although the U.S. Constitution doesn't mention the word "privacy," the state of California's Constitution explicitly states in its opening Article:

> All people are by nature free and independent and have inalienable rights. Among these are enjoying and defending life and liberty, acquiring, possessing, and protecting

property, and pursuing and obtaining safety, happiness and privacy.

California is the only state that includes the word privacy in its constitution. With voter approval, residents added the word to the document in 1972 and created the strongest privacy protection in the nation. Implementing and practicing this privacy has been a challenge, however. Especially when one looks at the case of slain TV actress Rebecca Schaeffer, who was stalked and violently murdered in the late 1980s by a man who obtained personal information about her from open records simply accessed at the California Department of Motor Vehicles.

Again, we will see this imbalance between the right to obtain information and the "right to be let alone."

Legal and Illegal Pre-Employment Inquiries

You were aggressively recruited for this job, did your research on the company and formulated some good interview questions. The woman interviewing you seemed so impressed with your background. So why didn't you get the job? You came across well in the interview, didn't shake hands with a sweaty palm, or drop your fork over lunch. What happened? Well, it's possible that it had to do with some information gathered by your potential employer. After saying adieu and promising to get in touch with you in the coming days, your future employer may have delved farther into your life—and past—by obtaining information on record. This type of information may even be that which the company may or may not have had a legal right to access.

Firms that have been stung by negligent hiring lawsuits are checking into the pasts of potential employees with more vigor than ever before. Databases that are readily available today—even via the Internet—contain millions of personal records. These databases offer quick, relatively inexpensive background searches to be completed by prospective employers.

From the employer's point of view, background checks make a lot of sense. Who would want to hire an individual with a prior record of

sexual harassment? And, since it's illegal to ask a prospect such a question, many employers are taking matters into their own hands. They don't have to ask you for the answer; they can get it somewhere else—alongside a slew of other juicy details about you.

Privacy advocates are concerned that the scope and easy availability of this data make this material seem more authoritative than it really is. If an employer can find out how many times you frequented the XYZ.com Web site, you wouldn't necessarily want him to decline from hiring you based on this fact. Or, if somewhere in your record it says you were evicted from your last apartment, and you didn't have the opportunity to explain and negate that fact, you would be at a disadvantage when the decision to hire you or not is made. Privacy advocates also fear that the newer, perhaps less responsible background-check services may not fully verify the accuracy of this information.

In truth, many databases are chock-full of errors. For example, a male retail worker (let's call him Bill) had his wallet stolen several years ago. Apparently, the thief committed crimes while carrying Bill's ID. As a result, information about this criminal conduct was wrongly attributed to Bill and archived in a database regularly visited by retail companies. Not only was Bill fired from his job, but he couldn't find work because this erroneous information kept appearing. Eventually, he learned of this information and filed suit against the background-check firm.

While it may seem like a great deal of work, it is a potential employee's responsibility to be aware of the information that is available to employers—damaging information notwithstanding. With the proliferation of incorrect information floating around in various databases, individuals need to become proactive and, in essence, become their own best private eye. Equifax, the United States' largest and most commonly used credit reporting agency, has routinely admitted that up to 70 percent of its reports contain some sort of factual inaccuracy. Multiply this by the increasing number of agencies and Web sites dedicated to providing information and you have a powder keg in the making.

What's in a Background Check?

Employers use background checks for many reasons, such as to verify the accuracy of information provided by job seekers; to uncover information left out of an application or interview; or to protect themselves from lawsuits that can spring from hiring an employee whose actions hurt another employee or a client/customer.

Background checks can reveal a variety of personal information, from both public records and commercial databases. This can range from merely the verification of an applicant's Social Security number to a detailed account of the candidate's history and acquaintances.

Before obtaining certain types of information, an employer must get permission from a potential employee. Such information includes the following:

- **Education Records.** Under the Family Education and Right to Privacy Act, transcripts, recommendations, disciplinary records and financial information are confidential. A school should not release student records without the authorization of the student or parent. However, a school may release directory information, such as name, address, date of attendance, degrees earned and activities, unless the student (if over age 18) or the parent of a minor expressly forbids release in writing.

- **Military Service Records.** Under the federal Privacy Act, service records are confidential and can only be released under limited circumstances. Inquiries must be made under the Freedom of Information Act. Even without the applicant's consent, however, the military may release name, rank, salary, duty assignments, awards and duty status.

- **Medical Records.** Medical records generally are confidential. However, if an employer requires a physical examination after making a job offer, the company can get the results. The Americans with Disabilities Act (ADA) allows a potential employer to inquire only about an employee's ability to perform specific job functions.

What's *Not* in a Background Check?

In theory, certain types of information either can't be gathered, or may be gathered but can't be considered by a potential employer. Federal and state laws generally exclude employers from using the following types of information in hiring decisions:

- **Arrest Information.** Although arrest record information is public, in many states employers cannot seek out the arrest record of a potential employee. However, in California, for example, if the arrest resulted in a conviction, or if the applicant is pending trial, that information can be used. Other states may deny access to arrest records altogether, or at least those of first convictions for minor offenses.

- **Criminal History.** Usually, criminal histories compiled by law enforcement agencies are not public record. Depending on your state's laws, only certain employers such as public utilities, law enforcement, security-guard firms and child-care facilities may have access to this information.

 However, with the advent of computerized court records and arrest information, private firms can and do compile virtual "rap sheets" from public records.

- **Workers' Compensation.** When an employee's claim goes through the state system or the workers' compensation appeals board, the case becomes public record in most states. However, only if an injury might interfere with one's ability to perform required duties may an employer use this information in making a hiring decision. Under the ADA, employers cannot use medical information to discriminate against applicants who filed a claim. Note that workers' compensation law is legislated differently in each state; the terms that define how an employer can use this information differ across state lines.

- **Bankruptcies.** While bankruptcies are public record, employers cannot discriminate against applicants because they have filed for personal bankruptcy.

While, technically, employers can't use this information against a job applicant in making hiring decisions, the reality of decision making is that it is an arbitrary, subjective and not always rational process.

Employee Monitoring: Are You Being Watched?

Workplace surveillance is about as old as work itself—and few would question an employer's right to prevent abuses or check how employees are performing. But computers, video cameras, tape recorders and a raft of Tom Clancy-like devices have added new tension to this age-old impulse. And the cultural impact of so-called "reality" entertainments (the seeming endless series of TV programs like *Survivor* and *Big Brother*) can't be ignored in this context. People are more accustomed to surveillance.

In fact, even workers themselves increasingly ask for monitoring of normal day-to-day workplace operations, according to a report on employee privacy in the workplace by the American Management Association (AMA).

These days, every act and every conversation can be tracked to almost every minute of your workday. Advances in technology have made it easier to keep close tabs on workplace activities. If they choose, employers can explore your computer screen and memory, get a count of how many keystrokes you make per hour, read your e-mail and voice-mail, keep track of your phone calls, and even chronicle how much time you spend away from your computer. Some employees may soon wear electronic badges signaling their whereabouts at all times, and *BusinessWeek* reported that some bosses are buying special chairs to measure wiggling (with the idea being that wigglers aren't working). Key-card systems, parking lot gates and door locks can also be fitted with devices to recognize the individual card so that the movements (time in, time out and location) of the employee using that card is tracked and recorded.

Most workplace monitoring springs from the desire of an employer to measure work performance. But too often, it's more than the work that ends up under the microscope. For instance:

- John, a gay man who worked for a junior college for 10 years, learned that the messages on the campus-wide voice mail system were backed up and stored. He had thought that by using the delete feature, he was truly deleting his messages. One of his colleagues, however, hinted that he was aware of some of John's messages. John then feared that old messages referring to his sexual orientation could imperil his chances for promotion. While nothing overtly occurred to suggest that John's voice mails affected his career at the college, the mere threat of his records encouraged John to eventually find employment elsewhere.

- Two systems administrators at a Nissan subsidiary in California were fired in a dispute involving their use of e-mail to criticize their supervisor. The supervisor, referred to in a derogatory manner in the e-mail exchanges, intercepted the messages. A judge held that the company had the right to read the e-mail because it owned and operated the equipment.

- A midwestern salesman was stunned when he accidentally discovered that his company car was outfitted with a location detector. He understood that his firm might have reason to know his whereabouts when he was supposed to be making sales calls. But what about over the weekend when he kept the car? Was the firm logging where he met friends, how many trips he made to the liquor store or whether the car remained overnight at his girlfriend's house? The salesman chose to do nothing, but others in similar situations have purchased a second car for offtime use.

- When a married McDonald's manager had a sexual affair with a coworker in New York, his amorous voice mail messages were retrieved by a fellow manager, who played them for the manager's supervisor and for the manager's wife. The manager was fired— not for having the affair, but for misuse of company property.

- A man and a woman working for a national retail department store were caught on videotape engaging in sexual acts in a private workroom during their break times. While the company had no issue with their relationship, they were nonetheless suspended for misusing company property.

Of course, there are lots of good reasons for keeping a close eye on workers. Numerous court rulings have held firms liable for a worker's crimes or negligence. With workplace behavior such a volatile issue, there's a need to ensure proper decorum—and maximum productivity. Furthermore, for employers to remain competitive, they must provide quality control and customer satisfaction. These things begin with their workers.

But workplace monitoring is essentially unregulated, and workers' dignity can be sacrificed. A Maryland hospital, for example, suspecting narcotics theft, secretly planted a camera in the nurses' locker room. The nurses were outraged when they discovered that the camera was connected to a closed-circuit TV monitored by a male security chief, who could watch them undress. As a result, the hospital removed the cameras and issued an apology to the women.

Monitoring can also impact one's job security if seemingly private conversations are overheard. Another example: A telephone company representative in the midwest phoned the state wage-and-hour board to ask how to file a complaint against her employer for commission money she believed was owed to her. Two hours later, her supervisor grilled her about the call, playing a tape of the conversation.

Another woman who had worked in the customer-services department of a utility for 27 years was terminated after being told that tapes of her conversations with customers indicated poor performance. She claimed, however, that a number of older employees, also nearing retirement age, were let go for the same stated reason. When she asked to listen to some of the tapes, company officials told her that they had been destroyed. Legal action is now pending in this case.

The Legalities of Monitoring Employees

Neither Congress nor state legislatures have effectively spelled out the respective rights of employers and employees in this area. But the bottom line is this: When you walk into the workplace, expect to check your privacy at the door.

This is not a new concept. Jobsite monitoring has been going on for as long as there have been bosses and workers. In the early decades of the 20th century, Henry Ford supposedly had 100 investigators visit the homes of his workers, unannounced, to see if they were living a proper, family-oriented lifestyle.

The main difference today is that technology allows employers to monitor you without your knowledge. Surveillance equipment can fit into a thumbnail and record what you do, say and write.

MacWorld, a respected computer magazine, surveyed executives at more than 300 large, medium and small businesses in a wide range of industries to find out how much they peek at employees' work on their computers. The results:

- 22 percent admitted having searched employees' computer files, voice mail, e-mail or other such networking communications;

- 66 percent said they didn't warn employees of any searches; and

- Only 18 percent of the companies had a written policy regarding electronic privacy for employees.

The larger the firm, the more likely the snooping, *MacWorld* discovered. Extrapolating to the workplace at large, the magazine estimated that as many as 20 million Americans may be subject to electronic monitoring through their computers (not including telephones) while on the job. Another study conducted by *Inc.* predicted that 30 million American workers will be monitored continuously by the year 2001.

Various studies conducted by major universities have found links between employee monitoring and stress, both physical and psychological. The issues addressed by the universities included the following:

- Is monitoring used manipulatively to affect behavior in the workplace?

- Are monitoring records used to discipline employees without proper due process?

- Is monitoring done in such a way as to rob employees of their basic dignity?

- Is monitoring discriminatory because it takes place at the lower end of the pay scale, such as clerks and factory workers, whose ranks are often disproportionately comprised of women and minorities?

Privacy advocates and labor unions have been pushing for fair monitoring laws since the mid-1980s. Bills introduced in Congress over many sessions in the late 1990s asserted the right of employees and customers to know if they're being monitored, perhaps by means of a signal light or beep tone.

These bills also generally would require employers to inform all employees and new hires that they may be monitored via phone, computer or e-mail and to explain how collected data will be used. Monitoring, according to these bills, should be part of a systematic program to collect information about people's work—not a license to snoop indiscriminately. A telephone company, for instance, may need to listen to directory assistance operators to ensure that they're giving out accurate information in a courteous manner. But managers shouldn't be allowed to randomly go on electronic or telephone fishing expeditions.

Title III of the Omnibus Crime Control and Safe Streets Act prohibits deliberate interception of phone calls and other oral communication. Implicit in this prohibition is the need for the interception to be surreptitious, that is, without the knowledge of the oral communicator. Most states have laws giving you the right to be informed at the outset if a phone call, interview, etc., is being taped. However, some employers have long-standing policies on monitoring business calls. Informing employees of these policies and allowing them to make conscious decisions while at work is surely a good practice. Employees need to remember: What you may think is confidential may not necessarily stand up in a defense for privacy protection. In the case of phones and voice mail, the company has a right to check phone records for personal long-distance or toll calls. The company also has the right to listen to your voice mail.

So far, bills like the Omnibus Act have died amid legislative gridlock, and there's little indication that they will be passed anytime soon. Meanwhile, existing federal and state laws are less exacting. Generally, federal law prohibits employers from listening in on employees' personal phone calls—but the government allows that supervisors won't know the calls are personal until they've already listened.

Make no mistake: The legal deck is stacked in the boss's favor. If you're a boss, lucky you. If not, and any of those issues strike a chord with you—if you feel your employer may be crossing the line between checking on your work and intruding on your personal space—there are organizations that can help you better understand your rights.

Privacy and the Workplace: Employee Surveillance

Nearly 63 percent of midsize to large companies conduct some form of electrical surveillance through the use of such methods as video cameras; phone bills indicating numbers called from employee extensions; voice mail messages; computer files and e-mail; taped telephone conversations, etc. However, the most common technique for detecting or corroborating allegations of theft or related wrongdoing in the workplace is the use of video cameras. Recent advances have made the camera and lens much smaller and extremely flexible, enabling almost any area to be placed under surveillance with minimal chance of discovery.

Although many employers assert that monitoring workers' activities is essential to minimize theft or related wrongdoing, such monitoring may not be permissible under federal and state legislation expressing protection of privacy.

Labor laws in the U.S. and Canada permit the use of surveillance cameras in the workplace for the security of their employees and facilities, such as in parking lots, and to detect theft and related wrongdoing. From a legal perspective, the major factor in determining whether video surveillance is justified is whether the employee had a reasonable expectation of privacy when he or she was videotaped.

In a recent court case between a major U.S. hotel chain and its workers, the hotel secretly videotaped employees in an employee locker room. The hotel lost the case. According to hotel officials, the camera was installed in response to rumors of employees smoking marijuana while on break. The video did not uncover any wrongdoing but did show at least one worker undressing. In the settlement, the employees received $200,000 each.

The use of surveillance cameras to substantiate rumors of wrongdoing may be questionable when other steps could have been taken to corroborate the rumors, such as having supervisors conduct more frequent rounds. Placing a camera in a locker room, where there is an expectation of privacy, is unreasonable.

There are certain considerations employers and supervisors should keep in mind when using advanced devices to monitor employees in the workplace, including the following:

1) Respect an employee's reasonable expectation of privacy. Even if employees do not have a legal right to privacy, it is reasonable to expect privacy in restrooms, locker rooms and other areas that relate to an employee's health and comfort.

2) Always review the business side of video surveillance. Have thefts or abuses been documented? Have customers complained about the behavior of employees? Compare the success of video surveillance with that of other investigative techniques.

3) Consider all the alternatives. Could supervisors or human resources personnel talk to an employee about the problem? Would additional lighting or security patrols negate the perceived problem?

4) Do not act on videotape evidence exclusively. Video may capture the act, but there might be a reasonable explanation for the behavior. Always interview the employee before taking disciplinary action or contacting legal authorities.

5) Implement a surveillance policy. When carefully developed, strict surveillance policies will protect employees, the company and security personnel.

Professional responsibility in any field requires a special perspective. Successful employers view themselves as business professionals with expertise in developing solutions to correct a business problem.

Employers should know where to draw the line. Monitoring of employees that is reasonable, maintained in confidence and limited in scope can act to negate any claims of unlawful invasion of privacy. Unsuccessful employers, however, are those that feel the only solution is to catch employees in the act, regardless of the implications on employee relations or corporate liability.

Employees, on the other hand, should be aware that employers have been given ample ammunition with which to monitor his or her workplace—and that monitoring is not an indictment of an employee. Whether an employer chooses an invasive system or not to monitor at all is solely at his discretion.

The best way to increase the likelihood that your personal life remains private is to keep it out of the workplace.

Privacy and the Digital Workplace: E-mail and the Internet

Companies that previously monitored Net surfing exclusively now have started monitoring employees' e-mail and blocking messages containing pornography, unsolicited commercial pitches and other material not related to work. The main reason businesses cite for monitoring e-mail is productivity. According to a 1998 report from California-based human resources researcher Saratoga Institute, a company's average cost of employee play on the Internet (e.g. reading and responding to personal e-mail) is $35,000 a year in lost productivity.

The digital world has opened doorways to everyone—the employer's liability notwithstanding. Several workplace lawsuits related to employees' e-mail and Web use have exposed employers to new liabilities. Still, policies set to protect the business and its employees are good enough reasons for monitoring computer usage. Another, less obvious reason, is that unnecessary messages consume disk space and memory banks on company servers. This, in turn, affects productivity.

Not only does e-mail play a vital role in company communication, but it has also become the gossip medium of choice. Conversations once whispered around the watercooler now are sent from computer to computer—often with a wholly unrealistic sense of privacy. A number of workers have paid a heavy price for such naivete when sending careless, inappropriate or even defamatory or offensive missives that they wouldn't want their bosses to read. For example, a Pillsbury manager logged onto his home computer, and in the course of exchanging messages with colleagues, said he'd like to "kill the bastards" in the sales department. He also referred irreverently to the company's upcoming holiday party. Several months later, he was fired for making tasteless, unbusiness-like remarks, and these computer-generated messages were cited as evidence.

Ninety percent of all firms with more than 1,000 workers use e-mail. Altogether, some 40 million workers send more than 60 billion messages annually. Unlike telephone conversations, which go out over public wires, e-mail is usually sent over the employer's equipment. Thus, courts have ruled that the employer owns the system and with it, the right to monitor, save and review such messages. Even after a message is deleted, it continues to reside in the computer's disk drive and in many cases is routinely backed up and saved by the company.

While the courts have ruled that employers can't listen in on office phone calls unless they have a business reason, no such restriction exists for e-mail or voice mail. And, it's difficult to discern between the private and business call without listening to part of the conversation.

For a company, the question of how private your e-mail is, is an important one. It's currently a highly charged issue, and generally favorable to the company. In one recent case, several employees sent e-mail back and forth at work, complaining about unfair treatment by a supervisor. The supervisor gained access to the e-mail, and the employees involved were fired. The employees sued the company, and the company won. The court ruled that, given the simple fact that the company had no formal policy on monitoring, the employees were unduly terminated. Yet the court stated, as in so many other cases,

that employees cannot *expect* to have such rights protected across the board. Therefore, the employees had no recourse against the company in this case. But, depending on the facts of the case, it might go either way. To protect itself in such a situation, an employer must have a written policy on Internet use.

For the sake of both employers and employees, it's important that firms and organizations spell out privacy policies from general ones to specific ones concerning e-mail and voice mail. On one hand, clarifying policies sets a fair and informed stage. On the other hand, it's a practical method for preventing costly litigation.

E-mail records now are routinely requested in lawsuits involving discrimination, harassment and other workplace issues. E-mail archives often provide the smoking gun. For example, Chevron was forced to pay out $2.2 million in a sexual harassment case in which an employee sent around an e-mail listing "25 reasons beer is better than women."

Wherever you work, the lesson is clear: You shouldn't have any expectation of privacy when you use the office computer. A dramatic case in point was Jean Lewis, a witness in the federal investigation of President Clinton and the Whitewater land deal. Lewis was visibly shaken when Senate investigators produced an incriminating letter she had written on her computer, then deleted. A technician, hired by the congressional team, had been able to reconstruct the contents of the subpoenaed disk.

As more and more employees are granted access to the Internet, other potential problems arise. Some workers may visit sexually explicit Web sites, gambling sites or sites that transmit hate mail, leaving companies open to harassment charges from other workers who may not appreciate what appears on a colleague's screen or what is forwarded to them via e-mail.

Such fears have led to counter measures. Software programs such as NetNanny and WebSense allow companies to monitor and regulate their employees' Internet activities. With these monitoring services, bosses can read e-mail and selectively block certain Internet sites

(though the proliferation of new sites threatens to outstrip this capability). Furthermore, such programs can generate reports that detail everything a worker has done on the Internet. And, while these programs may be helpful to employers, companies should also be aware that younger employees who have grown up with computers and the Internet, are often savvy enough to get around Internet monitoring, according to media guru Don Tapscott, author of *Growing Up Digital: The Rise of the Net Generation*.

Work-related privacy in regard to the Internet, specifically e-mail, is not just a concern for employees. Clients and customers should understand that incoming e-mail messages are often read by more parties than the individual. Certain organizations will disclose this in any e-mail correspondence, although many companies believe that it is fairly implied by the state of doing business. Nonetheless, to protect themselves from legal action, many companies are including footers on their e-mail correspondence, such as this example:

> [The company] has a legal and ethical obligation to make sure that the messages our employees receive are neither illegal nor inappropriate. For this reason, we reserve the right to retain, review, and copy, if necessary, any e-mail messages sent through our company systems.

Currently, the Internet is regulated on a state-by-state basis, and a number of states have already passed Internet regulation laws. For example, in New York, a law took effect in November 1997 which makes it a felony to use any computer communication system to distribute material containing nudity or sexual content and which is harmful to minors. There have been attempts at regulating Web content nationally. The most aggressive effort as of yet—the Communications Decency Act—was recently struck down by the Supreme Court.

Personal Web sites make for easy targets, too. Even if created at home, the Web is a public venue, and companies can use any information found there to decide whether a person is an appropriate employee. This has been put to the test in a slightly different arena in recent months.

In one high-profile case, the Navy discharged a sailor after 17 years of service when it learned through America Online (AOL) that he was gay. Apparently, he used the word "gay" to describe his marital status in an online profile. The army has postponed the discharge, however, while it answers a suit filed by the sailor alleging that the government violated federal privacy laws by not obtaining a warrant or a court order when it sought his identity from AOL.

Another interesting dispute, which was widely publicized in 1999, involved a husband and wife who claimed they were fired from their jobs because they ran a pornographic Web site. George and Tracy Miller—both critical care nurses in the Phoenix area—developed a Web site during the late 1990s that included hard-core pornographic pictures of themselves engaged in sexual acts...with each other and other people.

The Web site was a commercial success, linking to several larger pornographic sites and attracting thousands of visitors. It became so well-known that the management at Scottsdale Healthcare, where both Millers worked, got wind of the pictures. After reviewing the situation (and, key to the hospital's position, *after* it received several complaints from the Millers' coworkers), the company suspended both.

The Millers responded by posting some pictures of Tracy wearing...or partly wearing...a nurse's uniform. The hospital responded to this response by firing the Millers.

Once they'd been terminated, the Millers filed a complaint with the EEOC and issued press releases publicizing their predicament. They emphasized that they didn't use their real names on the Web site and they made no mention of their jobs or their employer. Their attorney argued that the Millers were being illegally punished for private behavior and protected expression. Specifically, he said:

> I have to type in an address. I have to go to their home, their cyberhome. I have to knock on their door [to see the pictures]. And I have to pay money to get [the pictures]. This is private.

The hospital's position was that the suspensions and terminations had more to do with the complaints from coworkers than the Millers' right to publish pornography on the Internet. Although the EEOC complaint had been filed in proper order, the Millers seemed content to use their terminations to publicize their Web site.

Some experts say that Web sites should be considered private, like the books and magazines that you read in your own home. Others argue that the Internet is a public forum and therefore not subject to the same legal protections. Ultimately, an employer's ability to restrict Internet access to employees may come down to the facts of the specific case and whether the employee crossed the increasingly thin line between personal and professional.

As an employee, whatever you do on company time with company tools and equipment belongs to the company. That gives the company certain rights, which vary from state to state, to monitor and check how the time and tools are used.

More to the point, remember that you leave a trail—a record of every Web site you visit when you use the Internet. If you're using a company computer, the company can easily—and legally—check that trail to see where you've visited on the Web and when. Employees are regularly being legally fired for viewing pornographic Web sites on company computers, even when the viewing occurred after normal business hours.

While surfing after regular business hours may seem reasonable to some employees, remember it's on property that belongs to someone else. Therefore, your employer has all the rights. However, there are actions that can be taken to protect privacy. If checking your personal e-mail or making a stock purchase is important to you, consider using your own personal laptop and cell phone for communications during your break and/or lunchtime. As long as you're not using company property or time, you can reasonably assume that your privacy is protected. If you want to be sure, clear it with your employer first.

Admittedly, as of the publication of this book, there hasn't been a rash of lawsuits related to Internet use. That goes to say that litigation

is notoriously slow, while technology and the liberties that it provides are not.

Changes in Internet regulation may come sooner than we think, as the issue of privacy and its invasion flood future court dockets and challenge the legal system. As companies hire more computer-savvy individuals, there is likely to be an increase in Internet-related suits involving issues such as harassment, slander and invasion of privacy.

Corporate Information Vendors

Orwell's vision of Big Brother—as opposed to the TV show of the same name—was wrong in that it foresaw only Big Government burrowing into our lives. Increasingly, the threat is coming from the private side. "Big Brother has simply contracted out to corporate America," one congressman said as he introduced legislation aimed at helping consumers control their personal information.

It used to be that people desiring privacy could get it as easily as unlisting their phone number—without having to pay a fee to do so—and obtaining a post office box. Of course, it was still possible to track them down by following a difficult paper trail. Now information vendors, including employers if they buy the service, can follow the same trail simply by pressing a few computer keys.

Corporate information vendors are compiling sophisticated, highly personal profiles listing your hobbies, court cases, buying habits, financial information, health data, computer usage—pretty much everything. Dozens of these vendors are releasing details about us without any restriction and, generally, without our knowledge.

A few years ago, for example, *MacWorld* magazine experimented with finding information about 18 well-known individuals from the world of entertainment, business, politics and sports, including football player Joe Montana, filmmaker George Lucas and U.S. Attorney General Janet Reno. The magazine used only legal methods involving online sources. Spending an average of $112 per subject, it was able to compile electronic dossiers that, for most subjects, included:

- Home address
- Home phone numbers
- Social Security number
- Tax liens/court filings
- Driving records and vehicles owned
- Commercial loans/debts
- Real estate owned
- Voter registration information

MacWorld's reporters made no tedious trips to distant courthouses and spent no time thumbing through dusty files. Instead, they just sat at a computer for slightly more than an hour for each subject.

As online services become increasingly interconnected and private information services proliferate, such searches will only become easier and cheaper. One writer called the surge in the sale of personal data "the electronic equivalent of the gold rush—few legal restrictions apply, and there's lots of money to be made if you own the mine."

One of the big mine owners is government. Increasingly, public agencies—especially cash-strapped local governments—are selling your information for commercial reuse. As a result, anyone with a computer and a willingness to spend a few bucks an hour can now search any of hundreds of databases for your personal information.

In 1996, a Portland, Oregon man paid the state $222 for the entire database of the state's department of motor vehicles. Then he put it up on the Internet so that anyone could instantly look up a vehicle owner's name, address, birth date, driver's license and title information. Data on any individual driver had always been available to anyone who visited the Oregon DMV and paid $4. But putting the same information on the Internet raised a furor.

Needless to say, Oregon (and countless other states) have been forced to rethink their privacy guidelines in light of this and other privacy issues.

Thus, the case of access becomes part of the problem, even with public records. It's one thing for, say, your divorce record—with its heated allegations and itemization of assets—to be on file at the courthouse. It's something else to have the same data available for anyone to pick through at his or her leisure, while sipping a latté in front of an iMac at the neighborhood cybercafé—in Baltimore, Budapest or anywhere else in the world. But that's the direction the information economy is heading.

Legal Actions Against Privacy Violations

High-profile romances, including those in the Oval Office, have focused national attention on issues of sex and privacy in the workplace. President Clinton first responded to allegations of an affair with Monica Lewinsky with indignant denials. Even after he admitted to a relationship that was "not appropriate" and "wrong," Clinton insisted that the whole affair was a private matter between him and his family. "It's nobody's business but ours," he said.

When does a federal employee's private romance become his or her employer's business? Or for that matter, when does *any* employee's private romance become his or her employer's business? An individual's privacy is protected by various laws and regulations, but as agencies, like private companies, find themselves paying huge settlements for sexual harassment and sex discrimination claims (some as a direct result of office romances gone sour), they believe they have a right to establish rules and regulations about office relationships. But experience is showing that such rules are all but impossible to enforce.

The January 2000 federal court decision *Earnest Johnson et al. v. K Mart Corporation* dealt with the combination of sex lives, workplace issues and privacy.

The case involved K Mart's use of private investigators at its distribution center in Manteno, Illinois.

During the summer of 1992, the center, which receives, stores and supplies merchandise, began receiving merchandise valued at several million dollars. Since its opening, the center had experienced theft,

vandalism and sabotage and also had concerns about the sale and use of drugs on the premises.

In August 1992, an on-site security audit of the center was conducted by Confidential Investigative Consultants, Inc. (CIC), a licensed investigative security company located in Chicago, Illinois.

Ed Gunther, vice president of CIC, and George McElroy, general manager of the center, met twice in August 1992, and agreed that an undercover investigator posing as an employee would be placed in the center. Periodic reports detailing the investigator's observations were to be sent to a post office box registered in CIC's name and located in Frankfort, Illinois, to maintain confidentiality. McElroy requested that CIC's investigation be discussed with him only.

CIC undercover investigator Al Posego was sent to pose as a janitor at the center. In his deposition, Posego stated that he was specifically told that the focus of K Mart's concern was theft, sabotage, safety and drug use.

In November 1992, Janet Posego, Posego's wife, also began working as an undercover investigator for K Mart. Mrs. Posego posed as an employee in the repack department. In her deposition, she stated that her role as an undercover investigator at the center was to gather information on theft and drug use.

The Posegos submitted handwritten reports—from memory based on the events they observed and conversations they participated in or overheard—to CIC by mail every few days. These reports were then forwarded to K Mart. The reports contained information including, but not limited to:

1) employee family matters (i.e., the criminal conduct of an employees' children, incidents of domestic violence and impending divorces);

2) romantic interests/sex lives (i.e., sexual conduct of employees in terms of number/gender of sexual partners);

3) future employment plans (i.e., which employees were look-
ing for new jobs and which employees were planning to quit
without giving notice);

4) complaints about K Mart (i.e., an employee's view that K
Mart was "screwing people up"); and

5) personal matters and private concerns (i.e., the paternity of
an employee's child, the characterization of certain employ-
ees as alcoholics because they drank "frequently").

This case and others like it set a disturbing precedent because they
place the burden of proof on the individual whose privacy has been
violated, not the organization that is intruding into private lives. And
it is easy to see how issues of privacy—or lack of it—can run head
long into harassment and sexuality issues.

Another Illinois court had already recognized the intrusion upon se-
clusion tort in the 1986 decision *Melvin v. Burling*. In that case, the
court set out four elements that must be proven to state a cause of
action for intrusion upon seclusion:

1) an unauthorized intrusion or prying into someone's seclusion;

2) an intrusion that is offensive or objectionable to a reasonable
person;

3) the matter upon which the intrusion occurs is private; and

4) the intrusion causes anguish and suffering.

Since the *Melvin* decision, other courts had applied these four ele-
ments without directly addressing the issue of whether a cause of ac-
tion for intrusion upon seclusion existed.

Back to the K Mart case. In early 1993, McElroy informed Chad Yager,
the center's loss control manager, of the presence of the undercover
investigators at the center. Yager began overseeing the investigation.
The first copies of the investigative reports received by Yager con-
tained information regarding union activity at the center.

Yager told CIC that he did not want information regarding union activity in the reports. Such references were edited. At this point, John Gemmaka, the director of human resources, was made aware of the investigation.

In February 1993, K Mart terminated Gemmaka based on allegations unrelated to this case. After Gemmaka's termination, Gemmaka exposed the undercover investigative operation to employee Lewis Hubble. Hubble subsequently researched Posego's background and confronted Posego about his status as an undercover investigator. Posego admitted that he and his wife were private investigators posing as employees for the purposes of observing theft and drug use at the center.

Posego informed Ed Gunther that his role as an undercover agent had been exposed. Gunther then notified K Mart and by April 1993, CIC's operation had been terminated.

In 1993, Local 705 of the International Brotherhood of Teamsters began organizing a campaign about the Manteno distribution center. A few weeks prior to the election, teamster officials contacted employees regarding the undercover investigation. Teamster officials met with employees and disclosed copies of the reports to them. According to union officials, the reports were received from an anonymous source.

Following this meeting, 55 current and former employees brought action against K Mart, alleging that the employer's act of placing private detectives, posing as employees:

1) invaded their privacy through an unauthorized intrusion upon their seclusion;

2) invaded their privacy by publicizing private facts concerning them;

3) intentionally inflicted emotional distress upon them; and

4) violated the Private Detective, Private Alarm, Private Security and Locksmith Act of 1993.

The claims against CIC were dismissed and summary judgment was granted in favor of K Mart.

The employees appealed.

The appeals court started by noting that the Illinois Supreme Court had never decided whether a claim of intrusion upon seclusion even existed.

Still, the appeals court went ahead into uncharted territory; it ruled that the circuit court had erred in granting summary judgment in favor of K Mart. A genuine issue of fact existed regarding whether there was an unauthorized intrusion. The appeals court explained:

> It is true, as K Mart argued, that the employees willingly provided these personal details to the investigators. However, we believe that the means used by K Mart to induce the employees to reveal this information were deceptive. Specifically, we believe that the act of placing private detectives, posing as employees, in the workplace to solicit highly personal information about the employees was deceptive. A disclosure obtained through deception cannot be said to be a truly voluntary disclosure.

The employees had a reasonable expectation that their conversations with "coworkers" would remain private, at least to the extent that intimate life details would not be published to their employer. K Mart violated this reasonable expectation. According to the appeals court:

> ...K Mart placed undercover investigators posing as employees in the plant to obtain information regarding theft, vandalism and drug use at the plant. ...[A]long with this information, the investigators compiled information regarding employees' family problems, health problems, sex lives, future work plans and attitudes about K Mart and reported this extremely personal information. In addition, the investigators gathered this information not only on work premises, but also outside the workplace at social gatherings.

K Mart admitted that it had no business purpose for gathering information about employees' personal lives. But it never told the investigators to change their practices or to stop including the highly personal information in their reports. So, a reasonable person might have found K Mart's actions to be an offensive or objectionable intrusion.

The employees also alleged that K Mart invaded their privacy through the publication of private facts concerning them.

A successful cause of action for the public disclosure of private facts requires an employee to prove that:

1) publicity was given to the disclosure of private facts;

2) the facts were private and not public facts; and

3) the matter made public would be highly offensive to a reasonable person.

The facts at issue were clearly private. So, the appeals court also considered the publicity requirement:

> [Illinois courts have] held that egregious conduct resulting in disclosure to a limited audience is actionable if "a special relationship exists between the plaintiff and the 'public' to whom the information has been disclosed." If the plaintiff is not a public figure, such a public may be fellow employees, club members, church members, family or neighbors.
>
> We, too, hold that the public disclosure requirement may be satisfied by proof that the plaintiff has a special relationship with the "public" to whom the information is disclosed. However, we also believe that [this] rationale...should be extended to include an employer as a member of a particular public with whom a plaintiff may share a special relationship.
>
> The evidence shows that personal details about the employees' private lives were disclosed to their employer by the investigators. We find that these facts raise a genuine

issue as to whether publicity was given to private facts. Therefore, we find that summary judgment should not have been granted.

In this case, the matter made public was private and publicity given to private facts would be seen as highly offensive to a reasonable person. Therefore, the court held that there were genuine fact issues as to:

1) whether K Mart's conduct was extreme and outrageous; and

2) whether K Mart knew that severe emotional distress was certain or substantially certain to result from its conduct.

To make a successful case for the intentional infliction of emotional distress, there must be a material issue of fact concerning all three elements of this tort as set forth above. However, the K Mart employees failed to establish that they suffered severe emotional distress as required by element two. They merely noted feelings of stress or distrust. So, the appeals court concluded that the trial court had been right in rejecting this claim.

The employees also claimed that K Mart had violated the Private Detective, Private Alarm, Private Security and Locksmith Act of 1993.

Section 120 of that Act states:

> The Department may refuse to issue, renew or restore, or may suspend or revoke any license...or may place on probation, reprimand, or fine...or take any other disciplinary action the Department may deem appropriate [against] any person, corporation, or partnership licensed or registered under this Act for any of the following reasons: ...Engaging in dishonorable, unethical or unprofessional conduct of a character likely to deceive, defraud or harm the public. ...Performing any services in a grossly negligent manner or permitting any of licensee's registered employees to perform services in a grossly negligent manner, regardless of whether actual damage to the public is established.

Section 15 of the Act enumerates those to whom the Act applies:

> It is unlawful for any person to act as a private detective, private security contractor, private alarm contractor or locksmith...unless licensed by the Department.

K Mart didn't count in any of these categories. The court concluded that the employees should have directed the charges at the private investigators. It allowed the charges against K Mart to stay dropped.

Conclusion

As we have seen throughout this chapter, the *right to privacy* is not as clear-cut as most people think. It comes from the constitutional shadows that are more useful to law school professors than people in the workplace. And, when it is useful, it has more to do with procedural technicalities than sweeping constitutional arguments.

When it comes to things you do...or say...in the workplace, the best advice is to assume nothing about privacy. People involved in open or secret sexual relationships with coworkers are bound to leave traces of their affairs—suggestive e-mails, incriminating voice mails and even physical evidence—on company property. These traces, in most cases, can be used by the company as justification for formal action.

Old prohibitions against any sexual expression at work admitted this more worldly notion of privacy. Confused by changing cultural norms and more relaxed workplace rules about flirtation or sexual activity, people involved in troublesome workplace affairs reach back reflexively to sweeping claims about privacy.

One of the hard parts of the modern workplace is that the right still isn't there.

Part Two:

Work

Workplace Etiquette

When someone talks about "sexual etiquette," you might begin to think in terms of *Dangerous Liaisons* and aristocratic intercourse among beautiful people. That's not what the term means in most workplaces.

Sexual etiquette speaks to the myriad issues that make up the normal, healthy sexual banter that exists among reasonable people. This can include off-color jokes, discussions of movies or books—even political debates. The challenge is to find a standard set of rules that govern this kind of exchange.

Etiquette is an underappreciated thing in modern society. It is a set of rules defining acceptable behavior that gives people a framework within which to operate. In an effort to accommodate diverse sexual lifestyles, societies often jettison codes of sexual etiquette that they deem restrictive. That's too bad, because etiquette is more about the framework than the restriction. Most people *want* to know what they can and can't say or do in a given social context—including work. If an employer can provide these ground rules, most reasonable employees will follow them in some fashion. Even if this means testing the limits from time to time.

The rulemaker has to realize that there will be some testing. So, the rules have to be robust enough that they can survive the exceptions, exclusions and gray areas that sex inevitably conjures.

The most effective codes of etiquette—sexual or otherwise—give people an understanding of how they are expected to behave. And

they offer some idea of what consequences will follow specific, noncompliant behavior.

In all the legal debates over the status of sexual etiquette, an important subtlety gets lost. Etiquette isn't about law; it's about manners. Violating the rule of etiquette has never been about criminality or liability; it's been about bad behavior. The penalty is usually social, not legal.

If you behave like an ass in sexual matters, you will be dismissed by reasonable people as an ass. In the workplace, this might mean that you don't get a promotion that you want. You may get fired. But the reason you suffer this way is not that you've broken the law—rather that you've shown bad judgment. Being a professional requires some level of good judgment. And a company can reasonably choose to get rid of someone who lacks good judgment.

Bad Manners Can Make Serious Trouble

The April 2000 Texas appeals court case *Wal-Mart Stores, Inc. v. Lorelle Itz* involved a bad situation and the repeated citation of the big retailer's sexual harassment policy. The case serves as a hard example of what can happen when people press the limits of acceptable behavior.

A.C. Bordwell was manager of the jewelry department at a Wal-Mart store in south Austin. Lorelle Itz worked under Bordwell's supervision and direction in the jewelry department. She told the following story.

In December 1995, Itz was hired to work in the jewelry department. Between December 17 and 21, Bordwell telephoned Itz at home each evening and asked if she and her boyfriend were going out. Itz told Bordwell not to call her at home and hung up. Finally, on December 21, Itz's boyfriend told Bordwell not to call again unless the call was business-related. Bordwell stopped calling.

Around the same time, Bordwell called Itz into a back room of the store and asked a series of questions with regard to the company's dress code. Bordwell told Itz that she had nice legs but needed to wear longer skirts to comply with Wal-Mart's dress code.

According to Itz, the conversation was kind of creepy; but it might have been defensible as work-related. That is, up until Bordwell "grabbed [her] skirt" and caressed her leg from her "knee all the way down to [her] ankle," commenting that she had "nice legs" and "a nice body." Itz said she was shocked and scooted her chair back.

Bordwell left the room a moment later when someone else entered.

According to Itz, she didn't report the incident because Bordwell was her boss and she "didn't know what to do." Bordwell had not previously commented on her body or legs. His behavior seemed wrong; but, new to the workplace, she wasn't sure how bad it really was. The grabbing episode did make her see some things in a new light, though. She became aware that "he was always hovering around" her and following her on the floor.

A few days later, Bordwell started talking about her personal life again. He told her she should break up with her boyfriend and—if she needed somewhere to live—Bordwell would "set her up." She declined.

This was enough, even for an inexperienced employee. Itz told co-worker Mary Edwards about Bordwell's conduct and that it made her feel uncomfortable. She also told Edwards that she felt her job might be in jeopardy if she didn't accept Bordwell's sleazy offers. On Edwards's advice, Itz spoke with assistant store manager Dolores Rodrigues who told her to write a statement explaining what had happened.

In early January, Itz took a leave of absence to recover from a miscarriage. When she returned, Bordwell approached her, in front of a customer, saying he "needed a hug." He then gave Itz a "very forceful hug" that lasted several seconds. Again, Itz did not report the incident to anyone—though the customer would later corroborate that it had taken place…and that it seemed inappropriate.

Later that week, Bordwell bought a watch from the store and gave it to Itz. He also ordered her to the back room again, where he asked questions about her family background and her relationship with her boyfriend. He said that "maybe it was better that [Itz] lost [her] baby because it wasn't meant for [the boyfriend and Itz] to be together." He

told her she looked good that day, that the dress she was wearing fit nicely on her and that her black stockings looked "very classy." He "then took the hem of [her] dress and brushed the back of his hand down it to tell [her] that was the appropriate length of the dress that [she] should be wearing." He brushed down from her knee to about half way down her leg.

Itz went home and told her boyfriend what was going on at work. She and the boyfriend met with Ed Taber—the south Austin store manager—on January 25, 1996 to discuss her complaints against Bordwell. During this meeting, Itz asked Taber for a transfer. He said he would see what he could do and remarked "that Mr. Bordwell was not the kind of guy that would do something like that."

Itz also gave a watch to Taber, saying it was a gift from Bordwell. Taber said he would put the watch in his safe and talk to Bordwell.

Taber then did something that was not only bizarre but also went beyond anything a manager dealing with possible sexual harassment should do. He asked one of Itz's coworkers if, "in the situation with" Bordwell, Itz might be confusing facts with memories of a grandfather who had allegedly abused her as a child. How Taber knew about this alleged abuse wasn't clear; why he thought it was an appropriate thing to mention to a coworker defies all logic.

Nothing more happened. Wal-Mart did nothing to respond formally to Itz's complaints.

In early February, Itz hired an attorney who sent a fax to Wal-Mart's regional manager requesting, on Itz's behalf, a transfer. The letter made the argument that Bordwell's conduct had amounted to a "display of a romantic nature," which was plainly forbidden by Wal-Mart's employee manual. Also, the conduct had made her uncomfortable in the workplace, which was also expressly forbidden by the manual. The attorney never received a response from Wal-Mart.

Several weeks later, Itz left Austin and moved to Corpus Christi. She stayed in contact with her former coworker Mary Edwards after the move. According to Edwards, Itz was not the same "sweet and bub-

bly" person she was when they first met. She wasn't happy and was still "going through a stage where she [didn't] know who to trust, to talk to."

A.C. Bordwell—the alleged harasser—told a completely different version of what had happened.

According to Bordwell, he never said Itz was pretty, never said anything about her legs and was alone with her in a back room only once—to talk to her about missing work. He insisted that he never called Itz at home and never talked to her boyfriend, except on one occasion when the boyfriend called Itz at work. He also said that the hugging incident was intended only to comfort her following her miscarriage.

Bordwell admitted giving Itz the watch and a $20 bonus at Christmas but insisted that he had not sexually harassed Itz and that he had never been questioned or interviewed by anyone regarding her complaints.

He agreed, however, that the conduct Itz attributed to him amounted to "sexual harassment" within the meaning of that term as used in the Wal-Mart employee manual. He also agreed that Wal-Mart had an obligation to investigate her complaints and had failed to do so.

Finally, Ed Taber—the store manager—told his version of what had happened.

According to Taber, he interviewed Itz on January 25 (with her boyfriend present) and interviewed Bordwell later that day. Bordwell told Taber that he had taken Itz into a back room twice—once to talk about her boyfriend and once about the dress code. Taber also spoke with Mary Edwards, who agreed with Itz's version of events.

On January 26, Taber talked with another Wal-Mart manager about Itz's complaints. The two managers decided that they did not have enough facts to take any action but concluded, nevertheless, that there was no wrongdoing on Bordwell's part. Taber never told Itz the results of his investigation. Later, however, Taber admitted that

Bordwell's conduct, if it actually happened as Itz claimed, would have constituted sexual harassment within the meaning of that term in the Wal-Mart employee manual.

Itz sued Wal-Mart and its managers for sexual harassment, mental anguish and several other charges. Her claim of quid-pro-quo sexual harassment was submitted to the jury as follows:

> Sexual harassment occurred if: (1) Lorelle Itz was subjected to unwelcome sexual advance(s) or demand(s); and (2) Lorelle Itz's submission to the unwelcome advance(s) or demand(s) was an express or implied condition for receiving job benefits or Lorelle Itz's refusal to submit to the sexual advance(s) or demand(s) resulted in an actual job detriment; (3) the conduct was committed by an employee who had authority over hiring, advancement, dismissals, discipline, or other employment decisions affecting Itz; and (4) a supervisory employee of Wal-Mart knew or should have known of the harassment and failed to take prompt remedial action reasonably calculated to end the harassment.

The trial court rendered judgment on the verdict against Bordwell and Wal-Mart jointly and severally for $1,500 for future psychological care, $50,000 for past mental anguish, $10,000 for future mental anguish and $2,765.75 for back pay; rendered judgment against Wal-Mart for $13,064.43 in pre-judgment interest, $122,058.75 in attorneys' fees, $5,000 for expert witness expense and $150,000 in punitive damages. It also awarded Itz court costs and post-judgment interest.

Wal-Mart appealed, arguing that the evidence was legally and factually insufficient to support the jury's findings. The company argued that Itz failed to plead a cause of action for quid-pro-quo sexual harassment because she did not allege all the requisite elements. The appeals court ruled:

> We disagree. It was only necessary that Itz state a "cause of action" in "plain and concise language." ...Bordwell and Taber both admitted that the conduct, if it occurred as de-

scribed by Itz, would constitute "sexual harassment" under Wal-Mart's written policy. We conclude the foregoing evidence would permit the jury reasonably to infer that Bordwell made "sexual advances" toward Itz. We hold these allegations, among many others in Itz's petition, sufficiently alleged a cause of action for quid-pro-quo sexual harassment....

Next, Wal-Mart argued that the evidence did not show Bordwell had made explicit sexual demands or that Itz had been threatened with a "tangible job detriment," such as a negative employment evaluation or denial of equal opportunity in the workplace, if she refused to accede to his demands.

The court didn't buy this argument, either:

Discriminatory intimidation, ridicule and insult, when sufficiently severe and pervasive, may be adequate to show a workplace environment adversely affecting a term, condition or privilege of employment; it is not necessary to demonstrate an adverse economic effect. The evidence is undisputed that Itz personally perceived her work environment to be hostile because of Bordwell's conduct. We hold that a reasonable jury could find that Itz was subjected to a hostile and abusive work environment.

Next, Wal-Mart made several arguments related to the jury's finding that a supervisory employee of Wal-Mart—namely, store manager Ed Taber—knew or should have known of the harassment and failed to take prompt remedial action to end it. The company pointed to evidence that Taber undertook an investigation of Itz's complaint and was willing to transfer her from Bordwell's supervision.

The appeals court found this argument as weak as the others:

...the jury could reasonably infer from the evidence that Taber's investigation was pretextual, or at least insufficient, given the gravity of Itz's allegations. The undisputed evidence reveals that Itz's complaint was objectively corrobo-

> rated by Taber's possession of the watch…and by the extraordinary fact that a disinterested customer personally observed one episode of which Itz had complained…. The jury could reasonably infer that Taber, not Itz, "jump[ed] to conclusions too fast."

Finally, Wal-Mart argued that its written policies and grievance and training procedures insulated it from liability for exemplary damages as a matter of law. And, if nothing else, Wal-Mart argued that the sums awarded to Itz were excessive.

However, the appeals court concluded that the evidence of wrongdoing by Wal-Mart managers was too strong to be ignored. As far as the awards being excessive, the court ruled:

> Reviewing all the relevant evidence and considering it in the aggregate, we believe the jury could reasonably find as it did. We refer, for example, to the psychologist's unrebutted testimony that Itz suffered from depression, anxiety and phobias at a rate exceeding that found in the normal population…and that her anxiety, depression and phobias "were caused or exacerbated by the sexual harassment episodes in the workplace." We will affirm the judgment.

The Underlying Issues

While the testimonies of the Wal-Mart case seem like the endless storyline of a daytime soap opera, this is actually the type of situation that makes up a large number of harassment claims.

When the costs are so high, why do sexual abuses occur in the workplace? There are a variety of explanations, from longer working hours to increased diversity in the workplace, liberal dress codes and relaxed attitudes. But none of these explanations is really useful…let alone a legitimate justification.

The themes run more deeply—into basic issues of what *work* means and what a *workplace* is.

In a September 1999 issue of *The Spectator,* Mark Steyn criticizes Americans for their child-like behavior. He observes:

> America seems determined to be the first society to abolish adulthood completely. Half a century ago, if you'd walked down a small-town Main Street at midday, the sidewalks would have been full of solid citizens in Hombergs and seersucker suits. Now, from the world's richest man (Bill Gates) down, most grown-ups dress like their kids—in baseball caps, logoed T-shirts, baggy diaper-style pants and big, bouncy, oversized sneakers. They walk along sipping from soda bottles with giant nipples. They eat kiddie food: Dunkin' Donuts and McNuggets.

Steyn goes on to poke fun at America's immaturity—both at a political and social level—and suggests that its superpower status can survive only so long. His points are clear and the conclusions, controversial. But nevertheless his observation that Americans indulge themselves is poignant.

Our avoidance of adulthood comes with another cultural trend: an insidious sense of entitlement. Advertising, entertainment and even scandalous news stories repeat the theme that any self-serving behavior is acceptable, even if it is self-destructive. Buy overpriced cosmetics because you're worth it. Trusted financial advisors steal money from their clients because they have expensive drug habits. The President of the United States indulges in an inherently exploitive sexual relationship with an office intern because his rough childhood has left him starved for female affection.

So, the rationalization begins to take shape. Sexual harassers are just big kids with some impulse control problems. They're sorry for what they've done. And, most of all, they're not to blame for what happened.

This approach may work well on television talk shows but it's disastrous in the workplace. American society doesn't encourage or validate the simple niceties that make up what most people mean by

etiquette—and there's a real cost to this drift. The workplace environment has been cut loose from traditional, cultural moorings. Important standards of behavior erode and are replaced by self-rationalizing predators—and their victims are both fellow employees and employers who end up paying the legal bills.

For employers, this also means that a simple slap on the wrist or a sharp word isn't enough. Not even a kind reminder will do. The crux of the matter is that there is no legally sanctioned "soul searching" privilege. Everything that is said in the classroom or boardroom can be used against an employer in a lawsuit.

How, then, does an employer engage in a real dialogue with employees and supervisors and by the same token, exercise "reasonable care" in preventing harassment when the best it can do is take refuge in politically correct affirmations of goodwill to all?

On the human, nonlegal level, what can an employer do to forestall victimizers from finding their victims? Since sexual harassment is about exclusionary treatment and the abuse of personal power, how effective can corporate policies and training be to deal with it?

We've all felt the pain of rejection, the downright boorishness of others. Everyone remembers the schoolyard bully—it's only the landscape that has changed, from the swing-set to the corporate boardroom. Is it right that we should be compensated for our sorrows beyond the remedies for practical harms offered by law? Concerns about emotional pain and suffering figure into many lawsuits—sexual harassment lawsuits, as well as others. Is it healthy for us to demand that we be made to feel better, bigger and stronger—as well as receive justice—for every wrong inflicted on us by others?

We live in an increasingly litigious society. At the root of our desire to bring those who hurt us to justice may be the view that we hold of ourselves as "victims in training," waiting for the next tyrant to inflict perceived damage. In a kind of guilt by association, this thinking trivializes all negative behavior. It makes it more difficult for the victims of real sexual mistreatment to defend their rights.

We will never succeed in rectifying our society's very real problems, such as sexual harassment, until we resolve a more personal issue: our baffling reluctance to take responsibility for ourselves, to get past others' mindless judgments and to get on with our lives.

Why We Started Talking About It

Sexual misconduct is by no means a new phrase and the term sexual harassment found its roots many years later in the 1970s feminist movement, as women began to "find their power" and wield a bit of it—both at home and in the office. Prior to this, sex at work had been a titillating subject of conversation, the "nudge nudge, wink wink" of the boss having a fling with his secretary.

There are many differing opinions about where this sexually charged atmosphere in the workplace began. Most likely, it has always been present. Over time, as women have increased both their numbers and power in the workplace, incidents have not only increased in frequency, but in individual intensity.

The topic of sexual behavior in the workplace surfaced as women themselves surfaced in suits with their own briefcases. By the mid-1970s, sexuality in the workplace was suddenly an issue. Two books explored the topic in great detail: Lin Farley's *Sexual Shakedown: The Sexual Harassment of Women on the Job* (1978) and Catharine MacKinnon's *Sexual Harassment of Working Women* (1979). Together, the two authors sought to bring harassment to the public's attention and to found ways in which the law could manage and remedy the problem. Researchers then began to seriously study sex at work.

Although MacKinnon's writing is considered extreme by most workplace law experts, there's little argument that sexual misconduct is a complex problem. The more women challenge traditional roles and expectations for females in the working world (and as a result, the cultural attitudes toward gender roles), the more sex will become a central part of our daily work lives.

Despite decades of research among industrial pyschologists and academics in a variety of other fields, basic questions remain about sexual

behavior at work. Two of these questions: Exactly what *constitutes* inappropriate sexual harassment? And what *causes* it?

Almost everyone can agree that certain behaviors constitute sexual harassment—namely, bribery (i.e. quid-pro-quo) and sexual touching. At the same time, coarse language, flirting and gawking are not considered harassment. But between these situations rest a variety of circumstances and possibilities.

In 1982, researchers Sandra Tangri, Martha Burt and Leanor Johnson[1] attempted to describe sexual misconduct using three models—all of which blame it on an abuse of power. A fourth model was later added by work led by Barbara Gutek,[2] and focuses on the effects of sex-role expectations in an organizational context.

The *natural/biological model* holds that sexual misconduct is not actually harassment as legal experts define that term. Furthermore, this model holds that most sexual misconduct is not sexist and not discriminatory. The theory is that men simply have stronger sex drives than women and, therefore, behave in a sexually aggressive manner both in the workplace and other settings. However, they have no intent to harass the individuals they pursue. This model suggests a reason that much workplace harassment begins outside of the office or shop floor—on a business trip or at work-related social function.

The *organizational model* assumes that organizations facilitate sexual misconduct through power differentials created by hierarchical structures. Individuals in positions of authority have the opportunity to use their power for their own sexual gratification. In more Machiavellian terms, this model assumes that bad behavior offers a way for superiors to intimidate and to control their subordinates.

The *sociocultural model* addresses the societal—and some would say political—context in which sexual misconduct occurs. This model argues that sexual behavior in the workplace is a manifestation of general male dominance. It holds that men and women are socialized in ways that maintain a structure of dominance and subordination. Males are rewarded for aggressive and assertive behavior, whereas

[1]Tangri, S.S., M.R. Burt and L.B. Johnson. "Sexual Harassment at Work: Three Explanatory Models." *Journal of Social Issues*, 38 (4), 33-54. (1982)
[2]Gutek, B.A. *Sex and the Workplace: Impact of Sexual Behavior and Harassment on Women, Men and Organizations*. San Francisco: Jossey-Bass. (1985)

women are socialized to be passive, to avoid conflict, to be sexually attractive and to feel responsible for their own victimization. This model suggests that aggressors justify their behavior and disregard any harmful consequences of their actions toward less powerful groups (namely, women).

The *sex-role spillover model*, attributes sexual misconduct to the carryover into the workplace of gender-based expectations that are irrelevant to, and inappropriate for, work. According to this model, sexual misconduct is most likely to occur in work environments where the sex ratio is skewed in either direction. For a woman in a male-dominated workplace, her sex role becomes a more salient feature than her work role—thus encouraging sexual response. This model combines aspects of the organizational and sociocultural models, and is therefore more comprehensive than any of the first three models.

These models may help the rulemakers in a given workplace refine the tone of groundrules that the organization sets. However, the core response will always share the basic theme that, regardless of *why* some-one behaves inappropriately, unwanted sexual attention won't be tolerated.

No Such Thing As a Sterile Workplace

Over 50 percent of all adult women are now in the workforce today. Not only are women beginning to dominate in the workforce but, it is estimated that by 2002, more than half of all businesses will be owned by women. The more that men and women come into contact in the workplace, the greater the potential for expressions of sexuality, espe-cially if women continue to defy the traditional male power structure by circumventing the traditional workplace and creating their own environment and rules.

Yet, while statistics celebrate accomplishments, the truth is that most women enter the labor force at low levels. Furthermore, women's sala-ries relative to men's have not appreciated; women currently make 67 cents to every dollar earned by men.[3]

[3]Statistics relating to women's earnings ratios vary depending upon the source (different sources use different methods). Recent studies have looked at the numbers by state, noting that places like California and Washington, D.C. exhibit high ratios (85.7 and 92.1 percent respectively), while states like Wyoming and Utah show ratios below 70 percent.

The Equal Pay Act (EPA), passed by Congress in 1968, requires that employers give equal pay for equal work regardless of age, sex, national origin, etc. This eliminated the most overt practices of paying women and men differently for the same jobs. However, disparities still exist between the incomes of men and women.

The current direction of women's employment—more women entering traditional women's work than nontraditional work—suggests that more men and women will spend time working together. In addition, more women will be working traditionally male jobs; and they will interact often with men who are peers and supervisors...and even subordinates.

Most importantly, this trend suggests that—regardless of which sexual misconduct model you find useful—the number and scope of work-related sexual issues will increase.

Cloaking Sexuality at Work

Presumably, past generations considered sexual behavior at work relatively infrequent and, when it did occur, having only minor repercussions for the individuals involved and for the organization in which they worked. The idea of frequent occurrence of sex at work was at odds with rational models of organizational and personal behavior.

From 19th century sociologist Max Weber's concept of bureaucratic rationality as a model of organization to current individual-focused theories of motivation in organizations, theories of organization don't provide much room for the expression of sexuality. Sexuality is emotional, not rational, which is why business generally doesn't want to deal with it. (And, in an ideal workplace, it shouldn't have to.)

In many instances today, sexuality is viewed as a frivolous concern at work compared to weightier matters such as commerce, government and education. But it was sex that almost brought the government down in 1999, with the impeachment of Bill Clinton. Thus, an organization that views itself as rational may respond to any expression of sexuality at work by ignoring, overlooking, suppressing or denying it.

Simply put, this response is dead wrong.

Besides the incompatibility of expressions of sexuality with models of organizational behavior, sex at work has been almost invisible for other reasons. As we've seen, in the male-dominated world of work, the woman is viewed as inherently sexual; her presence elicits the expression of sexuality. Removing the sexual woman from the setting restores an asexual environment. For example, in the past, when two employees in an organization married, the wife frequently left the organization voluntarily, at her husband's insistence or because of the organization's regulations. Thus, the evidence of a sexual liaison—namely, the woman—is no longer at the scene of the crime.

Relationships that don't have happy endings are often even more quickly forgotten since one of the parties—often the woman, because of lower perceived value to the organization—quit the job, is transferred or is asked to leave.

Reliable statistics about the effects of dating at work are just beginning to surface in research on workplace behavior, although women's magazines and other media have traditionally debated it (to mixed reviews) in their glossy pages and broadcasts.

The right rules for dealing with dating in the workplace are hard to define. The general drift seems to be toward giving employees greater discretion in starting consensual sexual relationships. This may or may not work for a specific workplace. But one conclusion seems clear: Turning a blind eye to sexuality at work is not a good idea. The cloak that had covered workplace sexual behavior is an obstacle to establishing useful groundrules.

Feminine and Masculine Types...and Stereotypes

Working women have always had to reconcile the impulses to act in a stereotypically feminine manner and to be aggressive enough to succeed in a performance-driven workplace. When relatively few women worked, few employers had to worry about accommodating this difficult mix.

Expectations about male and female behavior are all too often derived from stereotypes: women are sex objects whereas the male stereotype revolves around his ability to achieve in a career. Following this stereotype is the notion that women are sexual and men are not (in the workplace). Barbara Gutek, who contributed to the development of the sex-role spillover model, points out:

> People attend to behavior that is expected, and behavior that is consistent with a stereotype is expected. Beliefs (stereotypes) take precedence over behaviors. Thus, men's sexual behavior is not noticed, and even some men's sexually intended behavior is not interpreted by women as much. On the other hand, women's behavior is interpreted as sexual even with it is not intended as such.

A woman who acts completely asexual is subject to the charge of being prudish, frigid and thus, "difficult." Her perceived lack of sexuality goes against the accepted stereotype and ultimately threatens her job track. Whether or not she wins the case in court, she has suffered a personal loss that cannot be rectified short of a change in social stereotypes and expectations. This is, in essence, an impossible goal for any individual.

At the corporate level, making this change starts with company policies. Employers must be careful that sex stereotyping[4] is not a factor when making employment and promotional decisions. Although a firm can decide what kind of interpersonal skills, for example, it wants its employees to have, a firm cannot take the extra step and determine what type of behavior is proper for females—and males for that matter.

This issue boils down misperceptions of the various ways that women and men express themselves. Is a gossipy man not masculine and thus not supervisor material? Does a well-dressed, assertive woman deserve to be promoted—regardless of her shaky qualifications? Of course not. But, speaking practically, appearance and behavior play a major role in the workplace.

[4] We consider the legal aspects of sex stereotyping (including the relevant Supreme Court decision *Price Waterhouse v. Hopkins*) in greater detail in Chapter 8.

How can good groundrules improve this situation?

Decisions that occur within organizations are often subjective…and based on corporate culture as much as hard facts. Progressive organizations—and businesses that work in creative fields—may actually seek and reward personalities that defy corporate norms. Blue hair and nose rings? No problem. And this flexibility works for any employee in a nontraditional group, including a woman carrying a Day-Timer and wearing a Liz Claiborne suit.

Whether it means blue hair or Liz Claiborne, organizations hire and support employees that best convey their corporate cultures. There are limits to flexibility in even the most progressive organizations. The best that a rulemaker can do is know where the organization fits on the spectrum of flexibility…and allow expression right up to that point.

The challenge is to ignore as many common stereotypes of sexual image and expression as possible. This is largely where the problem lies in today's working culture.

When something happens at work that is sexual, people can recount these incidents the same way they tell a beloved family story or recall some humorous anecdote. The expression of sexuality at work might be the simple attraction of two people, or it may involve a one-sided attraction. That attraction could be pursued outside of the workplace, or the interested person could try to create opportunities within the workplace to further the interest. These scenarios occur on some level every day, in every workplace. In the most outrageous cases, the interested party attempts to exert power over another to further his interest. In some cases, sexual favors are requested (or required) for an individual to keep his or her job or receive a promotion. This is most often what is considered sexual harassment.

Sex at work can take on many other forms, such as sexual comments and innuendos, staring and even touching. Issues of sexuality can also be influenced by tight or revealing clothing, which in some professions is the required uniform, or the employee's own decision. Sexuality can also be acted out through artwork, posters or pinups or the

voluntary sharing of intimate information. The experts call these actions social-sexual behaviors since they reveal a component of both. Because of the disparate forms that sexuality can take, many businesses today have reacted by implementing rigid rules—jokes may even be off limits, depending on your corporate environment.

Thinking about sex at work is essential for both employers and employees today because it affects everyone directly and indirectly. Sex impacts job performance, satisfaction and advancement. It can enhance or impair an organization's image and productivity. For those who feel victimized and for the managers and organizations who must sort out the indiscretions from the misunderstandings, sexual dynamics at work are also a challenge that must be faced on a daily basis.

Power and the Plague of Common Interaction

Again, these challenges have a lot to do with corporate culture an organization must convey and, therefore, the etiquette it can promote. Arguing over whether sexual harassment is rooted in power struggles and he said/she said scenarios does not help employers deal with the problem.

Some employers set up workshops wherein managers can discuss preconceptions and stereotypes about women and others who fall into the "protected-class" categories, such as race, age and disability. This seems like a common-sense approach—let's get it all out on the table, confront negative attitudes and correct the problem.

But workshops alone aren't an answer. Scheduled and selected thoughtlessly, they can actually create more problems than they solve. In the early 1990s, petroleum giant Texaco got into major legal and public image trouble when several middle-managers were recorded making sarcastic and bigoted jokes about a diversity workshop they'd attended.

While the numbers of employees of both sexes who are hurling accusations of harassment against their employers are multiplying, the quantity alone does not mean that we have reached any stable definition of just what sexual harassment is. More important, we have not reached

a strong consensus on how to prevent it. In fact, sexual harassment is an evolving concept, both legally and socially, and, as such, is fraught with confusions that confound the complainers and the complained-against alike.

Still, one might say, at least we're addressing the sexuality angle. And it would be good if sexual harassment were really only about the demand for sexual favors. But the issue is more complex.

Many legal theorists argue that the issue is really about power—and power is an acceptable aspect of corporate behavior. The one doing the harassing is demonstrating his (or her) power over another. Others argue, however, that it results from the power of peer pressure or simple commercial influence (the company's main customer loves you, which means that the company loves you).

Because it is about power masquerading as sex, sexual harassment becomes an uncomfortable topic, difficult to discuss, difficult to prevent, difficult to address effectively. A speaker for a national woman's group articulated it this way:

> Workplaces are defined by language and sexist language is a covert definition of who belongs there and who doesn't. Teasing, intimate terms such as *Honey* or *Darling* can be debilitating because they carry a mixed message of power and intimacy. It's not nice to say, "How dare you?" when someone calls you something intimate. But out of the true context of intimacy, those words or deeds convey a power difference, saying, "I can do this to you, but you can't do it to me." The fact that it is an expression of power, and an ambiguous one, makes it difficult to confront.

The law attempts to present a straightforward definition of sexual harassment. It prohibits conduct such as unwelcome sexual advances, requests for sexual favors and other verbal or physical conduct of a sexual nature if that conduct results in a "tangible employment action" (such as a termination or demotion), or if an employer does not exercise "reasonable care" in preventing or correcting harassment.

Romance in the Workplace

The sex-is-about-power argument may work…for some people…to help define sexual misconduct issues. But what about more desirable and desired sexual relationships? If women's magazines are any indicator, it's a good thing to start a relationship with your boss, colleague or associate. The truth is, the jury is still out on this one—both figuratively and literally. Since one in three extramarital affairs begins at the office, work can be a very sexual place indeed.

According to a survey in the February 1998 issue of *Details* magazine, nearly 59 percent of 400 workers polled have noticed coworkers flirting on the job. Even though 85 percent revealed that flirting one's way up the corporate ladder is unacceptable, a surprising 23 percent said it's okay to sleep with your boss—even though only 4 percent admitted to having done it.

Next to college, the workplace is the place where people most frequently meet their eventual spouses and significant others. "However, Cupid's arrows have been known to be misdirected at times," says Jack Erdlen, Vice President of the Human Resources Division of Romac International of Tampa, Florida, a specialty staffing and recruiting firm. "Broken and spurned relationships have created jealousy, resentment, animosity and other negative factors between employees and their coworkers. Even healthy relations can cause serious internal repercussions, including the loss of key personnel."

"Despite all of the notoriety given to this topic, romance in the workplace continues to be a thorny problem for employers," notes Erdlen. "Companies want to be realistic and not set old-fashioned rules that may infringe upon their workers' freedom," he explains. "However, they are very much afraid of sexual harassment complaints leading to expensive legal suits." Romac's last workplace survey and ongoing conversations with human resources executives have revealed that:

- Sexual harassment is a major issue for 91 percent of companies;

- Over 90 percent of corporations have no policies in regard to dating among coworkers;

- Nearly 63 percent of these firms allow supervisors to date subordinates;

- Almost 25 percent had serious problems with consensual office romances that ended badly; and

- Over 31 percent received sexual harassment complaints in the previous year.

"We are seeing an increasing number of legal issues arising from supervisors dating their subordinates," states attorney Michael Brown of the Boston law firm Palmer & Dodge.

"While most of our clients have not yet addressed this issue in a formal manner, I see that coming very soon. In many states, employers are still strictly liable for their supervisors' actions and therefore complaints of sexual harassment, sex discrimination and the like, can be very costly to both the company as well as the individual's supervisor," he adds. "Such romantic alliances can create real or perceived preferential treatment, and disruption in the workplace, thus impacting morale and productivity."

"Tragically, the workplace is a lot less fun now than it was a decade ago," says employment attorney James J. MacDonald, Jr., a partner with the Newport Beach, California, employment law firm Fisher & Phillips. "The threat of a lawsuit by hypersensitive people has made most individuals much more afraid of what they say to one another."

Flirting with Trouble

How about workplace behavior that falls into a "gray area" between sexual harassment and innocent social banter? Many people believe such conversation among coworkers contributes to a more pleasant work day. Should you nip workplace banter in the bud—or let everyone have fun? It's tempting to let things slide. You will be labeled a killjoy if you clamp down on social chitchat.

Every off-color remark is a ticking time bomb, ready to explode. It is a myth that sexual harassment cannot be caused by coworkers—only by supervisors. In fact, a pattern of remarks by coworkers can be actionable in a court of law.

MacDonald offered insight on how to deal with these potentially damaging issues. "I suggest every employer adopt a Personal Appearance and Behavior Policy, which is an adjunct to the policy prohibiting sexual harassment," says MacDonald. "The policy should prohibit unprofessional dress, conversations or sexually-related comments. Such activities may not rise to the level of unlawful sexual harassment on their own, but plant seeds that sprout into litigation."

There is an important benefit to this policy. Managers who hesitate to brand individuals as "sexual harassers" will often resist disciplining employees for off-color remarks. It's much more acceptable to write up individuals for violating the Personal Appearance and Behavior Policy.

And "write up," by the way, is the correct phrase. In the event of a lawsuit, written documentation can provide evidence that you took steps against an individual who had made inappropriate remarks. What about the charge that this kind of heavy-handed rule-making takes all of the fun out of the workplace? Well, maybe that's true.

Even though sexual harassment actions have risen in recent years, some corporate giants—IBM is one—have actually relaxed their rules about workplace dating, including hierarchical affairs (that is, supervisors dating subordinates).

Rather than forbidding the relationships outright, IBM's new policy encourages supervisors to inform their higher-ups if they're dating a subordinate. Then there can be some discreet reallocation of job assignments so that this direct relationship of the subordinate and the supervisor is not maintained.

Yet other experts shudder at the thought of allowing supervisor-subordinate relationships.

Regardless of the company's position on office romances in general, the best course of action is to discourage and avoid the situation of a manager dating a subordinate through a written policy or by verbal directives from senior management. Dating relationships must be truly consensual. When a manager is dating a subordinate, that issue becomes critical because a quid-pro-quo harassment case could be loom-

ing. "We find a high number of lawsuits are based on soured personal relationships between supervisors and subordinates," says Attorney Lawrence R. Levin (of Levin & Funkhouser in Chicago). "Usually the supervisor wants to continue the relationship and the subordinate does not."

Employers generally have no policy to report such dating. Levin says this is a mistake. "You should have a policy that requires supervisors to report their dating of subordinates to a high-level authority in the business," he says. "And they must also report any change in the dating relationship."

Unwanted sexual attention consists of behaviors that are more widely recognized as harassing such as repeated attempts to establish a romantic relationship after refusal; unwanted touching and sexual imposition or assault. Sexual coercion, the least common, yet most universally-recognized type of harassment, involves bribery or threats (either explicit or implied) for sexual cooperation.

Additionally, the parties in consensual relationships should answer a question about whether the relationship is consensual. The policy requiring reporting of a change in the relationship will allow the business to address the issue to make sure that no sexual harassment occurs. "Sometimes just knowing the ground rules is sufficient to forego problems," says Levin.

Using Sex to Advance a Career

While a lot is spoken about unwanted sexual interest, what about the individual who generates sexual interest in the hopes of advancing her or his career? While Hollywood films used to glorify the "glamorous" career girl who would marry her boss and thus be launched into a life of luxury, today's objectives are a bit more nebulous. Provocative attitudes and behaviors can be counterproductive and lead other employees to assume that an employee is advancing because she is "putting out."

While these stereotypes are wrong at least as often as they're right, nevertheless everyone suffers from them. For example, an intriguing

news article recently reported that male construction workers largely believed that women who worked in their industry were looking for sex or husbands. These stereotypes assume that women encourage and welcome sexual advances from men.

Not that these stereotypes are of women only. Comparable statements about men are increasingly common as women wield their influence and homosexuality is more openly displayed in work environments. A welcomed sexual advance may be flattering, but what happens when these behaviors solicit unwelcomed attention?

When the issue arises in the context of a hostile environment sexual harassment claim, the state and federal courts have taken a bewildering variety of stances. Some have held that same-sex sexual harassment claims are never recognizable. Others say that such claims are actionable only if the employee can prove that the harasser is homosexual (and thus presumably motivated by sexual desire). Still others suggest that workplace harassment that is sexual in content is always actionable, regardless of sex, sexual orientation or motivations.

What Does This All Mean?

Ultimately, there's no clear remedy. The best defense, not to be trite, is a good offense—and that takes the form of a comprehensive employment policy with clear-cut repercussions for any violations.

The damages can be sky-high. "Typically these sexual harassment claims are combined with common law torts such as intentional infliction of emotional distress," says Peter A. Susser, a partner in the Washington D.C. office of the law firm Littler, Mendelson. "The result is a very substantial source of employer liability."

That *intentional infliction of emotional distress* often gets back to basic issues of etiquette. In the workplace, people simply have to behave like adults to each other. If they do, problems can be managed; if they don't...lawyers wearing $800 suits will get involved.

As we have seen before (and will again in this book), the solutions to many sex-at-work legal hassles are often not legal in nature. In fact,

the Supreme Court has noted repeatedly that laws like Title VII do not apply to "genuine but innocuous differences" in the ways men and women interact with each other.

Federal law requires neither asexuality nor androgyny in the workplace; it forbids only behavior so objectively offensive as to alter the "conditions" of a *reasonable* person's employment.

The Supreme Court has always regarded that requirement as crucial, and as sufficient to ensure that courts and juries do not mistake ordinary socializing in the workplace—such as male-on-male horseplay or intersexual flirtation—for discrimination.

As Antonin Scalia has written:

> A professional football player's working environment is not severely or pervasively abusive, for example, if the coach smacks him on the buttocks as he heads onto the field— even if the same behavior would reasonably be experienced as abusive by the coach's secretary (male or female) back at the office.

The challenge to employers and employees in the modern American workplace is to create an environment in which these common-sense distinctions can be made and reasonable person standards can be met.

The proper behavior at work is cordial, cheerful and obliging, but somewhat distant and impersonal. Bosses and coworkers are not meant to be friends, nor must they strive to have such a relationship.

These days it seems like the only people who get this right are coworkers actually having a secret affair: They take the trouble to maintain a formal and professional demeanor, while those who don't care for another pretend to be pals for the sake of maintaining their job.

As we have seen (and will see many times throughout this book), it is most often management who sets the tone for behavior in the workplace and is responsible for reinforcing it. Etiquette is sometimes one of those things in life we manage ourselves; we learn from our parents

and harbor a bag of personal etiquette practices throughout our life—both at work and in the homes we establish.

But etiquette can also refer to a collection of universally accepted norms that are reinforced through company policies, rules and guidelines. One of the subtle ways to enforce common etiquette is to establish a dress code and other standards for how the company expects employees to present themselves.

Let's move on to the meat of workplace politics: benefits, rights and the responsibilities placed on employers and employees alike. These issues bring us closer to the core of how to manage sex at work, and how to better deal with inherent problems to workplace etiquette.

Benefits, Rights and Responsibilities

High-profile investigations like those experienced by Clarence Thomas and Bill Clinton have made sexual harassment in the workplace a hot topic of discussion. But issues of harassment and discrimination in the workplace—as highly publicized as they might be—actually impact fewer people than other, less colorful matters.

Benefits and notification issues that relate indirectly to sex or gender are the problems that you—as an average American business person or worker—are most likely to encounter.

Of course, the media doesn't see things this way. The talking heads of TV are more interested in scandalous sex issues that sell (sex in the Oval Office, gays in the military, video cameras in the employee locker room of a high-profile employer, etc.). While these incidents are important and salacious, situations like a single mother fired because she is pregnant again or a man "eased out" of his job because he takes off time to be with his dying partner are the kinds of things that matter most...to most people.

Numerous laws—each with its own agenda—seek to define sex issues in the workplace. For example, Title VII of the Civil Rights Act of 1964 prohibits, among other things, employment discrimination on the basis of sex, including sexual harassment that creates a hostile or offensive environment. In addition, the Equal Pay Act of 1963 (EPA) prohibits discrimination on the basis of gender in compensation for substantially similar work under similar conditions. And, the Family Medical Leave Act (FMLA) grants full-time employees (of employers

with 50 or more employees) the right to take up to 12 weeks of un-paid leave per year for specified family and medical reasons—includ-ing pregnancy and care of certain family members.

Some of these laws might appear, at first glance, to be irrelevant to sex-at-work issues. If you look more closely, you begin to the see the connections.

Long before Monica Lewinsky graced the front pages of leading jour-nals, laws regulating the rights and responsibilities of an employee—or an employer—with regard to benefits and equal pay topped the list of concerns infused with the influence of sex issues. And this is likely to remain the case. Why? Most people care a lot more about the money and benefits they earn than they do about politics.

The laws that aim to regulate work-related benefits don't always deal with sex issues well. Sex—unlike race or simple gender—is a concept that's tough to define and usually requires major changes to both cor-porate cultures and people's sexual biases...and behaviors. Also, sex—unlike quality or productivity—defies easy measure. You can't rely on statistical processes to implement guidelines on what constitutes "per-missible" sexual policies.

But you don't have to shy away from all this subjectivity and perspec-tive. In this chapter, we'll take a quick survey of the main work-re-lated benefits laws—as well as other similar rules—and discuss how they shape the workplace rights and responsibilities stemming from sex and sexuality.

Doing the Grunt Work

When you delve into your rights and responsibilities as an employee—or an employer—in today's workforce, you'll have to learn a whole new set of acronyms and jargon: ENDA, EEOC, EPA, ERISA, FEP, FLSA, FMLA, Title VII, etc. You'll need to become intimately famil-iar with what each of these terms means for you and the people around you. (Don't panic. I'll go over each of these in more detail.) And, beyond that, you'll need to stay abreast of related legislation and court cases—on the local, state and national levels.

Employee benefits laws and regulations change about as often as Intel turns out new microprocessors. Sometimes, these changes come from state legislations; other times, they are the result of aggressive court rulings. To make things worse, these laws are designed erratically. Some, such as the Civil Rights Act, apply to businesses employing at least 15 people; others, such as the FMLA, apply to businesses with 50 or more employees. Federal employee benefits law doesn't apply at all to some small businesses. And, some state or local Fair Employment Practices (FEP) laws and regulations have broader coverage than the federal statutes.

Whether these changes and today's rights-sensitive workplace are a net positive—or negative—is the subject of constant debate, legislation and court interpretation. But one thing is certain: The whole field of employee benefits has become one of the hottest battlegrounds. That's where issues of equality—equal pay, equal opportunity, equal treatment across the board—and issues of discrimination so often collide in the courtroom.

These benefits can include everything from subsidized health insurance to complex company-sponsored life insurance to...severance packages. As you'll see in the following case, benefits disputes, although indirectly related to sex, can get thorny.

The April 2000 federal court decision *Cindy Brown v. Dr. Pepper/Seven Up, Inc.*, *et al.* illustrates the problem well. What's interesting about this case is that it highlights the fact that the growing role of women in the workforce has also raised several questions about both subtle and overt gender-based discrimination, as well as harassment and even assault. Another complicating effect of the influx of women to the workforce: An increase in the number of men basing legal claims on reversed gender discrimination.

Cindy Brown began working for Dr. Pepper/Seven Up, Inc. (DPSU) in 1980. During her 17 years of employment, she enjoyed increasing amounts of responsibility and received several promotions.

In 1988, Brown became Manager of Finance and Risk Administration; in 1992, she received a promotion within the Finance Depart-

ment to the position of Director of Corporate Planning. With these promotions, Brown also received several salary increases and took graduate studies at DPSU's expense, obtaining her MBA in economics and finance as well as her CPA license. (Brown was clearly an executive. Her pay records showed the following base salaries: September 1993—$78,000; August 1994—$81,120; July 1995—$100,000; February 1996—$115,000.)

On March 2, 1995, Cadbury Schweppes acquired DPSU through Cadbury Schweppes's subsidiary, Cadbury Beverages, Inc. And, as part of the acquisition, many departments of DPSU were reorganized. The result: consolidation of the finance and management information systems functions. During the reorganization, Brown was made VP of Information Services. But she was dissatisfied with the new position, which she considered a demotion.

According to the company, the move was considered a developmental one and Brown would be transferred back to a finance position within two years. But after the job change, Brown unsuccessfully sought out several opportunities to transfer back into various finance positions. The last position in which Brown expressed interest was the position of CFO/Senior Vice President of Finance and Information Systems. The position was vacated in January 1997 by Brown's direct supervisor, Lynn Lyall, who said that he would recommend Brown as his replacement.

Lyall soon informed her that, when he had recommended her for the position, John Brock, CEO of Cadbury Beverages, North America, told him that she was "too difficult" to work with and "too direct to fit in with the executive team."

After having been denied several transfers, Brown tendered her resignation to DPSU on February 20, 1997. On that same day, she accepted a position at Blockbuster Video as Senior VP of Finance. Four months later, DPSU finally named its new Senior VP of Finance.

After Brown resigned from DPSU, she filed a claim for severance benefits under DPSU's Special Plan and Severance Benefits Program for

Employees of Dr. Pepper/Seven Up, Inc.—a plan that was enacted prior to the acquisition by Cadbury.

The stated purpose of the plan was to:

> provide employees with a measure of job security that will encourage them to remain in the employ of [DPSU] at a time of wide spread market speculation regarding the continuing independence of [DPSU].

Brown's claim asserted that her position with DPSU was diminished after the acquisition and the changes involved an assignment of duties inconsistent with her previous position, authority, duties or responsibilities within the meaning of the plan. However, DPSU contended that her new position was a promotion.

Brown filed a complaint with the Equal Employment Opportunity Commission (EEOC), alleging that DPSU constructively discharged her after denying her the promotion. She followed the EEOC complaint with a lawsuit filed on January 26, 1998, alleging sex discrimination in violation of Title VII. She later amended her complaint to include claims for violations of the Employee Retirement Income Security Act (ERISA), the main federal law controlling employment benefits.

Brown claimed that DPSU had permanently sidetracked her career by placing her in a non-finance position and then refused to promote her or transfer her back into a finance position because she was a woman. She also alleged that DPSU wrongfully denied her severance request because her position as VP of Information Systems was a diminished position, or at least a change in position substantial enough to qualify for benefits under the original DPSU severance program.

The trial court considered the benefits claims first.

The original DPSU plan provided an employee with severance benefits if, following an acquisition, the employee was "terminated with good reason." *Good reason* was defined as:

> ...the assignment to the employee of any duties inconsistent in any respect with the employee's position, authority, duties or responsibilities, or any other action by the Corporation (or a Successor) which results in a diminution in such position, authority, duties or responsibilities.

DPSU interpreted this definition to require a demotion in order to qualify for severance benefits. According to DPSU, although Brown's job change consisted of very different duties and responsibilities, it did not constitute any type of demotion. The court agreed.

But Brown also accused DPSU of denying her benefits on the basis of her sex—even though she admitted herself that at least two other women had received severance benefits. Moreover, undisputed evidence showed that benefits had been denied to a male coworker.

This left the court with no other choice but to conclude that DPSU used a legally correct interpretation of the plan when evaluating Brown's request for severance benefits. As a result, DPSU could not be found to have acted arbitrarily or capriciously.

Brown's ERISA claim alleged that DPSU had failed its fiduciary duty to her in denying severance benefits—a tough claim to substantiate.

According to DPSU, it reviewed a large volume of material in making its determination. DPSU's VP of Human Resources, William Burke, considered DPSU organizational charts and job descriptions, written and oral input from Brown, oral input from members of management who were familiar with these positions, his own personal familiarity with the positions, compensation and job bands or grades, job titles, scope of duties and responsibilities, reporting relationships and authorities. The company also contracted an independent reviewer to review all of the materials submitted by Brown in support of her severance claim.

In light of these factors, the court ruled that Brown had failed to produce any genuine issue of material fact as to whether DPSU abused its discretion when it found her ineligible for severance benefits and dismissed her ERISA claim.

Next, the court considered Brown's sex discrimination claims—which fell largely under Title VII of the Civil Rights Act of 1964.

The Mechanics of Discrimination and Title VII

Title VII of the Civil Rights Act prohibits discrimination on the basis of sex. It further requires that persons of like qualifications be given employment opportunities irrespective of their sex.

Section 703 of Title VII states:

> It shall be an unlawful employment practice for an employer...to fail or refuse to hire or to discharge any individual, or otherwise to discriminate against any individual with respect to compensation, terms, conditions, or privileges of employment, because of such individual's...sex.... Notwithstanding any other provision of this title, it shall not be an unlawful employment practice for an employer to hire and employ employees...on the basis of...sex...in those certain instances where...sex is a bona fide occupational qualification reasonably necessary to the normal operation of that particular business or enterprise....

As the above points out, the exception to this prohibition occurs when gender is a *bona fide occupational qualification* (BFOQ) reasonably necessary to the normal operation of business. Hence, this is why there are no male Hooters Girls, Radio City Rockettes or *Sports Illustrated* swimsuit models.

But when conflicts between BFOQs and gender stereotyping result in claims of disparate treatment, the rights and responsibilities of employer versus employee switch gears. In order for an employer to be found guilty of disparate treatment, the employee must prove that the employer discriminated *consciously* against an individual on the basis of sex stereotypes.

Brown did not involve BFOQs or disparate treatment. What the case does illustrate is a lesson on how bruised egos often turn into allegations that have nothing to do with sex discrimination. And, more

importantly, how a whole generation of conditioning by popular media and scatter-shot government regulation has made today's workers very certain about their rights—even when they are *mistakenly* certain.

According to Brown, a major reason she'd been sidetracked at DPSU after the acquisition was that she was a woman. DPSU, on the other hand, offered three legitimate business reasons for refusing to promote Brown and denying her severance claim:

1) Brown's management style clashed with that of the board of management;

2) Brown's experience came from the Dr. Pepper side of business rather than the Cadbury side; and

3) Brown did not qualify for severance benefits under the terms of the plan.

I'm a Pepper, You're...Evidently Not

Members of the board disliked Brown's management style, which even she described as "more of a benevolent dictatorship style." The board considered her to be too direct and too difficult to work with.

As for the board's predisposition for a candidate with Cadbury experience, Brown claimed that Cadbury had a heavy influence in filling the empty Senior VP position. She also believed that after the acquisition, people from the Dr. Pepper side of the company received less favorable treatment than the Cadbury employees had received.

One of the managers, John Kilduff, testified about the differences between Brown's management style and the general Cadbury style. In his words, "Brown was known for her very direct and independent management style, which was more in the style of DPSU prior to the acquisition. Following the acquisition, Brown's management style had at times clashed with the more consensual style of some members of senior management and the Board of Management with a Cadbury background."

Brown also said that Kilduff told her that she would face a hard time getting the promotion because she came from the Pepper philosophy. Bill Tolaney, the Senior Vice President of Corporation Relocation and Building, also predicted she would not get the promotion because she was a "Pepper person."

Brown argued that these reasons are merely pretext for sex discrimination and offered several statements of various managers as support for pretext.

According to Kilduff, Brown's gender could only be an asset because she would add some diversity to the board of management.

The court concluded:

> The alleged remarks made by members of the executive team about her sex often contradict Brown's purpose and do not provide sufficient evidence of pretext to defeat summary judgment. Moreover, despite [her] arguments, the Court declines to find the description of her as "direct" and "difficult to deal with" as euphemisms for sex stereotyping prohibited by Title VII.

Finally, Brown tried to demonstrate pretext by citing DPSU's more favorable treatment of its male employees, but failed to produce any evidence proving her allegation.

The court noted:

> [Brown's] own career at DPSU contradicts her claim that the career advancements and promotions were given predominately to men. During her seventeen years at DPSU, [she] advanced from working as the accountant for one of DPSU's company-owned bottling plants to serving as a Vice President of the corporation. DPSU also paid for Brown to attend graduate school, where she obtained her MBA in economics and finance as well as her CPA license.

Her argument that, when she desperately wanted to return to a finance position, several of the available positions were given to men didn't support a finding of sex discrimination—especially since one of the VP finance positions went to another woman.

This strongly negated her argument that DPSU denied her an opportunity to transfer back into finance because of her sex; Brown simply did not meet her burden. She produced no evidence that any of DPSU's stated legitimate business reasons for its actions were pretext for discrimination on the basis of sex.

More than anything else, this case stands as a lesson on how an angry employee's allegations can backfire if he or she can not meet the burden of proof. And, more importantly, the burden of proof in a discrimination suit involving promotion or benefits is tougher than many people realize.

Equal Employment Opportunity

Of all the laws that regulate sex issues in the workplace, those enforced by the Equal Employment Opportunity Commission (EEOC) are probably the most influential and relevant to running a business in the real world.

If you're one of the business owners, employers or managers whose blood pressure rises when someone mentions the EEOC, you may already know its reputation in the business world. (You might get an argument from some business owners that the Occupational Safety and Health Administration is worse.) Yet, the EEOC's goals are, at their core, admirable. It's the agency's enforcement of those goals that is problematic. Why? Because the EEOC can investigate a company's management policies and practices at its discretion—if it suspects discrimination or if someone has simply complained.

If you're a manager or employee with a gender-discrimination or sexual harassment problem in your workplace, you'll have a whole different view of the EEOC than a ranting and raving employer might. In fact, you'll be happy to have the EEOC on your side.

So just what or who is the EEOC? According to its own Statutory Authority statement, the EEOC, which began operating on July 2, 1965, was established by Title VII of the Civil Rights Act of 1964 to enforce the principal federal statutes prohibiting employment discrimination, including:

- Title VII of the Civil Rights Act of 1964, as amended, which prohibits employment discrimination on the basis of race, color, religion, sex or national origin;

- the Age Discrimination in Employment Act of 1967, as amended, (ADEA), which prohibits employment discrimination against individuals 40 years of age and older;

- the Equal Pay Act of 1963 (EPA), which prohibits discrimination on the basis of gender in compensation for substantially similar work under similar conditions;

- Title I of the Americans with Disabilities Act of 1990 (ADA), which prohibits employment discrimination on the basis of disability in both the public and private sector;

- the Civil Rights Act of 1991, which includes provisions for monetary damages in cases of intentional discrimination and clarifies provisions regarding disparate impact actions; and

- Section 501 of the Rehabilitation Act of 1973, as amended, which prohibits employment discrimination against federal employees with disabilities.

For purposes of this book, we'll only touch on the laws that are most relevant to our analysis of the overall picture of sex at work.

The EEOC operates roughly 50 field offices nationwide, providing funding and support to state and local fair employment practices agencies (FEPAs) as well as processing discrimination claims.

In addition, the EEOC issues regulatory guidelines to help employers and employees interpret the laws it enforces. In fact, in 1998, the agency conducted Technical Assistance Programs and public presentations to help educate public and private sector business people on the laws enforced by the EEOC.

So how does the EEOC process work and what does it have to do with sex at work? If you are an employee and you believe you've been the victim of gender discrimination or sexual harassment, you first file "administrative charges" with the EEOC's headquarters in Washington D.C. or a local field office near you. (Individual EEOC commissioners can also initiate charges if they are made aware of any gender discrimination or sexual harassment.)

After charges have been filed, the EEOC conducts an investigation of the charges to determine if there is "reasonable cause" to believe that discrimination has occurred. If there is reasonable cause, the agency must then seek to conciliate the charge to reach a voluntary resolution between the charging party and the employer. If conciliation is not successful, the EEOC may bring suit in federal court.

When the EEOC concludes its processing of a case, it issues a "notice of right to sue" which enables the charging party to bring an individual action in court.

It's not hard to see how the EEOC gets a bad reputation. In 1996, its litigation program won over $50 million for victims of discrimination. In 1997, the figure was $111 million; and in 1998, it was $90 million. In 1998, the agency also obtained $169.2 million (not including the litigation awards) through settlements and conciliation.

It's best to make friends with the EEOC, whether you're an employer or employee. And as far as gender discrimination and sexual harassment are concerned, that means getting intimate with Title VII of the Civil Rights Act of 1964, as well as the revised Civil Rights Act of 1991, too. (We addressed both of these Acts in more detail in Chapters 1 and 2.)

The EEOC issues new guidelines, revisions and clarifications from time to time that directly affect how Title VII—which prohibits employment discrimination on the basis of race, color, religion, sex or national origin—is enforced. Court rulings also have a significant impact on antidiscrimination enforcement in the workplace. So it makes good business sense to keep ahead.

One way to keep ahead is to visit the EEOC's Web site at: http://www.eeoc.gov. The site offers updates on regulations, legislation and court decisions.

Sex and the Equal Pay Act (EPA)

An additional factor influencing sex at work issues is the Equal Pay Act of 1963. According to the Act:

> No employer having employees subject to any provisions of this [law] shall discriminate...between employees on the basis of sex by paying...a rate less than the rate he pays wages to employees of the opposite sex...for equal work on jobs the performance of which requires equal skill, effort and responsibility and which are performed under similar working conditions.

The Act is narrow in scope, applying to only wage differences between men and women. It does not apply to issues of race, age, disability, sexual orientation or any other potential protection class.

Although the Act applies to both genders equally, if you're a woman, or you know one who works for a salary, then you probably know that women have historically been paid less than men for similar work.

In fact, writing about the EPA, the Supreme Court has explained:

> Congress's purpose in enacting the Equal Pay Act was to remedy what was perceived to be a serious and endemic problem of employment discrimination in private industry—the fact that the wage structure of "many segments of American industry has been based on an ancient but outmoded belief that a man, because of his role in society, should be paid more than a woman even though his duties are the same."

Despite this "wage gap" or discrepancy in the status of women's earnings relative to men's, men can make a claim if their employers pay women more for the same work. The EPA does not address gender or

sex issues in regards to hiring, managing, promoting or firing employees. It only applies to pay; to issues of benefits and compensation.

If an employee's case is successful, the Act allows the award of back wages, benefits and attorneys' fees. It also allows certain liquidated damages (effectively the same as punitive damages) equal to the same amount in back wages, unless, of course, the employer can show that it made a good faith effort to comply with the law.

The EPA follows the enforcement model of the Fair Labor Standards Act (FLSA). This allows employees to sue privately or make a complaint to the EEOC. If the EEOC tries the case, the employee is not allowed to bring a separate private lawsuit until the public action has been completed. In addition, the employer can't fire an employee because the employee is taking part in an EPA lawsuit.

The EPA applies to all jobs—whether they are executive, managerial, supervisorial or labor. The only exemptions are seasonal businesses, certain small retail sales operations and a few kinds of local newspapers and utilities.

In addition, the EPA limits complaints to single "establishments." Unequal pay comparisons for men and women at different establishments is allowed under the law. However, the definition of *establishment* may change according to the circumstances of the case.

In most cases, *establishment* means a physical plant. This means you can't usually compare women's wages in a Tennessee factory with men's wages in a New York corporate headquarters. However, a court may allow this kind of comparison, if the employee making the charges can offer a compelling argument.

Similar Work

So, what constitutes similar work? A single job with a single job description, regardless of the gender of the person who holds the position is similar work. However, the EPA deems several jobs as similar— if they have *quantitative equality*.

This notion of equality has sparked many political debates; certain feminist groups have argued for very broad definitions of equal pay. But, in fact, the law is quite specific about what the notion means.

Quantitative equality consists of four work characteristics:

- skill, which refers to the objective level of ability or dexterity required to perform job tasks;

- effort, which refers to the physical or mental exertion required to perform tasks;

- responsibility, which refers to the degree of accountability a job entails—measured by supervisory, decision-making and business-impact standards; and

- working conditions, which refers to the surroundings or hazards that a job entails.

In the past, several federal courts have ruled that the skill, effort and responsibility of different jobs must be "equal" in order for the jobs to compare. Working conditions only have to be "similar."

The EPA provides four defenses for paying unequal wages for work that the EEOC, another agency or a court deems equal, including:

- a bona fide seniority system;

- a merit system;

- a system which measures earnings by quantity or quality of production; or

- a differential based on a factor other than gender.

According to some of the statistics at least, those and other "exceptions" have actually turned out to be the rule. Employers have still not closed the wage gap between men and women. Currently, two separate, but similar, bills are slogging through Congress: the Fair Pay Act, introduced by Democratic Senator Tom Harkin and Congressional Delegate Eleanor Holmes Norton; and the Paycheck Fairness Act, introduced by Democratic Senator Tom Daschle and Congresswoman Rosa DeLauro. Although the bills differ slightly, both seek to

put more teeth into the Equal Pay Act and the FLSA equal pay regulations. For example, the bill summary of the Paycheck Fairness Act published by Congress includes the following:

> ...an amendment to FLSA to provide for enhanced enforcement of equal pay requirements, adding a nonretaliation requirement. Increases penalties for such violations. Provides for the Secretary of Labor to seek additional compensatory or punitive damages in such cases.

> ...a requirement that the Equal Employment Opportunity Commission (EEOC) and the Office of Federal Compliance Programs must train EEOC employees and affected individuals or entities on matters involving wage discrimination.

> ...a requirement that the Secretary conduct studies and provide information to employers, labor organizations and the general public concerning the means available to eliminate pay disparities between men and women, including convening a national summit and carrying out other specified activities.

The Fair Pay Act includes an additional section that:

> Directs courts, in any action brought under this Act for violation of such prohibition [i.e. discrimination in payment of wages], to allow expert fees as part of the costs awarded to prevailing plaintiffs. Allows any such action to be maintained as a class action.

The effect of these bills would be to bring them to par with the enforcement, penalty and class-action provisions that have worked fairly well for Title VII of the Civil Rights Act of 1964, as revised in 1991.

The Wage Gap

The wage gap, a statistical indicator that is calculated by dividing the median annual earnings for women by the median annual earnings

for men, is also used to compare the earnings of people of a different race to those of white males. (To calculate the wage gap for each race/gender group, the median annual earnings of the race/gender group are divided by the earnings of white males, who are typically not subject to race- or sex-based discrimination.)

The statistics of the wage gap are often controversial. The growing role of women in today's workforce has raised several questions about both subtle and overt gender-related discrimination—with wage discrimination remaining at the top of the list.

Also, non-cash benefits are not calculated consistently in many of the wage gap formulas. Generally, good benefits packages make the gap smaller—which makes benefits all the more important and disputes over them all the more urgent.

According to the U.S. Census Bureau, the earnings gap between men and women is narrowing, but even women who work in highly paid fields still make less than their male counterparts. Women's earnings as a percentage of men's earnings increased from roughly 62.5 percent in 1979 to 76.5 percent in 1999. The pay gap for black and Hispanic women is even wider; black women receive only 64 cents for every dollar earned by white men, and Hispanic women get just 55 cents.

So, no matter what race you are, you earn less on average if you're a woman than if you're a man. And what's incredible about the disparity is that the Equal Pay Act (EPA), which was intended to close the gap by requiring employers to give equal pay for equal work regardless of ages, sex, national origin, etc., has been around for 37 years.

Not everybody believes these statistics reflect the true gap. Some skeptics argue that the wage gap exists, in part, because women choose to work part-time, take unpaid leave or not to work at all more often than men do.

Okay, the skeptics retort, but aren't Bill Gates (Chairman of Microsoft), Steve Case (Chairman and CEO of America Online) and a hundred other dot.com billionaires year-round, full-time workers? If so, it doesn't take many of them to skew the numbers.

Just the point, say pay equality advocates, why aren't more women at the tops of these companies?

This kind of argument can go on and on. And there are other arguments, too. Some suggest that the gap exists because: 1) women are still segregated into a few low-paying jobs; 2) there are differences in education, experience or time in the workforce; and 3) discrimination occurs in the wage-setting system.

But is there any way to figure out the truth about why the wage gap exists? The best way, of course, is to compare pay for men to pay for women working in virtually identical jobs. To this end, the National Committee on Pay Equity (NCPE) points to several telling studies:

- A survey of public relations professionals, revealed that women with less than five years of experience make $29,726 while men with the same amount of experience earn $47,162. For public relations professionals with five to 10 years of experience, women earn $41,141 while men earn $47,888. With 10 to 15 years of experience, women earn $44,941 and men earn $54,457. With 15 to 20 years of experience, women earn $49,270 and men earn $69,120.

- A salary survey of professionals in purchasing, estimated that women purchasers with three or fewer years of experience earn $35,900 while men with the same amount of experience earn $47,700. For purchasers with four to six years of experience, women earn $38,300 while men earn $52,100. Female purchasers with seven to 10 years of experience earn $42,300 while their male counterparts earn $56,400. And, for those with 11 to 15 years of experience, women earn $43,500 and men earn $63,400.

- A study of women in the telecommunications industry reported a gap between the salaries of men and women even when education was the same. For example, among video programmers, women with advanced degrees earn 64.6 percent of the earnings of their male counterparts, and women with college degrees earn 80 percent.

And if you still don't believe there's a gap, consider why the following companies had to pay up after Department of Labor audits.

- Texaco agreed to pay $3.1 million to 189 women employees who were found to be systematically underpaid compared to their male counterparts.

- Trigon Blue Cross/Blue Shield had to pay $264,901 in back pay to 34 women managers who were paid less than male managers of equal qualifications and seniority.

- US Airways agreed to pay $390,000 in salary adjustments to 30 female managers who were paid less than their male coworkers.

And these companies aren't alone. Other organizations, including, American University, American Greetings Corp., Aramark Corp., Fairfax Hospital and Marriott Corp. have also had to cough up a significant amount of money in recent wage discrimination settlements.

As courts have proven, time and time again, pay equity, or the means of eliminating sex and race discrimination as wage determinants, is law. And, if an angry employee can prove that his or her employer pays men and women differently for the same work, an employer's defense will need to rely on a well-documented explanation that fits the four defenses we describe later in this chapter.

The EPA prohibits unequal pay for "substantially equal" work performed by both sexes, but Title VII of the Civil Rights Act of 1964, also prohibits wage discrimination on the basis of race, color, sex, religion or national origin. In fact, in 1981, the Supreme Court made it clear that Title VII is broader than the EPA, prohibiting wage discrimination even when the jobs aren't quite identical.

Moreover, the EPA contains three restrictions pertinent to most disputes over compensation. These restrictions are:

- coverage is limited to those employers subject to the Fair Labor Standards Act; the Act does not apply to businesses engaged in retail sales, fishing, agriculture and newspaper publishing,

- coverage is restricted to cases involving "equal work on jobs the performance of which requires equal skill, effort and similar working conditions," and

- the Act's four affirmative defenses exempt any wage differentials attributable to seniority, merit, quantity or quality of production, or "any other factor other than sex."

The four affirmative defenses of the EPA, which state that an employer can pay unequal wages for work that the EEOC, another agency or a court deems equal if the difference in pay is based on a factor other than gender, were designed to confine the application of the Act to wage differentials attributable to sex discrimination.

Thus, EPA litigation has been structured to permit an employer to defend against charges of discrimination where their pay differentials are based on a bona fide use of "other factors other than sex."

In addition, the 1968 Bennett Amendment to Title VII of the Civil Rights Act of 1964 was designed to resolve any potential conflicts between Title VII and the EPA.

With respect to the first three defenses, the Bennett Amendment guarantees that courts and administrative agencies adopt a consistent interpretation of like provisions in both statutes. Under other circumstances, inconsistent case law might develop, interpreting two sets of nearly identical language. And, more importantly, incorporation of the fourth defense could have significant consequences for Title VII litigation.

Federal courts interpret the Amendment to incorporate only the affirmative defenses of the EPA into Title VII. The Amendment bars any sex-based wage discrimination claims under Title VII where the pay differential is "authorized" by the EPA.

What's Inappropriate about Gender Stereotyping?

No matter who you are, who you work for or who works for you, you're susceptible to gender and employment problems—whether they are compensation-related or not. As an employer, the key to complying with the laws that regulate gender issues is relatively the same as for complying with other diversity law: treat all types of people fairly and make no broad assumptions about what certain types of people will do or be good or bad at.

The costs of gender stereotyping are enormous. One way an employer can avoid the types of problems we've discussed is to review the EEOC's regulations, which provide:

> The Commission believes that a bona fide occupational qualification exception as to sex should be interpreted narrowly. Labels—men's jobs and women's jobs—tend to deny employment opportunities unnecessarily to one sex or the other.

> ...the following situations do not warrant the application of the bona fide occupational qualification exception:

- The refusal to hire a woman because of her sex, based on assumptions of the comparative employment characteristics of women in general. For example, the assumption that the turnover rate among women is higher than among men.

- The refusal to hire an individual based on stereotyped characterizations of the sexes. Such stereotypes include, for example, that men are less capable of assembling intricate equipment; that women are less capable of aggressive salesmanship. The principle of nondiscrimination requires that individuals be considered on the basis of individual capacities and not on the basis of any characteristics generally attributed to the group.

- The fact that the employer may have to provide separate facilities for a person of the opposite sex will not justify discrimination under the bona fide occupational qualification exception unless the expense would be clearly unreasonable.

Sex and the Family Medical Leave Act

Is the Family Medical Leave Act (FMLA) really relevant to sex at work issues? Although it may seem like a stretch at first, a closer look reveals there are important connections. In fact, of all the laws that regulate benefits in the workplace, the FMLA probably sparks the largest number of legal sex-related concerns.

First, the FMLA is often used by pregnant women (and some husbands of pregnant women) to take time off around the births of their

children. And childbirthing—and rearing—are clearly key issues for women in the workforce. But the FMLA actually considers pregnancy a "family" issue, not a gender-specific matter.

Second, the FMLA was intended to ease some job-related stresses for working mothers. Some politicians deny that this was the purpose of the law—they claim that it is gender neutral, intended for all working people with families. Are these politicians being disingenuous or is the FMLA plainly intended to help working women? Benefits for childbirth—and rearing—are clearly a gender equality issue that is showing up more and more.

Third, the FMLA has been part of a general move in American law to regulate workplace benefits. What were once informal extras, offered by employers to make jobs more attractive, are now a major focal point of federal lawsuits. And many of these lawsuits—alleging that benefits were wrongly denied or minimized for groups like women and gays—are hot topics in employment law.

Take, for example, the March 2000 federal court decision *Sharon M. Frankel v. United States Postal Service,* which shows why the FMLA remains a pivotal issue in employment benefits law.

The case arose out of an extremely unfortunate series of events. In early November of 1996, Sharon Frankel suffered a miscarriage, which caused her to miss some work. She told only one coworker about the reason for her absence; and, on Frankel's instruction, that coworker reported the reason to Frankel's supervisor, requesting that the information remain confidential.

Frankel's supervisor, Peter Bombassaro, honored her request and did not share the information with anyone in the office. But on or about December 6, 1996, Patrick Ring, then manager of Customer Service Support for the Post Office, instructed his subordinates to take action against employees to control the use of sick leave, and unknowingly set forth a chain of events.

Thomas Lyons, a management employee subordinate to both Ring and Bombassaro, decided to conduct "official discussions" advising

five employees of the Post Office's sick leave policy. Each of the five employees had used more sick leave than they had accrued in the previous quarter. Frankel was among them.

While Frankel had used more than her accrued sick leave for the previous quarter, she maintained (and the Post Office did not dispute) that she had significant amounts of accrued sick leave as of mid-December 1996. The sick leave policy seemed to permit an employee to use sick leave that was accrued and not used in previous quarters.

Some of the sick leave time Frankel had used in the previous quarter was in connection with her miscarriage and subsequent treatment. However, when Lyons decided to conduct the "official discussion" with Frankel, he did not know about Frankel's miscarriage. Lyons assumed that Frankel's absence was for routine illness.

On December 19, 1996, Lyons conducted the official discussions. Frankel did not want to have a discussion with Lyons concerning her sick leave without a union steward present. The union steward informed Lyons that he believed the discussion constituted harassment.

Lyons indicated that he would continue with the discussion and Frankel requested that the union steward file a grievance. The union steward agreed and left the office.

After the steward left, Lyons explained that Frankel had exceeded her accrued sick leave time for the previous quarter. He showed Frankel her attendance record, on which the dates of her recent absences were highlighted. At that point, Frankel began to cry and, while rising from her seat, exclaimed, "Do you want to know what happened to me on those dates, you fucking asshole? I had a miscarriage, and I hope you are really proud of yourself now."

She then ran out of the office. A number of postal employees approached her and discussed the incident, and then one employee accompanied Frankel to her car.

Lyons maintained that Frankel also intentionally struck him on the shoulder. Frankel denied it. Lyons testified that the blow startled him,

but it caused no injury, resulted in no bruise and did not cause him to lose his breath.

While Frankel testified that she did not touch Lyons during that meeting, she believed that she may have come into contact with a vacant chair that was two feet from Lyons and in her path to the door.

That same day, Lyons reported the incident to Ring who then called Frankel at home and told her that she had been accused of assault and that she was placed on emergency off-duty status without pay. She was forbidden to enter the workplace.

While Frankel originally lost her grievance challenging this decision, on January 2, 1997, she appealed that decision as well as other Post Office actions and ultimately prevailed in an arbitration proceeding and was awarded back pay for the time she missed from work on December 5, 1996.

The arbitrator's decision was based on the finding that the Post Office overreacted to the seriousness of the December 19, 1996 incident and failed to properly investigate it in a timely fashion.

In late February, two months after the incident and while Frankel was still on off-duty status, the Post Office ordered Frankel to submit to a "fitness for duty" medical evaluation.

On March 13, 1997, for the first time, Frankel contacted the EEO counselor at the Post Office. On the "Information for Precomplaint Counseling" form, which Frankel signed on March 20, 1997, Frankel stated that the basis for her discrimination claim was that she was "disciplined for sick leave due to a miscarriage."

The "fitness for duty" evaluation was not held until April 4, 1997. The evaluation cleared Frankel to return to work that day. However, the Post Office had decided to abolish her position and reassign her to a similar position in another section, though in the same building with the same job description. Frankel refused to accept the reassignment believing that Ring would be her direct supervisor and that the abolition of her job was discriminatory.

Accordingly, Frankel instituted a grievance challenging the reassignment. The grievance was settled and the parties agreed "[t]he position was improperly abolished therefore the grievant will be returned to the former position."

On April 10, 1997, the Post Office suspended Frankel for 14 days for her actions on December 19, 1996. The suspension was to take effect April 26, 1997, but was later reduced to a letter of warning. Frankel received payment of her wages for the 14 days.

Frankel became pregnant again in early May, and ultimately decided not to return to work.

On June 18, 1997, Frankel filed an official complaint with the EEO office of the Post Office indicating that the basis for discrimination was sex, handicap and retaliation. In the complaint, Frankel again stated that she was disciplined for taking FMLA leave time.

Frankel sued, alleging that the Post Office discriminated against her because of her sex and because she took leave time protected by the FMLA. She also brought the following retaliation claims under both the FMLA and Title VII based on:

1) Lyons's decision to conduct the "official discussion" with Frankel,

2) Ring's decision to place Frankel on emergency off-duty status without pay on December 19,

3) the February 27 order that Frankel submit to a "fitness for duty" evaluation,

4) the elimination of Frankel's position in her section of the Post Office, and

5) the 14 day suspension issued on April 10 which was ultimately reduced to a letter of warning.

In her deposition, Frankel testified about general work conditions at the Post Office during her tenure, contending that: Lyons favored male employees, Lyons had treated Frankel rudely on occasion,

Bombassaro had once denied her request for leave to attend a funeral and in the same month granted three days leave for a male employee to attend a funeral. She indicated that males in the office received more bonuses and awards than the female employees (even though the female employees worked harder), that males were accorded special treatment with regard to leave and that males were more frequently permitted to attend to personal issues on work time. Frankel had no personnel records supporting her impressions.

The court ruled that Frankel had at least established the *prima facie case* of discrimination and retaliation. So, it fell to the Post Office to offer defensible reasons for taking the actions that it did, including:

1) Lyons's decision to have an "official discussion" with Frankel concerning sick leave was the result of a decision to meet with all employees who had used more sick leave than they had accrued in the previous quarter; this decision was made without regard to the sex of the employee or whether that person had exercised rights under the FMLA.

2) Frankel's placement on emergency off-duty status was an appropriate response to the alleged assault given Ring's understanding of the Post Office policy of "zero tolerance" for violence in the workplace.

3) The medical evaluation was consistent with Post Office policy requiring such evaluations whenever an employee has been absent because of conduct that suggests the employee may be a risk to herself or others.

4) The decision to eliminate Frankel's position was based on the advice of expert management consultants and the Postal Service Personnel Department.

The Post Office argued, essentially, that all of these actions were reasonable responses to Frankel's reported misconduct. The court agreed:

The "official discussions" of December 19, 1996, were undeniably carried out without regard to an employee's sex. A sex-neutral criteria was used for determining who would

receive these discussions and both men and women were selected. Nor is there any evidence that could support an inference that any of the other adverse actions were motivated by a discriminatory animus against women. Frankel has not produced any competent evidence of the type used to prove pretext.

Frankel's claims that there were incidences of unequal treatment of men and women in the workplace were found only "conclusory allegations, wholly unsupported by the record."

Therefore, the court agreed to the Post Office's motion for a summary judgment and dismissed Frankel's sex discrimination claim.

But Frankel had also claimed that she'd been subjected to inappropriate and discriminatory discipline because she took leave covered by the FMLA. She argued that there could be no issue of intent with this matter, because the Post Office "must acknowledge that it gave [her] an official discussion concerning her sick time use, and that it would not have done so had [she] not taken FMLA leave."

But the court didn't buy this argument:

> Frankel confuses intent with causation. It is true that if Frankel had not taken leave time protected by the FMLA, she would not have used more sick leave than she had accrued in that particular quarter—which was the basis for the decision to give the "official discussion." However, this does not establish that the Post Office decided to give her an official discussion because she took FMLA protected leave time. It merely establishes that the "official discussion" would not have occurred but for her taking the leave time.
>
> Her inability to produce any evidence of pretext or discriminatory animus doomed the FMLA claim. Frankel herself conceded that Lyons had absolutely no idea that she had suffered the miscarriage when he gave her the "official discussion."

Finally, the court concluded:

> There simply is no way that the decision to give the "official discussions" was motivated by anything but a desire to control the use of sick leave—regardless of whether the person had taken the sick leave for a serious medical condition, routine illness or was inappropriately escaping from a day at the office. The only reason for giving the "official discussions" was because those particular employees had used more sick leave than accrued in the previous quarter. It is not the role of the Court to determine whether this was a wise or fair reason for the decision, simply whether it was a nondiscriminatory one.

Since the animus of the FMLA was not an arbitrary form of bias but was derived purely from the prospect of economic loss, it would be irrational for the Post Office to take such drastic steps against Frankel (suspension, ordering her to attend a "fitness for duty" evaluation, etc.) simply because she suffered a miscarriage and missed a few days of work. "In other words," the court ruled, "Frankel's brief leave did not even approach the type of economic threat to the employer contemplated by the drafters of the FMLA."

Therefore, the court dismissed Frankel's claim that the Post Office had discriminated against her under the FMLA.

But the Post Office wasn't completely off the hook.

While there was no basis to infer that the Post Office's challenged conduct was motivated by Frankel's use of leave time protected by the FMLA, the court ruled that it was possible that the conduct was motivated by Frankel's opposition to her discipline. Both Title VII and the FMLA have a provision to protect employees from retaliation for protesting actions believed to violate the underlying statute.

These provisions forbid discrimination against employees "for attempting to protest or correct allegedly discriminatory conditions of employment."

Frankel first complained to the EEO counselor on March 13, 1997. It is unclear if she complained of sex discrimination at that time, but she did state in the "Information for Precomplaint Counseling" form that she was disciplined for "sick leave due to a miscarriage."

On April 4, 1997, just three weeks after her initial contact with the EEO counselor, her position was eliminated and she was reassigned to another section in the Post Office. This was the same day she was cleared to return to work by the "fitness for duty" evaluation.

On April 10, 1997, less than one week after the termination and reassignment, Frankel was suspended for her conduct on December 19, 1996. She had already been placed on emergency off-duty status without pay for approximately three months at the time the suspension was issued. The Post Office ultimately changed the suspension to a letter of warning and provided compensation for the two weeks.

Each of these actions were taken shortly after Frankel complained to the EEO counselor. Each of these actions were ultimately withdrawn or modified.

The Post Office itself agreed that the elimination of Frankel's position was "improper." The court found all of these actions troubling:

> To remove Frankel from work for an additional two weeks without pay is arguably excessive. Whether the Post Office's excessive discipline was motivated by Frankel's contact with the EEO counselor is by no means clear from the record. However, (1) the timing of these actions, (2) the excessive nature of the discipline, (3) the Post Office's agreement that one action was improper, and (4) the Post Office's voluntary abandonment of the other, taken together, provide a sufficient basis for a reasonable jury to determine that the actions were retaliatory.

So, Frankel's retaliation claim was allowed to proceed.

Essentially, the FMLA was designed to eliminate the economic pressure that prevented employers from offering leave policies that were

compatible with the medical needs of families. Congress considered numerous studies of existing family leave policies which "taken together, indicate that while many employers are providing family and medical leaves to their employees, a significant percentage of employers of all sizes have yet to adopt such policies."

Unlike discrimination statutes seeking to protect a class of persons from the bias of their employers, the FMLA addresses an economic problem. Employers who are pinching pennies in a competitive market might prefer to terminate and replace an employee rather than provide a generous leave policy that will allow the employee to resolve the particular situation and return to work.

Shortly after the FMLA's passage, Ohio Senator Howard Metzenbaum said, "This is a major step, but it does not go far enough. There will have to be a second and a third step so all Americans are covered."

But Metzenbaum didn't have to wait long for steps two and three. Within 12 months, Congress introduced a bill to take away the exemption for highly compensated employees. A number of union locals had arranged seminars on how to expand workplace rights under the law. Among the proposals discussed: demand "income replacement" to compensate workers for unpaid leave; relax the definition of "serious illness"; expand the definition of "family" so more people are eligible for leave; and lengthen the list of reasons people can use to take paid leave.

No matter how compelling family leave sounds in legislative sessions, the FMLA remains problematic because it's so often abused by both employees and employers.

Employers contend that employees often abuse FMLA benefits by attempting to stretch the qualifications for coverage (minor illnesses, such as ear infections, remain a problematic issue).

On the other hand, some employee groups complain that mandatory benefits and benefit extensions like FMLA actually create the unintended consequence of keeping women down—by pitting them, in all, as more expensive to maintain as employees.

In addition to the cost of pregnancy, working women are often chastised for bearing the brunt of child care in our society. Working women require more flexibility in their work schedules and because of this, have frequently found themselves blocked in their career path and stereotyped as lacking the commitment to the company that men are perceived to have.

With the increasing divorce rate, today's employers are being forced to face the realities of the Mommy Track or single-parent families and the need to provide more family friendly policies.

In addition to the FMLA, a woman taking maternity leave from work is also protected by the Pregnancy Discrimination Act (PDA).

The PDA, which is part of Title 29 of the federal Labor Code doesn't solve all problems. For example, many companies still have maternity leave programs in place that do not guarantee employees the same duties upon their return to work. In addition, the widespread layoffs and mounting workplace tension over sex roles taking place through the late 1980s and early 1990s increased the uneasiness that makes pregnancy leave issues so difficult—and so politically potent.

Responding to the Happy News

Pregnancy is the main flashpoint of sex-related workplace benefits disputes. Employers are often hobbled by mixed response when it comes to news that an employee is pregnant. The positive feeling of encouragement and congratulations lowers defenses and the negative feelings of having to grant a long leave and the possibility of losing an employee conjures up unwise and discriminatory thoughts. And there is the potential for these disparate emotions to come crashing together.

When this happens, you're in a bind as an employer. All because you put yourself in legal jeopardy—often unintentionally.

In the case of benefits, legal and illegal pre-employment questions are a good example. It would be great to know how much benefits liability you're about to incur, yet the only relationship-related question you're legally allowed to ask a prospective employee is "What is your

marital status?" You can't ask if they're engaged, have a boyfriend or girlfriend or whether a baby is in the plans (or already on the way).

The idea behind this is to prevent gender discrimination. And that's a generally good idea. But, the problem is that there are some women that take jobs only to get the maternity benefits.

As an employer, you have some protection because maternity benefits often have a waiting period. But you still have to take the time, trouble and expense to train a new employee and let them get up to speed. This is why some employers feel that they should be permitted to ask about childbearing plans.

Congress has stated that the purposes of the FMLA include the following:

> ...to balance the demands of the workplace with the needs of families, to promote the stability and economic security of families, and to promote national interests in preserving family integrity;

> ...to entitle employees to take reasonable leave for medical reasons, for the birth or adoption of a child, and for the care of a child, spouse or parent who has a serious health condition....

To support its decision to pass the FMLA, Congress made six findings, three of which are usually cited in disputes over the law:

- It is important for the development of children and the family unit that fathers and mothers be able to participate in early child rearing and the care of family members who have serious health conditions;

- The lack of employment policies to accommodate working parents can force individuals to choose between job security and parenting;

- Due to the nature of the roles of men and women in our society, the primary responsibility for family caretaking often falls on

women, and such responsibility affects the working lives of women more than it affects the working lives of men....

Under the FMLA, an eligible employee will be entitled to a total of 12 workweeks of leave during any 12-month period for one or more of the following:

- because of the birth of a son or daughter of the employee and in order to care for such son or daughter;
- because of the placement of a son or daughter with the employee for adoption or foster care;
- in order to care for the spouse, or son, daughter or parent, of the employee, if such spouse, son, daughter or parent has a serious health condition;
- because of a serious health condition that makes the employee unable to perform the functions of the position of such employee.

In addition, any eligible employee who takes leave under section 102 of the FMLA is entitled, on return from such leave, "to be restored" to the position of employment held by the employee when the leave commenced.

The legislative debate over this law was much less substantive than the debates over the ADA or Title VII of the 1964 Civil Rights Act. The law worked its way through a Democratic Congress in the last months of George Bush's presidency. It was a minor issue in the presidential campaign of 1992.

Through 1995, though, the courts had made little use of the scant legislative debate that surrounded the FMLA. Like the 1991 Civil Rights Act, the FMLA passed into law with little dispute.

This safe passage through Congress reflected the general public sentiment in favor of the law. However, about a year after the FMLA took effect, one survey of managers and consultants found that employees jeopardize their climb up the career ladder when they take family leave.

The survey, conducted by The Conference Board, a New York-based business research group, examined the workplace impact of the FMLA.

In what the report termed an "unsettling finding," 64 percent of respondents said women have "some" or "substantial" reason to worry about job advancement if they take a leave, because of "prevailing attitudes" of coworkers and managers.

For men, the news was even worse: 75 percent of respondents said men face at least some risk when they opt for leave. That difference seemed to account for another study result. Respondents said they believed men are more reluctant than women to take family leave.

The survey polled over 100 members of The Conference Board's work-family research and advisory panel, which was composed primarily of work and family managers from large American employers. What made the results all the more striking: The group was largely drawn from the country's most "family friendly" companies.

The difference between general political sentiments and the specific realities of the business world highlighted the essential problems of issues that link family and work.

FMLA and Same-Sex Marriages

On the practical business front, some employers argue that if companies traditionally offer benefits to married employees' spouses and children, and same-sex marriages become legally recognized, then private companies will lose their choice about paying same-sex benefits. Well, yes. But from strictly a cost-saving perspective, in most areas of the country, it would almost certainly be more cost-effective to recognize same-sex marriages—or civil unions. Why? Simply because there will be arguably fewer same-sex marriages than heterosexual live-ins applying for benefits.

High-profile legislative battles over same-sex marriages have rocked several other states including Hawaii, Oregon, California and New Hampshire. In fact, those frays tend to overshadow the less controversial but related wrangling over same-sex partner benefits.

Some states provide antidiscrimination statutes that do not require private companies to provide benefits for same-sex partners. But only

11 states have sexual-orientation non-discrimination statutes, including: California, Connecticut, Hawaii, Massachusetts, Minnesota, New Hampshire, New Jersey, Oregon, Rhode Island, Vermont, Wisconsin and the District of Columbia.

Wherever you stand on same-sex marriages (and we will consider the issue in greater detail later in this book), there's no question that the legal landscape is in upheaval regarding domestic-partner benefits, and it may be quite some time before the dust settles.

Meanwhile, as an employer or manager, you'll be well advised to keep up with the changes in benefits-related legislation and court decisions—not only on the federal level, but on your local and state levels as well. That's because many of the changes that affect benefits obligations take place first in city, county or state lawmaking bodies. Only afterward do they work their way up to the national level via the courts. And that can take years. In the interim, you may be affected by the state or local statute.

Even though the FMLA is an administrative hassle many agree on one point: that the act has ushered into the workplace new honesty about the weight of family concerns on employees.

But not everyone believes the law is being followed. Noting that the current law applies to only about 44 percent of working women and 50 percent of working men, employee-rights advocates hope that the FMLA can be expanded to include employees of smaller companies and part-time workers. They also want to get rid of the law's geographic loopholes and provide paid leaves for lower income workers.

"There is not as much secrecy now about 'Yes, I'm pregnant,' or 'Yes, I have elder-care responsibilities,' said Dana Friedman, co-president of the Families and Work Institute, a New York-based research group. The FMLA "is really opening up the door to talking about these issues and having companies better understand employees and what their family needs are."

"Business and market factors are dictating that the issues surrounding cultural diversity be taken more seriously," concludes a report by the

Illinois-based management consulting firm Hatbridge House Inc. "It means a corporate culture that values everyone, with particular groups no longer being disadvantaged."

One report published by the New York-based working women's group, 9to5, said some employers may be trying to avoid FMLA compliance by hiring part-timers to work fewer than the 1,250 hours a year—about 25 hours a week—that help make an employee eligible for leave coverage. "If something is good and it's the right thing to do, you need to make it right for everybody," said Ellen Bravo, executive director of 9to5.

The Conference Board has defined three types of families that are most likely to need special support: adoptive families, single-parent families and step-families or blended families.

Conclusion

Of course, sex-and-work issues are about much more than benefits. But these relatively unexciting issues offer a good understanding of how sex issues can hit home for people who are not involved in high-profile sexual politics or engaged in sordid sexual activities. Sex at work can mean basic disputes over how much time a person can take off, how secure her job is and what an employer can—and cannot—do when someone needs personal time.

Some pundits argue that these issues mean employers should cut benefits for everyone. But that's a smirky, unrealistic response. Benefits are a big part of the reason people choose to work at one place instead of another. They are an important part of work. So, to the extent they relate to sexual activity or identity, they are always going to be a major issue.

Finally, benefits are an important aspect of workplace parity because they are a major aspect of why people work. They are a measure of status among employees. A job with benefits is usually a better-paying job—but it's more than that. It's the kind of *real* job that means a lot to people who have been marginalized...and are working their way up the economic ladder. In a visceral way, benefits are about equality.

CHAPTER 7

What Is Company Policy and Why Do We Need It?

For most working adults, the phrase "It's company policy," is equivalent to an authoritarian parent replying, "Because I said so." For others, company policy is nothing other than a nebulous swamp of rules and regulations. But with sexual harassment lawsuits reaching all-time highs—tackling issues as diverse as benefits for same-sex domestic partners and Internet surfing on an employer's time—company policies are by far the most effective way to establish guidelines that prevent problems across the board and protect both employer and employee.

Policies can also provide a process for settling disputes quickly and, when it comes to sexual harassment specifically, they can foster a non-hostile, productive work environment.

In fact, a sharply written anti-harassment policy can play a critical role in the outcome of a dispute; and its enforcement is usually enough to shield a company from the majority of, if not all, related liabilities. This is because courts now tend to subsidize employers that have policies and procedures in place—and even go so far as to order employers to adopt and maintain a court-ordered policy if they haven't already done so.

In this chapter, I'll focus on company policies that target sexual behavior and look at various rulings that reflect current trends in managing sex at work. From companies establishing an affirmative defense, to policing romance and implementing policies on dating, adultery and customer harassment, you'll come to understand the importance and relevance of such policies today.

A Case in Point: The Hooters Girls

In a complex legal action involving multiple plaintiffs and defendants, a Denver court considered several instances of hostile environment sexual harassment, quid-pro-quo sexual harassment, retaliation under Title VII of the Civil Rights Act, gender motivated violence in violation of the Violence Against Women Act, and outrageous conduct against two women who had previously been employed at the bar and restaurant known as Hooters, which caters largely to male customers.

What's interesting about the circumstances in this case is that, while Hooters notoriously favors physically attractive women willing to wear scant uniforms, the defendants here were corporate businessmen who had lured the women away from Hooters to new jobs. Following the trial, one of the women returned to Hooters, where the element of sex appeal in the workplace was still very much a part of the job and the work environment.

Lobb & Company and LCI Maintenance Services, Inc. hired Kimberly Kral and Hyacinth Wells from their respective positions as bartender and waitress at a Denver-area Hooters. Neither Kral nor Wells had experience or education for the positions for which they were hired and suggested that they were employed instead because of their sex and appearance. In addition, a fellow employee, Julia Cantarovici, who had significantly more education and experience than Kral and Wells, contended she was also hired because of her sex and appearance.

You may wonder why this matters, since the women's previous employer—Hooters—had also hired them based on their sex and appearance. The difference here is the fact that their new positions didn't require the element of sex appeal as part of the job description. Hooters, on the other hand, utilizes the female sex appeal to generate business and in turn, a profit. It hires women who best fit the image for the position of "Hooters Girl" because the job entails this element of sex appeal that prevails in the restaurant.

I'll explore this idea later, and see how the Hooters argument that "sex appeal is legal and it sells" can at the same time disarm charges of sex discrimination and harassment. For now, consider an environment whereby a woman is hired because of her sex and appearance but the job should *not* entail an element of sex appeal—and she is subjected to inappropriate behavior. This was the case in *Wells v. Lobb & Company, Inc.*

According to the women, once hired, they were continually subjected to a pattern and practice of sexual harassment and intentional discriminatory treatment by reason of their sex. This included vulgar and sexual remarks, jokes, overtures and touching.

Neither company maintained an appropriate sex harassment policy. And, even after several employees complained about the improper conduct, the companies failed to take appropriate steps to remedy the problems.

Eventually, Kral and Wells felt compelled to resign when the inappropriate behavior continued. Hooters rehired them. And they sued the corporate jerks who had lured them away.

The Settlement and the New Policy

Judgment was entered against Lobb & Company, Inc. and LCI Maintenance Services, Inc. and the court ordered the companies to enact a detailed anti-harassment policy. The court also imposed substantial punitive damages—jointly and severally—to punish them for their conduct and to notify others that such improper conduct in the workplace will not be allowed.

The companies were also ordered to comply with various EEOC record-keeping and reporting provisions and, most pivotal to rendering change, to post a detailed antidiscrimination policy. Such a posting is intended to remind employers and employees of what constitutes sexual harassment, what laws govern sexual harassment, what to do in the event of a situation and how claims are treated. If nothing else, the posting warns potential offenders and comforts potential victims.

The following is an example of such a policy statement:

SEXUAL HARASSMENT and ANTI-RETALIATION POLICY

Pursuant to Title VII of the Civil Rights Act of 1964, as amended, it is unlawful for an employer to subject an employee to acts of harassment based upon the employee's sex, race, color, religion, or national origin, or to permit or encourage a work environment in which such conduct occurs.

Further, it is unlawful for any employer to retaliate against an employee because he or she has opposed discriminatory employment practices, including sexual harassment, because he or she has filed a charge of discrimination with any municipal, state or federal equal employment opportunity agency, or because he or she has participated in an investigation of a charge of discrimination. The term "sexual harassment" includes: A) any unwelcome sexual advance; B) requests for sexual favors; C) conduct that demeans or intimidates an employee or group of employees because of their gender, including jokes, name calling, labels, or stories; and D) other verbal or physical conduct of a sexual nature if either: 1) Submission to such conduct is made explicitly or implicitly a term or condition of employment— i.e., Your employment depends on "going along" with harassing conduct, or "giving in" to sexual demands; OR, 2) Such conduct has the purpose or effect of unreasonably interfering with an individual's work performance or of creating an intimidating, hostile or offensive work environment.

It is the policy of [this company] to prohibit the types of harassment described above. All persons, including supervisors and managers, who are responsible for such conduct shall be disciplined.

Employees who believe that they have been subjected to sexually harassing conduct may complain to anyone in management and/or to _____ who can be reached at _____. Within 10 calendar days of the complaint, management officials will conduct a full investigation, which will include a thorough interview with the complaining employee, the alleged harasser and any witnesses, as appropriate. Upon conclusion of the investigation, the investigating managerial official will report back to the complaining employee, and take any appropriate action against the offending party. Employees may also complain by contacting the Equal Employment Opportunity Commission by telephone…or by mail….

[This company] respects the right of its employees to work in an environment that is free from sexual harassment. In compliance with federal law, no official at [this company] will retaliate against an employee who complains about sexually harassing conduct or who participates in a sexual harassment investigation either: 1) through the internal complaint procedure described above; or 2) through any municipal, state or federal equal employment opportunity agency investigation.

In *Wells*, the court also prohibited the companies from mentioning this action to any prospective employers of any of the women. The companies were required to apologize in writing to Cantarovici, Kral and Wells, as well as conduct annual training sessions for all its employees on what constitutes sexual harassment.

The outcome of this case suggests that even with a posting, companies need to remind employees in other ways that sexual harassment of any kind will not be tolerated if they are to stave off legal claims and engender a discrimination-free workplace. Behavior in this sense is not policed, but rather managed to ultimately reduce liability.

Companies that maintain workplace antidiscrimination policies, as we will see, fare well in the courtroom arena—regardless of substantive claims. In essence, lucid policies protect employers and employees.

Hooters of America, Inc.—Sex Appeal for Profit

Though Hooters was not the bad guy in the previous case, it has had its share of problems in the area of discrimination. Over the years, Hooters has been forced to acknowledge a certain level of discrimination when it hires, despite its proactive lead in the industry for addressing issues raised by sexual harassment. Because of the prevalent element of sex appeal in its restaurants and its practice of hiring women only for the Hooters Girl position, the company has landed in court defending itself against *reverse*-discrimination lawsuits.

Hooters employs approximately 15,000 people—nearly 10,000 of which are women. These "Hooters Girls," scantily clad in orange shorts, pantyhose and a white tank top or T-shirt, represent the Hooters concept, which is the all-American cheerleader who makes promotional and charitable appearances within the community. The concept of a Hooters Girl is what enables the company to be successful and remain in business. Although the company hires women who best fit the image of the Hooters Girl (and not men), it hires both males and females to work in management and host, staff, service bar and kitchen positions. Claims that it exploits attractive women are, according to Hooters, "as ridiculous as saying the NFL exploits men who are big and fast."

Hooters has a long-standing non-harassment policy forbidding unwelcome physical or verbal behavior and maintains a confidential reporting system for complaints, including a toll-free phone number. But even so, the company ran into problems with two separate incidences, one with the Equal Employment Opportunity Commission (EEOC) in 1991, and another with a group of men in Chicago and Maryland who brought forth class action lawsuits challenging Hooters' right to hire only women in front-of-house positions.

In the first case, the EEOC's commissioner brought a charge against Hooters, claiming that its hiring practices discriminate against *men*. However, after a little coaxing from the media, which called the charge "another example of ridiculous government waste," and the efforts of some 500,000 Hooters customers who sent postcards to Congress, 23 members of the 104th Congress, led by Rep. Charles Norwood, asked the EEOC to drop the matter. And following what it called an intensive investigation, the EEOC announced that it would not pursue litigation. Thus, the federal agency determined that Hooters can choose to hire only women as Hooters Girls.

To boost its argument, Hooters stated: "Hooters Girls have the same right to use their natural female sex appeal to earn a living as do super models Cindy Crawford and Naomi Campbell. To Hooters, the women's rights movement is important because it guarantees women the right to choose their own careers, be it a Supreme Court Justice or Hooters Girl." Indeed, this is an agreeable argument to make, but one that doesn't take into consideration the fact that men are discriminated against because they do not—and cannot—fulfill the role of a Hooters Girl. If women's rights foster self-determination (to hold a job as a Hooters Girl), then what rights do men have to hold the same job?

This argument is really just a colorful extension of the bona fide occupational qualification theory we have considered before. It assumes that there are roles that men and women must accept and reject based solely on the nature of their sex. Women cannot become NFL players; men cannot become Hooters Girls. Whether this is fair or unfair is moot; it's a realistic and practical restriction. In another example (excluding the limits of science), men cannot bear children, and likewise, women cannot produce sperm. Simply put, there are limitations inherent to each sex, which we are compelled to accept.

In the second, similar episode, a federal magistrate in Chicago approved a settlement in 1997. Under the settlement agreement, Hooters could continue to hire only women for the position of Hooters Girl. More importantly, the agreement acknowledged that "being female is reasonably necessary" to perform the Hooters Girls' job duties and preserve the integrity of the Hooters Girls' concept.

Another important point to make concerns the right of the employer to create the most productive, profitable yet safe environment for employees. Hooters claims that newspapers, magazines, daytime talk shows and local television affiliates consistently emphasize sexual topics in order to boost sales. Hooters marketing, stressing the Hooters Girl and her sex appeal, along with its commitment to quality operations continues to build and contribute to the chain's success.

No one can take away Hooters's right to make a profit and conduct business—so long as it does so with respect to the rights and personal privileges of its employees. Any company, like Hooters, has an inherent right to promote a concept that generates business. Following this train of thought, since being female is a reasonably necessary requisite for performing a particular job, it preserves the integrity of the business concept.

The point of mentioning the Hooters scenario is to demonstrate the complexities of sex at work and the odd interplay between legitimate and illegitimate uses of sexuality in the workplace. The women employed by Hooters understand and acknowledge that they are using their sex appeal in support of the business establishment. To this end, we can say that sex at work is part of the job, and go as far as to say that it mutually benefits the restaurant and the employees. The compromise, however, is that while sex appeal is legitimate for creating a profit here, abuse of that sex appeal is not, which is clearly stated in the company policy. Hence, the circumstances that legitimize Hooters are far different from those that characterize the company in the earlier case, Lobb and Company.

No Dough in the Baking Business

The March 1999 U.S. district court decision *Deena Pritchard v. Earthgrains Baking Companies, et al.* is another example of how a company's anti-harassment policy can play a critical role in the outcome of a sexual harassment dispute. This case clearly shows how the mere existence of a policy can shield a company from liability and shift the responsibility onto the employees.

The plaintiff endured unwelcome sexual advances, requests for sexual favors and other verbal and physical conduct of a sexual nature—all of which violated Title VII of the Civil Rights Act of 1964. However, she failed to take responsible steps toward solving the problems when they started, which later jeopardized her allegations and her ability to prove her case in a court of law. Again, we find that a disconnect exists between how people think evidence can substantiate a claim in court, and how the law works.

Deena Pritchard began working as a sanitation worker on March 10, 1997 for Earthgrains Baking Company, which operates Rainbo Bread Co. The following day, she was transferred to work on the production floor and assigned to the third shift as a bun seeder. Here, she removed trays of buns from a rack and loaded them onto a conveyor belt. She worked closely with Mark Drew and Anthony McCrea. Raymond Bowman, the production superintendent, supervised Pritchard while Gary Ferris, the third shift production supervisor, was responsible for maintaining the production schedule and overseeing production. The problems started on day one.

That day, Bowman gave Pritchard and another worker a tour of the facility. He asked them about their social lives and drinking habits. He then asked them if they wanted to get a six pack of beer and drink it in the parking lot later. Both women declined and the subject was dropped.

Shortly thereafter, a series of incidents concerning Bowman began. According to Pritchard, Bowman stared and gawked at her; visited her area of the production floor and chatted with Drew in a manner that suggested they were talking about her in a sexual manner. Drew later told Pritchard that Bowman would stand behind her, extend his tongue, feign panting like a dog and make pelvic gestures that simulated sexual intercourse.

Pritchard never saw any of these acts take place, but she relied on her coworker's accounts. Drew also told Pritchard that he'd overheard Bowman saying he "sure would like to f— that" or "hit that," and that he would "tear that thing up.... My wife don't give me none." Several

other events exacerbated the workplace environment and placed Pritchard in an uncomfortable, compromising situation. Among them:

- Bowman imitated having sex with pans while in Pritchard's presence.

- Pritchard asked Bowman if it was necessary to moisten the dough for unseeded buns, and he replied, "It helps it to be wet, but no, the buns don't need to be."

- Bowman asked Pritchard for a place to go and drink, and said that his wife was out of town and that he wanted to have a good time.

- Despite repeatedly asking Bowman to be relieved from duty when her menstrual period began, Pritchard had to wait three hours and endure soiled clothing.

- Pritchard asked if the bakery had an ice machine, and Bowman responded, "Why, do you got to cool that hot thing off?"

- Gary Ferris, the third shift production supervisor, commented that he could see her underwear, that her rear end was "fine" and that he "[felt] sorry for [her] old man, having to get up behind that ass every night." He further asked her to engage in "a sex affair with no love." Ferris discussed intensely personal matters with her, including masturbation, his sex life and how he guiltily fantasized about her while having sex with his wife—and that his wife noticed the distraction.

- Ferris suggested that he and Pritchard have an affair; he gave her his pager number and mentioned a hotel for sex.

- Ferris offensively touched Pritchard on two occasions: 1) he attempted to massage her shoulders when she complained of soreness, and 2) he seductively grabbed her shoulder.

These incidents occurred throughout her employment. Many times, when Pritchard told her offenders that she disliked their behavior, the men acknowledged their wrongdoing and often apologized. Although Pritchard occasionally discussed the problems with supervisors and managers—and even had a conversation with the on-site

EEO coordinator and union stewards—she didn't file a formal complaint until *after* she was fired on May 8, 1997. And, despite earlier suggestions from superiors that she file a complaint, Pritchard tried to make it seem that she had everything under control.

Obviously, this wasn't the case, and the repeat behavior of her co-workers during her employment allegedly caused her to underperform at work and sacrifice her potential to secure a job. When she was fired, the bakery cited excessive absences. Before her 45 work day probationary period ended, she had already missed five days and left work early twice.

Earthgrains had a policy prohibiting sexual harassment, and Pritchard received a copy of this policy. The company also had its EEO Complaint Policy posted in the hallway near the break room and time clock.

Pritchard testified that she had seen the policy, but that she never really had time to read it completely. The policy contained detailed statements concerning Earthgrains' policy against discrimination and harassment. It also included information on how to file a complaint, much like the one seen earlier in this chapter.

In her lawsuit, Pritchard claimed that she was retaliated against for telling supervisors about the various incidents. She claimed that she was moved to the more difficult job of depanning and that the menstruation incident was retaliation. She also claimed that her schedule was changed often and her hours were reduced. Finally, she claimed that she was fired in retaliation for her sexual harassment claims.

In all, Pritchard made three claims based on Title VII:

1) hostile work environment sexual harassment;

2) sex discrimination; and

3) retaliation.

As we have seen before, certain criteria must be met in a court of law in order to establish a claim for hostile work environment sexual ha-

rassment. Pritchard had to prove: (1) that she was harassed because of her sex; (2) that the harassment was unwelcome; (3) that the harassment was sufficiently severe or pervasive to create an abusive working environment; and (4) that some basis exists for imputing liability to the employer.

The court found no basis for such a claim in this case, and noted:

> Viewing the facts in a light most favorable to the plaintiff, this is a weak case at best. In [the court's] opinion, this conduct is unlikely to meet the level of severe and pervasive, but it is possible that a reasonable jury could find this to be a violation of Title VII.

Here, the key words are *severe* and *pervasive*, subjective terms interpreted by courts, and words that could not describe the actions against Pritchard.

The court wrote that Pritchard's claims for sex discrimination and retaliation were even weaker than her hostile work environment claim. The problem: It was unclear which acts she claimed were sex discrimination and which were retaliation.

To establish a prima facie case of discriminatory discharge, Pritchard had to prove that the male employees engaged in conduct of comparable seriousness to the conduct for which she was discharged, and that the male employees were not discharged.

The court ruled:

> [Pritchard] has not made such a showing. Viewing the facts in a light most favorable to [her], the evidence shows that hours were being reduced for all newer employees due to the loss of the Burger King business, a major account for Earthgrains.... Further, [Earthgrains] has articulated a legitimate, non-discriminatory reason for Pritchard's discharge—her excessive absences. She was absent at least five days and late twice.

Earthgrains had a policy of terminating probationary employees who were excessively absent and has terminated employees with attendance records similar to Pritchard's. Additionally, Pritchard failed to show that the reason for her termination was false and that sex discrimination was the real reason. It's important to repeat that the court made an effort to view the facts of the case in a light most favorable to Pritchard—and not Earthgrains. In this manner, the burden of disproving the claims rests heavily on her employer, and yet Pritchard still failed to establish her case.

Next, Earthgrains had to show that it exercised reasonable care to prevent and correct promptly any sexually harassing behavior. According to the court:

> The primary goal of Title VII is not to provide redress; rather it is to prevent discrimination and the harm that results from such acts. In recognition of this goal, the Supreme Court [has] held that employers must be given credit for making reasonable efforts to embrace an affirmative obligation to prevent harassment. Proof that Earthgrains has in place an effective anti-harassment policy is compelling proof of meeting this element of the defense.

The element of prevention, rather than redress is an important aspect to laws enacted that address issues of discrimination. Much to the dismay of victims, the laws are not meant to provide a safe haven for those seeking legal retribution for wrongs that have already occurred. On the contrary, they aim to prevent and give employers a shield from liability when the laws are acknowledged, displayed and practiced.

Unlike some companies, Earthgrains maintained good practices when it came to preventing discrimination. It had an anti-harassment policy posted on the company bulletin board. The policy stated that there would be no retaliation for making a complaint and that all complaints would be reviewed and/or investigated. Employees were instructed how to file a complaint, and multiple channels existed for doing so—including calling a toll free number. And, there was an EEO Coordinator on-site.

Furthermore, Earthgrains appeared to have acted promptly to any reported sexually harassing behavior. Even in the instances in which Pritchard made unofficial complaints, the company took action to end Bowman's inappropriate behavior.

In short, the court concluded that Earthgrains had fulfilled the requirements of an affirmative defense. The court expressly said, "Pritchard unreasonably failed to take advantage of the procedures." Also, "It is unreasonable for an employee complaining of harassment not to investigate a known posted policy concerning that harassment." Considering how many times supervisors encouraged Pritchard to file a sexual harassment complaint and how many times she refused to do so, the court assumed that her claims were weak and unsubstantial.

One might argue that the unwelcome environment caused her to miss work, which in turn caused her to lose her job—but these theories do not sufficiently meet the burden of proving claims of discrimination. So long as the company acts responsibly, which this one did by posting laws and encouraging victims to file claims, and the victim acts irresponsibly by *not* acknowledging reasonable courses of action prior to pursuing legal action, claims of discrimination and harassment cannot rise to an actionable level. In the end, the court dismissed the Title VII claims.

As this case points out, victims have an obligation to take reasonable steps to avoid or mitigate damages that arise from statutory violations. This element of responsibility came from the Supreme Court as recently as 1998 with the addition of the affirmative defense clause to Title VII.

Establishing an Affirmative Defense

As we touched upon and briefly explained in Chapter 2, employers are routinely escaping liability in harassment suits by establishing an affirmative defense. In its two 1998 decisions *Faragher v. City of Boca Raton* and *Burlington Industries v. Ellerth*, the Supreme Court established the following affirmative defense to Title VII liability: When no tangible employment action is taken, a defending employer may raise an affirmative defense to liability or damages, subject to proof by a preponderance of the evidence.

The affirmative defense comprises two necessary elements:

1) that the employer exercised reasonable care to prevent and correct promptly any sexually harassing behavior, and

2) that the plaintiff employee unreasonably failed to take advantage of any preventive or corrective opportunities provided by the employer to avoid harm otherwise.

We saw these two elements in the previous case, where Pritchard failed to take reasonable action within a company that discouraged inappropriate behavior. The landmark cases, however, that established these necessary elements were *Burlington* and *Faragher*.

These cases dealt with the liabilities created by sexual activity between employees and supervisors and with the question of whether an employer needs to know that sexual harassment is occurring in order to be liable for it later. In short, the court said no, an employer can be held liable even if it doesn't know about the illegal behavior.

Let's briefly take a look at each of these cases.

Faragher shows a situation that employers with sizable workforces may find frighteningly familiar. The woman who filed the suit had worked as a lifeguard for the City of Boca Raton, Florida. Beginning in 1985, she and other female lifeguards were subjected to various harassing behaviors—including uninvited physical touching and lewd comments—by two male supervisors, according to the woman. The behavior continued on and off for about five years.

In 1990, one of the female lifeguards wrote a letter to the city's personnel department complaining about the harassment. After an investigation, the city determined that the supervisors had behaved improperly and reprimanded both. However, Faragher—now in law school—decided to sue the city for taking too long to respond.

The city's defense: It responded quickly and conscientiously as soon as it found out about the harassment. The Supreme Court ruled against the city, arguing that sexual harassment has become such a well-known risk that an entity should anticipate it—even when there's no specific evidence that it's occurring.

The *Burlington* decision involved murkier facts. The woman who filed suit had worked for the company for about 15 months. And, after she resigned, she claimed that she had been subjected to harassment from a mid-level manager. Although the manager never directly propositioned or threatened the woman, she argued that his behavior created a hostile work environment—which courts have ruled can itself be a form of sexual harassment.

The high court ruled that, even in a case in which the behavior was less than certain (and more environmental), the employer may be on the hook. In order to avoid liability, an employer has to prove by a preponderance of evidence that policies and procedures in place at the time were sufficient to prevent and remedy harassment…and that the complaining employee failed to follow them.

Burlington Industries couldn't prove this. And, frankly, few employers in its position could. But, the upshot of the cases for employers is that these cases created an affirmative defense that incorporates agency principles of vicarious liability but recognizes that common law doctrines cannot simply be transplanted in their entirety into the realm of Title VII law.

In addition to supporting the affirmative obligation policy discussed above, this finding reflects the policy that victims have a duty to take reasonable steps to avoid or mitigate damages, too.

The Supreme Court elaborated:

> An employer may…have provided a proven mechanism for reporting and resolving complaints of sexual harassment, available to the employee without undue risk or expense. If the plaintiff unreasonably failed to avail herself of the employer's preventive or remedial apparatus, she should not recover damages that could have been avoided if she had done so. If the victim could have avoided harm, no liability should be found against the employer who had taken reasonable care, and if damages could reasonably have been mitigated no award against a liable employer should reward a plaintiff for what her own efforts could have avoided.

For example, in the 1998 case *Duran v. Flagstar Corp.*, a Colorado district court addressed the *Faragher/Burlington* affirmative defense. In *Duran*, the employee handbook contained an anti-harassment policy and provided instructions for reporting such conduct. The policy made it clear that harassment was not allowed, permitted reporting through various channels including a toll-free number, contained an anti-retaliation provision and stated that the company would investigate and take corrective action. The employee stated that she had received the handbook, read the policy and was familiar with it. The district court found that the employer had exercised reasonable care to prevent and correct promptly any sexual harassment in its organization and that it met the first prong of the affirmative defense.

"We're pleased [that the court] set down a clear-line rule," said Stephen Bokat, general counsel for the U.S. Chamber of Commerce. "This is exactly what we wanted from the court: Employers can protect themselves against liability if they have a policy against harassment, if they properly communicate it to their employees, and if they act properly on complaints brought to their attention through a grievance mechanism."

Women's groups were pleased, too. Marcia Greenberger, co-president of the Washington-based National Women's Law Center, an advocacy and litigating group, said, "I think these cases together provide an important win for women. The court has set up a promising carrot-and-stick approach." According to this approach, the stick is, if tangible employment actions are taken against sexual harassment victims, or if employers don't take steps to prevent harassment, then the employer is liable. Greenberger adds, "The carrot is, if [companies] do take strong and effective action to eliminate sexual harassment, which is what employees really want, employers have a way of limiting liability."

An Employer's Right to Adopt Policy Voluntarily

Employers, of course, have every right to restrict speech, forbid the display of pictures (sexual or not) or limit dating on the job. They certainly have the right to require that employees treat each other with courtesy and respect, though different workplaces can be ex-

pected to have different cultures. But when the state and the courts impose these rules, which businesses adopt voluntarily to avert legal action, that's a different matter.

The current interpretation of Title VII has empowered federal judges, juries and regulators to act as the sex and speech police. Apart from the constitutional concerns this situation raises, it leads to the usual consequences that follow when the state seeks to control private behavior: People are discouraged from resolving personal conflicts on their own and encouraged to snitch on others and to use laws and regulations to settle personal scores.

If you have to ask why sexual harassment and discrimination have become so prevalent in today's workforce, you can be sure there's no one simple answer. To begin with, there are at least two categories of contributing factors:

1) philosophical/psychological/sociological (i.e. sexual harassment isn't about sex, it's about power and how men or women compensate for their fear of losing that power); and

2) practical, nuts-and-bolts (i.e. anti-harassment policies aren't clearly communicated, so employees don't know what's acceptable and what isn't).

Generally, there are two schools of thought when it comes to answering the question of why sexual harassment happens. For one, the old Bud Dry beer commercial has it right: Why ask why? Behavior running amok in the workplace is simply a fact of life. It's bound to happen; always has, always will. There is no need to debate whether or not the entire history of civilization is fraught with examples of how abominably people treat each other, in and out of the workplace. This does not accomplish anything but lead to polarization and finger pointing. The people who subscribe to this school of thought believe the challenge lies in how to manage workplace behavior—and the less mention of past injustices, actual or alleged, the better.

The other school insists that no change in workplace dynamics can ever occur unless the context of the behaviors—historical, social and psychological—are explored. In other words, without understanding

the root of human behavior, we cannot arrive at a solution to things like sexual harassment and discrimination in today's work environment. Unlike the first school of thought, this second one takes into consideration the past in an effort to manage the present.

An effective solution requires a balance of the two approaches. It's certainly unrealistic to expect employees to behave ideally under all circumstances (although many employers are in denial about this), and the longer hours and greater stresses of the workplace foster a ripe environment for aberrant behaviors.

Any work environment is a microcosm of the larger world. From the most complex corporate structure to the smallest garage start-up, the workplace is a mirror on society that exaggerates general tensions, conflicts and passions. It's naive to expect people to leave their emotions and desires at home.

On the contrary, people who work intensely and are dedicated to their careers are *more* likely to bring their personal lives to work. Employers—and employees—in today's business world have to accept this reality—and find constructive ways to deal with it.

When a Joke...and Seinfeld...Aren't Funny

Allegations of sexual harassment, wrongful termination and even interference with employment can cost companies millions—as well as years of litigation. On July 15, 1997, a jury awarded $26.6 million to Jerold Mackenzie, a former Miller Brewing Co. executive who sued the company for firing him after he discussed a racy episode of the TV sitcom "Seinfeld" with a female coworker. This verdict came nearly a decade after the roots of the case sprung in 1987. Then, in February of 2000 the appeals court reversed the judgment. Milwaukee-based Miller Brewing Co. commented that the case was "more about Jerry Seinfeld than Jerry Mackenzie."

The "Seinfeld" case, as it became known in media reports, highlights how intricate and complex some claims of sexual harassment, as they relate to employment law, can become. As in this case, one complaint brings to surface hundreds of other issues that deliver frustration and

legal agony. *Mackenzie v. Miller Brewing Company* totaled a record of more than 10,000 pages and briefs from the parties totaled more than 300 pages.

In 1993, Mackenzie, who had worked for Miller Brewing for approximately 19 years, was fired from his $95,000 management position, after he told Patricia Best, a Miller distributor services manager who had previously been under his supervision, about an allegedly racy episode of "Seinfeld" and she complained to superiors. Her complaint played prominently in the court and the media, despite the fact that problems with Mackenzie dated back to 1987. Mackenzie had been with Miller since 1974.

In the relevant "Seinfeld" episode, Jerry Seinfeld can't remember a girlfriend's name, only that it rhymes with a female body part. Jerry and his friends try a few guesses, including "Mulva" and "Gipple." Only after the girlfriend realizes that he does not know her name and runs off does Jerry remember and scream out "Dolores!"

Mackenzie testified that he did not say the word of the body part, but only showed Best a page from the dictionary with the word *clitoris* on it. Nevertheless, shortly thereafter, the company fired Mackenzie for "poor management judgment."

The jury's verdict—almost three times the $9.2 million sought—included $24.5 million against Miller, $1.5 million against Best and $501,500 against Robert Smith, a Miller executive. Of the total award, $18 million represented punitive damages. Mackenzie alleged that Miller, Best and Smith interfered with his employment—an allegation that the company denied. According to Miller Brewing, however, this incident was one in a long line of bad decisions made by Mackenzie. In fact, he had been reprimanded in 1989 for allegations of sexual harassment by his secretary, Linda Braun—a claim that Miller eventually settled for $16,000. But the legal gymnastics between Miller and Mackenzie did not end with settled claims and an eventual termination of employment.

The case, according to Miller, was "not about sexual harassment, nor about wrongful termination, a charge that a court previously dismissed."

The case was a "narrowly based complaint by Mr. Mackenzie." When he was fired following the "Seinfeld" incident, a variety of other issues were brought to the table—all of which danced around harassment and pointed fingers at wrongful maneuvers on the part of Miller and the company's interest in promoting and maintaining Mackenzie. In the end, however, Mackenzie failed to prove his case.

Amid the flurry of appeals and expert opinions, all claims were dismissed. One judge filed an opinion that partially dissented from the verdict. Later, when we discuss the subtle issues related to sex at work in Chapter 8, we will revisit this case for a look at a unique argument added to the case's long record. But for now, we'll turn to ways in which a company can reduce liability.

Reducing Liability

Fortunately, there are ways for companies to reduce their vulnerability. Mitchell Consulting, a Los Altos, California-based management consulting firm, specializes in minimizing sexual harassment and wrongful termination liabilities. The firm offers courses that educate employees on how to avoid paying high punitive damages in liability suits. According to principal Mitchell Davis, an attorney, in most sexual harassment cases, "employers are getting hit with high punitive damage [penalties] because they knew what was going on and did nothing to stop it." Furthermore, training won't necessarily prevent liability lawsuits, because employers can't control the one bad apple in the bunch. But by putting employees through training, companies often can drastically lower the amount of punitive damages that they are ordered to pay, because they have at least tried to prevent a hostile work environment.

Davis adds that when managers are alerted to any type of harassment, they should "investigate both quickly and confidentially," because juries factor time into damage awards. In addition, promptly responding to a wrongful termination case can lessen the damages paid out by decreasing the loss of income.

Setting standards is important, too. "If a company fires an employee for sexual harassment, the issue may not be over. In fact, it could be

worse if the company turned around and gave the former employee a severance package of $350,000 because it had no policy against it. A jury could make them pay." Companies should be aware, said Davis. "They should have policies in place, undergo training and, if something does come to their attention, they should try to solve the problem right away." Thus, education and training can help thwart vulnerability while prompt investigation and mediation when problems arise can help prevent taxing legal actions.

Another important question: Is there a way to deal with abusive behavior that doesn't turn men and women against each other, doesn't obsess about trivial missteps and doesn't count on government bureaucrats to mediate every problem? The answer has already been offered: the best way is to create and implement fair policies.

Even legal experts are beginning to shift the focus of their thinking on this subject. In a widely read *Yale Law Journal* article, professor and workplace law expert Vicki Schultz argued that gender-based "hostile acts"—such as a man denigrating his female coworker's competence or sabotaging her work—have become an underreported problem while the mania over trivial matters like sexist comments or off-color jokes gives feminists a bad name.

The hostile acts probably do more harm to more women than the jokes do. An effective company policy can anticipate either…and allow managers to make the subjective decision about which needs their attention and involvement.

Setting guidelines for the company prevents you from having to make these determinations on a daily basis. If sexually explicit conversations or teasing is prohibited, then it is prohibited across the board with repercussions. And if staff members violate these prohibitions, then they need to be interviewed individually and informed that their behavior violates the organization's policy.

Now we will move on to the actual process of creating and implementing a policy on harassment. The overall goal is to reduce liability and foster a productive work environment.

Creating a Policy on Harassment

Whether you're a manager, employer, independent contractor or employee, finding out the letter of your organization's policy on sexual harassment is simply good sense. If there isn't a written policy, you should find out why and when one would be implemented.

In recent years, a consensus has developed that nondating policies are unenforceable. One Time/CNN poll reported, 53 percent of American women and 57 percent of American men believe the country has gone too far in making common interactions between employees into cases of sexual harassment. This, of course, assumes that dating is a common interaction and that policing it is going too far.

Most would agree that the point at which we police common interactions—including whom we date—is the point at which workplace policies become impractical and unenforceable. Of course, this nuance is often left to the discretion of the company—and many companies stumble over that nuance. And what happens when they stumble? Flawed notions of privacy can become an issue.

This is probably why most people prefer to look the other way until disruption develops. "Federal employees have privacy rights," says a supervisor at the Bureau of Alcohol, Tobacco and Firearms. "If they date each other and it doesn't interfere with getting their jobs done, I don't want to know. It's none of my business."

Likewise, a manager at the Equal Employment Opportunity Commission says he tells employees that "dating is your business, until it begins to interfere with the work. Then it becomes my business, and one of you will have to go. Transfer or leave. Take your choice." This is a common, and reasonable attitude to take.

Supervisors tend to view relationships in a different light. One reason supervisors may not look askance at office relationships is that many of them have been involved in such relationships themselves. In fact, nearly one-fourth of managers and executives surveyed by the American Management Association in 1995 said they'd had an office fling. Of those, one third of the men and 15 percent of the women said the

relationship had been with a subordinate, while 9 percent of men and 17 percent of women said it had been with a superior. The reality is that in today's world, both managers and employees have as much chance of finding their Prince or Princess Charming in the workplace as anyplace else—maybe more, given the 60- to 80-hour work weeks common today. And when they do, there is little their employers can do about it.

Guidelines As Proactive Steps

One way employers have chosen to deal with the reality of sexually-charged workplaces is to take proactive steps to mitigate sexual and/or discriminatory misconduct. This means implementing and adopting a company policy that not only describes sexual harassment and discrimination, but also informs employees on how to handle it. Such a policy can attempt to prohibit, restrict or merely manage all types of sexual behavior—whether consensual or not.

Michael Karpeles, head of the Chicago-based employment law group Gold, Kohn, outlines some steps employers have taken to mitigate disruption caused by office romances:

- Develop a clear written policy on dating;
- Require employees in relationships to inform their supervisors when their jobs require them to work together;
- Prohibit people involved in an office romance from reporting to each other; and
- Make the rules apply to everyone—including senior executives.

These steps, of course, hinge on the willingness of the involved parties—including the employer. But, if handled properly, these rules can help derail potential problems before they occur. And when the policies are not followed, or a serious violation occurs, be sure steps have been outlined for dealing with these situations.

In the case of a developing relationship within the same department, a single transfer of one person to another division is the best option. This is exactly what happened at one major New York publishing

company. When a female employee of the company began a relationship with a male coworker, there was little concern. But, after a few months of dating, the man she was dating was promoted to the head of the division for which the woman worked. The two immediately contacted the appropriate people and the woman was transferred to a position in which she did not directly report to her love interest. This did not quell gossip or feelings by some workers that the woman had an advantage at work due to the relationship. However, because the company was aware of the relationship, it was able to take preventative measures, thereby avoiding a potential risk exposure.

But employees aren't always as conscientious as the individuals in the scenario above. Rules on office romance are almost impossible to enforce, and some employees resist the responsibility of reporting their dating lives to their supervisors. For these reasons, many companies have chosen not to use written guidelines. Instead, these companies make suggestions but, for the most part, let employees make decisions and police themselves. AT&T is one such example of a company that does not implement a written rule to intraoffice dating, but it discourages dating between subordinates and their supervisors.

Still, some companies endorse office socializing—even going so far as to organize official social gatherings and outings. This is because, for some companies, keeping workers happy seems to outweigh the potential legal problems stemming from harassment suits. Nonetheless, seemingly innocent work-related social events can end in a lawsuit. Consider the 1993 California case in which a female police dispatcher was awarded $65,000 in damages for post traumatic stress disorder she allegedly suffered after being harassed by a police chief during an office Christmas party. Thus, the challenge lies in how to create a flexible atmosphere, where workplace relationships are not necessarily forbidden, but also to limit the possibility of sexual harassment.

Policing Romance

Researchers disagree widely on how to formulate fair policies that govern workplace romance. And, to add more fuel to the fire, there is no established decision as to an employee's rights when it comes to dating a colleague.

Legal scholars and state court decisions provide contradictory opinions regarding an employer's right to impose non-fraternization rules (rules against coworkers dating coworkers). Yet Title VII and the laws prohibiting sexual harassment do not prohibit an office romance. One might think rules against dating at work would be an intrusion on an individual's freedom of choice, if not the right to privacy, but numerous courts have upheld companies' rights to fire employees for engaging in affairs with coworkers.

In an interview with National Public Radio, Wells Fargo Bank Regional Vice President Marilyn Taylor explained why relationships between employees are such an important issue. Simply said: Security.

According to Wells Fargo fraternization rules, employees who are having a relationship—whether married or not—can't work at the same physical location (branch). "Employees understand it's a matter of security because bank procedures often require one employee to witness and back up what another does," said Taylor. "And Wells Fargo is concerned that the romantic involvement might cause other employees to question the objectivity when lovers are involved." However, Taylor explained that employees feel free to engage in workplace dating and, "They freely tell us about these kinds of things when they come up. And then our human resources specialist immediately steps in and figures out how to keep the two employees together as a couple but apart as banking professionals."

Clearly, companies have more than sexual harassment lawsuits to worry about in the workplace when it comes to sex. Situations like those described by Wells Fargo point out that dating colleagues can threaten the safety framework of a business, which in this case happens to be a bank with millions of dollars at stake.

Faced with similar concerns, many private-sector organizations have avoided establishing specific policies on office relationships. But others have enacted policies strictly limiting employee romances. Enforcing such policies is proving to be a difficult, sometimes embarrassing process. Some interesting cases to note:

- A senior executive at Staples, a corporation that had instituted a no-dating policy, was forced to resign when it was revealed that he was having a consensual affair with his secretary. Staples lost a valued officer, and the executive forfeited his lucrative job for violating company rules, even though he committed no illegal act.

- A San Francisco company asked its legal counsel to develop a "consensual relationship agreement" for a senior manager and his female assistant. They were asked to document that their affair was voluntary on both sides, that they had read their company's sexual harassment policy, and that their situation wouldn't affect either's job progress or their working relationship.

- The New York State Department of Labor challenged a Wal-Mart policy that prohibited "romantic involvements between workers regardless of whether such involvement takes place outside of work hours and off the employer's premises." Several employees discharged for violating the policy counter-complained that their rights of privacy were violated. Citing the New York State Legal Activities Law, which prohibits discrimination against employees who engage in lawful activities outside of work hours, they pointed out that dating is a lawful activity. Judge Robert Patterson agreed. He ruled that, "a careful reading of the statue…indicates that 'cohabitation' that occurs off the employer's premises…and not on the employer's time, should be considered a protected activity for which an employer may not discriminate."

Despite an increasing number of sexual harassment actions in recent years, not all companies are clamping down on employees. The realities of the modern work world—long office hours, telecommuting and more balanced gender demographics—have encouraged companies such as IBM to relax their rules about workplace romances.

Rather than forbidding the relationships outright, these companies adopt policies that encourage employees to date responsibly within the company.

Experts will always disagree as to whether companies should allow a supervisor to engage in a relationship with a subordinate. According to San Francisco legal employment consultant Susan Spade:

> Regardless of the company's position on office romances in general, the best course of action is to discourage and avoid the situation of a manager dating a subordinate through a written policy or by verbal directives from senior management. Dating relationships must be truly consensual. When a manager is dating a subordinate, that issue becomes critical because a quid-pro-quo harassment case could be looming.

In addition, attorney Steven Mitchell Sack cautioned in the October 1998 issue of *Inc.*:

> ...since the law is unsettled in this area and each case is decided on its own set of facts and circumstances, never assume that a company's actions are legal in this area. Although it may be legal to forbid employees from fraternizing, all employees must be treated similarly to avoid violations. For example, if an employer reprimands a male employee for dating a coworker but fires a female employee for a similar infraction, the employer may be committing illegal sex discrimination.

The little bit of scholarly research that exists on workplace romance and sex suggests that the work environment is even more likely to spawn romantic liaisons and relationships than the world at large. Psychologist R. J. Sternberg has advanced the notion that love relationships display three important attributes: passion (romantic feelings and sexual attraction); intimacy (feelings of connectedness and closeness between two people); and decision/commitment between the two lovers.

In the October 1998 issue of the *Journal of Management*, Gary N. Powell and Sharon Foley reported the application of Sternberg's theory of love in general to the workplace in factors that contribute to interpersonal attraction (i.e., feelings of intimacy) and factors that contribute

to romantic attraction (i.e., feelings of passion and, in some cases, decision/commitment as well as feelings of intimacy). They depicted the formation of romantic relationships in organizational settings as occurring in three stages: First, feelings of interpersonal attraction arise toward another organizational member; second, feelings of romantic attraction arise toward the same person; third, the decision is made to participate in a workplace romance.

Interpersonal attraction is influenced by proximity, which may be divided into physical and functional proximity. *Functional proximity* refers to closeness that results from the actual conduct of work. Employees who interact with each other more frequently or more intensely because of ongoing work relationships are higher in functional proximity. In turn, employees with higher physical and functional proximity are more likely to be attracted to each other. Thus, business trips, which entail high levels of both physical and functional proximity away from the constraining influence of others, are particularly conducive to the formation of romantic relationships.

If you've observed or participated in an organizational structure for any length of time, you already know that working long hours with people who share similar goals, education and sensibilities likely leads to sexual affairs among some employees—especially when business trips and/or conventions in places such as Las Vegas or Atlantic City are part of the mix. But it's comforting to know that bona fide academics are studying the phenomena, too, even if they sometimes describe the obvious in stilted, formal prose. The root issues of office romances and their effects are very serious business with real and sometimes drastic consequences, particularly in today's litigious atmosphere.

When Romance Fizzles

From the perspective of an employer or manager, it might seem that the biggest common-sense concern about workplace romances is the potential for negative impact if—and more likely, when—the romance fizzles. This is a reasonable concern, since post-breakup consequences can have an effect on the company. A breakup could lead to disruptive tension, recriminations or retribution between the ex-lovers. Worse, it could lead to a sexual harassment suit; the U.S. Supreme

Court has ruled that sexual harassment may be proven even if the complainant voluntarily engaged in sexual activity with the alleged harasser.

The waters become even murkier when it comes to employee versus client/vendor relationships. In 1987's *Schwarz v. Frost*, a woman involved in an uninsured motorist insurance lawsuit started an extramarital affair with her lawyer. When she didn't get as much money from the insurance company as she wanted—and the affair ended— she sued her lawyer for malpractice. The court wasn't sympathetic. It ruled that "the parties here chose to enter into a consensual extramarital affair, and it turned out badly. Such behavior may have been immoral and unethical for the [lawyer]. But unless there is a claim that rises to the level of malpractice based on breach of a professional or contractual duty, Frost is no more liable to Schwarz than are the many other Americans who make bad judgments in choosing a mate or engage in nefarious extra-marital coitus."

Office romance—even if it's "nefarious extramarital coitus"—is not sexual harassment. Romance is about attraction and desired advances. Sexual harassment typically involves unwanted advances and typically involves issues of power and control. Nonetheless, the line between romance and sexual harassment can get blurry, and a manager who engages in an office romance can find himself or herself charged with sex discrimination even if no allegations of harassment are raised. It happens quite easily: a romance goes sour and the scorned party files suit. Or perhaps an office colleague feels slighted by this romance and feels that he or she is being given a less than ideal workload. In either instance, a seemingly harmless romance can transform into a powder keg.

A Start: Clear, Concise Communication

You may have run into the Three Cs (Clear, Concise Communication)—an absolute essential when it comes to managing sex at work. Employers want to create an environment that is relaxed, yet productive. The optimal situation is a flexible atmosphere, where workplace relationships are not forbidden but sexual harassment cases are limited. No one wants to feel as if she is walking on eggshells, but if your

employees don't perceive that there are consequences (I added a fourth C) to ignoring policies—or at least some positive reinforcement for following them—then there's little incentive to change negative behaviors or to initiate positive ones.

Nevertheless, as necessary as the Four Cs are to the process of implementing and adopting company policies and procedures that work, this is only the beginning point for creating a successful discrimination—and harassment—free workplace. The key to success is engendering a positive sense of personal responsibility and respect in all employees for themselves and their coworkers alike.

Workplace romance and its consequences are inevitable. In fact, according to a recent interview with NPR's David Molpus, almost 40 percent of Americans admit they have dated someone from work at least once. And, according to a survey conducted by the American Management Association, said Molpus, " . . .about half the romances spawned at work blossomed into lasting relationships or marriage."

But as some critics point out, concern lies not only with the happy half but with the half that experiences a bad ending to the relationship. Formulating no-nonsense policies against sexual harassment and sexual discrimination can minimize the negative effects of workplace romance. Furthermore, the development of realistic policies on dating (fraternization) between employees—especially between supervisors or managers and workers they directly or indirectly supervise—can help manage the situations. Both verbal and written communication of said policies is vital. In fact, an increasing number of companies now include a response sheet with the packet explaining corporate policies that employees must sign and return. This response sheet indicates their receipt of the information and that they understand the policies.

Cyberproblems: Guidelines for E-mail and Internet Usage

Employers are increasingly concerned not only with what sort of information is being passed around on the company computers, but also with the fact that lots of employees are spending lots of time on the Internet engaged in a variety of non-business pursuits from checking

their stock portfolios to booking their vacations, shopping for a new job and smut-surfing. Even if employees are savvy enough not to forward sensitive materials to coworkers, a question remains: what about the fact that so many are using company time and equipment to view this material? Does the company have the right to check up on employees' Internet logs? Do employees understand that computers are designed to automatically archive and record every Web site visited?

If you'll recall, even after Monica Lewinsky erased all those e-mails regarding her Big Creep, President Bill Clinton, hardware professionals managed to acquire the content of the hard drive. And it's even easier to imagine your every mouse click being traced if you're hooked up to a company network.

Privacy and intrusion issues aren't altogether clear in the legal sense, and many employers want to avoid creating a sort of Big Brother atmosphere where employees fear that their every call, keystroke and movement is monitored. Often, managers use indirect ways to keep Internet, e-mail and phone usage under control. In one company of roughly 700 employees, mid-level managers gave each employee a copy of that employee's phone bill each month. Employees were asked to highlight any personal, long distance or toll calls. Employees were assured that they weren't being asked to reduce or eliminate the calls, and that the highlighting was just for some internal accounting purpose. Nevertheless, the practical result was that many employees reduced the number and length of their personal long-distance and toll calls.

Clearly, employers want to reduce their liability in this area, both financially and legally. At the same time, employees want to know their rights when it comes to mixing privacy issues with work-related issues. And as such, we've dedicated an entire chapter to this topic. (See Chapter 4 for more on workplace privacy issues.)

Policies on Dating, Adultery, Divorce, Etc.

Myriad instances of workplace behavior running amok could have been minimized, resolved painlessly or avoided altogether by clear, concise communication of the rules and policies. It's no mystery that

communication is one of the hardest tasks in our daily lives—and the aspect to relationships that goes unchecked. Lack of communication in general dismantles millions of relationships at all levels: family, friends and lovers alike. The fact is that confusion, disagreement and room for debate run rampant today. Employers and employees are edgy, anxious and uncertain—especially when guidelines aren't clear. Even if the policy may change in a week, it's better to commit to paper the best policy now. When it comes to workplace behavior rules, something, even if imperfect, is better than nothing.

With a clear written policy on interoffice relationships and harassment issues, and a response sheet, anxiety level is greatly reduced because people know what the rules are, and if a problem arises, there are written documents to help mitigate any disruption caused by workplace romance.

Under certain circumstances, managers or supervisors can be held personally liable in sexual harassment actions. According to labor attorney Michael Roumell, although the courts have concluded that managers cannot be held personally responsible under federal antidiscrimination laws (e.g., Title VII), some state sexual harassment laws impose liability on agents of the employer (e.g., managers). This means that an employee can also sue the manager for such things as assault or battery when the sexual harassment involves inappropriate touching.

The most troublesome workplace romances are called hierarchical, meaning that the partners hold positions at different organizational levels. Lateral romances—those between employees at the same organizational level—will be addressed later. Typical horror-story examples of hierarchical romances include a manager/supervisor dating someone he or she directly supervises or the boss dating someone several steps down the company ladder. The conflict potential in these cases is obvious:

- The supervisor might give special consideration to the lover in plum work assignments, raises, promotions, desirable business travel opportunities or other perks, even though others in the ranks might be more qualified in skill, rank or seniority.

- The supervisor might show favoritism to the lover by accepting less in terms of work performance, quality, deadlines, punctuality, etc., compared to the lover's coworkers.

- A supervisor can be put in an extremely awkward and uncomfortable position if one of his or her directly reporting employees has an affair with the supervisor's supervisor.

- The lower-level partner might use the fact of the relationship with a higher-level lover to exert office-political power over his or her peers.

Failed workplace romances (breakups) are most likely to spawn sexual harassment when a supervisor and a directly-reporting lover are involved, according to informal statistics. Yet beyond these more obvious problems, some employers and managers aren't quick to recognize the subtle but damaging toll that a hierarchical affair may take on the lower-level lover's peers.

Even if the supervisor shows the lover no favoritism whatsoever, the lover's peers may fear, imagine, suspect, assume or act as if favoritism is happening. Often, the results are disruptive, even if they're not justified. They include jealousy, eroded morale and resentment toward both the manager and the lover.

Workplace affairs, especially hierarchical ones, are usually about power, too. And it goes beyond the traditional sleeping his or her way to the top. The supervisor may need to feel power, prestige or ego gratification that he or she isn't getting in personal relationships outside the workplace—or he or she may feel the need to augment workplace power or control via the affair. The lower-level partner may need the affair to augment or assuage feelings of personal or professional insecurities or deficiencies, too. Either way, the power plays between the two may spill over to affect their workplace peers.

Assuming the affair doesn't remain secret (and how many ever do for long?), the mere fact that it's happening can stir up destructive moral and/or ethical outrage among the partners' peers. This can be especially troublesome if the affair is adulterous or involves same-sex partners.

A 1990 report in the *Journal of Business Ethics* suggested that coworker peers are most likely to respond most negatively to a hierarchical affair when the higher-level partner is a woman and the lower-level partner is a man. Moreover, any hierarchical affair in which any sort of exploitation of the lower-level partner is suspected or perceived, is also particularly damaging.

As you might suspect, lateral romances—those between coworkers at the same level—are usually less disruptive and troublesome, and are more often tolerated in the workplace. Simply put, work is a great place to meet potential romantic partners. As we mentioned earlier, the work environment often includes the physical and functional proximity that encourages interpersonal attraction. And coworkers are likely to fall within the general age range, educational level, social outlook, sophistication, etc., that are usually factors involved in choosing partners.

Yet there are pitfalls associated with lateral romances, too. Sexual harassment actions can be spawned by failed lateral romances as well as by failed hierarchical ones. For example, a rejected lover may try to rekindle the romance by pursuing the ex-partner well beyond the ex's comfort level. The pursued feels trapped because the pursuer is a coworker with whom frequent contact is unavoidable. If the pursuer persists with unwanted advances, the stage is set for an intimidating, hostile or offensive working environment. This creates an environment that Title VII of the Civil Rights Act of 1964 tries to prevent.

In addition, some studies suggest that some workplace romances lead to less productivity, loss of punctuality, missed appointments and meetings and lower motivation. Yet in other romances, the effects are the opposite. In some cases, the partners showed negative work-related effects while they were in the initial stages of the romance (the smitten, twitterpated phase). But once the romance settled into a stable relationship, a productive, positive side surfaced at work. Thus, to some degree, fostering an environment that allows for healthy, inter-office relationships is a good way to go. That is, of course, assuming that people learn to accept the set guidelines and act responsibly within them.

Lateral romances that involve morally, socially or religiously sensitive factors such as adultery can engender the same sort of coworker discontent you'd expect in reaction to a hierarchical affair. A manager needs to be sensitive to both the participants' right to privacy and non-interference, and to the practical, day-to-day workplace effects the romantic partners' choices have upon your other employees' morale and productivity. Striking a fair, workable and legal balance between these conflicting responsibilities is one of the biggest challenges most managers have to face.

Policies on Dating Clients and Vendors

One good way to think about sexual exploitation and power is to consider the way that people who work in the law—attorneys and legislators—deal with sexual relations. Attorneys who serve in a counseling relationship and a relationship of trust have a moral, legal and ethical responsibility to act in the best interest of their clients. However, a mix of sexuality and power often develops between attorneys and their clients.

A few states (Iowa, Minnesota, North Carolina, Oregon and Wisconsin) have adopted nearly complete bans on sexual relationships between attorneys and clients. Although each state's regulation has unique characteristics, all create what lawyers call a "bright-line rule"— a clear delineation between client and attorney, for which there is no argument to be made toward violation—against these relationships. These rules prohibit all sexual relationships with clients as a form of professional misconduct.

Florida's rule is an amendment to its general professional misconduct provision. It prohibits attorney-client sex only when it exploits the lawyer-client relationship. There is no guidance as to what "exploit" means, however, rendering the statute vague as to boundaries.

Although each state's rule slightly differs from another's, there is a recurring theme in policies about sexual relationships and business or work: The most flexible rules rely on a professional's ability to make good judgments about a sexual relationship. And, if the sexual relationship even appears to be problematic, the professional should step

back from the business relationship. This again reiterates a point made throughout the book: a certain level of responsibility lies with the parties involved in a relationship. But, in a litigious society, even good professional judgment isn't a complete solution. Any time you engage in a sexual relationship with someone in a business environment, legal problems can follow. Most of the time, of course, these won't be criminal problems—they'll be civil lawsuits filed by people looking for money.

There are few reported cases involving civil actions against attorneys for sexual misconduct with clients. One case in point, however, twists the typical scenario involving professional, sexual misconduct.

The Rhode Island Supreme Court found a client could recover under a malpractice theory for an attorney's sexual misconduct, although the facts did not support a finding in that case. In *Vallinoto v. DiSandro*, a client sued her attorney for, among other claims, negligence-based legal malpractice because she felt compelled to comply with his sexual demands and feared that he would terminate his representation and that she would not be able to engage another competent attorney if she did not do so.

Finding no evidence that DiSandro's legal services were contingent on ongoing sexual relations with his client and that his representation was excellent, the court concluded that his legal services met the required standards. The absence of any damages mandated a directed verdict for DiSandro on the negligence-based legal malpractice claim.

Of interest in *Vallinoto* is Judge Robert Flanders's dissent. The judge said that DiSandro committed legal malpractice by breaching the fiduciary duties owed to his client. Flanders said the client did not assert "just a 'negligence-based legal malpractice claim' limited solely to the breach of an attorney's duty to perform legal services competently, but it was also a claim based on the conflict of interest [DiSandro] created with his client when he entered into a sexual relationship with her." Flanders disagreed with the directed verdict, finding that enough issues of fact existed to submit the legal malpractice claim to the jury.

Flanders wrote:

> An attorney's foremost obligation to the client must be loy-
> alty and trust—not the attorney's personal sexual gratifica-
> tion at the client's expense. Thus, a client who is
> damaged...by the attorney's breach of his or her fiduciary
> duties through sexual exploitation of the client should be
> able to recover for legal malpractice regardless of whether
> the attorney's legal efforts were performed well and success-
> fully.

This might be considered the hardline against sexual relations in the
workplace. It's not forgiving or flexible. But it is philosophically con-
sistent and does make sense to many people.

Policy on the Harassing Conduct of Customers

Can an employer be held liable for the harassing conduct of its cus-
tomers? According to a federal appellate court for the Eastern District
of Oklahoma, an employer that condones or tolerates the creation of
a hostile work environment should be held liable regardless of whether
the environment was created by a co-employee or a non-employee,
since the employer ultimately controls the conditions of the work
environment.

In September 1993, Rena Lockard was hired as a waitress at an Atoka,
Oklahoma, Pizza Hut restaurant owned and operated by Pizza Hut
franchisee A&M Food Service, Inc. On the evening of Nov. 6, 1993,
two male customers "familiar to the wait staff" entered the restaurant.
Upon their arrival, the wait staff, including males, argued over who
would seat them because no one on the staff wanted to serve them.

According to Lockard, these two men had eaten at the restaurant
several times prior to November 6 and had made sexually offensive
comments to her such as, "I would like to get into your pants." Lockard
had informed shift supervisor Micky Jack that she did not like waiting
on the men; however, she had never explained why she did not like
waiting on them and had never relayed the substance of their re-
marks. Jack instructed Lockard to wait on the men.

After being seated, one of the gentlemen told Lockard that she smelled good and asked what kind of cologne she was wearing. After Lockard told him it was none of his business, he grabbed her by the hair.

Lockard informed Jack that the customer had pulled her hair and that she did not want to continue to wait on them. She asked Jack if he could find another server to wait on the gentlemen. But, according to Lockard, Jack denied her request, stating "You wait on them. You were hired to be a waitress. You waitress."

When Lockard returned to the table with a pitcher of beer, one of the men pulled her to him by her hair, grabbed her breast and put his mouth on her breast. At that point, Lockard told Jack she was quitting and called her husband to pick her up.

Lockard gave Pizza Hut her notice of termination on Nov. 13, 1993. She then filed a complaint with the Equal Employment Opportunity Commission (EEOC).

Following an investigation into the incident, Pizza Hut, Inc.'s Manager of Equal Employment Opportunity and Affirmative Action, wrote a letter to the EEOC. It stated that Pizza Hut denied the charge, asserting that, contrary to Lockard's complaint, Jack was not aware of the incident between Lockard and the male customers until after the men had left the restaurant.

Lockard filed suit against Pizza Hut, Inc. and franchisee A&M Food Service, Inc., alleging a Title VII claim of hostile work environment sexual harassment under the Civil Rights Act, as well as a state law claim for intentional infliction of emotional distress. Lockard testified that she had informed Jack on three separate occasions before November 6 that she had felt uncomfortable waiting on these men. However, Jack failed to respond adequately and promptly on all occasions.

Lockard requested more than $50,000 in compensatory and punitive damages as well as costs and attorneys' fees.

Not surprisingly, Pizza Hut and A&M sought dismissal of the claims, as well as dismissal of Pizza Hut, Inc. named as a party to the suit. The

district court granted their motions with regard to the state law claim and the issue of punitive damages. However, the jury returned a verdict in favor of Lockard on the hostile work environment sexual harassment claim and awarded Lockard $200,000 in compensatory damages.

Pizza Hut and A&M filed for a post-trial motion judgment, alleging that: Lockard was employed by A&M, not Pizza Hut, and Pizza Hut therefore could not be held liable on the sexual harassment claim; the harassment suffered by Lockard was not sufficiently severe or pervasive to constitute an actionable claim of sexual harassment; and Pizza Hut and A&M cannot be held vicariously liable for the alleged customer-created hostile work environment.

The company also claimed that the jury's verdict was excessive and not supported by evidence; that the district court erroneously allowed prejudicial testimony concerning Jack's homosexuality; and that the court erroneously allowed the rebuttal testimony of Mona Harrison, a coworker of Lockard's at the time of the incident. The district court denied all of the defendants' motions and awarded Lockard $1,514 in costs along with $37,088 in attorneys' fees. The defendants appealed.

The appeals court reversed the judgment against Pizza Hut, Inc. and held that Lockard failed to prove that Pizza Hut should be held liable as an employer under Title VII of the Civil Rights Act. However, it ruled that A&M was in fact responsible because Lockard had informed Jack of the hair-pulling incident and had also told him on three occasions that she did not wish to serve these customers.

According to EEOC regulations, an "employer may also be responsible for the acts of non-employees, with respect to sexual harassment of employees in the workplace, where the employer (or its agents or supervisory employees) knows or should have known of the conduct and fails to take immediate or corrective action."

"Mr. Jack had notice of the customers' harassing conduct and failed to remedy or prevent the hostile work environment," said the court. Accordingly, "A&M is liable for Mr. Jack's failure." In addition, the appeals court ruled that the district court did not abuse its discretion

in setting either the rates or the numbers of hours used to calculate Lockard's award of attorneys' fees.

Policy on Nasty Employees

A question we have not answered thus far regards employees who treat their coworkers poorly. Is an employer responsible for the actions of an employee toward a colleague? The answer to this question depends in part on a variety of factors, including where the alleged conduct occurred—that is, on or off the workplace premises—when it occurred, and whether the employee treated all of his coworkers poorly. A good example: In *Hardin v. S.C. Johnson & Son Inc.*, a U.S. appeals court in Chicago recently upheld a lower court's decision to dismiss a case involving sexual and racial harassment claims by a black female employee at S.C. Johnson & Son Inc.'s Wisconsin-based home-cleaning products company. The employee, Katie Hardin, was hired by S.C. Johnson in 1972.

In 1988, Hardin transferred to a new production line and began working under Nels Anderson. According to Hardin, Anderson was a crude, boorish person who often used expletives directed at Hardin and other coworkers. Hardin also alleged that Anderson had touched her on numerous occasions, though her complaint did not specify where or in what manner.

A year after her transfer, Hardin and several other coworkers complained to a supervisor, who told Anderson that his profanity was inappropriate for the workplace. Nonetheless, Anderson continued to use foul language and behave crudely toward Hardin and other employees.

In 1993 and again in 1995, Hardin complained to upper management about Anderson's behavior, asserting that she was being treated poorly because she was a black woman. Hardin also complained that Anderson had let a door slam in her face, cut her off in the parking lot, and startled her by driving up behind her in an electric cart without warning.

S.C. Johnson reiterated its warnings to Anderson about his inappropriate behavior and told him to avoid Hardin unless it was absolutely necessary to speak to her.

After the 1995 complaint, S.C. Johnson conducted an investigation and found that no other African American employees believed they were being discriminated against on the basis of race. However, a number of white men on the line said they felt they were mistreated by Anderson. Additional complaints—including one to the president of S.C. Johnson—resulted in Anderson being transferred to another production line.

On June 1, 1995, Anderson was temporarily reassigned to work on Hardin's production line. Hardin chose to stay home that day—a decision for which she was not penalized. S.C. Johnson had told her that she and Anderson would rarely be assigned to work together, but that if it came to pass, Hardin would be informed in advance and given the option to refrain from working with him.

On June 13, 1995, Hardin filed a complaint with the Wisconsin Department of Industry, Labor and Human Relations' Equal Rights Division (ERD). She received a right to sue letter on September 8 of that year and filed suit against S.C. Johnson alleging harassment based on race and gender. The magistrate judge ruled in favor of S.C. Johnson, and the district court upheld the decision. Hardin appealed.

According to Magistrate Judge Goodstein, although Hardin was mistreated by Anderson, her case could not survive the S.C. Johnson motion for summary judgment because Hardin was time-barred from relying on any evidence of harassment occurring prior to August 16, 1994—300 days before her complaint with the Wisconsin ERD.

Although there is an exception to the statute of limitations under the "continuing violation doctrine," according to the appeals court, Hardin's evidence could not apply to this doctrine. The continuing violation doctrine was inapplicable because Anderson's rude and obnoxious behavior—brief touching, offensive language and statements to Hardin that she leave his production line—began in 1988.

According to the appeals court:

> It is apparent that Hardin believed that she was a victim of harassment long before she filed her complaint with the Wisconsin ERD; it follows that it would not have been unreasonable for her to seek redress for this conduct by filing before June 1995. Accordingly...she may not reach back and rely on evidence occurring prior to 300 days before she filed her complaint.

The court ruled that the only actions committed within the limitations period include: (1) allowing a door to close in Hardin's face; (2) startling her by approaching her from behind in an electric cart without warning; (3) cutting her off in the parking lot; and (4) his persistent cursing and use of abusive language. "Obviously, we agree with the district court that it is unfortunate that Ms. Hardin was subjected to such behavior. Nevertheless, we cannot conclude that these actions constituted sexual or racial harassment."

For this reason, the most damaging evidence of harassment by Anderson—an alleged string of odious statements about Hardin and other black women to his then-girlfriend—was irrelevant. Because these statements were made outside of the workplace, and Hardin never heard them, they were not relevant to the case either. In addition, even if the court considered such statements, they would not have been relevant because Anderson was not a decisionmaker at work. Thus, his statements did not provide the basis for a determination that he acted upon racially discriminatory motives.

The evidence also demonstrated that Hardin was not singled out for abusive verbal treatment. Hardin herself testified that Anderson cursed at all employees on the line—white and black, male and female. "This is supported by the depositions of nearly everyone who testified," said the court. "[I]t is undisputed that Anderson was a crude individual who treated all of his coworkers poorly. Thus, it would not be rational for a trier of fact to conclude that Anderson made the workplace less congenial for women or blacks than he did for men or whites," the court ruled.

Additionally, Hardin's claims of discrimination were insufficiently severe to give rise to a hostile environment. The court noted that there is a "safe harbor for employers in which the alleged harassing conduct is too tepid or intermittent or equivocal to make a reasonable person believe that she has been discriminated against on the basis of her sex."

The appeals court therefore affirmed the district court's ruling, stating that Hardin could not establish that she was subjected to either gender or racial discrimination creating a hostile work environment. In addition, she failed to point to anything that showed either that white coworkers complaints about Anderson were responded to with more alacrity or that their complaints about any similar incidents were treated more solicitously by the company.

Arbitration and Self-Policing

In our discussion about good policies that companies should enforce, there's one that has received recent criticism and has been a cornerstone in the securities industry for years: mandatory arbitration. This is the requirement that, as a condition of employment, employees must waive their rights to a trial by jury in federal district court and must instead file their discrimination claims with arbitration boards. Stockbrokers, for example, have been routinely forced to waive their rights to sue in exchange for a job.

Companies began this trend in the hopes of reducing the potential costs that claims of harassment and discrimination bring to a company. However, such a company policy "is nothing more than a way for employers to evade the stricter Civil Right Act of 1991," according to the National Organization for Women's (NOW) president Patricia Ireland. In fact, NOW led the fight against mandatory arbitration, calling for companies like Hooters, Circuit City and J.C. Penney to stop the practice. And, on May 8th in 1998 the 9th Circuit Court of Appeals handed down a landmark decision prohibiting mandatory arbitration of Title VII claims. The ruling forbids all employers—including the securities industry—from requiring employees to sign mandatory arbitration agreements as a condition of hire.

Conclusion

We started this chapter with a look at Hooters and went as far as to applaud their methods for limiting sexual harassment claims via policies. Obviously, the company is also known for having utilized an arbitration system that, some would say, unfairly favors the employer. A point to be made here is that while we can applaud Hooters for one good practice and condemn them for another, every company has the right to create and implement its own policies.

There is no right way to go about formulating policies in order to please everyone and erase liability. Companies that take the initiative to set policies place themselves ahead of the rest. Keeping abreast of legal actions—like that which made mandatory arbitration illegal—is an added challenge, but one that can further protect the rights of both employer and employee.

Company policies couldn't be more vital today. I've covered several aspects to creating and implementing such policies, and have noted that there is no sure-fire way to prevent harassment and illegitimate behavior on the job. But with clear, concise policies in effect, liability is greatly reduced and productivity can reach a maximum.

It's not easy when it comes to hard decisions like policing romance or managing a relationship that blends work and private lives together. That is why sex at work is a stubborn issue and why lack of communication—whether it be between the dating parties or between the company and employees—can lead to expensive legal battles and unwanted consequences. Once we accept the reality of our working lives, and the fact that personal matters all too often present themselves between the hours of nine to five, we can learn how to cope with certain behavior and act responsibly.

The Subtle Stuff

So many subtleties convolute the issues of sex at work, that we've mixed a few last topics into this final chapter to finish the picture of today's workplace dynamics. The way we dress, the schools we attended (or didn't), the jokes we tell and even the partners we choose affect how people at work treat us.

Fair enough. But that's not the whole story. The problem is that these reactions and treatment are all too often based on *misperceptions* that others have about us: A short skirt means a woman is open to sex with coworkers, a few effeminate gestures mean a man is a homosexual, vaguely sexual banter means two people are having an affair.

Some of these misperceptions may veer toward...or crash headlong into...sex-at-work issues. This is especially true, given the wide range of issues raised by hostile environment sexual harassment claims. But, as we've seen before, federal law is not designed for dealing with subtle issues. And people who think that it is are usually disappointed.

The December 1999 federal court decision *Jacqueline Naylor v. City of Bowie, Maryland*, shows that subtle acts of an apparently sexual nature do not necessarily rise to the level of *severe and pervasive behavior*—the requirement for proving a case of sexual harassment.

In this chapter, we'll first look at the *Naylor* decision as it relates to questionable behavior, then turn to a variety of other topics that make up gray areas when it comes to sex at work. These other topics include dress codes, gender stereotypes, class and education status and even something as philosophical as what constitutes a lie.

On August 30, 1995, Jacqueline Naylor was hired by the City of Bowie to work as a laborer at the city's Wastewater Treatment Plant. As the only female employee at the plant, Naylor was given her own changing room, which included a restroom. Her immediate supervisor, Joseph Schneider, the plant Superintendent and a 35-year city employee, was responsible for completing Naylor's employee performance evaluations until June 2, 1998. Not only was she satisfied with all of Schneider's evaluations, but she maintained that he rated her fairly.

On November 3, 1997, Naylor's husband passed away. Profoundly affected by the loss of her husband, she nevertheless worked her regular shifts at the plant beginning soon after the death. She suffered crying spells in the middle of her shift as the result of her grief and attended a grief counseling group for several months.

During this time, Naylor began taking Prozac, an anti-depressant drug, to help her better cope with the depression she felt after her loss. She had never taken Prozac before. (Her doctor prescribed sleeping pills for her as well.)

Beginning in early 1997, intensifying in regularity from November of that year through May of 1998, Naylor claimed that some 24 incidents constituted an atmosphere of sexual harassment at the plant.

The first two of these incidents occurred sometime before November 1997. Naylor states that on two occasions when she was cleaning a piece of machinery and when she was working in a stall, Schneider approached her from behind and commented that he "loved" to watch her work. On another occasion while watching her work, he said that "he wished he could take her home."

After the death of Naylor's husband, she claims that Schneider and other coworkers came to her house to deliver some food. And, according to Naylor, there was nothing significant about this contact with Schneider.

In December 1997, Schneider asked Naylor to meet with him in private in the conference room at the plant, where he gave her a Christmas card with a $50 bill inside. He requested that she not tell anyone

about this gift. Naylor accepted the gift, but claims that it made her "uncomfortable" because it occurred "behind closed doors."

Schneider also touched Naylor during this encounter; however, according to Naylor, this touch was only "to put his hand like on my shoulder, you know, to like confide in me like, 'Oh, have a Merry Christmas and I got this for you....'" Naylor subsequently tore up the card outside of Schneider's presence, but used the money to buy a Christmas gift for a friend.

In January 1998, Naylor and Schneider made arrangements for Schneider to come to her house during working hours one day to try to repair her broken furnace. They traveled in separate cars to her house, where Naylor's daughter was present. Unable to fix the furnace, Schneider drove back to the plant, retrieved two space heaters and delivered them to Naylor at her front door.

Naylor ensured that her daughter was present the entire time because she felt "uncomfortable" about Schneider coming to her house. At the same time, however, she testified that no objectionable behavior took place on the part of Schneider during that visit.

Around Valentine's Day the following month, Schneider gave Naylor a Valentine's Day card with another $50 bill inserted in a money holder inside the card. This exchange occurred in private in the conference room at the plant. Although Naylor acknowledged that "there was something going on that was not right," she kept both the card and the money—failing to object to the gesture at the time of the exchange.

Sometime in April, Schneider requested that Naylor accompany him in a walk down to the woods on the plant grounds and check the fence line near the lake for holes. During this walk, they talked about "life, [Schneider's] childhood, about anything in life" for 15 minutes and then returned to the plant.

There were no inappropriate comments made by Schneider during this trip nor was there physical contact of any sort. However, Naylor testified that she felt "uncomfortable" because she was the only em-

ployee at the plant "asked [by Schneider] to go do that." Later that April, Schneider left a multi-pack of microwave popcorn in Naylor's bathroom, which he knew she liked. Again, Naylor expressed her displeasure with the gesture by throwing the popcorn away when she discovered that it was from Schneider, but did nothing to express her disapproval to him. Naylor did not at the time or thereafter tell him to stop giving her gifts or stop leaving them for her in her bathroom.

Schneider gave Naylor another $50 that spring to buy a new pair of work shoes because he said that her "work shoes were falling apart." Again, she kept the money but did not use it to buy shoes. She stated that she found Schneider's conduct with regards to this exchange to be objectionable because it was "strange" and "uncomfortable."

During this same period, Schneider on one occasion invited Naylor to meet him at a local Mobil gas station in her car so he could fill up her gas tank using his new Mobil Speedpass. Naylor told him that she did not need gas, and she did not meet him at the gas station.

Schneider later told Naylor that he had gone to the gas station anyway and had waited for her for about 30 to 45 minutes. Naylor responded by stating that she had already told him that she was not going to come. Schneider spoke to Naylor about this in a "calm, regular conversational tone" and took no adverse employment action against Naylor for not having met him.

She found his request to meet her at the gas station objectionable because it was "strange."

In another incident, Schneider gave Naylor a box of peanut-butter cookies, wrapped in a taped blue rag. Shortly thereafter, Schneider left a bottle of Canadian Club liquor on the front seat of Naylor's car as a gift. Naylor accepted both of these gifts without objection.

During the same period, Naylor found a tub of candy in her bathroom that Schneider had left for her. She threw the candies in the trash. But again, while Naylor found this conduct objectionable because Schneider had "been in [her] bathroom," she did not immediately complain to him or any city officials about this behavior.

Later, Schneider left a large container of LifeSavers candies in Naylor's bathroom after she had been out sick from work. The note attached to the candies stated that Schneider was "sorry" she had been out sick and that he hoped she was feeling better.

On yet another occasion, Naylor and Schneider went on a field trip to inspect the fence. During this trip, Schneider gave Naylor a white envelope containing $50, which she kept. Again, no objectionable conduct or improper physical contact happened on this trip.

In May 1998, Naylor cleaned out her garage at home and brought to work some containers of oil to be disposed of at the Bowie recycling center, which was located a short distance from the plant. Although Naylor told Schneider that she did not need assistance with this task, he accompanied her anyway in her car on the trip to the center. When Naylor attempted to start her car to drive back to the plant, Schneider requested that she "stop and sit here for a minute," an invitation that Naylor did not refuse. Schneider then gave her a card with a note stating "extra pay for special person" with $250 inside.

Schneider then stated to Naylor: "I don't want you to think that this money is to get into your pants," after which Schneider turned his head and mumbled, "but I certainly wouldn't mind."

Naylor did not respond in any way to this comment. After this exchange, Naylor and Schneider drove back to the plant, and Schneider left the car and "went about his business." Naylor kept both the card and the money.

This type of conduct—of gift-giving, cards and trips that made Naylor feel uncomfortable, yet which did not lead her to complain or direct her disapproval to Schneider—happened repeatedly and at various occasions. Naylor agreed that no objectionable behavior took place on many of these occasions. However, hints of interest on the part of Schneider kept coming and increased in obviousness. For example, underneath a box of candies she had received from him, Schneider had left a wrapped condom. Then, in late May of 1998, a final trip to inspect the fence led to the defining moment for Naylor.

According to Naylor, this was a trip when "everything happened." Schneider placed his hand on Naylor's shoulder, neckline and back, and he left his hand on her back while they talked about subjects ranging from Schneider's family to Naylor's deceased husband. She did not ask him to remove his hand from her back. At no point during this trip or immediately thereafter did Naylor express any objection to Schneider or to any city officials about this unwelcome physical contact. Nonetheless, Naylor testified that had she been in her right state of mind, "[she] would have punched him in the face and kicked him in the balls." Naylor described her state of mind at the time as "functional" and stated that she knew the contact was "hurting her inside" and making her "uncomfortable."

Jealously began to come into play when Naylor and a coworker composed a list of people they "like[d] the most" at the plant. When Schneider managed to obtain a copy of this list—noting that he wasn't number one—he told Naylor that he wanted to be number one on her list. Later, his birthday card to Naylor around Memorial Day weekend, 1998, read, "Happy Birthday from Friend #8." This gesture upset and embarrassed Naylor.

Although Naylor acted passively throughout most of this period, she finally actively responded on May 29, 1998. Schneider again met with Naylor in private in the plant conference room at his request, where he gave her a card with a $50 bill inside that read, "[w]hich would you rather have, a little love or a little money, how about a little of each?" Later, Schneider specifically asked Naylor "which one do you want, the love or the money?" at which point Naylor pushed the card back into Schneider's chest and told him she did not want or need his love, his money or anything from him.

When Schneider insisted that she keep the card and money, she shoved them in her pocket, left the conference room and began to cry. Shortly afterward, Naylor went back to work.

Several days later, Naylor's father reported Schneider's conduct to David Deutsch, Bowie's City Manager. The day after that, Naylor met with John Clinton, a city official, and specifically complained

about many of the incidents in question. The City of Bowie had a sexual harassment policy in effect during the period in question, which was outlined in the employee handbook. It was clear from this stated policy that the city had adopted a no-tolerance position with regard to sexual harassment.

Naylor did not tell Clinton about several of the incidents that she would later rely upon as support for her claim of sexual harassment. Interested in remedying the situation, Clinton assured Naylor that she would not lose her job. He indicated that he would interview some of her coworkers about her complaint and then contact her with the results of his investigation.

On June 5, 1998, three days after Clinton's meeting with Naylor, Clinton sent a letter to Schneider, informing him that his behavior toward Naylor was unacceptable. The letter outlined in some detail the actions that the city would be taking against Schneider as the result of the complaint and the city's subsequent investigation.

Schneider was told that Naylor had been instructed to report to Clinton any recurrence of Schneider's conduct and that severe discipline would be administered if the conduct continued. Schneider was ordered to:

1) stop at once all of the conduct to which Naylor had objected;

2) immediately cease any supervision over Naylor;

3) not socialize or have any social interaction with Naylor in or outside the workplace; and

4) in no way retaliate against Naylor for having made her complaint.

Naylor acknowledged that, after she filed her complaint in early June of 1998, the behavior to which she objected ceased altogether. Naylor also admitted that since her complaint, she has been supervised by another city employee.

For the most part, Schneider was not even present in the administrative building in the plant when Naylor undertook her cleaning du-

ties. During her deposition, Naylor indicated that she found it "hysterical" that Schneider would on occasion leave a building or room where she was present or would change his direction upon seeing Naylor.

Nevertheless, Naylor complained in September of 1998 that Schneider had recently been becoming more visible to her at the plant. City officials then changed Schneider's work schedule so as to ensure that Naylor and Schneider would not have any contact with each other whatsoever. Then she filed a charge of discrimination with the Equal Employment Opportunity Commission on October 22. On November 5, the EEOC issued her a "Right to Sue" letter. Naylor filed a lawsuit against the city in federal court on February 3, 1999.

To Naylor's dismay, the city moved for a summary judgment dismissing the claims. The court wrote:

> The vast majority of the incidents in question were innocuous occurrences between a man and a woman interacting during the course of their employment. Naylor characterized many of Schneider's acts as being "strange," and she has testified that she felt merely "uncomfortable."

The court reasoned that only a few of the challenged acts had a sexual connotation. It was certainly offensive conduct when Schneider offhandedly mentioned that he "wouldn't mind" getting "into your pants" and when he left a condom underneath a box of candies that he gave to her. However, these isolated "offensive" occurrences did not rise to the level of being sufficiently severe and pervasive to create an objectively hostile or abusive work environment.

Furthermore, according to the court, at no time was Schneider's conduct physically threatening or humiliating. There were no attempts on his part to kiss her or to physically force himself upon her in a sexual encounter. He never requested that they engage in sexual relations, nor did he threaten her with the loss of her job if she did not comply with such a demand. If anything, some of their interaction seemed childish—subtle and coquettish on his part and weak on her part.

In characterizing his conduct as "strange" and her feelings as "uncomfortable," Naylor did not show that she had been humiliated by what Schneider did. Indeed, she did not return any of the money and she did not tell him that his conduct was unwelcome until late May.

Although Naylor testified that she was fearful of losing her job, the evidence that Schneider actually threatened her with such a loss was "meager and insubstantial." Once, he indicated that she might lose her job if she mentioned that her timecard had been falsified by him. She had only a vague recollection of one other such occasion—when Schneider might have told her that she would lose her job if she told his wife and kids that he was giving her money and cards.

Also, there was no evidence that Schneider's challenged conduct unreasonably interfered with Naylor's work performance. Throughout the period of time in question, Naylor continued to perform her employment duties in a satisfactory manner. She received annual increases in her pay—and she testified that Schneider rated her fairly.

With regard to the hostile work environment claim, the court concluded:

> ...the behavior of her supervisor, Schneider, challenged by plaintiff in this case, was not so objectively offensive as to alter the terms or conditions of Naylor's employment. What occurred here was no more than "intersexual flirtation" which, as noted by the Supreme Court, should be considered a part of ordinary socializing in the workplace and not a discriminatory condition of employment.

Naylor may have found Schneider's conduct to be annoying and offensive, but evidence of severe and pervasive conduct must exist in order to satisfy the Title VII requirement that the conduct in question, when viewed objectively, amounts to sexual harassment.

Naylor also alleged that the city failed to take proper remedial measures to deter Schneider's sexual harassment after it was informed that a workplace harassment situation existed. However, the court concluded that "there [was] no merit to the claim alleged by [Naylor]."

Specifically, the court noted:

> First, plaintiff's…claim must fail because this Court has con-
> cluded as a matter of law that the alleged sexual harassment
> was not sufficiently severe or pervasive to sustain plaintiff's
> Title VII claim. In the absence of facts indicating a viola-
> tion of Title VII, defendant Bowie had no duty to under-
> take proper remedial measures.

Moreover, the court explained that Naylor has the burden of proving,
as alleged, that the City of Bowie had failed to take proper remedial
measures when it learned of a workplace harassment situation. There-
fore, it was not necessary for Bowie, in responding, to raise the affir-
mative defense to liability, as outlined in *Faragher*. The court in this
case was not satisfied that Naylor had met this burden. And as such,
the court threw out her entire lawsuit.

Workplace Gray Areas

While discrimination and harassment can be hard enough to define,
much less correct or prove, several other gray areas cloud the work-
place. Few of these ever find clear-cut satisfaction in the legal arena,
which is why it is so important for both organizations and employees
to address any nebulous policy or behavior outright.

Yet while this seems like the common sense approach to creating the
harmonious workplace, you can't overlook the reality that people bring
their baggage to the work. Just as work-related issues tie knots into
everyone's personal life, so do personal aspects knot the work-related
environment. There is no distinct boundary between the two arenas.
In fact, statistics released in 1999 report that men work an average of
49 hours a week, adding up to three additional months a year. Women
work a bit less at 42 hours a week. Why is this significant? When
employees begin spending more time in the workplace than at home,
the job then becomes a surrogate home for them with coworkers as-
suming the roles of surrogate family members—thus recreating all the
dysfunction of an American family unit.

In essence, the workplace has become one big gray area—a place
where we work but also a place where we interact, share ideas and

stories, rely upon and confide in colleagues, plan futures, celebrate all sorts of accomplishments and meet potential mates. To a large extent, we are left to police ourselves, and hope that every other person does the same with a sense of respect and sensitivity. This, too, adds to the gray area because policies can only go so far.

Dress Codes

It doesn't take entering the working world to understand the importance of dress codes. Most private schools—and even several public schools—have begun to enforce dress codes because of the tone they set in the classroom. The theory is: Dress codes automatically establish a decorum that fosters a productive, equal environment. As Oscar Wilde once said, "It is only shallow people who do not judge by appearances." Likewise, Shakespeare cautioned in *Hamlet* that "apparel oft proclaims the man."

Fair or not, how an employee dresses speaks volumes about him or her. In the business world, attire sends instant messages about status, career and professionalism, self-image, self-confidence—even work habits and the workplace. For years, entire societal categories were identified by clothing terms: "blue collar," "white collar" and "pink collar." These haven't changed.

Fashions have certainly broadened and evolved since the days of the three-piece corporate uniform or the 1980s "dress for success" model. Today's attire is more situational, which essentially means adapting your appearance not only to the day-to-day flow of life at the office but to the expectations of those with whom you do business.

IBM, renowned in corporate America for its rigid dress code of white shirts and dark suits, adopted a policy in 1998 of allowing employees stationed at headquarters to wear casual dress. The *Wall Street Journal* reported that IBM employees at other, already casual, locations seemed to have adopted a chinos-and-loafers look just as rigid as the old one. That is, chinos and loafers *are* the dress code.

So just how important are dress codes in the workplace and what function do they serve? Organizations that employ professionals gen-

erally favor "industry-appropriate" dress codes in which employees are allowed to decide what is appropriate given their position, rank, job and duties. Personal responsibility factors largely into this kind of dress code, but the same holds true when it comes to general company policies on discrimination, harassment and intraoffice dating.

A company can only regulate and manage its people to a degree; at some point, the majority of responsibility lies within each individual—as it should be in a free world.

Class Issues: Anita Hill v. Paula Jones

Clothes played a small role in at least one infamous sexual harassment case. When Paula C. Jones sued Bill Clinton, she alleged that the President (who, at the time, was Governor of Arkansas) singled her out of a crowd of women working at a state business function at a Little Rock hotel. Apparently, he was attracted by her short skirt, revealing stockings and aggressive make-up. He invited her to come upstairs to a room in the hotel...and propositioned her sexually.

Was Jones dressed inappropriately? Apparently not. But she wasn't dressed like, say, a high-powered attorney trained in the Ivy League. Her dress suggested a lower workplace status—clerical rather than professional. This may have had something to do with Clinton's interest, which supports the familiar feminist argument that harassment is more about power than sexual attraction. And it certainly doesn't say much good about Clinton.

The whole Jones/Clinton episode turned the politics of sex in the workplace on its head. By comparison, the Anita Hill/Clarence Thomas hearings a decade before—which involved many of the same issues—had been relatively straightforward. A powerful, politically-conservative man had apparently made a series of awkward passes at an attractive (less politically conservative) subordinate. Arguably, these passes could be considered harassment. The alleged harasser, because of his status as a Supreme Court nominee, had to speak in cautious terms about the charges. The alleged victim was free to speak her mind...and was articulate in doing so.

It's hard to convey to men and women too young to remember the Hill/Thomas hearings the effect that they had on most Americans. Sexual harassment became a key issue in the courts and the workplace. Many women felt free to speak about years of bad treatment...if not outright harassment. Courts treated the charges more seriously. Several were elected to the U.S. Senate because the men there "just didn't get it."

Ten years later, when Paula Jones made similar charges against Bill Clinton, the issues were less clear-cut. The alleged harasser was a political ally of the feminist establishment. The alleged victim was supported by right-wing political action groups pushing an anti-Clinton agenda. The alleged harasser was glib and articulate. The alleged victim was not.

So, the same groups that had been outraged by the Hill/Thomas hearings had to hold their tongues during the Jones/Clinton lawsuits. Instead of well-focused passion, there was philosophically inconsistent rationalization. One well-known feminist argued that, if Clinton's harassment and philandering was the cost of his support of reproductive rights, she was glad to pay it.

These tortured positions highlight a bias that may be casting a large shadow over the current era: class-based bigotry. There were a number of differences between Anita Hill and Paula Jones, but the most distinctive was probably their level of education and career tracks. A member of the media elite like Susan Estrich considered Anita Hill a "friend of ours" not only because of the political orientation of Hill's charges but also because Hill had gone to the same kinds of schools as Estrich, studied for same profession and traveled in the same professional circles.

Paula Jones, on the other hand, was not a college graduate. She had held a series of low-status jobs in and around Little Rock, Arkansas. Her clothes, makeup and mannerisms spoke plainly to a working-class background. Her legal advisors had connections with the Religious Right.

Perhaps the least kind—and most telling—thing said of Jones during her case was attributed to former Clinton advisor James Carville.

Carville said, in an indirect reference to Jones, "Drag a hundred dollars through a trailer park and there's no telling what you'll find." Carville clearly characterized Jones as a tramp, as did many Americans watching the demise of an American President.

This quote, however humorous, makes Carville sound more like an obnoxious fraternity brother than the liberal politico he is. And that is exactly why the class-based bigotry seems so defining of the political response to Jones's claims.

There's another, less cultural but even more troubling, difference between the charges made by Anita Hill and Paula Jones. Hill never made any sort of formal complaint against Thomas; Jones did make a formal charge—in the form of a lawsuit—against Clinton.

Anita Hill made her charges against Clarence Thomas not in a legal arena but in a political one: the Senate hearings on Thomas's nomination to the Supreme Court. There was no formal, legal process to the proceedings. If there had been, Thomas would have likely rebutted Hill's charges more aggressively—and his lawyers or allies might have attacked her more personally.

Instead, because he had not been formally charged with any wrongdoing, Thomas was stuck in a kind of limbo...and couldn't directly confront or cross-examine his accuser. This is part of the reason he would later refer to the proceedings as "a high-tech lynching."

Jones sued Clinton in federal court. As a result, she was deposed by Clinton's attorneys before trial and—as often happens in these cases—her background and sexual history became fair game for public discussion. (As did Clinton's, which resulted in the unearthing of his affair with Monica Lewinsky.)

This distinction is troubling because it suggests that an accuser is in a better position, tactically, if she doesn't make a formal charge against a harasser. Leaving aside the respective politics of the Hill and Jones charges, this perverse "advantage" seems like a bad thing for a less notorious accuser who has truly been wronged. In other words, playing it straight and responding to harassment as the law suggests may

be a less effective road for a victim to take if someone has actually treated her badly and harmed her at work. This is especially true of the alleged harasser is high-profile. This is, surely, an unintended consequence of the law. But it fits the consistently unpredictable nature of laws related to sexual behavior.

Stereotyping

Despite advances made by just about every minority group in the U.S., stereotyping still exists in many areas, including the workplace. And, despite the fact that many traditionally male-dominated jobs—such as construction and aerospace—are no longer comprised of only men, subtler forms of stereotyping exist within many organizations. Men and women are not segregated by jobs, but they are increasingly segregated *within* jobs.

Stereotyping can indeed make employees feel and therefore act invisible. Yet stereotyping is not generally an organizational decision, but rather an insidious bias or prejudice by management. Simply put, stereotyping is often a consequence of mere human behavior, and hard to avoid, let alone manage. Addressing issues of stereotyping can best be accomplished by enforcing clear company policy.

Is this necessary? Probably. Women and minorities continue to face barriers to career advancement in today's workplaces, according to a survey of human resource professionals. The survey, by the Society for Human Resource Management (SHRM), found that nearly nine out of 10 human resource professionals believe that women face barriers to career advancement, and more than seven in 10 believe that minorities encounter similar obstacles.

The results of the survey indicated that employers need to continue to focus on workplace diversity, said Sue Meisinger, senior vice president of SHRM. Survey respondents suggested that the main barriers to career advancement faced by women were corporate cultures that favored men; stereotypes and preconceptions of women, such as family responsibilities interfering with work; lack of women on boards of directors; and exclusion from informal networks.

What is the most effective way to eliminate these barriers? Respondents to the survey said that two things were key: 1) gaining chief-executive support for women and minorities in professional and senior roles; and 2) making a dedicated effort to recruit and retain senior female and minority managers.

In the 1990s, with women reaching numeric parity in many industries, the issue has become more central. Labor Department data shows that men lost nine times more jobs than women in the 1990-1991 recession and gained only about one-third as many jobs as women after. As a result, more couples—including many with high-income jobs—are willing to sue over alleged bias "to protect the family's economic future." This indicates that men, as well as women, may have an invested interest in assuring that women receive equal pay.

Stereotyping Based on Gender-Specific Behavior

Because gender diversity problems usually depend on sex stereotypes, it's possible to make a few generalizations. In the United States, as in many countries and cultures, women have historically been tagged as passive and deferential, while men have been deemed aggressive and forceful. More often than not, behaviors that fall outside of this norm are categorized as negative, whether it be an assertive woman or a passive man.

Feminist and egalitarian challenges today similarly have met with a renewed emphasis on segregation of the sexes in the increasingly popular fundamentalist Christian, Orthodox Judaism and Islam religions. But religion aside, preconceived notions about gender-specific behavior are rooted within our common, shared culture, and are hard to change. Women's demonstration of abilities equaling those of men in business, the professions and skilled blue-collar work has often resulted in a backlash directed not at their technical abilities, but at their interpersonal skills.

Women lawyers, for example, find that male colleagues regard them as socially awkward, stiff and inflexible (as opposed to the men's view of themselves as warm and relaxed). Women working in blue-collar jobs often face hazards put in their way by resistant men, such as as-

signment to broken-down equipment or poor schedules. Recognizing this trend, the courts are now forcing employers to monitor such activities. And the goal, in the long run, is a slowly evolving societal culture that rids the boundaries between the sexes.

Gender-linked preconceptions and prejudices cut both ways. Sometimes, women regard men who work at the same jobs as unsuited to "women's work" and expect the men to be transferred to better jobs faster than women. Similarly, some men complain that customers show surprise and even anger when encountering a man when they expect a woman. If you're a woman, do you seek out a female nurse when visiting a clinic, knowing that you will have to strip down to a gown? If you're a man, do you feel that working as a secretary to a woman would result in unpleasant ridicule?

Attitudes toward these situations are easy to understand, because we are not used to changed status quo—a climate in which women and men are not divided by their choices in jobs. Attitudes are changing as colleagues and customers get used to desegregation at the job site.

Carolyn Desjardins is the author of an often-quoted academic study on "Gender Based Team Building." Her work in the field of psychology followed that of Carol Gilligan at Harvard University. Desjardins's post-doctoral research with Gilligan aimed to determine gender differences in leadership styles and leadership concepts.

Together, the two interviewed 74 college presidents to determine moral orientation and leadership competencies. The research found that the genders are equally competent in leadership, but often have different approaches based on moral orientation toward leadership roles.

The research demonstrated that moral orientation is gender related, but not gender specific. According to Leslie Jenness, who studied with Desjardins:

> More men are in the justice/rights approach, which is less personal and more concerned with what is right and just. More women are in the care/connected approach, which is more personal and concerned with maintaining

connections. Keep in mind this is only the "norm" for men and women. This norm continually shifts and changes, but we still find it to be a significant truth to recognize while working on gender issues in the workplace.... Combined with the differences in moral orientation the research showed that men are more threatened by intimacy/vulnerability and fear oppression, whereas women are more threatened by autonomy/isolation and fear abandonment. The movement between the differences leads to a variety of problems in the workplace for each gender, i.e., sexual harassment, misunderstandings, discrimination, anger and difficulty in relating on a professional adult-to-adult basis.[1]

Of course, reading this you might conclude that the study was rationalizing sex stereotypes. That's not what it means to do. The critical point is that while we can acknowledge the *differences* between the sexes, workplaces should strive toward a certain level of equality at work via how we *manage* the sexes, their interactions at work and individual needs.

To protect the organization, many managers are now choosing diversity training for (at the very least) their management-level employees. A great deal of the inequities that occur in the workplace are due to simple ignorance, which organizations can no longer overlook.

A wealth of psychology can be brought to the table for the purpose of understanding—and managing—workplace inequities but, alas, as people we surrender to human behavior and at best, must learn to tolerate deficiencies in workplace equality.

Is Stereotyping Actually Discrimination?

Establishing policies that treat men and women as equally as possible is the obvious first step in a solution. But, even though the flood of women into the workplace has upended traditional gender prescriptions, some people still cling—consciously or unconsciously—to biased stereotypes. In today's corporate work environment, sex stereotyping is generally displayed in more subtle varieties.

[1]This analysis comes from a Web site authored by Leslie Jenness (www.scheduleearth.com/Articles/gender.asp). Jenness is the President of the National Association of Gender Diversity Training.

Legally, sexual harassment is a form of discrimination. Practically, it's based on the respective perceptions of the perpetrator and the victim. One person's harmless flirtation is other's debasing malice. It's an issue obscured by a mix of political perspectives and subjective interpretation that make the Japanese folk tale *Rashomon* seem simple.

Employment decisions generally involve a variety of objective and subjective factors; decisions are often made by the group the candidate would be joining. Under these circumstances, subjective judgments of interpersonal skills and collegiality are vulnerable to gender stereotyping. For example: A woman's criticisms of a policy are seen as picky or caustic while a man's are seen as detailed and incisive. This kind of double standard is simply illegal. You can't use it—and you can't allow the people who work for you to use it.

In its 1978 decision, *City of Los Angeles v. Manhart*, the Supreme Court concluded:

> Employment decisions cannot be predicated on mere "stereotyped" impressions about the characteristics of males and females. Myths and purely habitual assumptions about a woman's inability to perform certain kinds of work are no longer acceptable reasons for refusing to employ qualified individuals, or for paying them less.

Working women have always had to reconcile the impulses to act in a stereotypically feminine manner and to be aggressive enough to succeed in a performance-driven workplace. This is a conflict...a sort of catch-22. When relatively few women worked, relatively few employers had to worry about accommodating it. Today, it's a bigger problem.

The 1989 Supreme Court decision *Price Waterhouse v. Ann B. Hopkins* dealt with some of the conflicts created by sex stereotypes in the workplace. But the case also shows that the burden of proof in a sex stereotype case is heavy. As with many sex-related issues, it's hard to show absolutely that an employer's decision is based on illegal biases.

Ann Hopkins was a senior manager in an office of the accounting firm Price Waterhouse when she was proposed for partnership in 1982.

Some details about how the promotion was supposed to go: A senior manager became a candidate for partnership when the partners in her local office submitted her name as a candidate. All of the other partners in the firm were then invited to submit written comments on each candidate.

After reviewing the comments and interviewing the partners who submitted them, the firm's Admissions Committee made a recommendation to the firm's Policy Board. The Policy Board then decided whether to submit the candidate's name to the entire partnership for a vote, to "hold" her candidacy or to reject her.

The recommendations of the Admissions Committee and the decisions of the Policy Board were not controlled by fixed guidelines: a certain number of positive comments from partners would not guarantee a candidate's admission to the partnership—nor would a specific quantity of negative comments necessarily defeat her.

Hopkins had worked at Price Waterhouse's Office of Government Services in Washington, D.C., for five years when the partners in that office proposed her as a candidate for partnership. In a statement supporting her candidacy, the partners in Hopkins's office pointed to her successful two-year effort to secure a $25 million contract with the U.S. State Department, labeling it "an outstanding performance" and one that Hopkins carried out "virtually at the partner level."

The proposed partnership was a big step for both Hopkins and Price Waterhouse. Of the 662 partners at the firm at that time, only seven were women; of the 88 people proposed for partnership that year, only one—Hopkins—was a woman. Forty-seven of these candidates were admitted to the partnership, 21 were rejected, and 20—including Hopkins—were held for reconsideration the following year.

Before the time for reconsideration came, two of the partners in Hopkins's office withdrew their support for her and the office informed her that she would not be reconsidered for partnership. Hopkins then resigned. She sued Price Waterhouse under Title VII of the Civil Rights Act, charging that the firm had discriminated against her on the basis of sex in its decisions regarding partnership.

The trial started with a dispute over how Hopkins had performed as an accountant. The firm admitted that she "was generally viewed as a highly competent project leader who worked long hours, pushed vigorously to meet deadlines and demanded much from the multidisciplinary staffs with which she worked."

That was the good part; there was also, Price Waterhouse argued, a bad part. The firm claimed that, on many occasions, Hopkins's aggressiveness spilled over into abrasiveness. Long before her bid for partnership, partners evaluating her work had counseled her to improve her relations with staff members. Virtually all of the partners' negative remarks about Hopkins—even those of partners supporting her—had to do with her "interpersonal skills." Both "[s]upporters and opponents of her candidacy indicated that she was sometimes overly aggressive, unduly harsh, difficult to work with and impatient with staff."

So far, Price Waterhouse raised legitimate issues. But some of its partners went farther...into illegal territory. One partner described Hopkins as "macho." Another suggested that she "overcompensated for being a woman." A third advised her to take "a course at charm school."

Thomas Beyer, the partner who bore responsibility for explaining to Hopkins the reasons for the Policy Board's decision to place her candidacy on hold, delivered the *coup de grace*. In order to improve her chances for partnership, Beyer advised, Hopkins should "walk more femininely, talk more femininely, dress more femininely, wear make-up, have her hair styled, and wear jewelry."

This was a problematic statement.

Susan Fiske, a social psychologist and Associate Professor of Psychology at Carnegie-Mellon University, testified that the partnership selection process at Price Waterhouse was influenced by sex stereotyping. Her testimony focused not only on the overtly sex-based comments of partners but also on gender-neutral remarks, made by partners who knew Hopkins only slightly, that were intensely critical of her. According to Fiske, Hopkins's uniqueness (as the only woman in the pool of candidates) and the subjectivity of the evaluations made it

likely that sharply critical remarks were the product of sex stereotyping—although Fiske admitted that she could not say with certainty whether any particular comment was the result of stereotyping.

Price Waterhouse seemed to have a history of sex stereotyping, too. The trial court noted:

> One partner repeatedly commented that he could not consider any woman seriously as a partnership candidate and believed that women were not even capable of functioning as senior managers—yet the firm took no action to discourage his comments and recorded his vote in the overall summary of the evaluations.

The trial court found that Price Waterhouse had not fabricated its complaints about Hopkins's interpersonal skills as a pretext for discrimination. However, some of the partners' remarks about Hopkins stemmed from an "impermissibly cabined" view of the proper behavior of women. It held that Price Waterhouse had unlawfully discriminated against Hopkins on the basis of sex by consciously giving credence and effect to partners' comments that resulted from sex stereotyping.

The Court of Appeals affirmed the trial court's conclusion but departed from its analysis in one particular: It held that even if a plaintiff (Hopkins) proved that discrimination played a role in an employment decision, the defendant (Price Waterhouse) would not be found liable if it proved "by clear and convincing evidence" that it would have made the same decision in the absence of discrimination.

This was a critical distinction. And it brought the case up to the Supreme Court for a final reckoning.

According to Price Waterhouse, an employer violated Title VII only if it gave decisive consideration to an employee's gender, race, national origin or religion in making a decision that affected that employee. By this theory, even if Hopkins showed that her gender played a part in the employment decision, it would still be *her* burden to

show that the decision would have been different if Price Waterhouse had not discriminated. This is a tough thing to prove.

In Hopkins's view, an employer violated the statute whenever it allowed one of these attributes to play any part in an employment decision. Once she showed that this had occurred, the argument that Price Waterhouse would have made the same decision in the absence of discrimination was of secondary importance.

The Supreme Court concluded that, as often happens, the truth lay somewhere in between. It wrote:

> [Title VII] forbids an employer to "fail or refuse to hire or to discharge any individual, or otherwise to discriminate with respect to his compensation, terms, conditions, or privileges of employment," or to "limit, segregate, or classify his employees or applicants for employment in any way which would deprive or tend to deprive any individual of employment opportunities or otherwise adversely affect his status as an employee, because of such individual's...sex." We take these words to mean that gender must be irrelevant to employment decisions. To construe the words "because of" as colloquial shorthand for "but-for causation," as does Price Waterhouse, is to misunderstand them.

So far this reasoning worked against Price Waterhouse. However, to say that an employer could not take gender into account was not the end of the matter. That described only one aspect of Title VII. Another important aspect of the statute was its preservation of an employer's remaining "freedom of choice." The court concluded that the preservation of this freedom meant that:

> [A]n employer shall not be liable if it can prove that, even if it had not taken gender into account, it would have come to the same decision regarding a particular person. The statute's maintenance of employer prerogatives is evident from the statute itself and from its history, both in Congress and in this Court.

How would these prerogatives apply in a case sex stereotyping? The court noted that it had considered this argument—in various forms—several times before.

> In saying that gender played a motivating part in an employment decision, we mean that, if we asked the employer at the moment of the decision what its reasons were and if we received a truthful response, one of those reasons would be that the applicant or employee was a woman. In the specific context of sex stereotyping, an employer who acts on the basis of a belief that a woman cannot be aggressive, or that she must not be, has acted on the basis of gender.

An employer who objected to aggressiveness in women but whose positions required this trait placed women in an "intolerable and impermissible catch-22." They would be out of a job if they behaved aggressively...and out of a job if they did not. Title VII clearly forbade this sort of bind.

In this vein, the court considered the impact of the smirky remarks about Hopkins that some of the Price Waterhouse partners had made:

> Remarks at work that are based on sex stereotypes do not inevitably prove that gender played a part in a particular employment decision. [However], the stereotyping in this case did not simply consist of stray remarks. On the contrary, Hopkins proved that Price Waterhouse invited partners to submit comments; that some of the comments stemmed from sex stereotypes; that an important part of the Policy Board's decision on Hopkins was an assessment of the submitted comments; and that Price Waterhouse in no way disclaimed reliance on the sex-linked evaluations.

In finding that some of the partners' comments reflected sex stereotyping, the trial court had relied in part on expert testimony. Without directly impugning Fiske's credentials or qualifications, Price Waterhouse insinuated that "a social psychologist is unable to identify sex stereotyping in evaluations without investigating whether those evaluations have a basis in reality."

The Supreme Court ruled that this argument came too late. Fiske had testified during the trial—without contradiction from Price Waterhouse—that she had discerned sex stereotyping in the partners' evaluations of Hopkins. And she had explained that it was part of her business to identify stereotyping in written documents. The court believed her:

> It takes no special training to discern sex stereotyping in a description of an aggressive female employee as requiring "a course at charm school." Nor, turning to Thomas Beyer's memorable advice to Hopkins, does it require expertise in psychology to know that, if an employee's flawed "interpersonal skills" can be corrected by a soft-hued suit or a new shade of lipstick, perhaps it is the employee's sex and not her interpersonal skills that has drawn the criticism.

Hopkins still hadn't proved her case, though. Even though all of this evidence suggested that Price Waterhouse had illegally used sex stereotypes in its decision about Hopkins, it still did not *prove* anything. The Supreme Court did not have enough information to rule for either Hopkins or Price Waterhouse.

> The [trial court] acknowledged that Hopkins's conduct justified complaints about her behavior as a senior manager. But it also concluded that the reactions of at least some of the partners were reactions to her as a woman manager. ...even if we knew that Hopkins had "personality problems," this would not tell us that the partners who cast their evaluations of Hopkins in sex-based terms would have criticized her as sharply (or criticized her at all) if she had been a man.

So, Price Waterhouse prevailed—at least for a moment. The High Court held that, when a plaintiff in a Title VII case proved that her gender played a motivating part in an employment decision, the defendant may avoid a finding of liability only by proving by a preponderance of the evidence that it would have made the same decision even if it had behaved legally.

Finally, the Supreme Court reversed the trial court's judgment against Price Waterhouse on liability and sent the case back to that court for another trial.

BFOQs: The One Exception

One exception to the prohibition against gender discrimination occurs when gender is a bona fide occupational qualification (BFOQ) reasonably necessary to the normal operation of the business.

Conflicts between BFOQs and gender stereotyping often result in claims of disparate treatment. To be guilty of disparate treatment, an employer has to discriminate consciously against an individual on the basis of sex stereotypes.

A case in point: In the 1971 Supreme Court decision *Ida Phillips v. Martin Marietta Corporation*, a female job applicant sued under the Civil Rights Act of 1964 alleging that she had been denied employment because of her sex. The trial court in Florida granted summary judgment for Martin Marietta and the Court of Appeals affirmed. Phillips, the applicant, pressed her case to the Supreme Court.

Martin Marietta had bluntly informed Phillips that it was not accepting job applications from women with preschool-age children. However, it employed men with preschool-age children.

At the time Phillips applied, 70 to 75 percent of the applicants for the position she sought were women. Even more questionable: 75 to 80 percent of those hired as assembly trainees—the job Phillips sought—were women.

The Supreme Court held that a genuine issue of material fact existed as to whether family obligations of women having preschool-age children were demonstrably more relevant to job performance for a woman than a man. It wrote:

> The Court of Appeals erred in reading [the 1964 Civil Rights Act] as permitting one hiring policy for women and another for men—each having preschool-age children. The

existence of such conflicting family obligations, if demonstrably more relevant to job performance for a woman than for a man, could arguably be a basis for distinction under...the Act. But that is a matter of evidence....

Because the facts of the case didn't lend a conclusion as to whether Martin Marietta's terms counted as a BFOQ, the high court overturned the summary judgment.

In a concurring opinion, Justice Thurgood Marshall doubted that a prohibition against hiring women with young children could ever count as a BFOQ. He disagreed that:

a "bona fide occupational qualification reasonably necessary to the normal operation" of Martin Marietta's business could be established by a showing that some women, even the vast majority, with preschool-age children have family responsibilities that interfere with job performance and that men do not usually have such responsibilities.

Certainly, an employer can require that all of his employees, both men and women, meet minimum performance standards, and he can try to ensure compliance by requiring parents, both mothers and fathers, to provide for the care of their children so that job performance is not interfered with. Marshall went on to say:

But...I fear that...the Court has fallen into the trap of assuming that the Act permits ancient canards about the proper role of women to be a basis for discrimination.

Marshall then cited the EEOC's Guidelines on Discrimination Because of Sex, arguing that the prohibition against job discrimination based on sex in the 1964 Act was intended to prevent employers from refusing "to hire an individual based on stereotyped characterizations of the sexes." Even characterizations of the proper domestic roles of the sexes were not to serve as predicates for restricting employment or promotion opportunities.

In specific, gender issues are defined in terms of gender stereotyping. The EEOC's regulations provide:

> The Commission believes that the bona fide occupational qualification exception as to sex should be interpreted narrowly. Labels—men's jobs and women's jobs—tend to deny employment opportunities unnecessarily to one sex or the other.

The following situations do not warrant the application of the bona fide occupational qualification exception:

- The refusal to hire a woman because of her sex, based on assumptions of the comparative employment characteristics of women in general. For example, the assumption that the turnover rate among women is higher than among men.

- The refusal to hire an individual based on stereotyped characterizations of the sexes. The principle of nondiscrimination requires that individuals be considered on the basis of individual capacities and not on the basis of any characteristics generally attributed to the group.

- The fact that the employer may have to provide separate facilities for a person of the opposite sex will not justify discrimination under the bona fide occupational qualification exception unless the expense would be clearly unreasonable.

The Implied Mommy/Daddy Track

Another, less obvious form of stereotyping is the Mommy Track (now applied to men as well in the Daddy Track). Since it is not legal to prescreen potential employees about their child-rearing intentions, many employers assume that women of childbearing age will eventually either leave or cut back their hours in favor of family. While this is certainly the case for some, it is not for others. Regardless, this predetermination by employers is illegal, yet remains a challenge. Again, we see the stereotyping of gender roles hard to surpass. Men may never be able to bear children, and this is a fact of life that meets its challenge in a working world that strives to maintain gender equity.

Juggling work and family is not easy for millions of employees. But the challenge is even greater, say some women, when colleagues and managers question a woman's dedication and loyalty to the company simply because she chooses to have children. This was the claim of successful lawyer and mother Joanne Frasca, who filed a discrimination lawsuit against her former employer, Cleveland, Ohio-based Jones Day Reavis & Pogue. Let's look at this case in greater detail.

Frasca began working at Jones Day's Los Angeles office in 1983, after graduating from Notre Dame Law School. She developed a very promising career as a litigator and, in 1986, became the first woman to be named a law partner at the Los Angeles office. She married another Jones Day partner, and the couple had a son in 1992.

In her lawsuit, Frasca describes how she worked through her pregnancy. After her son was born, she took a total of six months off—three months of maternity leave and three months of accrued vacation. Even while on leave, Frasca continued to work. She prepared an appeal of a case she had successfully defended at trial, then successfully argued the appeal before the 9th Circuit.

Soon after she returned from maternity leave, Jones Day cut Frasca's compensation by 20 percent. Frasca claims the firm never explained the cut. Moreover, according to Frasca, the firm started treating her differently, excluding her from meetings in which she had previously participated. In one instance, Frasca claims that a client was kept away from her after the firm falsely told the client she wasn't available to handle a matter.

Hoping to avoid the tension at the firm, in 1994, Frasca transferred to Jones Day's Irvine, California, office. However, things only got worse. She claims that Thomas R. Malcolm, the partner who ran the Irvine office, disclosed to her that despite the fact that her billing was on schedule for the year, she was a poor role model for associates because she spent a great deal of time with her son. Soon after this, Frasca resigned from the firm.

Jones Day denied any discrimination in this case. The firm explained that company policy allows women to choose part-time partnerships

or make other arrangements if necessary. The company reportedly has 50 women among its 379 partners.

Jones Day countered that Frasca was not carrying her weight as a law partner. Her client hours were, on average, more than 400 hours less than the average of other California litigation partners, claimed Jones Day in documents filed in the case.

Malcolm states in court documents that after he told her the firm did not want her to leave, he informed her of alternative non-partner arrangements available to her if she did not want to work full-time. He also told her that she was not carrying her fair share of the workload, and that having a child at home was not a reason for not carrying her fair share and asked that she do so.

We will have to wait until this case plays out in court to see who comes out on top.

More and more women are joining the ranks of companies that require employees to put in long hours—especially with clients. Some of these women are likely to become working moms. As the Frasca case illustrates, companies that fail to recognize and address the issue are likely to see this as a growing employment practices liability problem.

Businesses looking for ways to improve gender relations need to examine and understand the research. Desjardins's work, "Gender Based Team Building," which we discussed earlier in this chapter, assumes four truths:

- All researched differences between the sexes are "gender related" and *not* "gender specific" and should never be used to perpetuate stereotypes of men and women.
- The "collusion of confusion" between and within the genders is one of the greatest barriers to establishing a business culture for all women and men to realize their full working potential.

- Change will only take place through well planned out programs with adequate time for interactive/participatory dialogue.

- Management must lead the way and model the desired culture of the organization.

Perhaps this last truth is most pivotal to managing sex at work in general, and more specifically, gender issues. Management must set the tone in a setting rife with politics, behavior and personal convictions, but each individual is the ultimate bearer of responsibility. Employees, in conjunction with management, must be a working unit, learning from mistakes and striving to achieve a culture that everyone can enjoy.

Can Subtle Discrimination Ever Be Proven?

A good example of a case where the plaintiffs successfully proved sexual discrimination and won a healthy settlement was *Jensen, et. al. v. Eveleth Taconite Company*. In this case, the women who sued Eveleth Mines in 1988, and its owner, Oglebay Norton, were some of the first to integrate northeast Minnesota's all-male mining industry. Nine years later, in 1997, they won their case following an appeals process whereby they asked for more money. A federal judge found that the women suffered sexual harassment and sex discrimination on the job.

Many men at the Eveleth iron mine had told the women they belonged at home. Sexual posters and graffiti, groping by male coworkers and inaction by supervisors contributed to the hostile environment. At trial, judge Patrick McNulty refused to hear from expert witnesses—a decision he was later criticized for—including the plaintiffs' psychologists. And, he excused the company, in part, by saying that the culture of the mining industry allowed sexual harassment. He awarded the women a total of $182,000.

Lloyd Zimmerman, a senior trial attorney with the Equal Employment Opportunity Commission, says that award had a dampening effect on sexual harassment cases. "I think it discouraged a lot of lawyers, in this community, from bringing that sort of case because after more than a decade of litigation the award that [the] women received

was in the range of $2,500 to $25,000. It was a dismal, shockingly low, result given what went into proving a pattern of practice of discrimination."

The plaintiffs challenged the award and McNulty's methods in the 8th Circuit Court of Appeals. Finally, in December of 1997, the appeals court vindicated them, issuing an opinion harshly critical of McNulty and calling for a new trial to determine damages. Fortunately, for the women, Eveleth opted to settle outside of another lengthy suit.

Although the exact settlement amount is confidential, plaintiff attorneys hint the per-person awards may exceed those in the $34 million Mitsubishi settlement. In that case, federal law capped the Mitsubishi awards at $300,000 per person. The Eveleth Mines case, however, was brought under Minnesota state law and faced no such restrictions. Punitive damages became part of the equation, and by January 1, 1999, 16 women had reached an agreement with Eveleth Mines.

This use of this case as an example case should not be seen to imply that claims are easy to prove, nor that wealth lingers in the sidelines for those that file a claim. Nevertheless, it's possible to succeed in a suit when legitimate claims exist and plaintiffs are willing to tolerate a long, exhaustive legal battle. And from the perspective of the employer, when discrimination and harassment runs rampant in a company, liability becomes a serious factor.

Sex, Lies and Modest Behavior

In Chapter 7, we reviewed the Miller Brewing case (*Mackenzie v. Miller Brewing Company*), where a former Miller executive sued the company for a slew of actions, including wrongful termination after he engaged a female colleague in inappropriate conversations about an episode of the "Seinfeld" television show. This, of course, became the most notorious—albeit media-frenzied—part of the case, when in reality the events that led up to his firing and subsequent action, were many and complex. In all, the case constituted a record of more than 10,000 pages and briefs from the parties totaled more than 300 pages. In the end, after all was said and done—from the initial $26.6 million

awarded to Jerold Mackenzie to the appeals process—every claim was dismissed.

This case played so prominently in the trial and even more so in the media reports—coined the "Seinfeld case"—that its attention drew opinions from other judges. One such judge filed a concurring opinion with the final judgment, but another—P.J. Wedemeyer—filed an opinion concurring in part and dissenting in part. His contribution to the record includes a unique discussion on what constitutes a lie. And, although his comments may border the theoretical and philosophical arena, which do not necessarily have to be linked to even this particular case, he demonstrates the subtlety of language and action.

The points made are very relevant to our look at how subtle acts can create a disconnect between one's true thoughts and one's perceived actions. We'll break down some of what Wedemeyer says, and then bring this chapter to full circle by looking back at Jacqueline Naylor's case. Here, Wedemeyer shows how one's actions can easily be misrepresented when one employs the faculty of speech[2]:

> We, as humans, are social beings by nature and destined to communicate with our fellow human beings. One of the means that we possess for communicating is the faculty of speech. Speech is an instrument by which a mind is brought into contact with another mind, by which the thoughts of one are conveyed to another. To use speech to convey a thought of the mind, which is not truly a thought of the mind, is to use the faculty of speech contrary to its primary purpose. Therefore, the right use of speech, as determined by its very nature, is to make known the thoughts of the mind to signify what one thinks is true. When one intentionally uses words or actions which belie one's inner convictions, one misuses the faculty of speech. To do so, is then to signify what is not true. It is the absence of conformity between the mind and speech which constitutes a lie.

[2]Part of Wedemeyer's discussion on fundamental duties not to lie incorporates ideas from John H. Garvey's *What Are Freedoms For?* pages 195-206 (Harvard University Press.)

Wedemeyer suggests that people, under the tradition of preserving fundamental individual and societal rights, have a fundamental duty not to tell untruths or intentionally misrepresent themselves; to do so is contrary to people's nature—and thus constitutes a lie.

In the case of *Mackenzie v. Miller Brewing Company*, one of the claims brought against Miller involved misrepresentation on the part of Miller. This is what provided the basis for Wedemeyer's discussion and partially dissenting opinion.

We need not delve into more facts of the case or Wedemeyer's dissenting arguments. Yet, his points serve as a general perspective worth noting. In the case that opened this chapter, a woman filed a claim of sexual harassment long after a culmination of seemingly innocuous events had mounted.

The man responsible, Joseph Schneider, repeatedly approached Naylor with affectionate gestures: sending cards, giving money, touching her to the extent that she felt uncomfortable. Naylor never expressed her disapproval and, from that outlook, one could probably argue that Schneider's advances were mere flirtations—attempts to get her to respond and liken his apparent interest.

For the most part, Schneider's advances were subtle, while on the other hand, Naylor's failure to make her intentions clear and apparent allotted to a misrepresentation.

Can we make a case for saying that Naylor "lied" to Schneider prior to alleging harassment and filing a claim? According to Wedemeyer's argument, we can view Naylor's passive actions while in the presence of Schneider (e.g. accepting gifts, agreeing to field trips and long, conversational walks with him and inviting him into her home) coupled with her active ones while alone (e.g. her throwing out or tearing up the cards) as misrepresenting her true convictions.

In essence, Naylor didn't use her faculty of speech to convey her convictions to a man that obviously caused her great emotional harm. We do not need to condone Schneider's actions, which were eventu-

ally regarded as "offensive" occurrences that did not rise to the level of being sufficiently severe and pervasive. But neither—as rational and responsible human beings—can we condone the apparent victim's inaction on a reasonable level prior to seeking legal redress. As we've seen before, the law refrains from policing sexually charged human behavior, much like that evidenced by Schneider's actions.

Enter the concept of *personal responsibility*—of tolerating certain behavior and knowing when the law can help end or compensate for misbehavior. Innocuous conduct, whether sexually charged or not, cannot meet the burden of proof, especially when it is not combined with adverse employment action. For example, if Naylor's denial of Schneider's advances had resulted in his terminating her job, then a legitimate cause of action would have existed—and the case would have had an entirely different end to it. But that wasn't the case here, and it often isn't the case in many frivolous legal pursuits.

Act Like an Adult...Not an Adulterer

It's easy to say that someone's sex life is a private matter. At a cocktail party or at dinner with friends, this notion doesn't require too much effort to defend.

But when you show up to work on Monday morning, this notion of "a private matter" is tested. Employees' private lives—like a boss's private life—tend to bubble up to the surface in the workplace. Business has become more intense and, therefore, more personal in the last 15 years. Easy platitudes about other people's business fall apart when people define themselves sexually—gay or straight, sexually active or celibate—and then demand recognition on the job.

The trouble is more than just the personal politics of sexual identity. It comes in smaller pieces.

People who work together often tease one another about personal traits and quirks. This can be a natural part of the bonding process that colleagues share. But it can swerve into comments about a person's sex life...especially if that person makes some peripheral matters of his or her sex life publicly known.

Sex seeps into business from new directions all the time. It is undoubtedly a powerful advertising tool; and today's ambitious firms use it more effectively than their grandfathers ever dared. When an ad agency produces a car campaign that plays heavily on sexual *double entendre*, how can it credibly discourage a young account exec from making a pass at a tattooed temp? It probably can't—even if it has clear guidelines in its employee handbook prohibiting harassing come-ons.

There's also the complex notion of professionalism. An organization can cultivate a workplace or workforce that conveys some desired image. A particular job applicant or employee's *sex* (read: gender) can't be considered as it relates to that image; but that person's *sexuality* (read: sex life and, until a law like ENDA is passed, sexual orientation) can be.

Most people don't understand these subtle distinctions. Many think of sex at work as sexual harassment...and little else. Worse still, they think of sexual harassment as a kind of lottery event that means big money for the victim. As we've seen throughout this book, it's not.

The law puts a lot more responsibility on individuals—both employees and managers, harassers and victims—to work out resolutions among themselves. That is, to act like adults. Clearly, not all working people can meet this relatively low standard.

Sex is a topic that fills libraries, Web sites and professional careers. So, why do so many intelligent, educated people have such problems with it? Why do they make such obvious mistakes?

The problems may stem from the fact that sex is a primal instinct. It has permeated human culture for centuries and, arguably, shaped our course of history through the ages. It combines mankind's concepts of mortality and transcendence with basic notions of beauty and strength. How can impulses and acts that combine all of these things *not* be problematic?

On certain levels, we humans are getting better about dealing with these problems. Our attitudes toward sex have changed steadily, often with the tides of science and politics. From Adam and Eve to the Age of Chivalry, from the introduction of the Pill to the unsuccessful impeachment of a President who prevaricated about sex with a White House intern, our tolerance for each other's sex lives—foibles and even misbehavior—has increased dramatically.

On another level, our growing tolerance has been matched by a growing prurience. Our appetite for hearing about each other's sex lives—foibles and especially misbehavior—has also increased dramatically.

From the *Jerry Springer* television show on the low end to the novels of Philip Roth on the high, our culture is amused by its confusion about sex.

But the joke stops when the locus changes to the workplace. Whether they watch Jerry Springer or read Philip Roth, people aren't amused about anything that affects their pay and benefits.

You've read this book because, from one perspective or another, you are concerned about sex at work. And, for this reason, you can't afford to treat the subject as smirkingly as culture vultures often do.

We began this book with references to recent notorious cases like the Hill/Thomas hearings and Bill Clinton's libidinous self-control problems. By the time you read this, a new sex scandal—even more salacious than the previous ones—may have landed on the front page of our daily newspapers. As the *New York Times* has noted with some contempt:

> Virtually every magazine on the newsstand, every book in the drugstore, half the stores in the tabloid press, vast quantities of television entertainment and movies galore depict sexual philandering as a common and casual pastime.

Interestingly enough, while we've come a long way in understanding the *mechanics* behind sex and gender—the connections between sex chromosomes, sex-linked characteristics and hormones—we certainly have not mastered the *management* of sex. That is, how to handle its incessant presence at work...and everywhere else.

For most of us, managing sex is not something we leave to a boss, a company or a colleague. Rather, it's something we find in ourselves—in the way we choose to act upon or restrain from our desires, much in the same way we choose to act in the right or the wrong. But there's a flipside to this preference: We have to accept some bumps and bruises along the way...as we bang up against other people and *their* choices.

And we can't run to court every time a signal is misinterpreted or a joke crosses the line of taste.

Despite the risks, we have to allow our colleagues the same prerogatives that we expect for ourselves. This is when the area between private and public (read: work) is fuzzy, and our search for defining guidelines leaves us feeling ill-equipped. How we perceive the role of sex in our lives—from healthy to illegal relationships—and how we experience that role out in the real world sometimes aren't equal.

In fact, as we've seen throughout this book, a disconnect exists between our *perceived* role of sex in our lives and how the law views our sexual choices when settling claims. Some harassers genuinely believe they've done no wrong; some adulterers insist they are honorable people.

The workplace is governed by commerce and law; it can't indulge in such self-serving delusions.

So what can *you* do to make sense of sex at work and its inevitable consequences on the personal, private side? I believe, as do many others, that employees should expect privacy and respect in the workplace—but that they must be willing to act responsibly in return.

In terms of dating, for example, this bargain would mean the freedom to carry on a personal relationship outside of the workplace. But, if you choose to complicate your working environment by dating a colleague, it would mean accepting the related responsibilities of maintaining productivity and professionalism...and perhaps some related costs.

(The research I've done and experiences I've had working on this book suggest that dating coworkers are fast becoming an accepted reality of the new economy. And it's not a problem, as long as both people in the relationship make a conscious effort to keep personal issues out of work and respect their coworkers.)

We all have the right to be heterosexual, homosexual, bisexual or celibate. Similarly, we all have the responsibility to manage our working and personal lives, so that the two can be mutually productive and fulfilling.

In the ideal work community, employees would be hired and retained on the basis of their qualifications and job skills. This isn't always the

case, in part because sex can complicate the workplace. Your attraction to a coworker, your need to keep your homosexuality secret or your problem with unwanted advances from a supervisor all impact the quality and quantity of work you do.

Hard realities of sex remain workplace issues—and may always linger, no matter how far we progress. Women are sometimes hired because of their physical attractiveness to an employer, then treated badly when they don't return the sexual interest. Gay people who keep their sex lives private are sometimes hired by conservative companies, then fired or blackballed when their sex lives become known. Men are sometimes victims of reverse discrimination, vulnerable to hypersensitivity to harassment and gender politics.

In researching and writing this book, I came across hundreds of cases that underscore the challenging nature of sex at work, as well as the unfair (and, often, illegal) actions taken against individuals simply trying to live their lives. I also, however, encountered numerous situations of abuse and mishandling by employees and employers who really believed they weren't doing anything wrong.

This again drives the point home: A disconnect exists between not only a perceived role of sex and the law, but also in the way I, for example, perceive sex and the way *you* perceive sex. This is how a level of subjectivity is inexorably linked to sex. Our job—as members of the new economy—is to accept the links and manage them in a way that doesn't overwhelm the reasons we are at work: to create value and be compensated for the effort.

As you've seen in this book, recent case law demonstrates that inappropriate behavior in the workplace isn't always grounds for a harassment or discrimination claim. Profanity, rude jokes and gestures may be offensive—but they aren't always illegal. These bad behaviors, by both employees and employers, push cases into the legal system that simply should be settled within the organization. Forcing the courts to act as the "behavior police" is a waste of everyone's time. Regulating behavior (or privacy, for that matter) is a chore the courts are not eager to take on.

Why do some believe they can engage in inappropriate behavior with coworkers? Along with Gap fashions and casual Fridays has come another level of informality at work: the implication that colleagues are friends or companions. In this capacity, coworkers are exposed to situations that we would have disclosed only to our closest friends just a couple of decades ago. And as we spend more and more time at the office, professional lives have merged into personal lives and really, no one can make an easy distinction.

Sex won't go away from work. In fact, we're only going to see more of it there. The tools within this book should help you manage the minefield—as well as help you maneuver your way through, should you find another's actions to be offensive.

Some workplace law experts end up exasperated, throwing up their hands and stammering about sex as part of the human condition. But sex isn't part of the human condition. Sex *is* the human condition.